Watercolour
Tips & Techniques

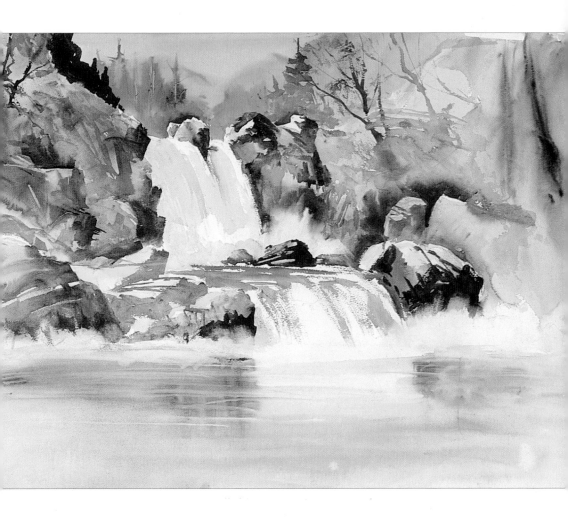

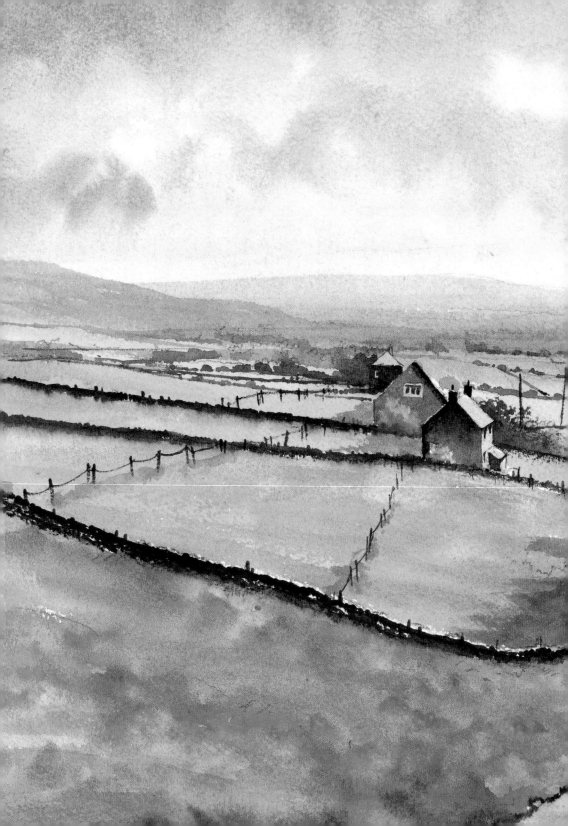

Watercolour
Tips & Techniques

ARNOLD LOWREY, WENDY JELBERT
GEOFF KERSEY & BARRY HERNIMAN

SEARCH PRESS

This edition first published in Great Britain 2011 by
Search Press Limited, Wellwood, North Farm Road, Tunbridge Wells,
Kent TN2 3DR

Reprinted 2012, 2013

Published in Great Britain 2007 as *Watercolour Tips & Techniques*, based
on the following books published by Search Press:

Starting to Paint by Arnold Lowrey, 2003
From Sketch to Painting by Wendy Jelbert, 2003
Perspective, Depth & Distance by Geoff Kersey, 2004
Painting Mood & Atmosphere by Barry Herniman, 2004

Text copyright © Arnold Lowrey, Wendy Jelbert, Geoff Kersey and Barry
Herniman 2007

Photographs by Search Press Studios except those on pages 282, 283,
284, 305, 314, 318, 332, 344, 357, 358/359, 362, 373 which are by
Barry Herniman

All photographs, except for the above, copyright © Search Press Ltd.
2007

Design copyright © Search Press Ltd. 2007

ISBN: 978 1 84448 662 5

The Publishers and author can accept no responsibility for any
consequences arising from the information, advice or instructions given
in this publication.

Readers are permitted to reproduce any of the paintings in this book
for their personal use, or for the purposes of selling for charity, free of
charge and without the prior permission of the Publishers. Any use of
the paintings for commercial purposes is not permitted without the
prior permission of the Publishers.

Suppliers
If you have difficulty in obtaining any of the materials and equipment
mentioned in this book, please visit the Search Press website for details
of suppliers: www.searchpress.com

Alternatively, you can write to the Publishers at the address above, for
a current list of stockists, including firms which operate a mail-order
service.

Publishers' note
All the step-by-step photographs in this book feature Arnold
Lowrey, Wendy Jelbert, Geoff Kersey and Barry Herniman
demonstrating how to paint in watercolour. No models have
been used.
There are references to sable and other animal hair brushes
in this book. It is the publishers' custom to recommend
synthetic materials as substitutes for animal products
wherever possible. There is now a large range of brushes
available made from artificial fibres, and they are satisfactory
substitutes for those made from natural fibres.

Printed in Malaysia

Page 1
Waterfall
by Arnold Lowrey

*The focal point of this composition is the water cascading down
between the rocks, so it is important to make this the lightest
area of the painting. The dark tones used for the background
sky and trees emphasize the brightness of the water at the
top of the falls, as do those for the rocks on either side. The
overall shapes of the foam at the bottom of each section of the
falls must be made interesting and, invariably, you will have
to make it so. The soft area of water in the foreground, with
its horizontal and vertical strokes, contrasts with the drama
defined by the diagonal strokes in the rest of the painting.*

Pages 2/3
Holmfirth
by Geoff Kersey

*I came across this scene while walking in the hills above the
attractive Yorkshire town of Holmfirth. The natural perspective
in the landscape leads the viewer's eye down the path, along
the line of trees and into the middle distance. The outlines are
drawn in, then masking fluid applied to highlight areas on the
buildings and walls. Washes are then laid in, the colours built
up, then details added.*

Opposite
Shawford River
by Wendy Jelbert

*A sketch of this scene was made before starting to paint,
then some of the elements moved to make a more pleasing
composition. The tree was too central originally, so I decided
to move it slightly to the right. There were more figures in my
sketch, but I removed them, leaving only the artist sketching on
the riverbank. The foreground is embellished with spiky grasses
and weeds, which add more interest to the painting.*

Pages 6/7
Church Rock, Broadhaven South
by Arnold Lowrey

*This is a quiet, peaceful painting, enhanced by using lots of
vertical and horizontal strokes and by keeping the tonal range
between light and middle tones. The sky and sea were both
painted wet, starting with a wash of aureolin followed by
washes of permanent rose and cobalt blue.*

Contents

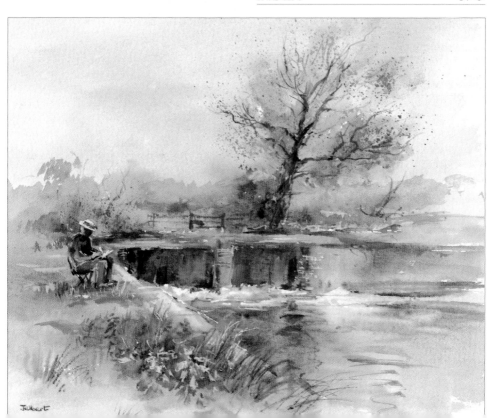

Starting to Paint

ARNOLD LOWREY

Learn about materials, techniques, choosing colours, painting skies,
trees, water and more. Six detailed step-by-step demonstrations show
you how to start using watercolours.

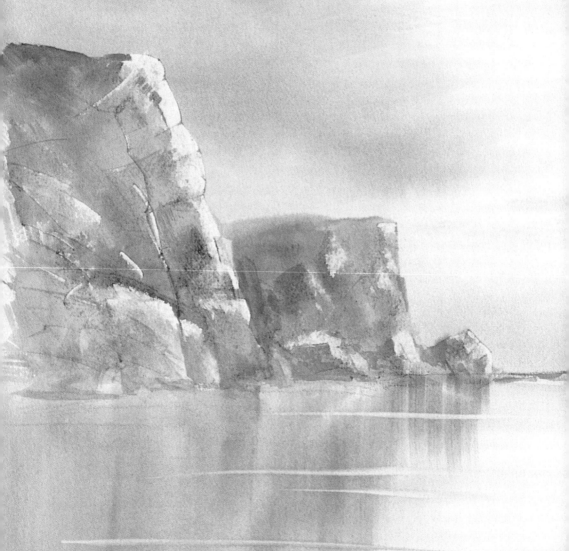

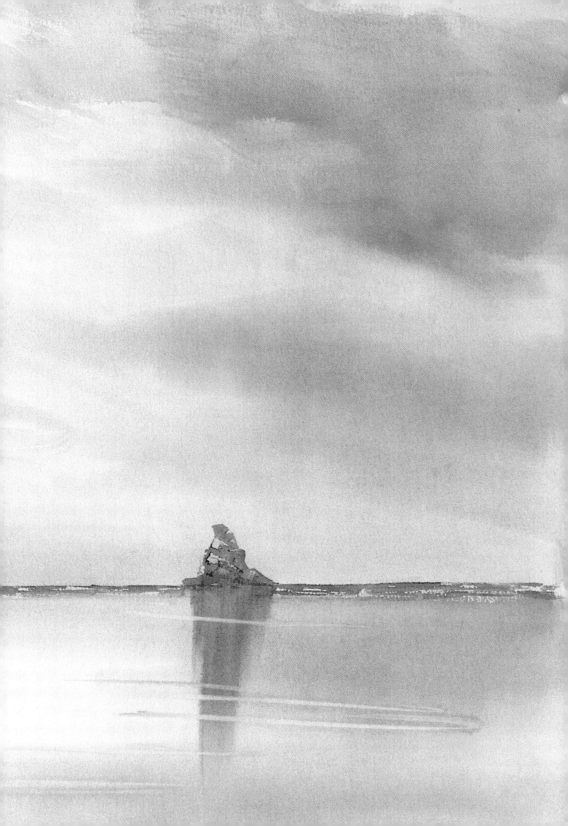

Introduction

So, you want to paint! And you have decided on watercolour. Well, the downside is that you have not picked the easiest medium. But you have picked a medium that creates the greatest light and luminosity, and the one which lends itself to small parcels of time. It also has other advantages, in that the equipment is small, less messy than most mediums and does not smell.

Having got that out of the way, let us explore your options to progress in this exciting medium. There are many ways of painting in watercolour and, in this book, I show you some of the important ones, in particular, the way I paint.

The most frequent questions I get asked are: 'What do I need?' 'What do I paint?' and 'How do I do that?' I hope to answer these points by taking you, step by step, through a series of projects. These include tips and techniques which, I hope, will help you produce effective watercolour paintings. These tips have been learned over the years, and were important to me when mastering this elusive subject. If only someone had shown me some of them when I started on this great journey.

Apart from dealing with the control of water, the use of tone and colour mixing, my most important tip is to fill your paintings with interesting shapes. To my mind, good shapes make great paintings, so you will find many references to this subject.

I was trained as an engineer and was always taught to find out how things worked. This is good advice, and I hope that my tips and techniques will show you the *mechanics of success*, stage by stage.

There are four great enquiries in life – philosophy, theology, science and art. You are about to embark on the last, a journey that will never end. It is not easy. If it were, no one would want to do it! So, pick up your brushes and start!

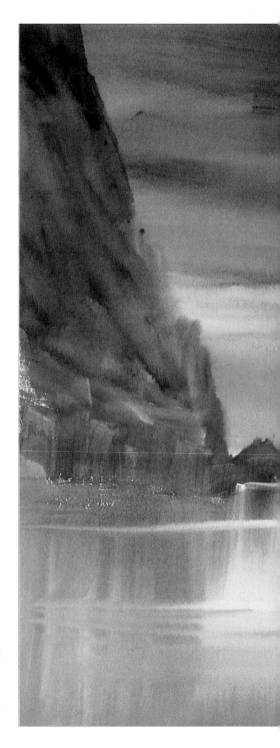

Boats at Sunset
Size: 635 x 495mm (25 x 19½in)

The sky colours in this dramatic sunset were painted wet into wet. Strong cadmium yellow and cadmium scarlet were laid in first, followed by washes of cobalt blue, ultramarine blue and a mixes of ultramarine blue and cadmium scarlet. The land areas were painted with a thirsty brush and mixes of ultramarine blue and cadmium scarlet. The sea contains similar colours to the sky. Finally, the boats and their reflections were added, using mixes of ultramarine blue and cadmium scarlet.

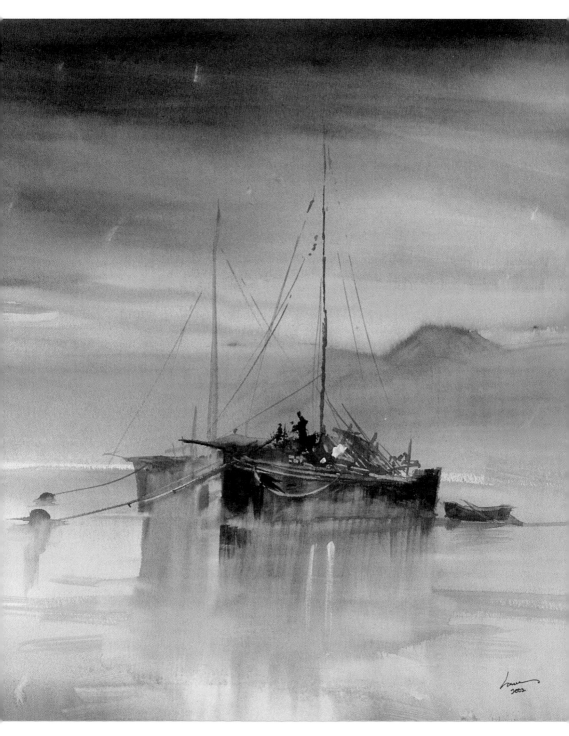

Materials

Art shops are like Aladdin's caves. There are so
many types of paint, paper, brushes, etc., that the
beginner can be totally overwhelmed. Even more
confusing is that different manufacturers have
different names for the same product. For example,
a cool blue paint can be called Winsor blue, intense
blue, phthalo blue and even Joe's blue. This does
not help you, so here are a few guide lines to
selecting equipment.

PAINTS

Watercolour paints are made in artists' and students'
qualities. I recommend that you start with student
colours, then work up to the more expensive ones
later. Both qualities are available in tubes and pans.
Tube colours produce effects that are extremely
difficult, if not impossible, to create with the solid
pan colours. However, pans have the advantage of
being portable and convenient. Do not be tempted
to buy cheap (unbranded) colours as these can turn
out to be not the bargain you had hoped for!

I tend to use tubes of artists' paints, but I often
use the student quality for earth colours (see page
14 for my palette of colours).

BRUSHES

There is an enormous variety of brushes designed for
the watercolourist. You may be tempted into buying
lots of brushes for particular applications, but you
can get by with just a few as each can do a variety
of jobs. Someone once said: 'Get married to your
brushes – know what they will and will not do!'

Sable hair brushes hold a great amount of water
and also give it out at a controlled rate. They last a
long time, but they are quite expensive.

Synthetic brushes are much cheaper than sable.
They are very hard wearing, but do not give you as
much control with the water.

Brushes with a mixture of synthetic and sable hair
are my suggested compromise. They are reasonable
both in price and in the application of colour.

Other natural hair brushes include pony and goat
hair ones, which are useful for applying washes, and
squirrel hair brushes (the softest of all) which are
great for glazing over existing work

Bristle brushes, usually used for painting with oils,
are good for lifting out mistakes and softening edges.
They also hold a lot of pigment with little water – a
must for painting powerful strong colours.

I use a 25mm (1in) sable/nylon, flat brush (also
known as a one-stroke brush); a 13mm (½in) nylon
flat brush with a scraper end; a No. 8 sable, round
brush; and a No. 3 sable/nylon, rigger brush. I also
use a 25mm (1in) bristle brush for spattering.

Palettes

Again there is a wide range of palettes available, from large studio palettes to small portable ones, some with empty wells for filling with tube paints and others filled with pans.

Apart from the spaces for your colours, water-colour palettes should have areas for mixing paint with controlled amounts of water and some wells for mixing washes. One of the problems of using tube paints is that unused paint dries when not in use. Some palettes have a lid which, in combination with a damp sponge, helps to keep unused paints moist.

I use two palettes. My studio palette, which I designed myself, has open-ended paint containers, a slightly angled, flat mixing area, a couple of wells for wet washes and a lid which locates under the palette to catch excess water. When not in use, the lid, together with a damp sponge placed on the mixing area, keeps the paints moist. My other one, a small enamelled-brass, portable palette for tube paints, is a joy to use in the field.

WATERCOLOUR PAPER

Do use proper watercolour paper. Do not try and save money by painting on, say, cartridge paper; you will never get a worthwhile result. Watercolour paper is made from either cotton (often called rag paper) or wood pulp, and is available in different thicknesses (or weights), surface textures and sizes. Most papers are treated with size which helps keep paint pigments on the surface.

Cotton paper produces glorious washes of colour that are so addictive in this medium. Wood pulp paper is less expensive but, to me, it is more absorbent than cotton paper. However, I suggest that beginners use wood pulp paper, as you can sponge out any mistakes more easily. Remember, the man who never made a mistake, never made anything! So, practise your techniques, first on wood pulp papers, then work up to the cotton ones. Eventually, you will choose your own personal favourites.

Sheet size
Although sheet sizes are now measured in metric units, the old imperial names are still used for some sizes. Full sheets of watercolour paper are called *imperial* and measure 760 x 560mm (30 x 22in), but you can also obtain larger sizes such as *elephant* and *double elephant*, or 10m (33ft) length rolls. Naturally, these sizes are for special work.

You can also buy smaller sizes of paper which are usually supplied as ring-bound pads or blocks. The latter consist of several sheets of paper glued together around their edges to form a solid block. This is ideal to paint on, and a small gap in the glue is provided for separating the sheets with a paper knife. So, you can either buy the full sheets and cut them to the size you want, or buy the pads or blocks for convenience.

Thickness
The thickness of paper is measured in grams per square metre (gsm), but you can still find some marked in pounds (lb). Thick paper, although more expensive, is less likely to bend out of shape when wet, and will hold more water. A good weight to start with is 300gsm (140lb).

Surface textures
There are three basic surface textures available: hot pressed (HP) papers (also known as fine or fino papers) have a smooth finish; cold pressed (NOT – meaning not hot pressed) papers have a medium grade finish; and rough, which speaks for itself. Below are samples of these three types of surface finish, each painted with similar brush strokes.

Hot pressed (fine or fino) paper

Cold pressed (NOT) paper

Rough paper

SUPPORTS

Single sheets of watercolour paper must be supported while you are painting. Any stiff board will do, but I use a piece of plastic-coated hardboard and I fix my paper with spring clips in the corners.

EASELS

Watercolours should be painted at an angle so that spare water flows downwards – puddles can form on flat paper. If you are painting indoors, a table with something underneath to tilt your paper support at, say, 30° will prove adequate. Outdoors, especially when painting on large sheets of paper, an easel is essential. Once again, the choice is quite vast and ranges from small table easels to large freestanding ones. You can also buy box easels which, as the name implies, includes a box for holding your equipment and paper; these are extremely firm structures but can be very heavy when full of kit!

For the beginner, I would suggest an aluminium or steel telescopic easel; these are inexpensive, robust, relatively lightweight and easy to assemble. Some wooden easels can be awkward to assemble and, if they get wet, the wood can expand and make them difficult to dismantle.

OTHER EQUIPMENT

I use soft **4B pencils** and **graphite sticks** for sketching and for drawing the outlines of a composition on watercolour paper.

A kneadable, '**putty eraser**' is useful for removing unwanted marks from watercolour paper; it is extremely soft, absorbs the graphite into itself and does not damage the paper.

A **razor blade** is extremely useful. Use the flat of the blade for scraping shapes out of wet paint and its tip for scratching highlights out of dry paint.

Paper towel is ideal for lifting out colour, drying brushes and mopping up spills. Small pieces of **sponge** are also useful for lifting out colour.

A roll of **masking tape** is always useful, but I tend to limit its use to creating sharp, straight horizons.

Process white is not a true watercolour but it is a very opaque white which is ideal for creating smoke, snowflakes and spray. It can also be mixed with watercolours to make opaque tones.

A **bristle brush** is useful for spattering tiny spots of spray or snow.

A hairdryer and water sprayer can prove useful additions to your workbox.

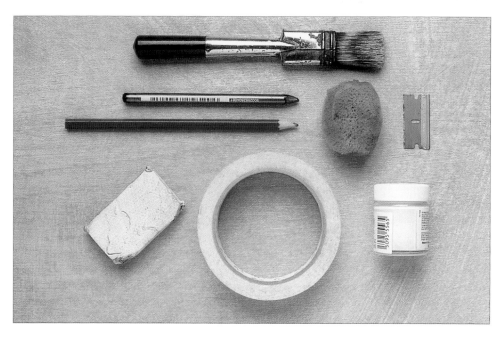

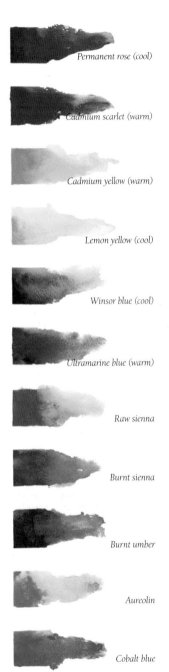

Permanent rose (cool)

Cadmium scarlet (warm)

Cadmium yellow (warm)

Lemon yellow (cool)

Winsor blue (cool)

Ultramarine blue (warm)

Raw sienna

Burnt sienna

Burnt umber

Aureolin

Cobalt blue

Winsor green

Painting techniques

In this chapter, I talk about my palette of colours, how I mix colours, and the different brush strokes and other techniques that I use when painting.

MY COLOUR PALETTE

The twelve colours shown on this page are always in my palette. It consists of two of each primary colour (red, yellow and blue), three earth colours, and three special colours (a yellow, blue and green). It is a range of colours that I have developed over the years; some of my original palette of colours remain, others have been replaced and new colours added.

COLOUR MIXING

It is important to understand the basics of colour mixing or you will never get beautiful colours in your pictures. As children, we were taught how to mix red, yellow and blue (the primary colours) to create orange, green and purple (the secondary colours). Beautiful, clean secondary colours can only be created from a mix of two primary colours however and, unfortunately, there are no perfect primary colours available. Cool reds such as permanent rose and alizarin crimson contain touches of blue, whereas warm cadmium scarlet and cadmium red contain touches of yellow. Similarly, yellows can have touches of red or blue, and blues can have touches of red or yellow.

To overcome this problem, my colour wheel, shown opposite, has two tones of each primary colour. Clean, bright secondary colours are produced by selecting two primaries that only contain touches of each other. Selecting two colours that contain a third primary colour will give dirty or greyed colours. However, just because a colour is described as dirty, does not mean that you cannot use it in your painting. The dirty green shown in the middle of the colour wheel might well appear in oak leaves, and earth colours (browns) are also dirty colours. Paler tones of all colours can be obtained by adding more water.

Red, yellow and blue, mixed together make black. Blacks can be mixed as cool or warm colours depending on the proportions of the three primaries. They can be thinned with water to greys, but more useful greys can be mixed in other ways (see page 16).

You may think it wasteful to use some of your valuable watercolour paper practising colour mixes. It is better to make mistakes on small pieces of paper, and learn from them, rather than to ruin a painting on a large sheet.

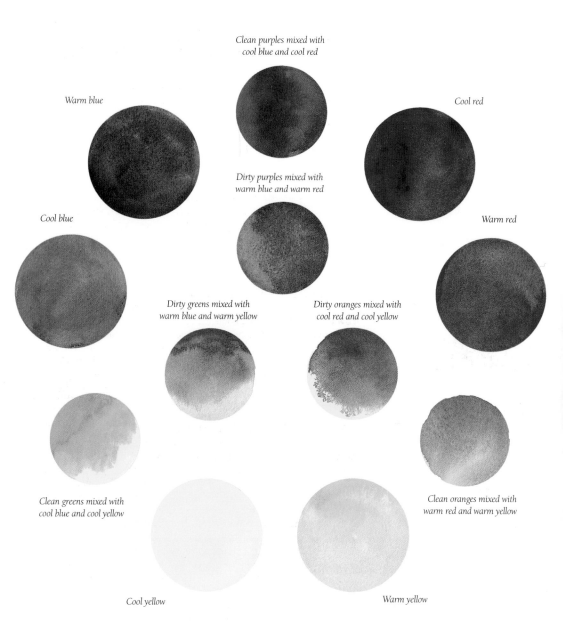

Clean purples mixed with
cool blue and cool red

Warm blue

Cool red

Dirty purples mixed with
warm blue and warm red

Cool blue

Warm red

Dirty greens mixed with
warm blue and warm yellow

Dirty oranges mixed with
cool red and cool yellow

Clean greens mixed with
cool blue and cool yellow

Clean oranges mixed with
warm red and warm yellow

Cool yellow

Warm yellow

15

Greens

Green is the colour used most badly by beginners. Quite a variety of ready-mixed greens is available to the artist, but I like to mix my own. Below I have included some greens that can be mixed from the two blues and yellows in my palette.

I do have the ready-mixed Winsor green in my palette, but I normally mix this with other colours, such as burnt umber, to make different shades.

Burnt umber and Winsor green

Winsor blue and cadmium yellow

Ultramarine blue and cadmium yellow

Winsor blue and lemon yellow

Ultramarine blue and lemon yellow

Blacks and greys

The earth colours in my palette are useful short-cuts for mixing natural blacks and greys. A mixture of burnt umber and ultramarine blue, for example, gives a strong black and some good greys. Burnt sienna and Winsor blue will also produce a good black and some slightly green greys.

For a really transparent grey, try mixing Winsor green and permanent rose.

Winsor blue and burnt sienna

Winsor green and permanent rose

Burnt umber and ultramarine blue

BRUSH STROKES

You do not have to own a lot of brushes to make different marks. This is evident from all the shapes shown here, which were made with a 25mm (1in) flat brush, a No.8 round brush and a No. 3 rigger brush.

Hold the chisel end of a flat brush at 90º to the paper to make these marks.

Use the full width of a flat brush to paint areas such as this roof, working each stroke from the ridge down to the gutter line.

Use the corner of a flat brush, held level with the paper, to make these marks.

Hold a flat brush parallel to the paper, then drag it across the paper to create this sparkled mark.

Twist a flat brush as you draw it across the paper to make these marks.

Hold a flat brush at about 45º to the paper, then, without lifting it off the paper, wiggle the brush up and down as you move across the paper.

The rigger brush is designed to make continuous, long, thin lines. However, if the brush is pushed down to the hilt, it will produce thicker lines which can then be made thinner as the brush is lifted off the paper.

All of these marks were made with the round brush.

PAINTING TECHNIQUES

On these pages I show you some painting techniques that I find most useful. They are quite easy to master, but it is worth experimenting with them on scraps of watercolour paper before using them in a painting. I have cross-referenced each technique to its application in one or other of the projects.

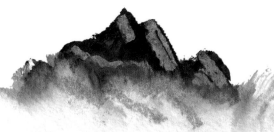

The texture on these rocks was created by scraping the handle of the scraper brush through wet paint. The foamy water at the base of the rocks is the result of lifting out colour with a sponge.

Single-colour wash painted on to wet paper. A plain wash can be worked by applying the same mix all over the wet area. However, for skies it is better to create a gradated wash by gradually diluting the mix as you work down the paper (see page 41).

You can create some fantastic effects with this mingling (wet into wet) technique, but you must work quickly. Mix each colour to the correct tone in a flat palette, wring out the brush, pass it just once through the wash then apply it to the wet paper (see page 82).

Lifting out colour with a sponge is an ideal technique for creating spray and clouds (see page 70).

... lifting it out with a piece of paper towel is good for hard-edged clouds (see page 49).

... while using a thirsty brush to lift out colour is useful for more defined shapes, such as the reflections of buildings (see page 54).

For this dry on dry technique, neat colour is applied with a damp brush held quite flat. Useful on Not and rough papers for creating sparkle on water and texture in foliage (see page 45).

Glazing or laying one colour over another that has been allowed to dry, shows how the transparency of watercolours can be used to create subtle changes in colour (see page 44).

This is a dry into wet technique, where a thirsty brush loaded with colour is applied to a wet background (see page 52).

Use the flat of a razor blade to scrape into wet paint. A good technique for trees, as shown here, and for rocks (see page 61).

These marks were made by scraping into wet paint with the handle of the scraper brush. Varying the angle of the scraper to the paper will change the width of the marks. A good technique for drawing in spindly tree trunks (see page 42).

These marks, created by adding water to half dry paint, are known as backruns or cauliflowers. Unintentional backruns can ruin a painting, but the technique is useful for denoting mistiness in distant trees (see page 52).

Starting to paint

When I raised the question about what to paint with my first teacher, he said: 'Whatever you want to paint, I will help you to paint it better!' Although it is important to try painting different subjects, when you are starting out, choose one that interests you and this interest will be reflected in your efforts. If you like boats, paint them, but do not pick a difficult three-masted schooner to begin with.

We are all very selective in what we want to see. A group of people looking at the same scene will all have different feelings about it; some may love it, others could be quite put off. The more you paint,

the more you realise how complex and interesting this subject is. So do not rush in with the brush; take time to absorb the scene, then think about painting what really interests you about it.

Beginners find painting on site a frightening thought, so why not start by working from photographs as a reference source and extract the relevant information to build your painting.

It is a good idea to work from a selection of photographs of the same subject. These could include a panorama of the whole scene and some closer images as shown below.

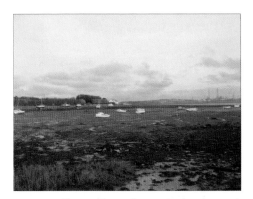

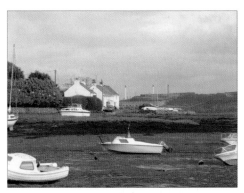

These two photographs were taken from the same viewpoint. Wide-angle views do not necessarily make good compositions, but they do help to define the mood of the subject. The second image, taken with my zoom lens, shows much more detail and the variety of interesting shapes makes it a reasonable composition.

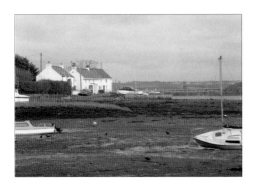

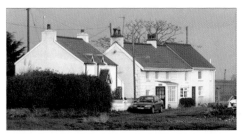

Again, these two images were photographed from the same viewpoint. For these images, I moved my viewpoint further to the right so that I could see more of the front of the cottages.

You do not have to paint everything you can see. Select a part of the scene that has a point of interest (focal point) which attracts you. The two paintings shown here (and enlarged on page 25), each of which reflects a completely different mood, were painted from the same reference photograph.

I talk about mood on the following pages, but here are a few rules to bear in mind about composition: never set your horizon halfway down the painting; place the focal point slightly off centre; and choose interesting shapes – remember, good shapes make great pictures.

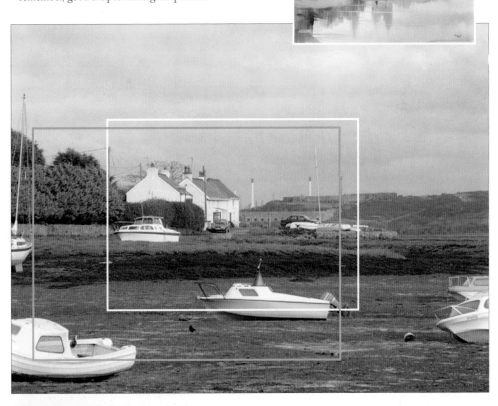

The two finished paintings shown here were taken from this photograph.

For the full-colour painting above, I used the part of the photograph bordered in white. Notice that I have removed all the boats and cars in the foreground, the large building behind the cottages and the two large chimneys in the distance. I have also painted the scene at high tide to allow me to have some good reflections in the water.

The monochrome, painted in burnt umber, shows how easy it is to make a completely different composition from the same scene. For this painting I used the part of the photograph bordered in orange. Again I removed all items that could take the eye from the focal point. Notice that at high tide the foreground boat is floating rather than resting on the sand, making it nearer to the distant boat.

When you have decided on a composition for your painting, you then have to consider how to paint it. Always remember that your painting, unlike a photograph, is your interpretation of the scene – other viewers of your finished painting will not have seen what you 'saw', so you can change anything. For the following exercises, which show different interpretations of the same scene, I chose this photograph, as it was the cottages that first attracted me.

You can affect the mood of a painting by varying one or more of the following: the tonal structure (the relationship between lights, mid-tones and darks); the temperature range of the colours (warm or cool); the direction of the light source and shadows; the time of day (the tone of the shadows); and edge textures.

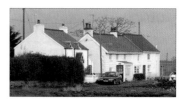

I used this photograph for the following exercises in tone, shadows, edge structures and colour temperature.

TONAL STRUCTURE

Before starting to paint a subject, it is always worthwhile making a tonal sketch of the scene and look at the relationship between the light, dark and mid-tone areas. Lots of similar tones next to each other will produce flat uninteresting pictures. If your first tonal sketch of what you see appears that way, try working it again setting light and dark areas against mid-tone ones.

These three tonal sketches of the same scene each have different relationships between the light, mid-tone and dark areas. See how they affect the mood of the picture.

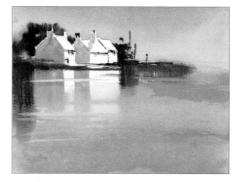

Mid-tones dominate this version of the scene, but they help emphasize the light areas of the cottages, (the focal point), which are also brought into relief by the dark areas on either side. The combined area of the light and dark tones makes an interesting shape.

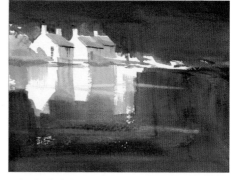

In this sketch, dark tones predominate, but the eye is still drawn to the light and mid tones used for the cottages. Note the different shapes created by the reflections.

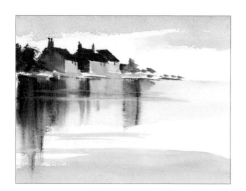

Here, the focal point consists of mid- and dark tones which are brought to prominence by the light tones in the sky behind the cottages and those across the foreground stretch of water.

Colour temperature

The range of colours used for a painting also has a profound effect on the perception of the viewer as to its mood. Note the difference between these two colour sketches – one is full of warm and inviting colours, the other cool and aloof ones. Both images, which are based on the first of my tonal sketches,

still look rather flat. This problem could be overcome by introducing touches of cool colours to the yellow sketch and touches of warm colours to the blue one (see the sketches below, and the warm red walls in the snowscene on page 88).

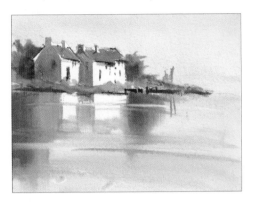

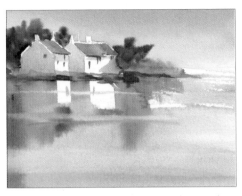

Direction of the light source

You can place the sun wherever you want it to be, but remember to make all the shadows consistent with the chosen position, especially if you are working from a photograph. Also remember that, if you are painting outside, the sun and shadows are moving all the time.

In the sketch, below left, the light is coming from the right-hand side, lighting up the front walls and roofs of the cottages. In the sketch below right, the light is from the left-hand side, lighting up the gable ends of the cottages. Note the use of cast shadows on the nearest cottage to create interesting shapes.

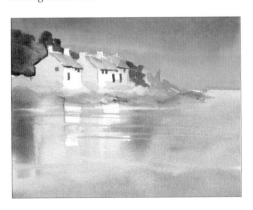

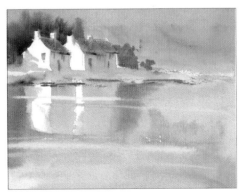

TIME OF DAY

The time of day has a great effect on the tone and shape of shadows. Contrary to common belief, the longest and darkest shadows appear early in the morning or late in the afternoon. At midday, when the sun is high in the sky, the shadows are paler because they are affected by glare reflected from the surfaces around them. You can use long cast shadows to break up large shapes into smaller, more interesting ones.

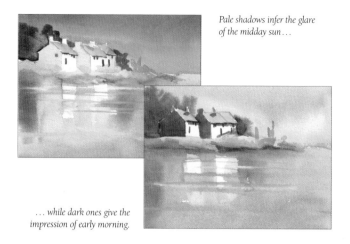

Pale shadows infer the glare of the midday sun . . .

. . . while dark ones give the impression of early morning.

EDGE TEXTURE

Varying the edge texture applied to the shapes in a painting can have a dramatic effect on the finished result. These two sketches illustrate this point – the small one is full of hard edges, while those in the other one vary from hard to soft to rough. Which one do you prefer?

The use of hard edges round every shape gives the impression they all the objects have been cut out of separate pieces of paper and stuck on the painting.

Varying the edge texture of shapes in a painting from hard to soft to rough, a technique sometimes referred to as lost and found, stitches each shape into the composition and makes it part of the whole.

CHECK LIST

I always fill this check list before I start a painting. It is well worth the effort of planning how you intend to paint a scene, and a simple record of your decisions can be referred to as you paint.

1. What is my focal point?	
2. Where shall I place the focal point? *	
3. How large shall I make the focal point?	
4. Is the tonal structure interesting?	
5. Is it colour temperature warm or cool?	
6. Are the shapes interesting?	
7. Where is the light source?	
8. Am I varying the edges of my shapes?	
9. Have I enough paint in my palette?	
* top left or right, bottom left or right	

This monochrome painting is also taken from the photographs on page 20. In this composition, the focal point is the more distant boat rather than the cottages. I washed a tone over the cottages to push them into the background, and left the hull of the boat white to attract the eye. The white area on the top of the boat in the foreground catches the eye first, but its shape does lead the eye to the other boat.

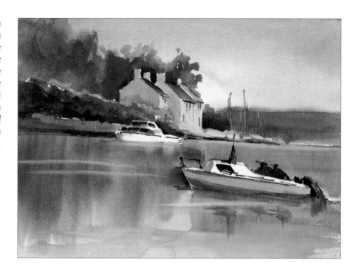

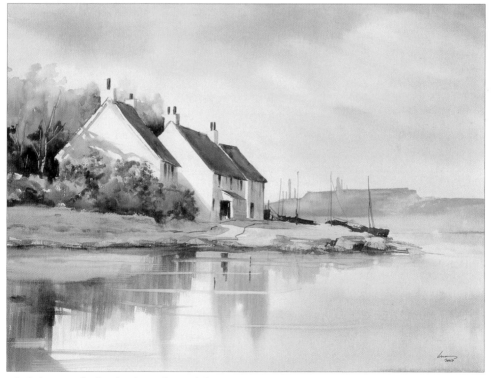

A finished painting taken from the reference photograph shown on page 21. Can you see which parts of the original photograph I selected and what tones, shadows, light source and colour temperature I used to give the painting my personal view?

Elements of a painting

There are lots of different elements that can be included in a painting, but, here, I concentrate on those that always seem to cause problems for the beginner: skies, trees, figures, buildings, water, rocks, hills and mountains

SKIES

The type of sky most frequently seen at exhibitions has three or four, equally-sized cotton wool balls sitting in a flat blue sky. This might be all right for some, but you should try to get away from this stereotype and start painting some real ones. The sky changes every minute, so it is impossible to paint a true image of what you see. When you see a sky you like, make notes about the time of day, where the sun is, the colours in the sky, how the light affects the colours on the ground, and the shapes cast by any shadows.

If your painting is mainly about the sky then you can paint lots of interesting cloud shapes. On the other hand, if it is about the land, choose a simple sky as lots of sky detail will take the eye away from your focal point.

It is important to remember that clouds, as with other more solid objects, should reflect the perspective of a composition.

Those further away from you should always be smaller and closer together than those nearby. Whatever the type, it is vital to have interesting cloud shapes. If these are predictable and boring, so will be your painting. There are so many types of sky that it is impossible to illustrate them all, but here are a few different types that you might try. Other types of sky can be seen in the finished paintings included throughout this book.

A clear sky is never the same colour all over. This midday sky, for example, has a pale, warm yellowy base which, higher up the paper, changes to a pale, cool blue and on to a darker blue at the top. I started this painting by wetting the whole of the sky area. Working quickly, I laid in a wash of raw sienna along the horizon, weakening it as I worked upwards. Then, starting at the top, I followed up with a wash of ultramarine blue, gradually weakening it as I worked downwards.

Cloud patterns vary from the large billowy cumulus to the wispy cirrus. Whatever the type, try to make your cloud shapes interesting. If they are predictable and boring, your painting will be the same. These two examples of billowing clouds were created using two different techniques. For the left-hand one, I used a paper towel to lift the clouds out of a wet blue sky (a damp sponge will produce a softer edges). The clouds in the right-hand example were produced by applying process white with a circular motion of a finger on a dry background.

Here, the clouds are darker than the sky, but, as they are pale and soft, they give a feeling of peace. Using a thirsty brush, I picked up the colour from the palette with one single stroke – to limit the water content – and applied this to the wet sky area.

The clouds in this sky were applied in the much same way as described above, but the stronger tones produce an angry looking sky.

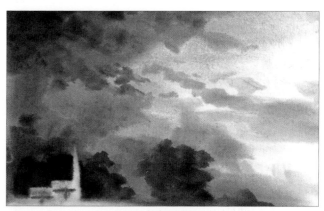

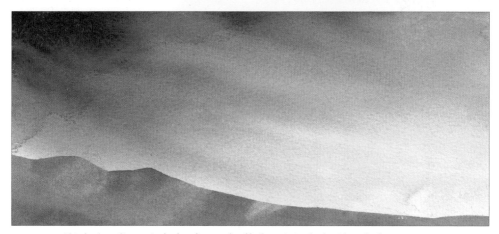

This sky shows distant rain clouds and was produced by first painting the sky without clouds and letting it dry. It was then carefully re-wetted and some dark clouds painted in with a thirsty brush. Quickly, before these were dry, I tipped the paper vertical and tilted it sideways (at the angle of the falling rain), then used a water sprayer to apply a mist over the sky. When the 'rain' started to pour from the dark clouds, I dried it quickly with a hairdryer.

TREES

Trees are a growing problem! We all have childhood memories of the things around us, but the problems come when we recall what we thought we saw and try to draw them. Trees are no exception; consequently, they are usually painted with the roots too big and the trunks too fat. When we were children, we were much smaller and our perception of trees was that the roots were big and the trunks huge!

Let's look at the way trees grow. I know that there are lots of different shapes of trees, but, for this particular exercise, there are two groups: deciduous (those that lose their leaves every year); and evergreens.

Deciduous trees

When painting a deciduous tree, look for the overall silhouette formed. If it has good shapes, then you have an interesting tree.

When the trees are covered in leaves, do not try to paint every leaf! Paint clusters of leaves, then put in the bits of branch that show between them. Look at the way the light falls on the tree and remember to paint in the shadows – the formed shadows on the parts of the trunk and foliage facing away from the light, and those cast by the tree on surrounding objects.

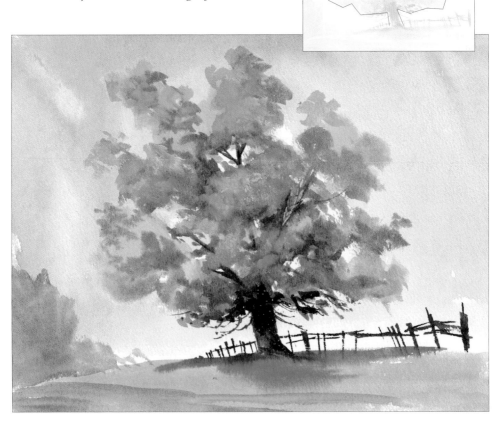

Although there are exceptions, the trunks of most trees in this group do not grow straight. When a young trunk grows up, it sprouts a branch. As this branch increases in size, and gets heavier, the main trunk starts to bend in the opposite direction to balance the weight. The same thing happens as each new branch is formed; the trunk usually ends up looking straight, but will have lots of kinks in it. Trees will sway in the wind, and those in exposed very windy areas can have a curved trunk, but these forces are counterbalanced by the strength of the root system.

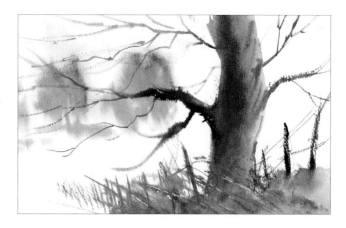

Evergreen trees

I use the term evergreen in a very loose way to denote trees, such as spruce and Douglas fir, with narrow and straight trunks.

Interesting silhouettes of single trees in this group are not easy to find, but look out for them. However, groups of these trees do make good shapes. Overlap them, include different sizes and heights, vary the angle of the trunks and the spacing between them, and you will have good shapes for your painting.

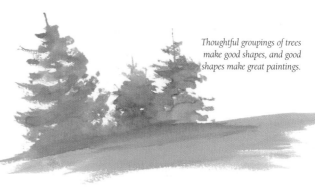

Thoughtful groupings of trees make good shapes, and good shapes make great paintings.

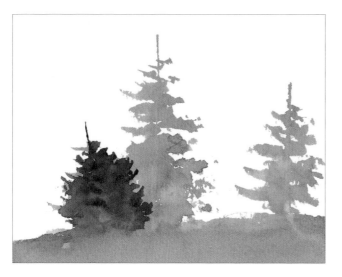

Distant trees should be treated as simple silhouettes. Paint them using the technique of aerial perspective (see also page 36). Make the distant ones soft edged and pale bluey-green. As you come forward, gradually make the edges sharper, and their colours darker and warmer.

29

WATER

Water is, on the face of it, a difficult thing to achieve in painting. This is because you want to paint every ripple on its surface, every wave and every drop of spray. The secret is to try to simplify things into interesting shapes and edge textures.

I have a great love of water scenes, especially seascapes, and I often spend hours watching the movement of the sea. I study the swells out at sea and how they develop into waves. Then, when the waves break on the sand and rocks, I look at the shapes of the resulting foam and spray patterns. You must do this too – not just for water scenes but for every subject you paint. Get to know your subject and you will be able to paint with confidence. Here are a few small watercolour sketches showing different types of water.

My tip for creating the impression of movement is to make the moving object out of focus.

For this sketch of waves lapping against a rocky outcrop I painted in the dark rocks, leaving rough shapes of the water along the bottom edges. These shapes were then enhanced with sponging while the paint was wet. When the paint was dry, I used the corner of a razor blade to scratch out the small splashes of spray.

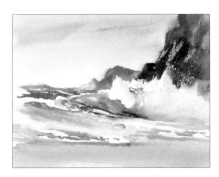

The wave crashing against the rocks comes to life if the overall shape of the white foam is interesting to the eye. Movement is enhanced by the variety of textures and the use of soft, sharp and rough edges.

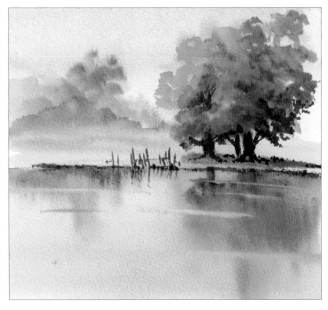

Soft, out-of-focus reflections on smooth surfaces of ponds, lakes and rivers are obtained by first wetting the water area, then quickly dragging the reflected colours into this wet area with a thirsty brush.

Depending on the position of the sun, the sea sometimes appears darker on the horizon than in the foreground . . .

. . . at other times, it is so pale that it is difficult to see where the sea and sky meet.

These sketches show two different ways of painting a seascape when the sun is directly in front of you and low in the sky, backlighting the subject and producing a lot of glare on the surface.

The one with the yacht was painted by dragging a loaded brush horizontally across the sea area, from right to left. The brush was held almost flat against the paper to make the sparkles.

In the sketch below, I painted all the sea with dark tones of blue, then, when this was dry, I used process white to paint the highlights on the surface of the water.

31

FIGURES

Incorrectly drawn figures can spoil a painting, and I see the little man opposite in many exhibitions – the legs and arms appear to be connected to the centre of the body, and the head is always too big. In reality, arms and legs are connected to the sides of the body, and only small children have large heads in relation to their height. Our bodies grows faster than our heads; whereas a baby might be four heads high, an adult could be eight heads high.

One of the reasons heads in paintings are too big is because they are often painted first. If you do this, you are committed to a body at least eight times as long and, as there is often not enough room, the figure ends up looking completely wrong. The answer is to paint the bodies first, then add a head, smaller than you would normally do, and gradually increase its size until it is just right. Do not include lots of detail. Very often, hands and feet are not necessary, and you should certainly not include buttons on a shirt!

On these pages I illustrate some important points that you should consider when putting figures in a landscape. Remember that details will not necessarily make your paintings realistic. Realism comes from good gestures, interesting shapes and the correct size of figures relative to the perspective of a composition.

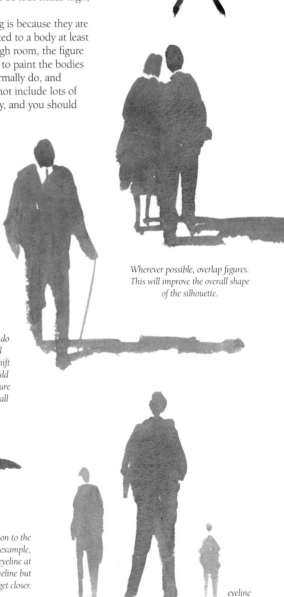

Wherever possible, overlap figures. This will improve the overall shape of the silhouette.

Give your figures a realistic shape. Rarely do we stand upright with our weight shared equally on both legs. When we move, we shift our weight from side to side, and you should try to capture this movement. Lock the figure to the ground with a shadow and the overall silhouette will be greatly enhanced.

Size the figures in proportion to the perspective of the composition. For example, in this worms-eye view, with an eyeline at ground level, all the feet are on the eyeline but the figures are larger as they get closer.

eyeline

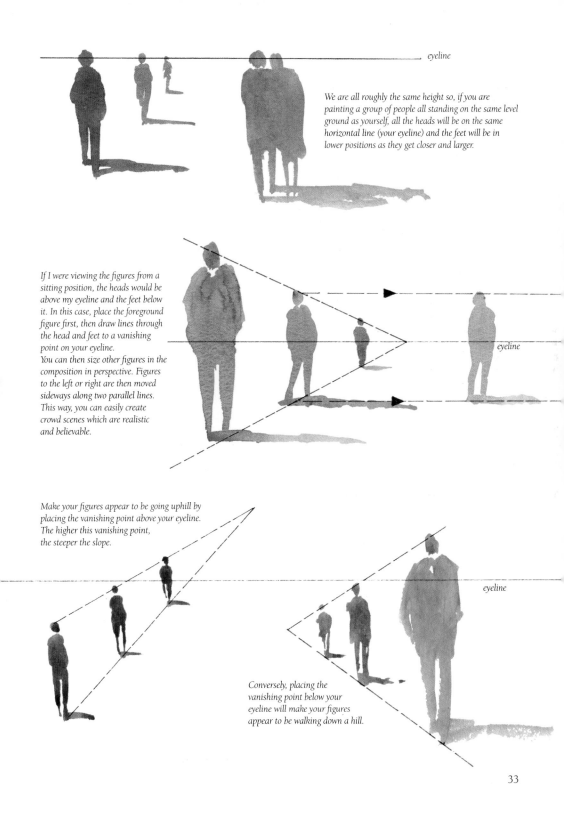

eyeline

We are all roughly the same height so, if you are painting a group of people all standing on the same level ground as yourself, all the heads will be on the same horizontal line (your eyeline) and the feet will be in lower positions as they get closer and larger.

If I were viewing the figures from a sitting position, the heads would be above my eyeline and the feet below it. In this case, place the foreground figure first, then draw lines through the head and feet to a vanishing point on your eyeline.
You can then size other figures in the composition in perspective. Figures to the left or right are then moved sideways along two parallel lines. This way, you can easily create crowd scenes which are realistic and believable.

eyeline

Make your figures appear to be going uphill by placing the vanishing point above your eyeline. The higher this vanishing point, the steeper the slope.

eyeline

Conversely, placing the vanishing point below your eyeline will make your figures appear to be walking down a hill.

33

BUILDINGS

If you want to paint buildings you come up against perspective. This subject is a great turn off for many students, and I never tell mine when I intend to cover it! So, rather than use the word perspective, let us talk about getting depth into the picture, and making objects sit correctly in their surroundings. This is a large subject – too big to be fully covered in this book – but there are a few important principles that you should understand.

First, it is important to establish your eyeline; an imaginary horizontal line, parallel to your eyes. You look up at objects above the eyeline, and down at those below it. For instance, when you stand close to a house, the roof is above your eyeline and the doorstep below it. On level ground, your eyeline will be level with a point three-quarters of the way up the front door. Your eyeline is also the true horizon, but, in reality, you will only see this when looking out to sea, or across an enormous flat plain.

Vertical lines should always be vertical in your picture except on rare occasions when your subject is a very tall building.

For any single building, the lines of the roofs, gutters, and the tops and bottoms of windows and doors (which a spirit level would show as level) all converge to a single 'vanishing point' on your eyeline. This principle also applies to all buildings in a straight row or in parallel rows. If, from your viewpoint, you can see two sides of a building, there will be two vanishing points, one for each side.

On the other hand, if you can only see one side of the building, there will be just one vanishing point – straight in front of you – and this is only for the sides of the building that you cannot see! The tops of the wall, doors and windows that are visible, are parallel to your eyeline.

Try this exercise in constructing a house on flat ground. Then attempt to create a curved road.

1. Establish your eyeline, then draw a vertical line for the corner of the building that is nearest to you. You are standing on level ground, so this will extend both below and above your eyeline. Now draw in lines from the top and bottom of the vertical to the vanishing points.

eyeline

2. Draw verticals at the ends of each side of the building. On the gable end, draw diagonals from corner to corner to determine the centre of the wall in perspective. Draw a vertical through this point up to the top of the roof.

3. Draw a line from the top of the vertical to the vanishing point to define the roof line, then draw in the oblique lines of the sloping roof.

4. Using the same technique as in step 2, draw a vertical line for the middle of the back gable end, then complete the roof.

5. Now add the door and windows, remembering that same-size objects become smaller the further away they are.

ROADS AND RIVERS

The sides of roads and rivers also converge to vanishing points on the eyeline.

eyeline

The sides of a flat straight road or river converge to a vanishing point on the eyeline.

eyeline

The sides of roads that go down- and uphill converge to vanishing points below and above the eyeline respectively.

eyeline

A curved road or river can be broken down into a series of blocks, like paving slabs, with the sides of each converging to a different vanishing point on the eyeline.

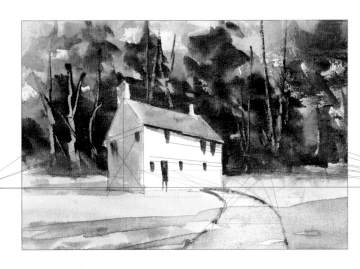

The eyeline for this colour sketch is just above the ground level at the house. The basic perspective lines for the house (shown in red) converge to two vanishing points on the eye level. The curved road goes uphill from the viewpoint, and its sides converge to various vanishing points on a line above eye level.

eye level

Tip Measuring angles

When painting from a photograph, measure angles with a protractor and transfer them on to the drawing. On site, place your pencil on the drawing at the point you want to start, then, without looking at the paper, look at the actual scene and draw the angle. You will be amazed to find that you have copied the angle fairly accurately. This technique is called contour drawing and everybody can do this.

ROCKS, HILLS AND MOUNTAINS

The lack of aerial perspective and poor shapes are the two most common faults that students display when they paint landscapes that include rocks, hills and mountains.

Aerial perspective, as opposed to the mechanical angles, shapes and sizes of linear perspective, uses colour to define depth and distance. Particles in the atmosphere make distant objects less distinct. As objects get further away, they get paler, bluer and more soft edged, and the tonal difference between light and dark areas also becomes less pronounced.

Mountains, for example, become bluer as they recede into the distance because the blue part of the spectrum passes through the atmosphere more easily than the red and yellow parts. I achieve soft edges on distant mountains by using the dry into wet techniques (see page 19).

The dreaded green is another big problem with beginners. There is a lot of green in most landscapes, but using the same green for both the distant and foreground parts of a composition flattens everything out and makes individual shapes difficult to distinguish.

Another problem, which I stress time and time again, is about poor, uninteresting shapes. So many paintings are ruined by placing 'Egyptian pyramids' in the middle of rolling countryside!

I remember a student asking the artist, William 'Skip' Lawrence, for a critique of one such painting. Skip's initial comment was: 'It has boring shapes'. The student justified his effort by saying that he had painted what was there, to which Skip replied: 'Well, don't go there again!'

Decide where your sunlight is coming from, then draw your mountains. Remember that you can use your own shapes, colours, angles, sizes and tones. Use shadows to divide your shapes into even better ones. This is being creative. You may not regard yourself as creative (it is something other people do), so change the word to *thoughtful*, then, if you spend a little time being extra thoughtful, you might just end up painting a winner!

Remember that good shapes make great pictures!

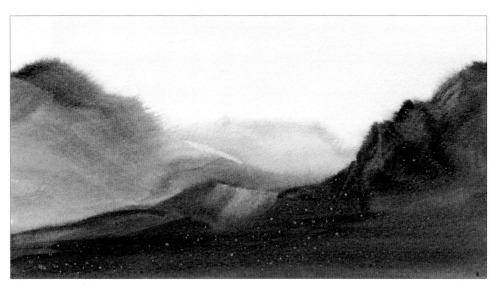

This sketch shows how the use of aerial perspective helps infer distance. The mountains get softer, bluer and paler as they get further away.

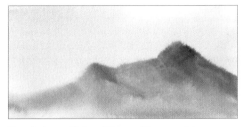

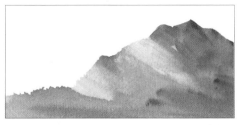

The soft edges and feeling of distance of these mountains were created using the dry into wet technique.

The angled highlights, and the broken edges on the slopes of this mountain were created by brushing a dry paper towel across the still wet colour.

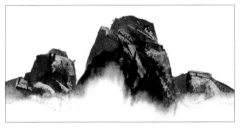

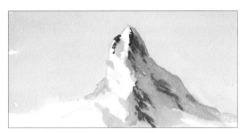

Look for interesting shapes. If you cannot see any, use your imagination to create some! I used the blade of a razor to move wet colour around within the painted shape to create texture and highlights. The spray in the foreground is the result of lifting off colour with a sponge.

Snow must be paler than the sky, and the shadows on the snow must be darker than the sky. For this sketch, I painted a wash of Winsor blue across the sky area and over all the areas of snow shadows on the mountain. I then used mixes of ultramarine blue and touches of permanent rose to strengthen the snow shadows and to add the dark tones.

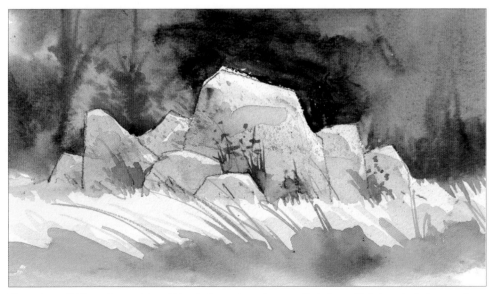

These rocks are all different shapes and sizes which make them an interesting group. The background is dark, yet the shadows are pale; a combination that gives the impression of sunlit glare on the rocks. Aerial perspective – the use of cool, dark greens in the background and pale, warm ones in the foreground – gives depth to this simple composition.

Two-colour landscape

Painting with a limited palette of just a few colours helps to create a natural harmony throughout a painting. For this first step-by-step demonstration, I chose to use just Winsor blue and burnt sienna. These two colours are roughly opposite each other on the colour wheel and mixes of them will, therefore, produce a wide range of colours, including some good darks. Placing these strong darks adjacent to light areas enables you to produce a powerful sunlit effect.

The focal point of this composition is the group of buildings, and the shapes of the road and the hedges lead the eye to them. The branches of the trees on the left-hand side also point in their direction. The rocks in the foreground offer the chance of creating interesting shapes and their position makes the shape of the road more exciting. The two figures in the distance were an afterthought, added to provide both scale and interest to the painting.

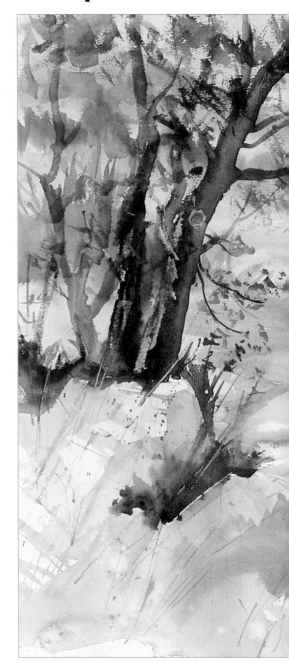

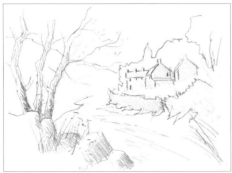

Original pencil sketch used to compose the painting.

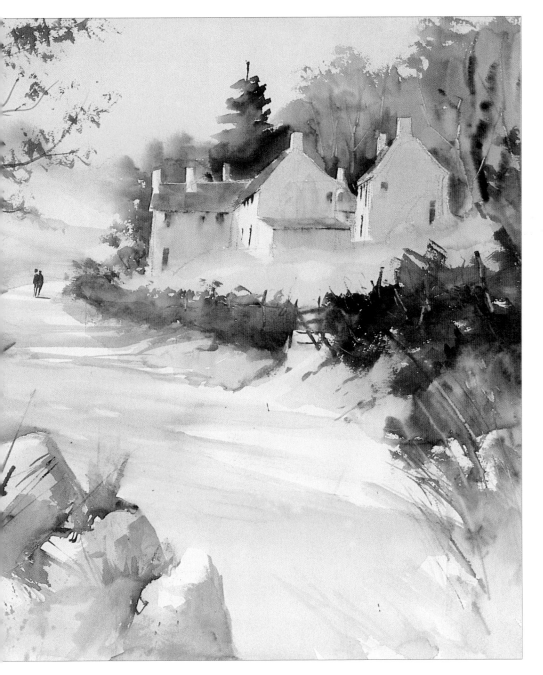

Burnt sienna

Winsor blue

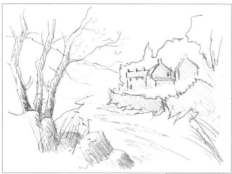

1 Referring to the original pencil
sketch above, use a graphite stick
to draw the basic outlines of the
composition on to the paper.

2 Use the 25mm (1in) flat brush to
wet the sky area down to just below
the hill and trees, but leave the shape
of the house dry.

3 Mix a wash of Winsor blue, then lay this into the wet sky, weakening the mix as you work downwards.

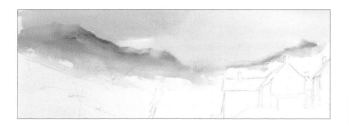

4 Mix Winsor blue and burnt sienna to make a dark, blue/green, then lay this colour into the distant hills wet-into-wet.

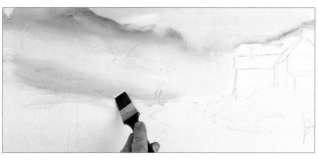

5 Use a pale burnt sienna wash to paint the lower hills, then introduce a line of blue in the foreground.

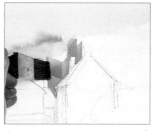

6 Using a strong green and the full width of the brush, cut round the shape of the roof for the start of the background trees.

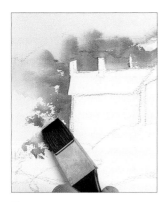

7 Flatten the brush to make random marks for the bushes.

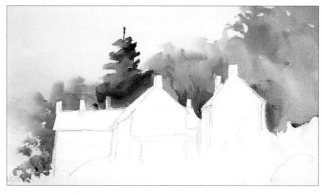

8 Mix different tones of green and brown, then build up the mass of foliage behind the buildings.

9 Use the rigger brush to paint the tree trunks.

10 Use the handle of the scraper brush to scrape out a few more trunks.

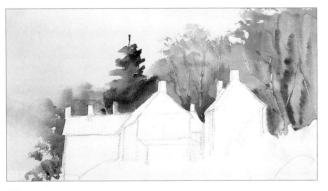

11 Using a flattened brush, add touches of broken foliage to the top of the trees.

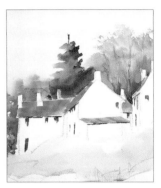

12 Use neat burnt sienna to lay in the roofs.

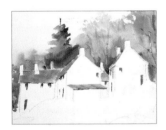

13 Make a mix of equal parts of both colours, then lay in the gutters and windows.

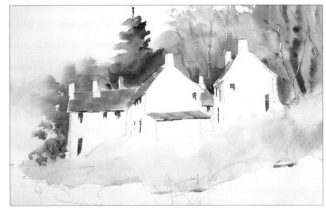

14 Use a mix of burnt sienna with a touch of Winsor blue to block in the fields in front of the buildings.

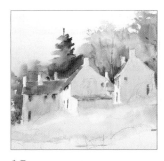

15 Now mix Winsor blue with a touch of burnt sienna, then paint in the shadows on the walls and roofs.

16 Wet the left-hand hills, mix a dark blue-green, add some trees in the middle distance, then soften the bottom edges with clean water.

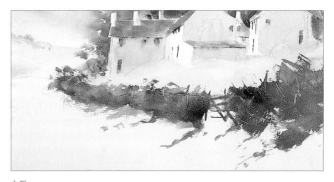

17 Lay in the hedge with random mixes of the two colours; use cool, weak colours in the distance, and warm, strong ones in the foreground. Use the handle of the scraper brush to make indications of twigs and fence posts.

18 Working with weak washes of both colours block in the fields at the left-hand side then, while the paper is still wet, lay in some more trees and bushes. Use the corner of the brush to work more detailed areas.

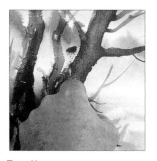

19 Using the No.8 round brush and a warm dark, lay in the tree trunks and branches. Create highlights with the handle of the scraper brush.

TIP KNOTS ON TREE TRUNKS

Press your knuckle on to the wet paint, hold it there for five seconds, then lift it off to leave a knot.

20 Block in the foreground rocks and lay in lots of colours of the same tonal value randomly. Leave to dry.

21 Glaze weak washes of both colours over the rocks to create areas of shadow.

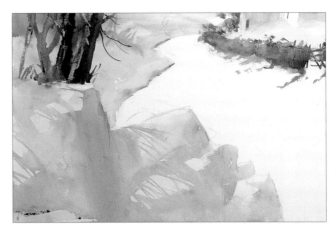

22 Mix a dark green, then use the rigger brush to add small bushes and grasses at the base of the trees and in between the rocks. Use the handle of the scraper brush to scratch through in places. Splatter spots of colour by tapping the rigger with your finger.

23 Wash in the grassy bank on the right under the hedge; use cool tones in the distance and warmer ones in the foreground.

24 Add some foliage at the right-hand side, taking colour up to link with the background trees.

25 Lay in shadows across the road, then, while the paint is still wet, use a dry brush to lift out some dappled highlights.

26 Add some deep shadows in the rocks to bring them forward and above for the road.

27 Start to work the foliage in the large group of trees, using a crisscross brush action to make large marks.

28 Continue working the rest of the foliage, making the marks smaller and paler as you work out outwards. Use the dry on dry technique and a damp brush to apply the very small leaves at the tips of the branches.

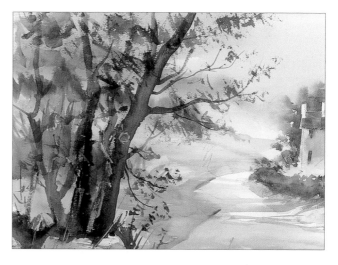

The finished painting. Having stood back and looked at the whole picture, I decided to add two small figures as a focal point.

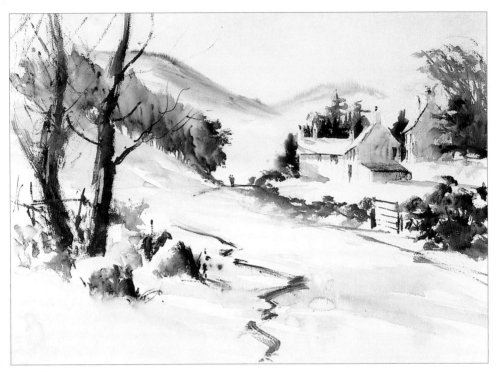

Sunlit Walk
Size: 710 x 510mm (28 x 20in)

This monochrome painting is a similar composition to the two-colour landscape shown on pages 38–45, but, as there are fewer leaves on the trees, there is a better view of the distant mountains.

It has the same basic concept as the small tonal sketches shown in many of the projects, but here I went on to produce this much larger and more detailed finished painting. A single colour painting – this was painted with burnt umber – relies solely on the relationship of light and shadow to produce the desired effect.

Opposite
Towards the Brow
Size: 485 x 470mm (19 x 18½in)

I used just three colours for this painting: ultramarine blue, cadmium scarlet and lemon yellow.

Although the farmhouse is one of the main components of this painting, it acts as a stepping stone to the focal point of the composition, the two figures on the brow of the hill. Notice that all of the other 'lines' – the road, the wall and even the shapes of the trees – lead the eye to them.

It is not common practice to paint landscapes in this format; they are normally worked within horizontal or vertical rectangles (usually referred to as landscape or portrait format). Occasionally, however, I like to break all the rules, so this one is roughly square.

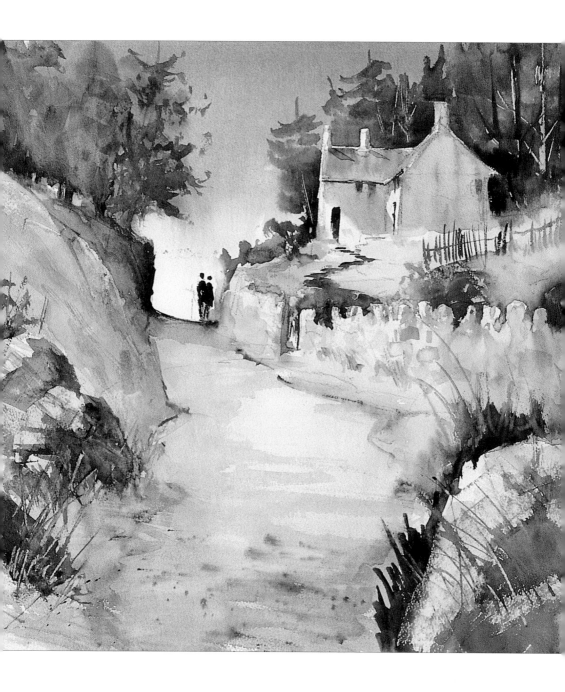

Full-colour landscape

I love painting panoramic landscapes, especially scenes such as this one with its tranquil lake and a background of mountains extending far into the distance.

Soft edges to the shapes of the mountains helps indicate their size, and an exaggerated aerial perspective (the mountains are warmer, darker and more distinct as they get closer) gives a feeling of distance. Note that, in this composition, each mountain has a completely different shape. Exact repetition of shapes does not look right in a painting, even if it is that way in reality. Remember that, unlike a photograph, a painting is your interpretation of a scene, and you can make as many changes as you want to give your composition more interest.

Diagonal lines in a painting generally denote movement and drama, whereas horizontal and vertical lines give the impression of stillness and peace. The tranquil quality of this expanse of water is accentuated by the use of horizontal and vertical lines for the reflections at the edges of the lake.

These reflections are created by painting the colours of the reflected objects into the wet water area with a thirsty brush, a technique which retains and softens the shapes.

The tonal sketch used as the basis for this demonstration. It was drawn when the sun was high in the sky. Contrary to the common belief that shadows are darkest at midday, the light reflected from other surfaces makes them quite pale. I accentuated this fact with the shadows on and around the building.

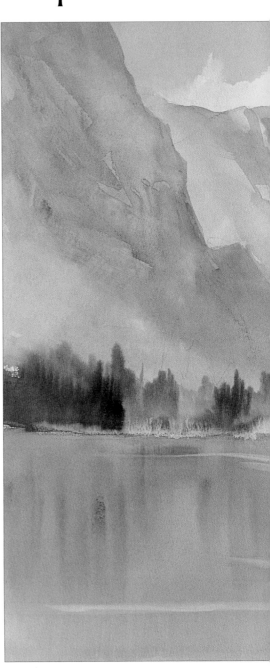

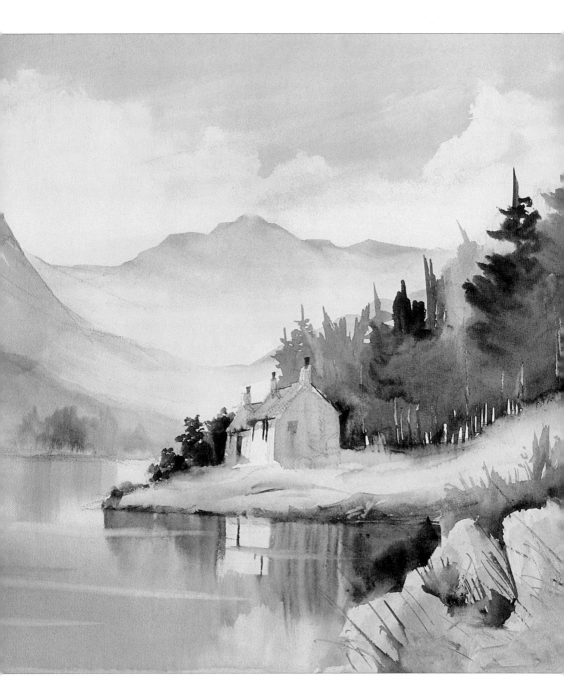

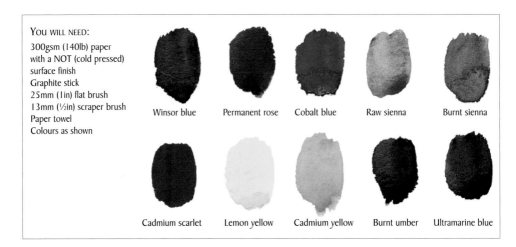

You will need:

300gsm (140lb) paper with a NOT (cold pressed) surface finish
Graphite stick
25mm (1in) flat brush
13mm (½in) scraper brush
Paper towel
Colours as shown

Winsor blue

Permanent rose

Cobalt blue

Raw sienna

Burnt sienna

Cadmium scarlet

Lemon yellow

Cadmium yellow

Burnt umber

Ultramarine blue

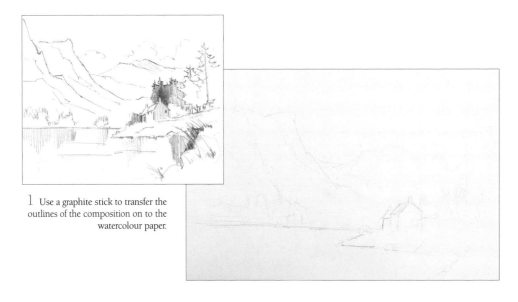

1 Use a graphite stick to transfer the outlines of the composition on to the watercolour paper.

2 Using the flat brush, wet the sky area, then lay in a wash of Winsor blue, strengthening the colour at the top left-hand corner.

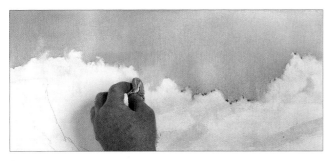

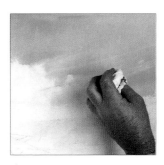

3 While the sky area is still wet, use a clean paper towel to dab out the top edges of the clouds.

4 Flick a clean paper towel across the paper to form streaky clouds.

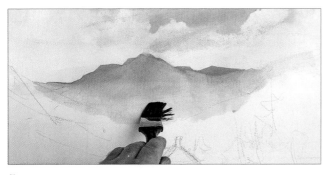

5 Using a mix of Winsor blue with a touch of cadmium scarlet and the flat brush, block in the far distant mountains, softening the bottom edges with clean water. Use a paper towel to drag colour from the hard edges at top.

6 Add more cadmium scarlet to the mix, then start to block in the top of the more distant hills at the left-hand side. Add raw sienna and permanent rose as you work down the slope.

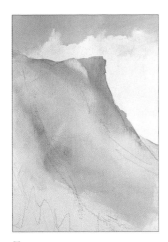

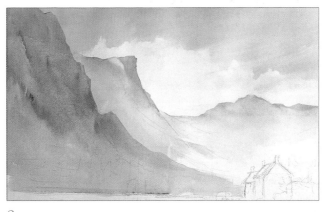

7 Allow the colours to soften and blend together, use a clean paper towel to lift out a subtle highlight then leave to dry.

8 Block in the near hills with burnt sienna, then drop in touches of the other colours on the palette. At this stage, I decided to increase the height of these hills, so I pumped in some Winsor blue at the top. Darken the right-hand edges to lift them away from the distant hills. Finish this stage with touches of lemon yellow at the base of the hills, across to the buildings.

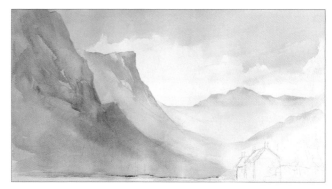

9 Mix lemon yellow and a touch of cadmium scarlet, then block in the right-hand hills. Add some Winsor blue, then soften the bottom edges with a clean brush.

10 Use cobalt blue, with touches of permanent rose and cadmium scarlet, to add shadows and shape to the hills at the left and right.

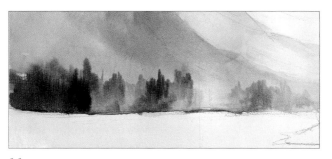

11 Mix various tones of green with Winsor blue and burnt umber and, while the paper is still wet, use a thirsty brush to lay in trees along the horizon line.

12 While the trees are still wet, drop in clean water along the horizon line and allow backruns to form and denote patches of mist. Lift off excess water with a dry brush.

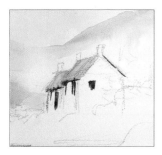

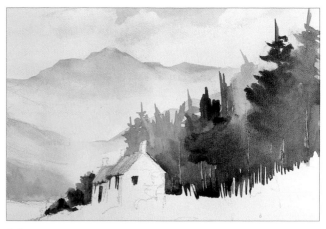

13 Use cadmium yellow to block in roofs on the buildings. While this is still wet, add a touch of cadmium scarlet. Mix burnt umber and ultramarine blue, then paint the gutters, windows and doors.

14 Mix greens with Winsor blue and burnt umber for the bushes to the left of the houses, then drop in touches of lemon yellow and cadmium scarlet. Use the greens to block in the large stand of trees with touches of burnt sienna. Use the handle of the scraper brush to scratch out some trunks.

15 Block in the grassy bank with lemon yellow, then pump in raw sienna in foreground and Winsor blue in the distance.

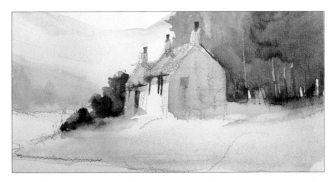

16 Mix cobalt blue with touches of permanent rose and cadmium scarlet, then block in the shadows on the walls and chimneys and the cast shadows on the grassy bank. Use burnt umber and ultramarine blue to add the tiny chimney pots.

At the end of step 16, I stood back and looked at the shapes in the painting. I did not like the shape of the foliage at the left-hand side of the building, so I changed it. I also added another small bush at the water's edge.

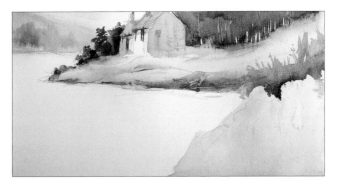

17 Use lemon yellow and permanent rose to block in the basic shape of the foreground rocks. Use burnt umber and ultramarine blue to add shape and shadow in the grassy bank and to define the top edges of the rocks.

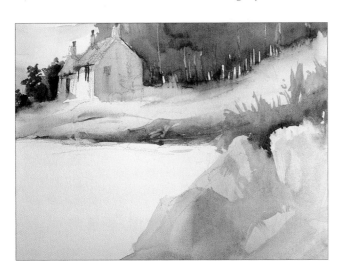

18 Mix ultramarine blue with touches of permanent rose and cadmium scarlet, then add shape and shadows on the foreground rocks. Leave to dry.

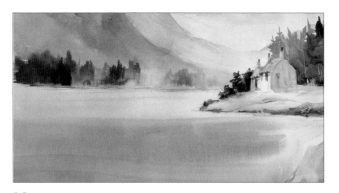

19 Thoroughly wet the lake area, then lay a wash of Winsor blue.

20 Use a damp, thirsty brush to pull out reflections of the buildings.

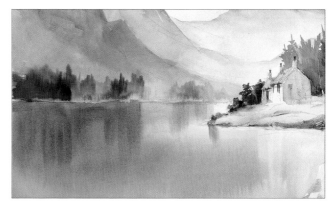

21 Add ultramarine blue to darken the far side of the lake . . .

22 . . . then use vertical strokes to pull the colour downwards to create the reflections of the trees.

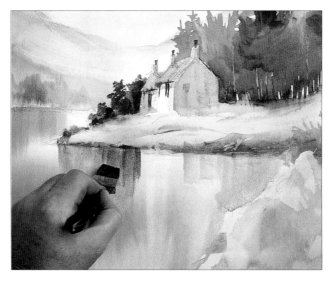

23 Using mixes of lemon yellow, raw sienna and Winsor blue, pull down reflections of the grassy bank.

24 Use a mix of Winsor blue and burnt umber to add reflections of the tree colours behind the rocks at the right-hand side. These marks pull the rocks away from the background.

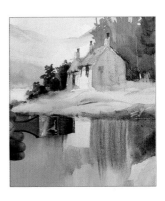

25 Paint the reflections of the buildings.

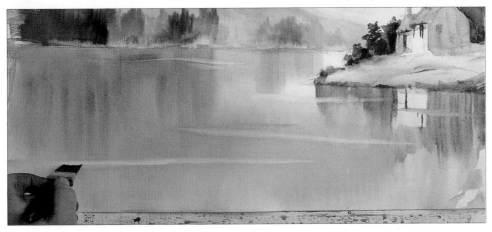

26 Use a clean dry brush to pull out horizontal ripples.

27 Finally, using a mix of Winsor blue and burnt umber, add some spiky grasses on the foreground rocks to help define shape.

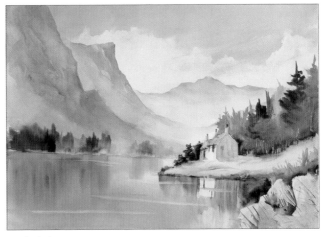

The finished painting

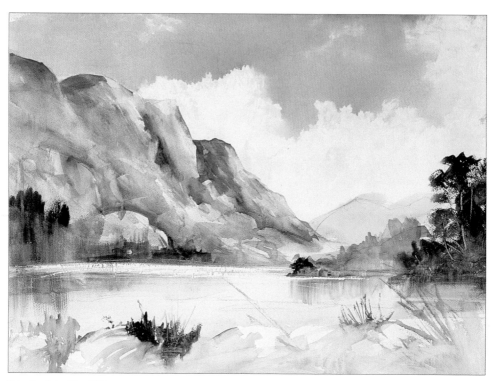

Tal-y-llyn Lake, West Wales

Size: 710 x 510mm (28 x 20in)

The soft, out-of-focus reflections on the surface of the lake allow the eye to move through the painting to the distant mountains. The foreground details, usually the warmest and sharpest parts of a painting, were left soft and pale, with gaps between each piece of foliage to help the eye enter the picture. I used the corner of a razor blade to scratch the highlights across the distant surface of the lake when all the paint was dry.

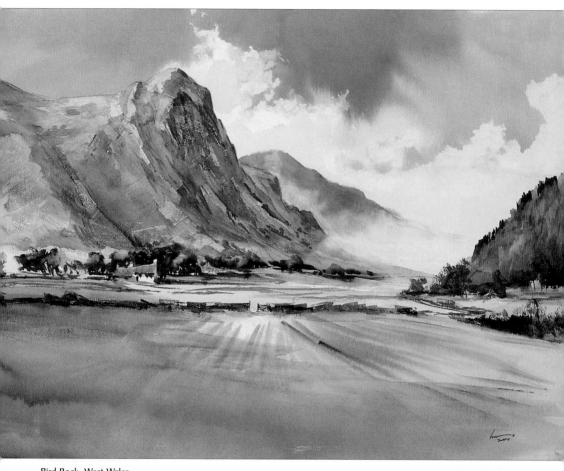

Bird Rock, West Wales
Size: 710 x 510mm (28 x 20in)

Bird Rock is in a hidden valley on the west coast of Wales. Many moons ago, the sea came right up the valley and cormorants nested on the rock. When the sea eventually receded, however, nobody told the cormorants! The rock dominates the valley, and it must be the focal point of any composition. The shapes and aerial perspective all lead the eye to this rock. The misty areas in the distance were created by sponging out the colours from the background. Compare these edges with those of the clouds which were lifted out with a dry paper towel.

Waterfall

I feel that the power of a waterfall requires powerful shapes. To this end I sketched the falls from different angles to find the most striking viewpoint. I have included two of these here. The top sketch, drawn face-on to the falls, is the most obvious choice of viewpoint. The bridge, however, has a horizontal top edge and a rather boring shape. Also, the shape of the first section of the falls is totally lacking in interest.

Compare this with the second sketch for which I moved a little closer, viewing the bridge from low down on the left-hand side. From this viewpoint, the bridge has an angled top edge, giving it a different and more interesting shape. The shapes of the rocks on the left-hand side also become more angular, and these combine to create an exciting shape for the first section of the waterfall. Notice that this viewpoint affects the shape of the composition, changing it from a roughly square to a portrait format, which emphasizes the height of the falls and makes a more dramatic painting.

The edge texture of shapes plays an important part in this painting. Rough and soft edges are symbols for moving water; sharp edges would make the water look stationary. Sponging out spray has the dual effect of producing better shapes for both the water and the rocks.

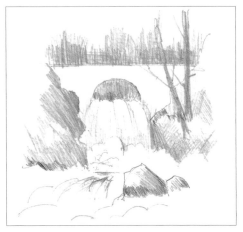

Compare this pencil sketch, drawn face on to the falls, with the tonal sketch below which was painted from a lower viewpoint.

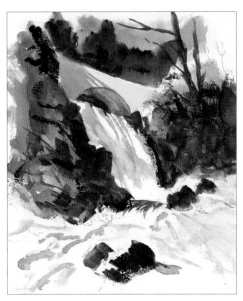

This tonal sketch was used to compose the painting.

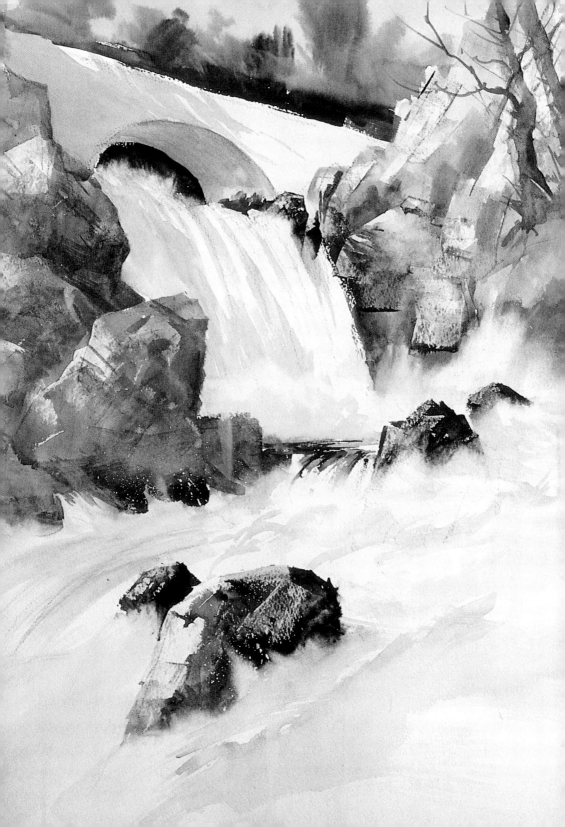

YOU WILL NEED:

300gsm (140lb) paper with a NOT
(cold pressed) surface finish
Graphite stick
25mm (1in) flat brush
13mm (½in) scraper brush
No. 3 rigger brush
Sponge
Razor blade
Process white
Colours as shown

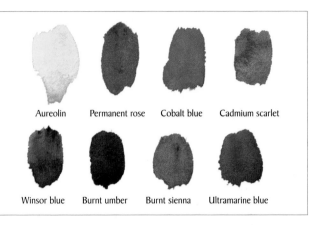

Aureolin Permanent rose Cobalt blue Cadmium scarlet

Winsor blue Burnt umber Burnt sienna Ultramarine blue

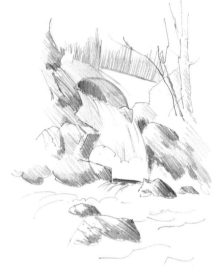

1 Use a graphite stick to sketch the outlines of the composition on to the watercolour paper.

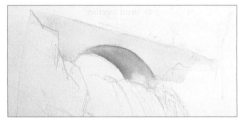

2 Use the flat brush and separate washes of aureolin, thin permanent rose and thin cobalt blue to block in the bridge. Allow the colours to blend on the paper, then leave to dry.

3 Mix a wash of cobalt blue with touches of permanent rose and cadmium scarlet, then glaze the shadows on the underside of bridge.

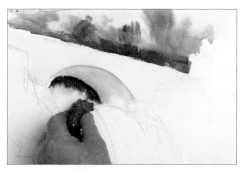

4 Use a wash of cobalt blue to lay in the sky, then, while this is wet, use mixes of Winsor blue and burnt umber to add trees behind the top of the bridge. Use the same mix to paint the foliage through the arch, then use a clean damp sponge to lift out colour to form spray.

5 Use a mix of burnt sienna and ultramarine blue and a flattened brush to form the line of the waterfall.

7 Now use the flat of a razor blade to scrape interesting shapes into the rocks.

6 Using washes of aureolin, permanent rose, ultramarine blue and burnt sienna, block in the rocks at the right-hand side and allow colours to blend together.

8 Use a clean damp sponge to soften the top edges of the mass of rocks. Mix burnt sienna with ultramarine blue, then add two large rocks at the top of the waterfall. Razor out some highlights on these rocks.

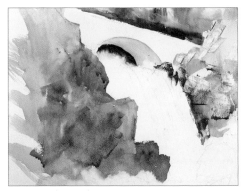

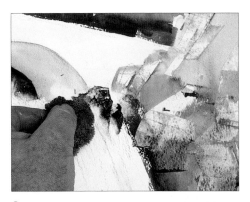

9 Use a clean sponge to soften the bottom edges of the two rocks at the top of the waterfall.

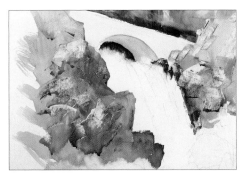

11 Use the razor to create interesting shapes on the rocks and to highlight the sunlit surfaces.

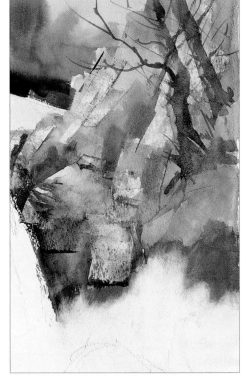

10 Use mixes of burnt sienna, ultramarine blue and burnt umber to block in the rocks at the left-hand side – use cooler colours at the top of rocks. Soften the edges at the water line with a sponge.

12 Mix some stony greys with cobalt blue, permanent rose and cadmium scarlet, then add shadows and shape to the rocks on both sides of the falls. Use the same colours to paint the cast shadows on the bridge.

13 Use burnt sienna to lay in the tree trunks at the right-hand side. Add ultramarine blue to the burnt sienna and apply shadows to the trunks. Use the handle of the scraper brush to create highlights. Use the rigger brush paint in some branches and twigs.

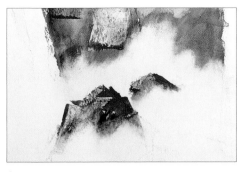

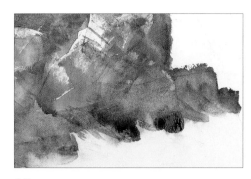

14 Mix a dark from ultramarine blue and burnt umber and block in the tops of two rocks at the base of the waterfall. Add touches of cadmium scarlet, then use the razor to create shape and highlights. Soften the bottom edges of these rocks with a sponge.

15 Use the same mixes as step 14 to apply dark areas at the bottom of the left-hand rocks.

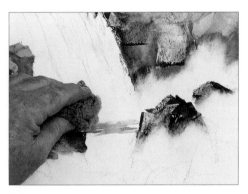

16 Add a touch of cadmium scarlet to cobalt blue, then paint a few horizontal lines to define the still water behind the rocks. Use a sponge to soften their top edges.

17 Add touches of burnt umber and ultramarine blue to the cobalt blue to make a darker blue, then add marks to the water to define movement between the rocks.

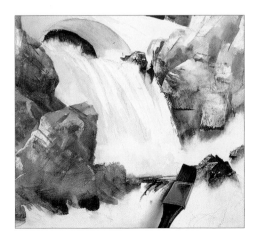

18 Make a weak wash of cobalt blue with a touch of cadmium scarlet, then flick the brush to create movement and shadows in the main waterfall. Sponge the bottom edges of all these marks, then add more shadows at the bottom.

19 Using mixes of burnt umber and ultramarine blue, paint the large rock formation in the foreground. Use the razor to create shape and highlights.

20 Use the cobalt blue and cadmium scarlet mix (see step 18) and sweeping strokes of the brush to build up movement in the water cascading round the rocks.

21 Apply process white with your finger to create spray, pushing the paint up into the rocks.

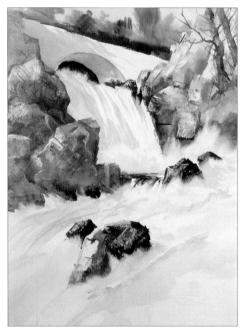

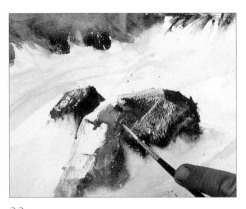

22 Spatter a few flying spots of spray over the dark areas of the foreground rocks by tapping a rigger brush, loaded with process white.

The finished painting. Having stood back and looked at the composition after step 22, I decided to add some dark marks at the top of the waterfall to give a distinct break between the water and the underside of the bridge.

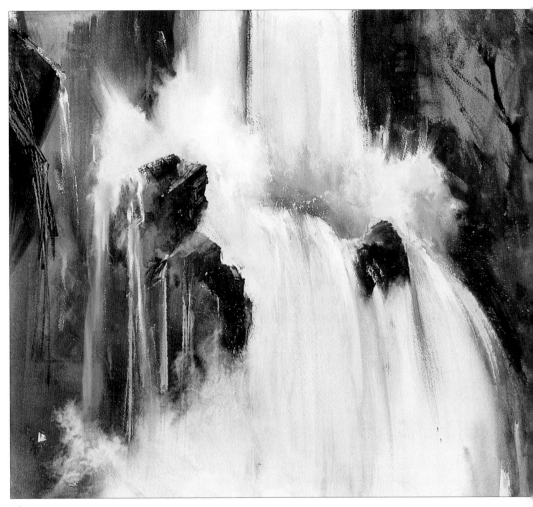

White Power

Size: 610 x 530mm (24 x 21in)

This composition is completely imaginary and is an example of using abstract shapes and different painting techniques.

The most important part of the composition was to develop an interest in the white shape of the water, which is totally unpredictable and takes up about 50% of the picture area.

More interest is created by varying the edges of each shape; some are hard, others are soft and roughly textured, all of which are symbolic of moving water. The water pouring off the rocks at the left-hand side and the spattered spray effects were created by using opaque process white.

The drama of this scene is accentuated by combining cool and warm tones. A variety of cool tones form the water in the centre of the painting. These are contrasted by the warm colours used for the rocks, that also serve to highlight the overall effect.

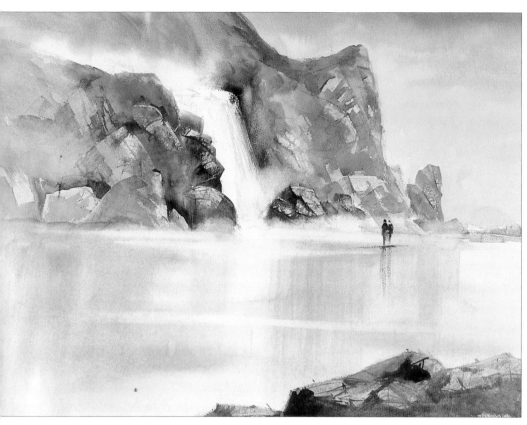

Tresaith Memory
Size: 735 x 535mm (29 x 21in)

The waterfall cascading on to the beach does exist, but, as I have not been to the beach for a long time, this painting is straight from the imagination. When composing it, I decided to enhance the size of the waterfall in relation to the beach and to use warm colours in the rocks. This practise is allowed because it is my painting! I also decided to add a couple of figures to give scale to the scene.

Opposite
Aberdulais Falls, South Wales
Size: 430 x 495mm (17 x 19½in)

The vertical format of this painting enhances the scene and gives prominence to the falls. The use of soft and rough edges indicates movement in the water. I used the corner of a razor blade to scratch out some sparkles in the water when the paint had dried.

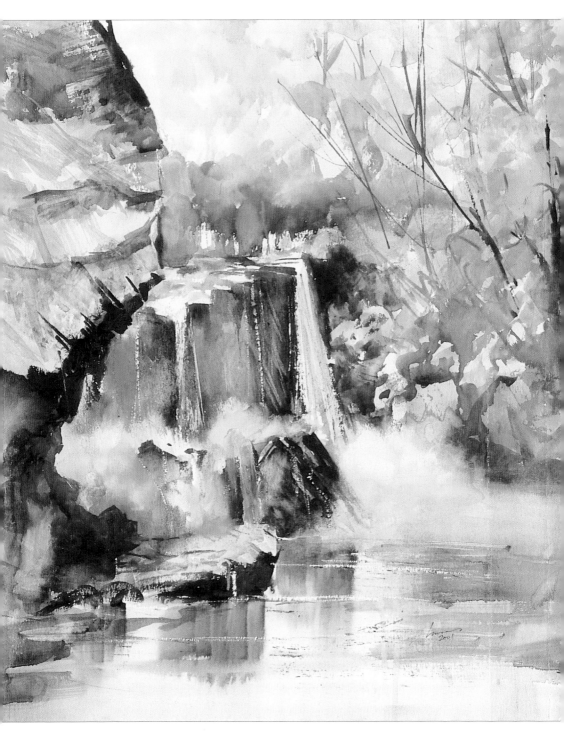

Seascape

It was very windy when I visited this beach and I wanted to capture that feeling in a painting. Rather than use horizontal and vertical lines that are normally associated with still, peaceful scenes, I used lots of diagonal lines and shapes at opposing angles. The rough edges on the cloud shapes, for example, helps create this mood and it is further enhanced by the shapes of the waves. Note that the focal point of this composition is simply a point (not an object) where the sea meets the beach in the bottom left quarter of the painting.

Rocks can be difficult to isolate from each other if you paint the colours exactly, so I tend to exaggerate the aerial perspective, making the furthest rocks cool (blue tones) and warming up the colours as the rocks become closer.

Soft and textured edges are applied to the base of the large rock formations where they meet the wet sand. Compare these edges with the rough ones used for the smaller, foreground rocks which are sticking out of dry sand.

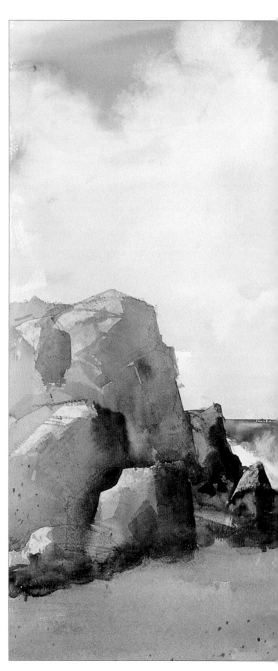

A monochrome tonal sketch of the beach scene.

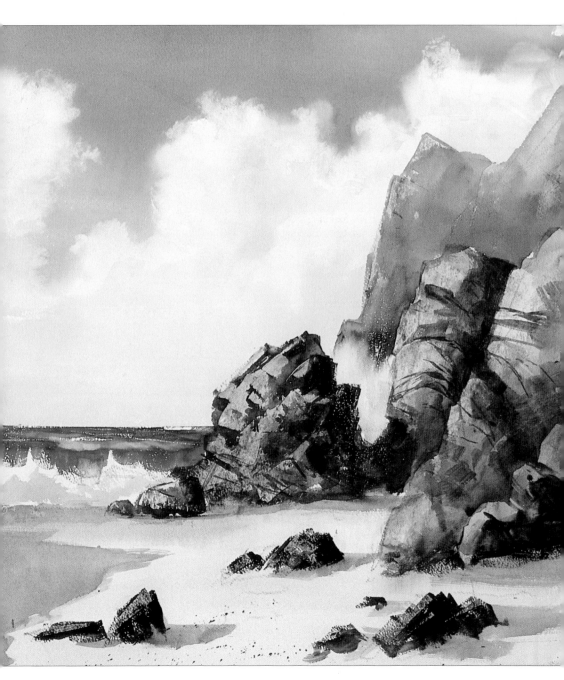

Winsor blue Cadmium scarlet Ultramarine blue Burnt sienna

Burnt umber Raw sienna Permanent rose

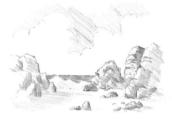

1 Sketch the outlines of the composition on to the watercolour paper. Use the flat brush to wet all the sky area, then brush in a wash of Winsor blue. Add a touch of cadmium scarlet to the mix and darken the top part of the sky.

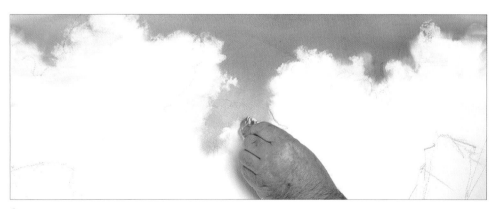

2 Using first a sponge and then a clean piece of paper towel, work the top edges of the cloud formation.

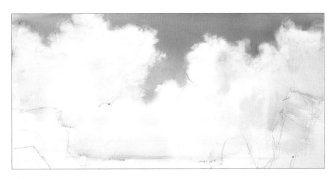

3 Rewet the cloud area, use Winsor blue and cadmium scarlet to mix a grey, then block in the undersides of the clouds.

4 Use paper towel to lift out colour and create shape and form in the lower clouds and the area of spray between the rocks at the right-hand side.

5 Mix Winsor blue and burnt sienna, then block in the large rock in the middle of the composition. Add touches of raw sienna in places.

6 Use the razor blade to create surface textures on the rock.

7 I was not happy with the shape of this rock, so I increased its width by adding darks to the right-hand side. I used the same mix to add shadows over the whole shape.

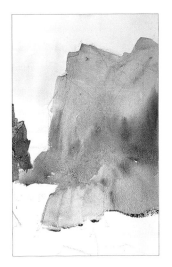

8 Using mixes of Winsor blue, raw sienna, permanent rose and burnt sienna, block in the cliffs at the right-hand side.

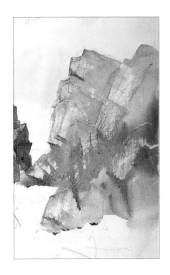

9 Use the razor blade to create shape, texture and highlights on the surfaces of the cliff.

71

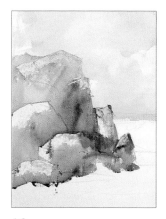

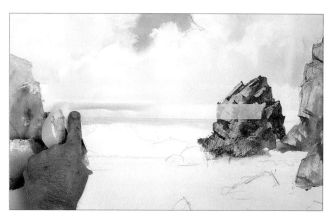

10 Use the same set of colours as in step 9 to block in the left-hand cliffs, then use the razor blade to create shape and texture.

11 Apply a length of masking tape along the horizon line and smooth down just the bottom edge.

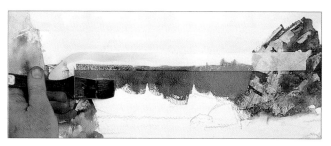

12 Mix Winsor blue with a touch of cadmium scarlet and paint in the sea along the horizon...

13 ... then flatten the brush to form rough edges at the top of the waves.

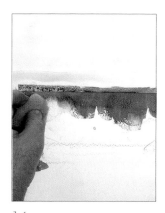

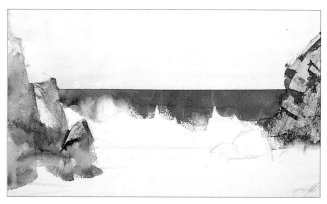

14 Soften the top edges of some of the waves with a clean damp sponge.

15 Remove the masking tape to leave a crisp, straight horizon.

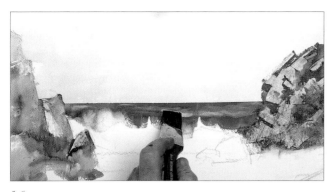

16 Use a clean, damp brush to lift colour out of the sea, to create swells and movement in the water.

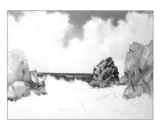

At the end of step 16, I stood back to look at the painting. The cliffs on either side were the same height and made the painting too balanced, so I decided to add more cliffs behind those at the right. Never be afraid of changing the composition as the painting progresses.

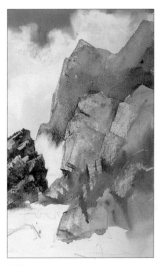

17 Overcome the problem of balance by using paler tones of the cliff colours used in step 8, to add taller cliffs behind those at the right-hand side. Use the sponge to recreate the spray at the bottom edges of these cliffs, and a razor blade to add texture.

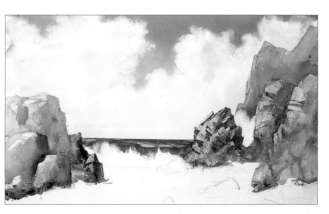

18 Mix ultramarine blue and a touch of cadmium scarlet to make greys, and use these colours to add shadows to the cliffs at both the left- and right-hand sides.

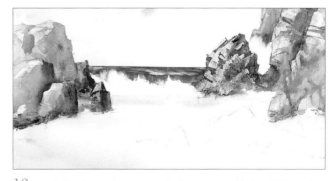

19 Wet the beach area, then use a wash of raw sienna to block in all the sand, including the small, pencilled rocks. Add a touch of burnt sienna in the foreground, to warm it up slightly, and a touch of Winsor blue to indicate wet sand in the distance.

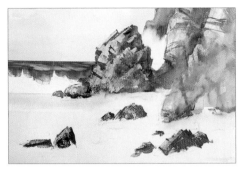

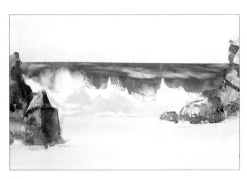

20 Mix ultramarine blue, burnt umber and a touch of cadmium scarlet, then use a dry brush to paint the rocks on the beach. The rough edges at the base of the rocks indicate dry sand. Use the razor blade to create shape and texture.

21 Mix Winsor blue with a touch of cadmium scarlet to add shadows in the breaking waves...

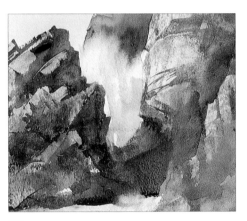

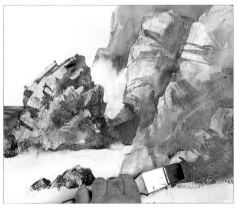

22 ... and in the spray between the rocks.

23 Mix ultramarine blue and burnt umber, then add shadows at the base of the cliffs. Soften some of the bottom edges with a clean damp brush.

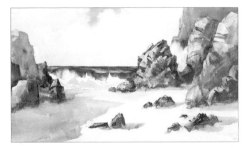

24 Mix ultramarine blue with touches of permanent rose and cadmium scarlet (to grey the mix), then paint in the cast shadows across the beach.

25 I still was not happy with the shape of the large rock, so I used the dark mix to alter it slightly. I also made subtle changes to the shapes and shadows on the right-hand cliffs.

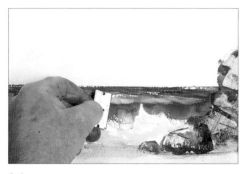

26 Use the razor blade to break the hard edge of the horizon line, and to add sparkles on the surface of the water.

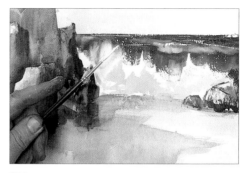

27 Spatter process white, by tapping a loaded rigger brush with your finger, to create spray above the waves.

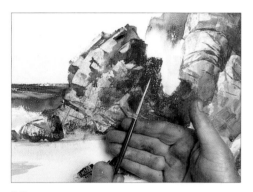

28 Spatter process white, by tapping a loaded brush against your other hand, to create heavier spots of spray between the rocks.

29 Use a putty eraser to remove the original pencil marks in the sky.

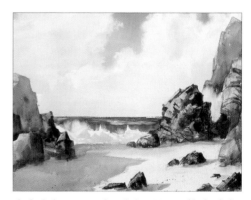

The finished painting. At the end of step 29, I stood back to look at the whole composition and decided to spatter a few pebbles on the beach.

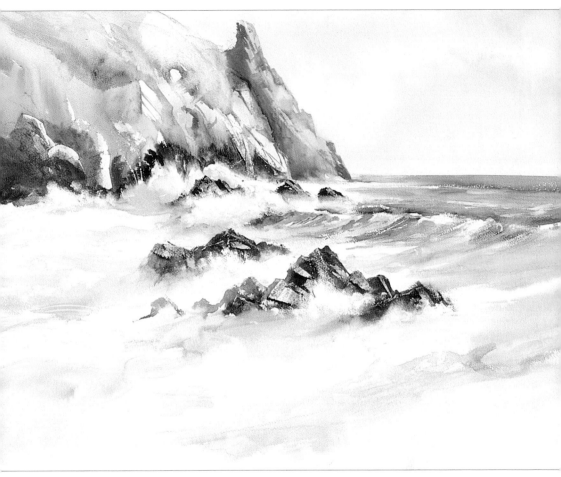

Pobbles, Gower Peninsula, South Wales
Size: 735 x 535mm (29 x 21in)

The diagonal directions of the shapes of the rocks and waves combine to give a feeling of movement in this composition. Added interest is achieved by giving these shapes a mixture of soft and rough edges.

Opposite
Beach, West Wales
Size: 710 x 510mm (28 x 20in)
I included clouds in this rather large sky area to create some more interesting shapes and to enhance the windy feeling of this scene.

Walking on Reflections
Size: 710 x 460mm (28 x 18in)
Although it is generally bad practice to have the horizon half way up the painting, in this instance, I felt that the lower horizontal edge, where the sea meets the sand, overrides it. The water lying on the wet sand causes powerful reflections and gives the impression that the figures are walking on water.

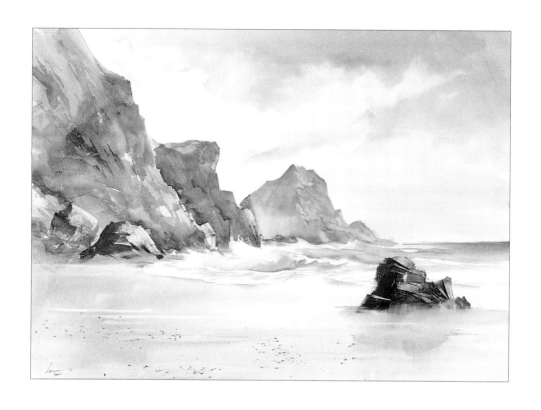

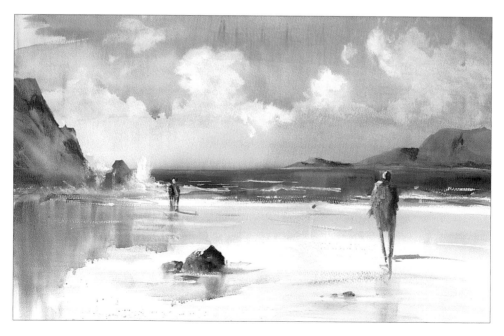

Buildings and figures

The eyeline in this composition is roughly level with the heads of two people in the far distance. Notice how the lines of the roofs and walls of the buildings on both the left- and extreme right-hand sides appear to vanish to a point on this line. In contrast, the far end of the road appears to vanish to a point above the eyeline giving it an uphill slant. The other two figures lower down the hill are drawn slightly larger to help create this effect.

I felt it was important to have a relatively dark tone both in the sky and in the foreground shadows to help the eye move through the scene to the lighter areas of the buildings. The church in the distance is entirely from my imagination, as are the trees on the left-hand side. Both have been introduced to form a counterchange (light against dark) and to help highlight the buildings.

The chimneys, windows and doors have been unevenly spaced to make the buildings more interesting, and I have used cast shadows to break up the flat surfaces of the walls into interesting shapes of light and tone.

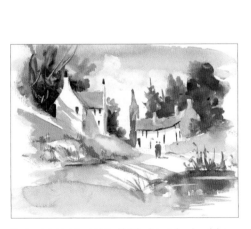

The tonal sketch into which I added the distant church and the group of trees on the left-hand side.

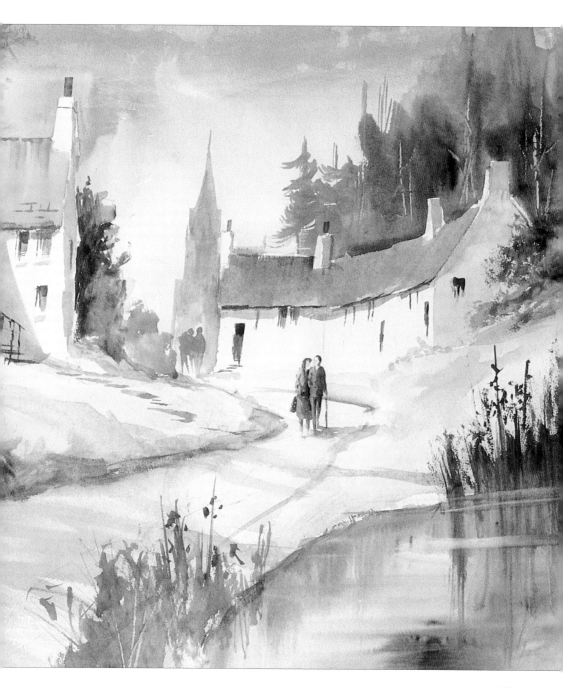

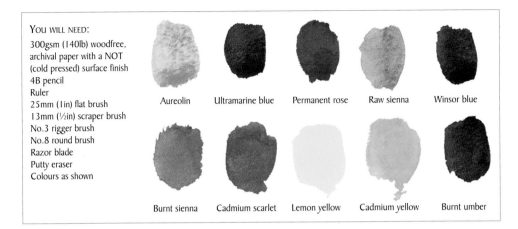

YOU WILL NEED:
300gsm (140lb) woodfree, archival paper with a NOT (cold pressed) surface finish
4B pencil
Ruler
25mm (1in) flat brush
13mm (½in) scraper brush
No.3 rigger brush
No.8 round brush
Razor blade
Putty eraser
Colours as shown

Aureolin | Ultramarine blue | Permanent rose | Raw sienna | Winsor blue

Burnt sienna | Cadmium scarlet | Lemon yellow | Cadmium yellow | Burnt umber

1 Using the tonal sketch on page 78 as a guide, make a pencil sketch of the composition. Use a ruler to draw in a true horizontal line at the eye level, then check the angles of your perspective. The buildings on the extreme left- and right-hand sides directly face each other, so their roof lines should converge to the same vanishing point (VP1). Note that the road first goes slightly downhill, so its first vanishing point, VP2, is below eye level. The road then turns and goes uphill and its sides then converge to vanishing point VP3 which is above the eye level. Note also that the heads of both groups of people walking on this stretch of road are also on a line from this vanishing point.

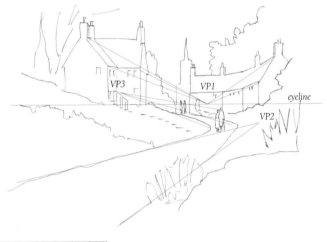

2 Amend the angles of the building as necessary, then draw a squared grid on to the revised sketch.

80

3 Using the grid on the pencil sketch as a reference, transfer the composition on to a scaled-up grid on the watercolour paper.

4 When the sketch is complete, use the putty eraser to rub out the grid lines on the paper.

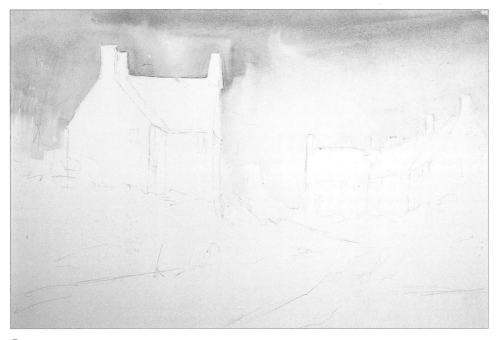

5 Wet the sky area with clean water. Make a wash of ultramarine blue mixed with a touch of cadmium scarlet, then use the 25mm (1in) flat brush to block in the sky, using the edge of the brush to cut round the outlines of the roofs and chimneys. Add a touch of raw sienna at the low, right-hand side of the sky.

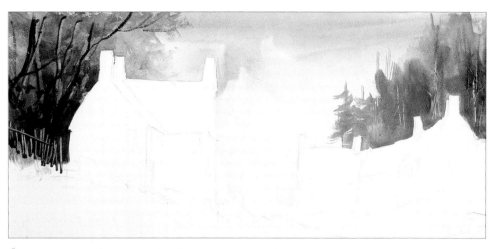

6 Mix some greens with raw sienna and touches of ultramarine blue, then block in the trees. Add touches of permanent rose and more ultramarine blue to build up shape. Add touches of Winsor blue and burnt sienna to build up a multicoloured background. Use the handle of the scraper brush to create tree trunks and large branches. Use the rigger brush and a dark mix of ultramarine blue and burnt sienna to draw finer branches. Finally scrape in an indication of a fence on the left-hand side. Leave to dry.

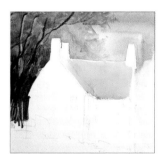

7 Use aureolin to block in the roof of the left-hand building.

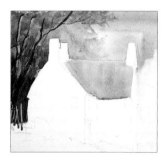

8 While the paint is still wet, mingle touches of cadmium scarlet into the yellow roof.

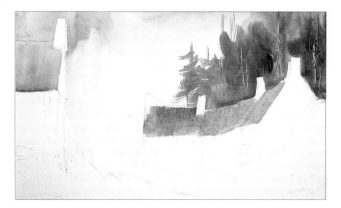

9 Use washes of burnt sienna to block in the roofs of the right-hand buildings, then mingle in touches of ultramarine blue.

10 Mix a dark with ultramarine blue and cadmium scarlet, then paint in the gutters and windows.

11 Use lemon yellow to block in the grassy bank on both sides of the road. While this is still wet, drop in some ultramarine blue at the top of these shapes and raw sienna along the bottom edges.

12 Use a mix of ultramarine blue and burnt umber to block in some rocks on the far side of the road. Use the razor blade to create surface texture and shape. Weaken the wash, then add indications of foliage behind the rocks. Use the same colour to define the nearside edge of the road.

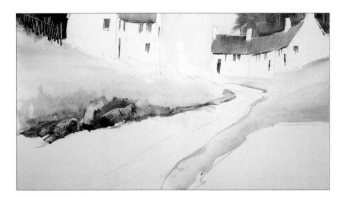

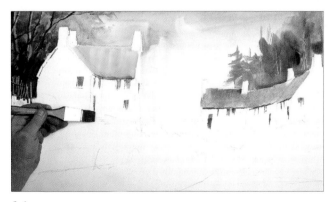

13 Mix ultramarine blue with permanent rose, add a touch of cadmium scarlet to grey the mix slightly, then paint cast shadows on the walls of the left-hand building.

14 Use a weak wash of ultramarine blue to block in the surface of the road. Add touches of cadmium scarlet in the foreground.

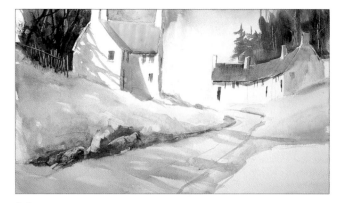

15 Mix a grey with ultramarine blue, permanent rose and cadmium scarlet and, separately, an orange with cadmium yellow and a touch of cadmium scarlet. Use the grey mix to add shadows to the other buildings, then drop a splash of the orange into the end wall. Allow the colours to blend together.

16 Use various tones of the shadow mix, to block in the cast shadows down the left-hand grassy bank, across the road and up the grassy bank at the right. Dry the brush, then lift out speckles of sunlight in the cast shadows.

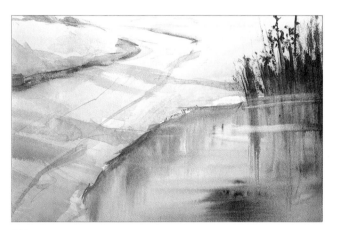

17 Wet the pond, then, using tones of the colours behind the pond, block in the surface of the water; use vertical strokes to create reflections, then finish with a few horizontal strokes to create ripples. Mix a dark with burnt sienna and ultramarine blue, then paint the reeds at the back of the pond.

18 Mix Winsor blue and burnt sienna, then use this colour to break up the large shape of the left-hand grassy bank by adding a steep rocky area. Use the razor blade to create shape and texture, then add darker tones. Use the rigger brush to create an old fence.

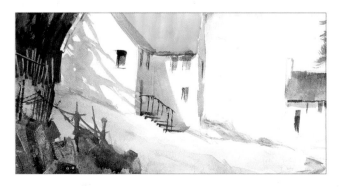

19 Use the edge of the flat brush to add a set of steps and a handrail in front of the left-hand building, and to darken the top part of the window in the end wall.

20 Use a soft pencil to draw two figures in the middle distance and two more further up the road. Remember to scale these figures to the buildings.

21 Use the round brush and cadmium scarlet mixed with raw sienna to block in the faces of the near figures. Use a mixes of burnt sienna and ultramarine blue for the man's coat and ultramarine blue and cadmium scarlet for his trousers. Use permanent rose to indicate the lady's dress. Darken the colours, then add hair, shadowed parts of the clothing and cast shadows on the ground.

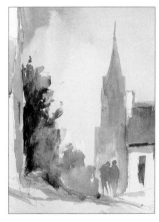

22 Use a pale mix of ultramarine blue with a touch of burnt umber to block in the two distant figures (these do not need the detail given to the foreground figures). Dry the paper, then use the same mix to block in a church tower, weakening the colour as you work down behind the figures. Mix a dark with burnt umber and Winsor blue, then use a flat brush to add trees behind the left-hand house to link the two sides of the painting.

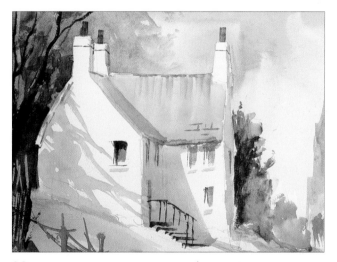

23 Use cadmium scarlet with a touch of Winsor blue to add details to the ridge tiles and an indication of tiles on the roofs. Mix burnt sienna and ultramarine blue, then add the chimney pots and a thin shadow round the chimneys. Weaken the mix, then add the shadows cast by the window sills.

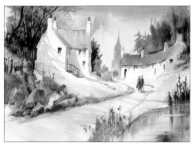

The finished painting. Having stood back for a look after step 23, I decided to add a few details: some spiky grasses in the foreground; more shape on the right-hand grassy bank; a few steps in front of the door of the right-hand building; and an indication of a path leading up to the left-hand building.

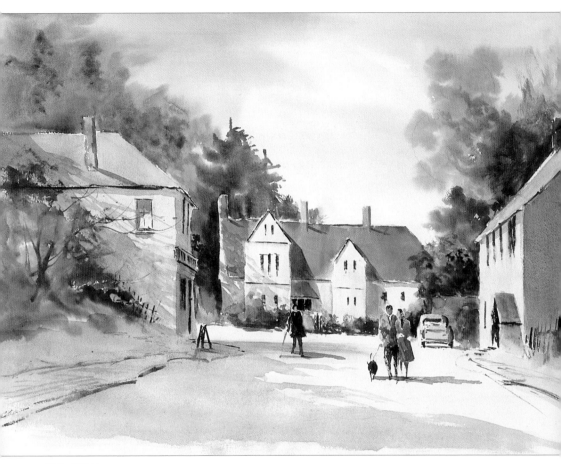

Wylie, Wiltshire
Size: 710 x 510mm (28 x 20in)

In this composition, the perspective lines of the road and the sloping roofs at either side lead the eye to the central figures. Figures give a more lived-in feeling to a painting, bringing it to life. They also provide scale to the composition, enabling the viewer to size the overall scene. Figures in the landscape do not have to be detailed portraits; a few simple strokes are usually sufficient for the marks to be identified as people.

Urchfont Village, Wiltshire

Size: 635 x 430mm (25 x 17in)

I painted this picture in situ *at a painting demonstration in the village of Urchfont. It may seem unusual to include the scaffolding, but I felt that the shapes and shadows it created were too attractive too leave out. I added the two figures to bring life to the painting.*

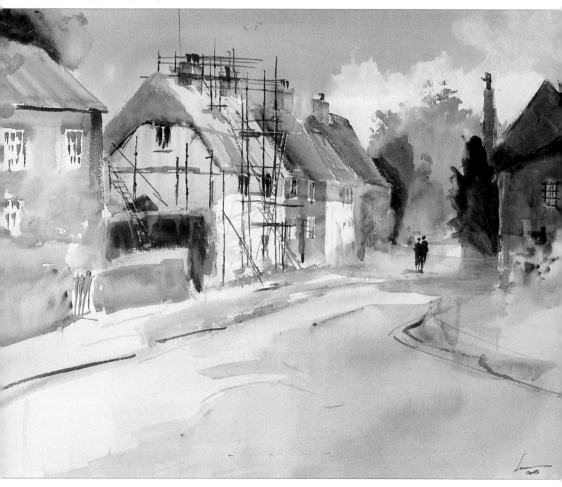

Snowscene

When painting snow scenes, it is so easy to fall into the trap of working everything in cool colours. You may have reproduced a scene perfectly correctly, but no one will buy it because it will look too sombre! So, make sure you introduce some warm colours to counterbalance the cools. You do not need much as you can see in this composition. Here I used warm colours to paint the middle-distant cottages, and force the eye to this focal point.

The shape of the road also helps lead the eye to the focal point and it creates depth in the painting as do the soft edges of the background shapes. By contrast, the bold, sparkled edges in the foreground add a crispness to the painting

A blanket of snow across a landscape means that there are lots of 'white' areas in paintings of snow scenes. Use shadows wisely to break up these areas into light and dark shapes. The shadows also help to show the contours of the ground and the depth of snow on the hedges. The gate in the hedge is placed to allow a nice shaft of light to break the shadow area.

This painting includes falling snow which has the effect of lightening the other tones in a painting. Bearing this in mind, I painted it with slightly darker tones than I would have done without the falling snow.

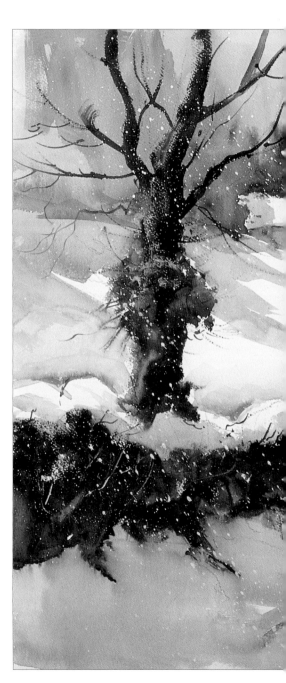

The original pencil sketch used to compose this painting.

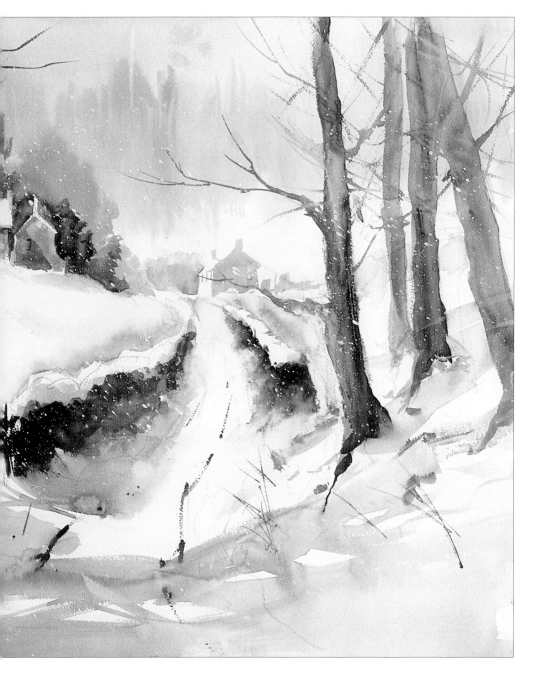

Ultramarine blue Permanent rose Burnt umber Burnt sienna

Cadmium scarlet Winsor blue Cobalt blue

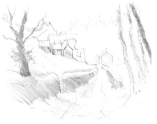

1 Use the graphite stick to sketch in the outlines of the composition on to the watercolour paper.

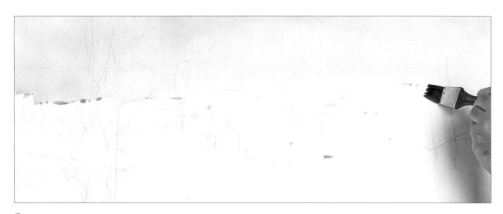

2 Use the flat brush to wet the sky area. Mix a wash of Winsor blue, then lay this into the sky.

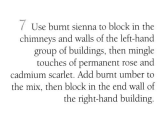

3 Working wet into wet, lay in a wash of permanent rose and allow the colours to blend. Darken the top left-hand side of the sky with more blue.

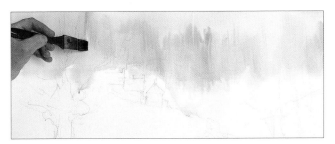

TIP MOPPING UP
Use a clean, damp sponge to mop up any dribbles of colour.

4 Mix Winsor blue and burnt umber, then drop tones of this mix into the damp sky. Pull the colour downwards to indicate the trees in the far distance.

5 Mix deeper tones with the same colours, then, cutting round the shape of the buildings, paint in the closer stand of trees.

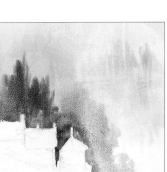

6 Add touches of burnt sienna to the damp greens to add a warm area at the left of the buildings.

7 Use burnt sienna to block in the chimneys and walls of the left-hand group of buildings, then mingle touches of permanent rose and cadmium scarlet. Add burnt umber to the mix, then block in the end wall of the right-hand building.

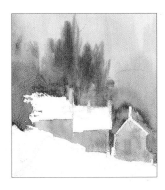

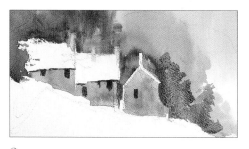

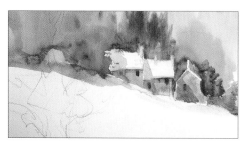

8 Use the scraper brush and a mix of ultramarine blue and burnt umber to add windows, doors and gutters. Use the same colour to reshape the right-hand building and to add a few bushes.

9 Mix cobalt blue and permanent rose with a touch of cadmium scarlet, then lay in cast shadows on the roofs and walls, and on the sloping area in front of the buildings. Note how the roof shadows indicate the depth of snow.

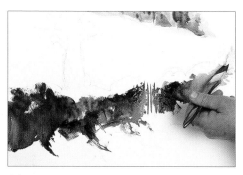

10 Use mixes of burnt sienna and ultramarine blue to block in the foreground hedge and fence, making the colours cooler and less dense as you work to the far end. Hold the brush flat to add sparkle along the top of the hedge.

11 Using the same colours as in step 10, mix browns, greens and darks, then use the flat brush to paint the trunk and main branches of the tree. Change to the rigger brush and add small branches and twigs.

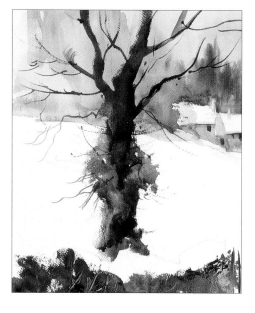

12 Mix a dark with ultramarine blue and burnt umber, then use a rigger brush to accent the shape of the road.

TIP REMOVING MARKS
If you accidentally make an unwanted brush stroke, cut a hole in a piece of scrap paper, place it over the offending mark and use a sponge to remove the mark.

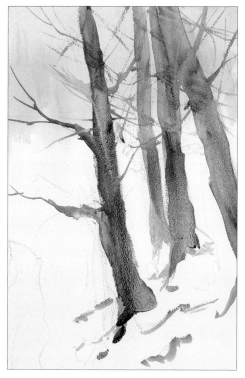

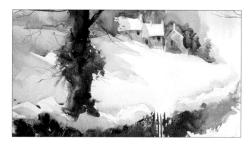

14 Mix up a good quantity of the shadow wash – cobalt blue with permanent rose and cadmium scarlet – then lay in more shadows across the sloping bank at the left-hand side. Add shadows on top of hedge to indicate the depth of snow and more behind the top of this snow to indicate a deep slope behind hedge. Soften the top edges of all the shadows with water.

13 Use mixes of burnt sienna and ultramarine blue and the flat brush to add tree trunks at the right-hand side of the road and a few indications of roots. Use the rigger brush to add finer branches and twigs. Use a dry brush and a criss-cross action to add twigs in the sky behind the tree trunks.

15 Use the same shadow mix to add shade at bottom of hedge and cast shadows across the road and up the right-hand bank.

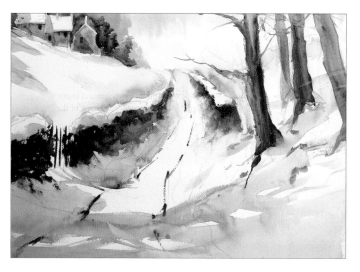

16 Use burnt sienna and ultramarine blue to lay in a hedge at the right-hand side of the road. Use the shadow wash, mixed in step 14, to add more shadows behind the trees. Balance these with deeper tones on the distant part of the left-hand hedge.

17 Make deeper tones of the shadow mix, then accentuate the shadows behind the top of the snow on the hedge at the left-hand side.

18 Mix burnt sienna with a touch of ultramarine blue, then use the rigger brush to flick in an indication a few grasses and twigs on either side of the road.

19 Mix a weak wash of ultramarine blue with a touch of burnt umber, then block in the distant building and some shadowy shapes at the right-hand side. Accentuate the sunlit side of the building (which is bare paper) by painting in an indication of trees in the distance.

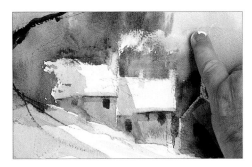

20 Apply process white with a finger to indicate smoke from the chimney.

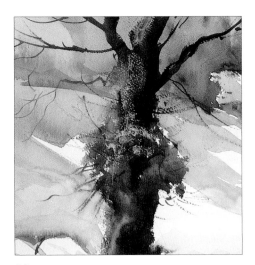

21 Use mixes of Winsor blue and burnt umber for the ivy on the tree. Hold the brush flat to produce sparkled edges.

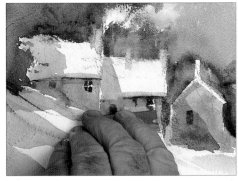

22 Use the corner of a razor blade to scratch out details on the windows.

The painting as at the end of step 22. You could stop painting at this point, but I wanted to show you how I add falling snow. Adding snow has the effect of lightening the tones in a painting, so, knowing this before starting this demonstration, I made them slightly darker than I would otherwise have done.

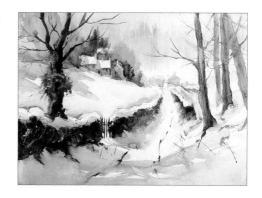

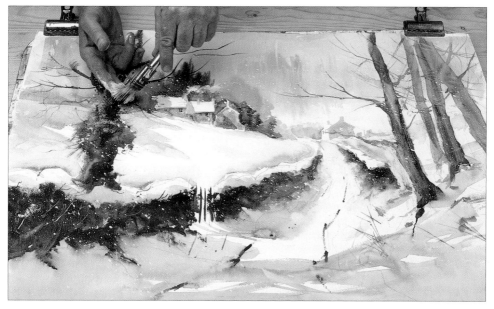

23 Load the bristle brush with process white and drag it across your fingers to flick specks of falling snow over the painting. Angle the brush to indicate the direction of the wind driving the snow.

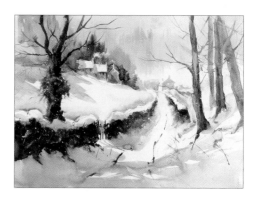

The finished painting.
The direction in which you apply the snow determines the wind conditions. For this painting, I applied the snow diagonally across the paper to imply a degree of windiness. Applying it vertically would have produced a still, peaceful effect, with less dynamics. For this large painting, which measures 735 x 530mm (29 x 21in), I used a large brush to produce a variety of sizes of snowflake to give added perspective. For smaller paintings you could use an old toothbrush.

Castell Coch, near Cardiff, Wales

Size: 735 x 510mm (29 x 20in)

This castle was rebuilt by the Marquis of Bute approximately one hundred years ago. The décor inside is magical with murals of Aesop's fables. It has been used as a film set many times for films such as The Black Knight *and* The Prisoner of Zenda. *The surrounding trees make it almost impossible to find an interesting view of the castle, but I was lucky to discover a detailed model of it in one of the rooms inside. This allowed me to photograph it from lots of different angles, and this unusual aerial view is taken from one of these photographs.*

Winter Lakeland

Size: 735 x 510mm (29 x 20in)

In this imaginary composition, it was important to get the tones of the distant mountains correct. Their sunlit sides are lighter than the sky, while those in shadow are darker. The use of soft edges pushes them back into the distance. All the shapes used in this painting – those of the river, the stands of trees and the mountains – were designed to lead the eye to the house.

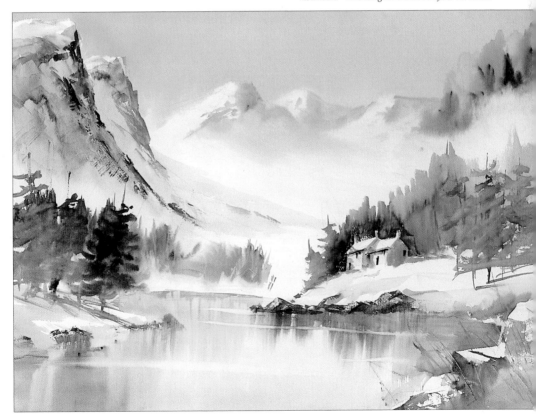

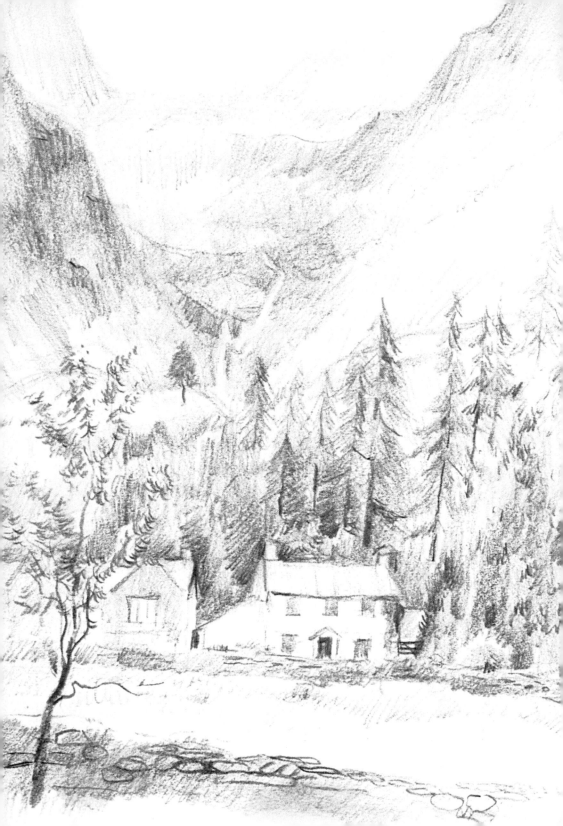

From Sketch to Painting

WENDY JELBERT

Learn how to capture special moments, images, holiday memories, colours and textures and how to transform these sketches into beautiful paintings. Three detailed step-by-step demonstrations illustrate the techniques.

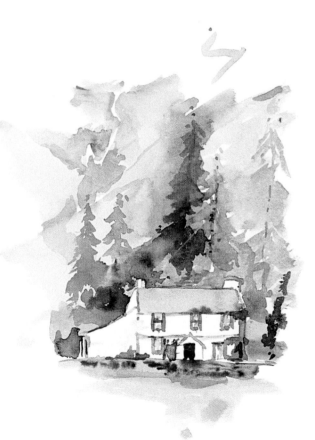

Introduction

What better than to be able to record precious holiday memories, a bustling market, shadows falling across a favourite building, textured foliage, buildings and much more in a sketchbook. This is what most artists enjoy – the gathering together of information that can be used in many different ways in future paintings. There are no hard and fast rules about what medium should be used when sketching, or how a subject should be approached, and this allows a freedom which is both exciting and invigorating. To be able to open a sketchbook and capture images, thoughts, colours and textures, using whatever medium you have to hand, is wonderfully liberating.

Quite naturally, novice painters often give up the idea of keeping a sketchbook without even trying to capture what they see, because they are not sure how to begin. It is more simple than they think and those who are keen enough to start often find that they are developing their own way of working, and in the process they are creating a book that is as individual and original as a personal journal. If they persevere, it does not take them too long to discover that sketching is simple, and it is not too hard to capture whatever inspires them.

In this section I give key pointers on how to observe and what to look out for. I talk about all the ingredients that make sketching rewarding and successful, with demonstrations and tips showing how they can be developed into beautiful paintings. The secret is to sketch what inspires you, to record useful details and to absorb them into a finished composition you can be proud of. Above all, you should relax and have fun!

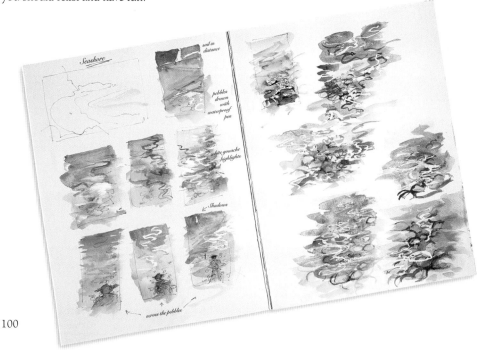

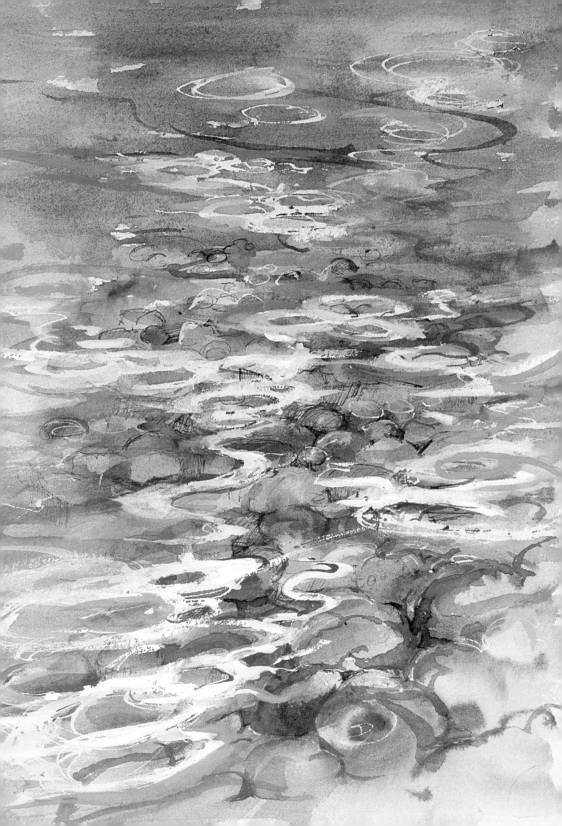

Materials

I sketch mostly when I am out and about and keep my materials lightweight and simple, cutting down on equipment where possible. If you are just starting to sketch, you should have a trial run before you venture out for the first time. Sometimes the materials you want to take just will not fit in your bag, and decisions have to be made about what to leave behind. There is only one rule: keep everything simple!

SKETCHBOOKS

There are many different sketchbooks to be found and it can be a bewildering choice for anyone just starting to sketch. They vary in binding, size, shape and the type and colour of paper they contain. Some have paper with a smooth surface and they are ideal for pencil techniques and pen and ink, others contain heavier watercolour paper and these can be used for quick watercolour sketches or even small paintings. Most sketchbooks hold only one type of paper, although the colours may vary. Some are spiral-bound, which facilitates drawing and sketching because the papers lie flat and do not spring up when you are working. It is worth finding out what you feel comfortable with and important to use the right media with the right paper.

I like to use hardback books 250 x 175mm (10 x 7in), but I also use smaller books 125 x 175mm (5 x 7in) that will fit into a pocket or a bag easily. The latter are very useful because I can carry them around with me wherever I go. I prefer to use 190gsm (90lb) watercolour paper sketchbooks, but I also have several books containing thick cartridge paper. These can be used for both drawing and painting. I also like gummed pads which are available in different weights and a wide range of sizes. I often carry small pieces of 190gsm (90Ib) watercolour paper with me, plus a lightweight cartridge paper sketchbook. If I am lucky enough to find something I want to record, I can quickly sketch it and secure it inside my sketchbook.

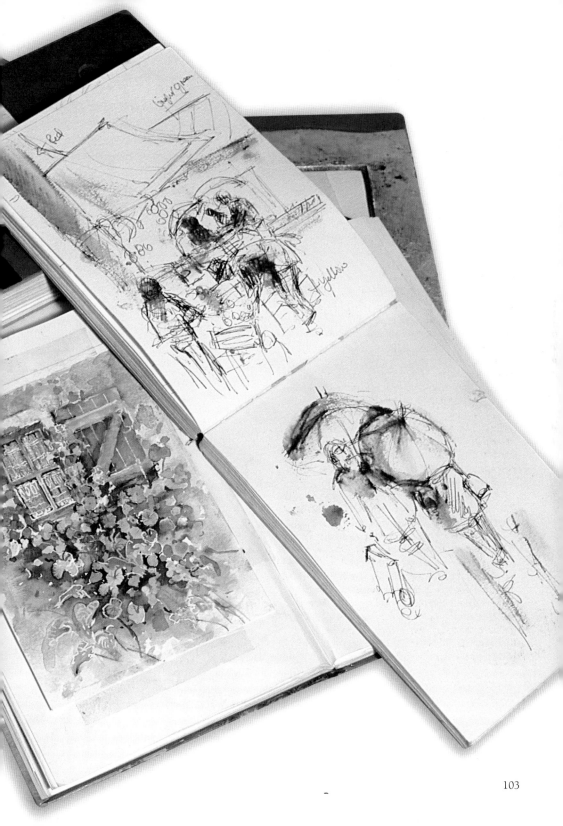

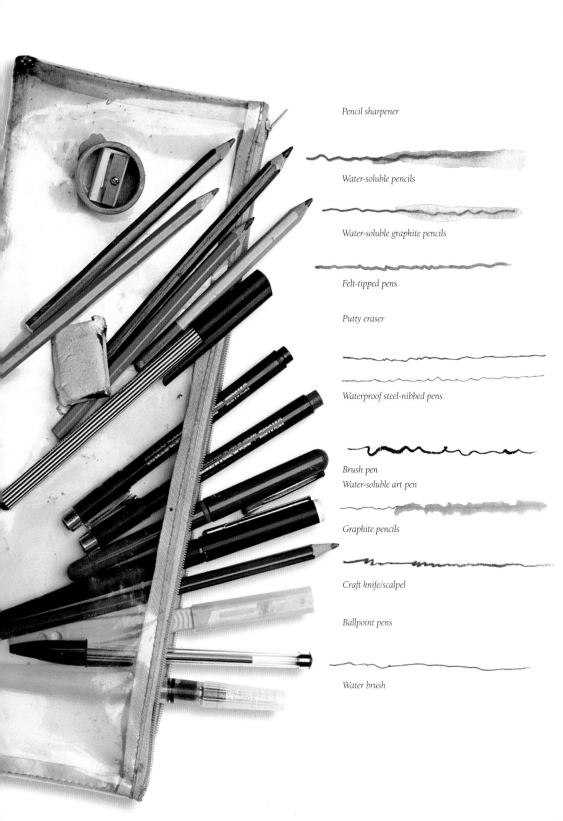

Pencil sharpener

Water-soluble pencils

Water-soluble graphite pencils

Felt-tipped pens

Putty eraser

Waterproof steel-nibbed pens

Brush pen
Water-soluble art pen

Graphite pencils

Craft knife/scalpel

Ballpoint pens

Water brush

Pencils and Pens

There are many different pencils and pens available and I use a wide variety of them. That's the beauty of sketching – you can capture a scene or image quickly with whatever you have with you. Make sure that pencils are always well sharpened and that pens are clean, and keep them together. I store mine carefully in a large, transparent zipped pencil case.

Water-soluble pencils

These are available in a good range of colours and they can be used wet or dry. They are excellent for making colour notes which can be used as reference back in the studio. Prices vary – you usually pay for what you get and it is worth buying better quality pencils if you can. I prefer the 'fatter' ones which have more pigment and flow better. Washes are easily achieved by extracting the colour from the pencil tip with a brush and water, or they can be used to enhance watercolour washes. When going sketching, I take just a few specially chosen colours rather than a whole set which can be quite heavy.

Felt-tipped pens

These are available in different sizes and varieties and they are great for making quick, bold sketches. You can buy both water-soluble and waterproof felt-tipped pens. The former can be diffused with water to create beautiful wash effects; the latter are great for detail and precise drawings.

Waterproof steel-nibbed pens

These are available in black, sepia and a range of nib sizes. I find 02 and 03 are the best size when sketching. They are ideal for a main drawing, or for pen, line and wash techniques, especially if the image needs to stay intact.

Ballpoint Pens

I use these frequently for quick spontaneous sketching and although they are limited in nib-width and colour, they are good for precise work and reference doodles.

Pencil sharpener

I carry one of these all the time, but it must be renewed quite often as it blunts quite quickly.

Craft knife/Scalpel

I use a scalpel for sharpening pencils in my studio. Keep the sheath on the blade when not in use!

Putty eraser

This is always useful and I keep one with my sketching materials.

Water-soluble art pens

These pens resemble cartridge-type fountain pens and they are available in black and sepia, and with an assortment of nibs. When a drawing requires a more fluid, or dispersed look, these pens are lovely, but care needs to be taken – do not use too much ink to start with if you are using watercolours, or outlines will merge with the paints and run!

Brush pens

Waterproof and water-soluble sets of these pens are available in black, sepia or colour with a variety of 'brush' widths. They are excellent for sketching because they resemble brushes with a constant supply of colour! Easy, free movements can create bold drawings and they are ideal for areas of colour.

Graphite pencils

These pencils range from very hard (9H) to very soft (9B). Halfway between the two are F and HB. I like to use the soft end of the range (3B to 7B), as these are great for creating dark, black marks on quick sketches. I use only one pencil when sketching outside – a 5B or a 7B, so that I can create a range of tones. I use a harder, lighter pencil for initial drawings when using watercolour. You can also buy solid graphite sticks for strong, bold work. These will shatter if dropped, so treat them carefully!

Water-soluble graphite pencils

These are extremely useful as they provide quick wet tonal areas. There are many brands to choose from, but I always buy the softest and darkest ones available. They can also be used as a dry medium for crosshatched tonal sketches.

Water-brush pens

The transparent bases of these pens are filled with water and the brush tops are screwed to the bases. They are an ideal accompaniment to water-soluble pens and pencils when you are planning a few simple sketches and you want to travel light. It saves you carrying a water container.

WATERCOLOURS

Watercolours are available in a large range of lovely colours and they can be bought in pans or tubes. They are excellent for making quick sketches and capturing the colours, mood and atmosphere of a scene or place. The sketch can then be worked up into a finished painting back in the studio. If you can afford it, buy artists' quality paints – they are better than the students' colours and they mix well. I prefer to squeeze tube paints into the pans of my palette allowing them to dry before closing the lid. I have a tiny pan set for sketching outside and a larger one for studio work (see below). Although I hardly ever use more than five of six colours in a painting, having a wide range of translucent and opaque colours available gives me more choice.

PAPERS

Watercolour papers are available with different surface finishes: Hot Pressed (HP) is smooth; NOT (Cold Pressed) has a slight texture; and Rough is heavily textured. All these types of paper are made in differnt weights (thicknesses) ranging from 190gsm (90Ib) to 640gsm (300Ib).

I like to use sheets of 300gsm (140Ib) NOT watercolour paper for finished paintings. Sometimes I secure the sheet of paper to a thick piece of cardboard, fitted with a heavy paper flap to protect the finished work. I also have a rectangular hardboard base with a lift-up aperture mount between which I secure my paper – this gives a white frame to the painting.

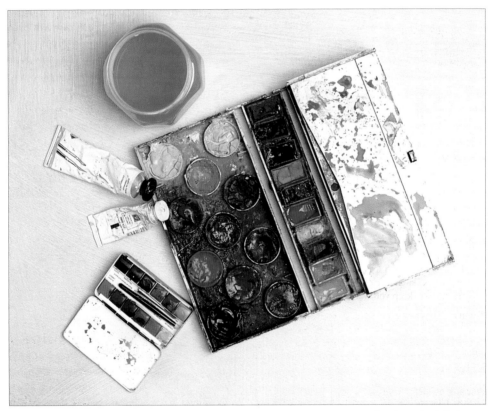

The colours in the small pans of my large palette are (from the top down): Payne's gray, sepia, Hooker's green, neutral tint, cobalt violet, cobalt blue, cadmium yellow, burnt sienna, yellow ochre and cadmium orange.

The colours in the large pans are (from the top down): leaf green, Naples yellow, Cerulean blue, Winsor blue, Vandyke brown, alizarin crimson, cadmium red, black, olive green (light), olive green (dark) and brown madder.

BRUSHES

There are many brushes available. They come in a variety of shapes, sizes and quality. Selecting the right ones can be quite daunting. To start with, I would advise you to buy a few of the best that you can afford, then gradually build up a collection. I suggest having at least one small round brush for general work and middle distance details, a rigger for fine details, and two flat brushes. Use the small flat brush for blocking in buildings, trees and objects with sharp edges, and the large one for applying washes.

I use just one brush which I designed myself. It is wedged-shaped with a fine rigger tip, and is specially made for me. It provides all the wash and detail action I need and is ideal if you want to travel light!

OTHER EQUIPMENT

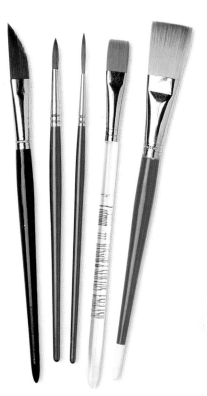

Masking fluid This is used to create highlights on a finished painting. I apply it to the surface of the paper before painting, or use it over a base colour prior to applying a wash. I always use a ruling pen to apply masking fluid, as it can ruin brushes.

Sponges These are excellent for the texture of trees, foliage and sea spray. Natural and man-made sponges give different effects, so try both.

Candles A candle (wax resist) rubbed on to the paper is ideal for creating highlights such as sunlight on water and snow.

Plastic food wrap An unusual, but very effective means of providing texture. It can create exciting backgrounds and some good flower and rock effects. The wrap is applied on to wet washes, pinched into shape, then left in position until the paint is dry.

Plastic card A redundant credit card can be used for dragging paint about, lifting edges and scoring narrow highlights.

Paper towel This is vital for mopping up spillages, but I also use it for lifting out colour.

Black bin liner If you are going to sit outside in cold weather, a large black bin liner, pulled up over your knees, will keep you warm inside!

Camera Throwaway cameras are super if weight and bulk is a problem, but one with a telescopic lens is better. This lens allows you to capture detail from a distance, and candid images of birds, animals and children without them noticing you.

Stool While you are out and about, it is a good idea to take a lightweight ruck-sack type stool with a bag attached. It needs to be large enough to carry a water pot if you are taking one. Plastic containers with airtight lids make good water pots.

Materials for creating highlights and textures: masking fluid and a ruling pen, plastic food wrap, a candle, an old plastic credit card, a piece of sponge and some paper towel.

Getting started

Whatever type of artist you are – a professional, a serious amateur, a weekend artist, or a beginner – a few crucial lines, some written notes and, maybe, a couple of photographs, will help capture forever a fleeting moment of time that sparks your interest. You never know when these moments are going to occur, so you must be prepared. Personally, I never leave home without a small sketchbook and a pen or pencil in my pocket; I might forget my keys, but never my sketchbook! Remember that you only have a brief time in which to record a scene, so it is important to get all the right information down quickly and accurately.

When I see something that captures my imagination I ask myself why it does so. Then, I say out loud why I like it! Whatever the answer, I try to capture the movement, the shapes, the contrasts or textures immediately.

I have been painting for many years now, and my collection of sketchbooks are as dear to me as my family. They are filled with memories of people, places and objects that I have come across over the years. Some of the sketches are just doodles to capture a particular pose or an interesting shape, others are more detailed, worked up in whatever medium I have to hand, and include handwritten notes about colours, tones and textures. I never discard anything, and many of my favourite paintings have been inspired by old sketches.

TIP SKETCH IN COMFORT

On a sketching expedition, dress in something comfortable and always carry a lightweight waterproof and a cardigan – even in summer or in a hot climate! When you are concentrating on sketching, you can easily forget how cold it can become.

If possible, carry a small stool so that you can sit in comfort; mine is combined in a rucksack.

A black plastic bin liner can be extremely useful in inclement weather conditions. Pop your legs inside the bag and they will be protected from cold winds. It does not look very fashionable, but you will be warm.

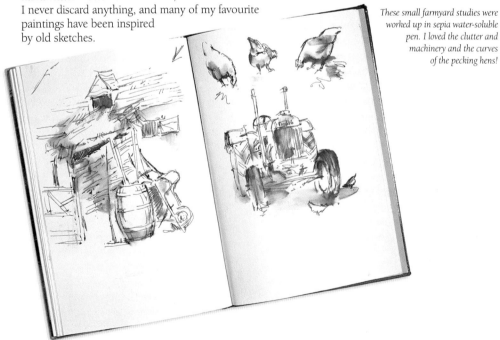

These small farmyard studies were worked up in sepia water-soluble pen. I loved the clutter and machinery and the curves of the pecking hens!

These rabbits, worked up in pencil, were a delight to sketch as they formed gorgeous and varied shapes.

Use simple free-flowing lines (you do not have to be very accurate at first) and concentrate on the very 'essence' or 'action' of the subject. Work up various widths of line; heavy ones to denote forceful and active feelings and thinner ones for distance and structure. Support these with accents of shading to give depth and contrast.

Runner beans sketched with waterproof pens. It was quite a challenge to sketch the fascinating negative shapes of these beans, some of which were in sharp contrast to adjacent shapes. Often this type of sketch can be done as fast spontaneous scribbles. Keep the pen or pencil continually on the paper, hardly looking at what you are drawing, but concentrating deeply on the subject. This method can add a freshness and freedom to your sketching which can give some unexpected results.

USING SKETCHING MATERIALS

Never be afraid of using different mediums, either on their own or mixed together. The images on this page show the same scene sketched in different ways, while opposite, I have included a finished painting of the same scene. The sketches were the result of an exercise I set some students while on a painting holiday in Greece. Every time we left our courtyard, we were confronted with this adorable doorway and hibiscus plant, so it was quite handy to use this as our subject.

In this image, the doorway was drawn in with pencil, then overlaid with a network of non-waterproof sepia ink, adding more detailed work in the darker areas and much less in the lighter ones. I then used a wetted brush to coax water over the doorway allowing it to seep and bleed into a diffused tonal wash. I added a tiny spot of blue for the wall colour and mid green for the foliage.

In this version of the scene, I drew the basic outlines using a steel-nibbed pen and black waterproof ink. I worked quickly to produce fine broken lines and light scribbles for the foliage. I then used watercolours to block in the shapes.

TIP COLOURS FOR FLOWERS

Flower colours can be very complex so analyse them carefully. Try out colours on a piece of paper and make notes about different mixes. These are just as vital as the shapes and tones on the sketches. Get things right before committing yourself to a finished painting.

The hibiscus colours are alizarin crimson, vermillion and permanent rose. For sunlit petals use weak washes of these colours. For the mid-tone areas, darken the wash with more pigment. At the flower centres, mix at least two colours together. For the shaded areas add touches of cobalt blue to the reds.

Greens are often regarded as a problem. Ready-mixed greens – Hooker's green, emerald or viridian – can look artificial, but they can be mixed with other colours to provide a wide range of natural greens. Add yellow ochre or cadmium yellow to the ready-mixed green for pale greens; burnt sienna or cobalt blue for mid greens; and sepia, violet or deep blue for a range of dark greens.

Here, I worked up a free-flowing watercolour study, then, when this was thoroughly dry, I penned in detail with sepia ink.

In this final study, I made an initial drawing with a mixture of waterproof and non-waterproof sepia inks. When I then added watercolours on top, some the non-waterproof ink ran into the colours while the waterproof ink remained stable.

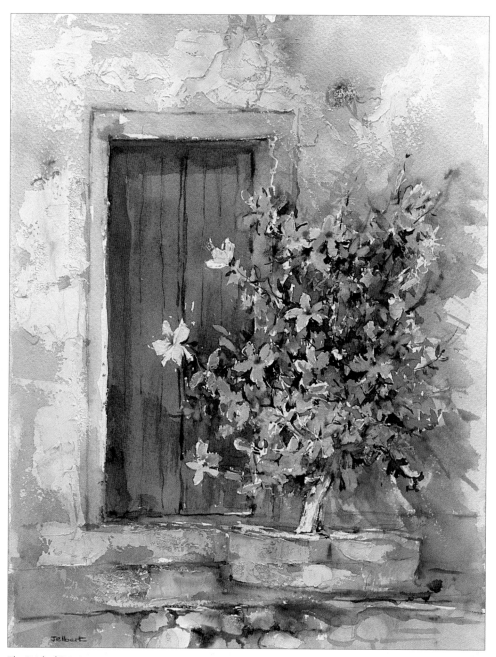

The Finished Painting

This composition was painted from the studies opposite using a mixture of inks with watercolours. This combination of techniques creates a fluid and gentle feel in the shaded areas and gives a more structured look to the stones and foliage.

Useful sketches

If your sketches are to become a reliable reference source for future paintings, you must include notes about colours that you see. These notes are very personal. There are no standard rules or codes to follow, so invent your own form of shorthand. But, remember that you must be able to read your notes as well as write them! Only practice will perfect your skills. Here and elsewhere in this book I suggest things that have helped me with my sketching.

Do not be tempted to rely on photographs for this aspect of sketching. With the busy lives we lead, it is an easily-formed habit, but, although photographs have their uses, the colours reproduced often bear no relationship to those of the subject.

If you are sketching with coloured water-soluble pencils or watercolours, try to make the colours as accurate as possible. On the other hand, if you like sketching with graphite pencils or ink, annotate the finished sketch with written notes about the colours. Sometimes dots or small slithers of each colour can be added to the sketch instead of words.

Pencil sketch with handwritten colour notes.

This sketch of a pot plant was worked with water-soluble pencils.

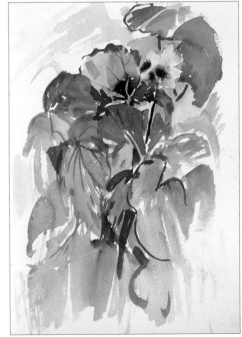

Here I sketched the same subject as above with watercolours.

112

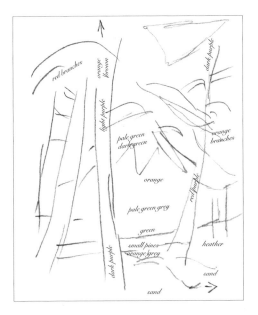

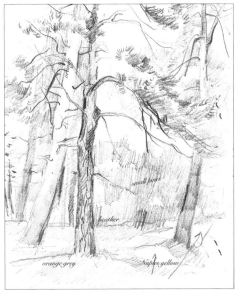

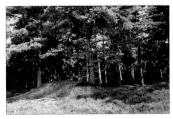

This painting of a woodland scene was worked up from the sketchbook references above.

The photograph of a large group of trees is a general reference of the scene; I chose to simplify the composition and to concentrate on just a few of the trees. A lot of colour information was needed, so I made two pencil sketches. One, top left, is a very simple sketch of basic shapes on which I added most of my notes. The other sketch is more detailed and shows different textures and tones.

Some artists like to make a regimented list of notes on a separate page, but I prefer to have them on my drawings.

Tip Sketching detail

More often than not, one-third of all detail can be left out.

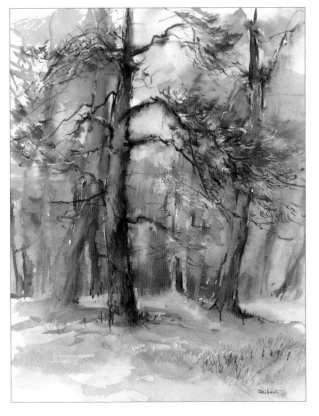

CAPTURING DETAILS

Collecting just the right material for a future painting can be quite a task, especially if you are under pressure and time is a limiting factor. Quite often, when you start sketching, the more you see, the more you add, and your sketch can become very detailed and crowded. Sometimes, this is not bad practice, as you may well be able to develop several compositions from just one sketch. If your sketch is too scanty and brief, there is a danger you will forget what is in that blank space, and you may not be able to recreate it properly even with a bit of imagination! If you have the time, it is worth the effort of producing a full sketch, rich with information and ready to work from – perhaps backing it up with a photograph or two.

Seeing things properly is all important, so be extra curious in your observations. Whenever you have a spare moment, take a look about you. Spot the extraordinary array of surfaces – the carpet, your clothing, the cat, a decorated pot, or your own hair. How do we sketch these? Look again, more closely this time, and absorb the rhythms and patterns you see. Do they have hard ridges, dots or scales, or is the texture wispy or feathery? Note how one surface compares or contrasts with another, then try to imitate them using lines, dots and dashes and by varying the thickness of your drawing line. Slowly, you will develop your own 'artistic language'. Practice will make you more observant, and will help improve your sketches and paintings.

West Dean Garden, Chichester

Ivy

Massed foliage

Flints

Iris

Stones

Ferns

Foliage

Grasses

These studies in waterproof and non-waterproof inks, show the different textural qualities of shells, leaves and dried plants.

Here in this study in the gardens at West Dean College near Chichester, my class and I had an enjoyable day sketching and one of the features we liked was this small flint building. We explored the variety of plants, steps, building materials and various surfaces around this busy corner.

The two watercolour sketches on this page, a bell tower and a detail of pomegranates, were painted while on a painting holiday in Greece.

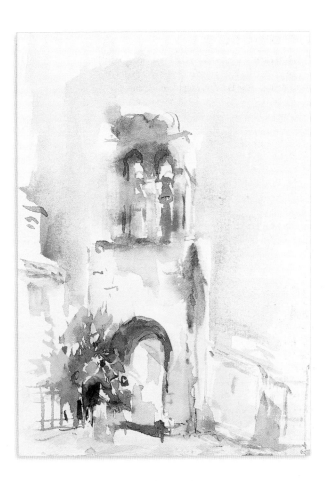

I used the wet-into-wet method to paint the bell tower so that it gently blended into the blue wash of the sky. This technique softened all the edges at the top of the tower emphasizing the archway and door which have harder edges.

Cascading over one corner, a beautiful display of pomegranates provided a sharp contrast to the pale area beyond. The bright colours of the fruit and foliage help draw the eye into the middle distance.

I loved the collection of these delightful pomegranate fruits so much that I decided to paint them for the sheer joy of doing so. I also bore in mind, however, that they could be a useful reference for future work.

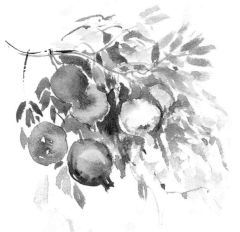

How to sketch

Composition is the organising of this chaotic world into something artistically pleasing. We often have to move things about and exaggerate tones, shapes and colours to arrive at an acceptable balanced picture. The subject or scene has to play on your heartstrings, and you need to sketch it before it vanishes.

FOCAL POINT

Look at the subject and decide quickly what part is the most vital, then make this the focal point of your composition. In the example here, painted in watercolours on a two-page spread of my sketchbook, the focal point is the bell tower. It is vital that this point includes the correct ingredients: it should contain the darkest and lightest parts of the scene; it should be the most detailed part of the composition; and the brightest colours should be placed around it. Although there are exceptions, I like to use the 'golden section' rule for placing focal points, as it provides a comfortable balanced picture. Try to avoid placing the focal point on centre lines as this can divide a composition into halves.

The golden section method divides the composition into thirds, both horizontally and vertically. The four intersections of these lines make the best positions for focal points.

SHAPES

Now place simple shapes around the focal point. Keep everything basic and direct, and develop it into a jigsaw-like study. For this composition, I contrasted the bold straight lines and solid mass of the bell tower with a large sky and simple undulating lines for the background. It helps to have 'rhythm' lines (directional indicators) that lead the eye to the focal point. These could be in the form of a path, a river, a row of fence posts or trees along a hillside or even the formation of clouds – anything that flows or nudges your eyes towards this area.

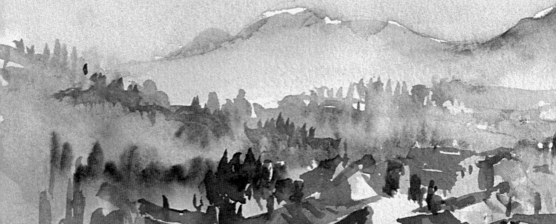

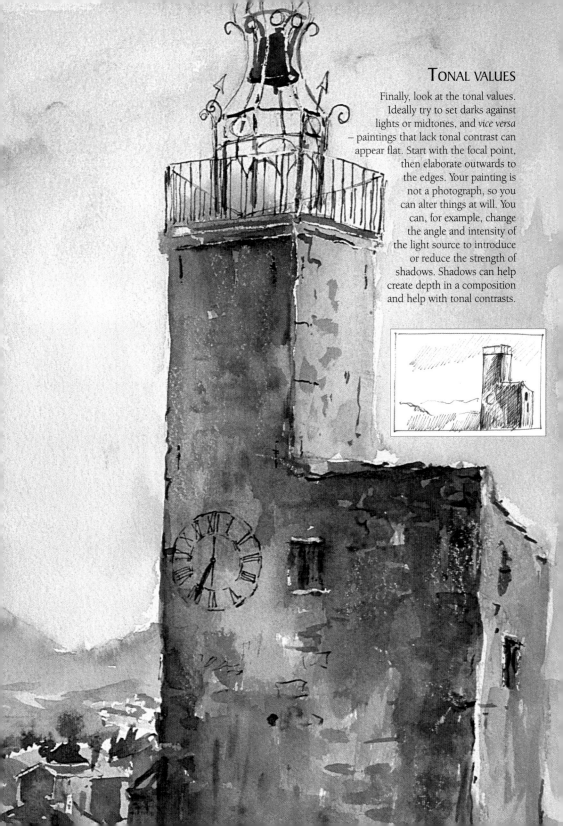

TONAL VALUES

Finally, look at the tonal values. Ideally try to set darks against lights or midtones, and *vice versa* – paintings that lack tonal contrast can appear flat. Start with the focal point, then elaborate outwards to the edges. Your painting is not a photograph, so you can alter things at will. You can, for example, change the angle and intensity of the light source to introduce or reduce the strength of shadows. Shadows can help create depth in a composition and help with tonal contrasts.

TONE

The tone of any colour varies from light to dark, and is governed by the ratio of pigment to exposed white paper. Transparent watercolours and inks, for example, can be diluted to form a range of tones from the weakest wash through to pure pigment. With pencils and pens, a similar range of tones can be achieved by varying the density of marks (scribbles, dots, dashes, crosshatching, etc.) made on the paper. Work up gradated columns of tone (see below), then number them from 1 (the lightest tone) to 6 (the darkest). Different mediums have different characteristics, and only practice will allow you to represent a particular tone in your chosen medium.

The tonal exercise (right) could help you build up confidence with using tones, before you start working on more complex compositions. The more you practise, the more you will discover the subtlety of tone. You will soon realise that there are more than just six tones, and that you will want to refer to a tone as, say, 2½ – somewhere between 2 and 3.

Pencil *Pen* *Sepia*

Use different mediums to build up a library of tonal charts.

Start with a soft 4B pencil, then, using hardly any pressure, cover a small area of paper. Now, with slightly more pressure cover another small area beneath the first. Continue building up the column with denser tones until you have an almost solid black.

Use a steel-nibbed pen to work up another column with crosshatching, varying the intensity of marks from almost nothing to almost solid.

Now, using a dark watercolour (I used sepia in this example) work up a third column. Start with a watery wash and build up to neat pigment.

> *Always start by marking the lightest and darkest areas of a composition. Then, having committed yourself to the extremes, you will find it much easier to decide on where to place the other tones. Finish the sketch with relevant colour notes and you should have all the vital information to allow you to construct a finished painting at a later date.*

Tonal exercise

Set up a simple still life composition with different coloured papers and, maybe, a pen. Bend the papers into shapes that catch the light at different angles.

Make a tonal chart in the medium you want to use. Draw the outlines of the composition in your sketchbook, then, referring to your tonal chart, number all the surfaces and add colour notes.

Cover the still life, then working from your notes, shade in the sketch. When this is complete, compare it with the original.

Summer Hedgerow

This carefully constructed sketch corresponds to the tonal chart in shading and bears the numbers and colour notes needed for future reference. Note how this sketch is on a large, separate sheet of paper which I folded and stuck into my sketchbook. Your sketchbook does not have to be neat and tidy, but it must contain all the relevant information to enable you to construct a painting at a later date.

If you do not have the time to work up a detailed tonal sketch, you can at least rough out the shapes and add tonal numbers and colour notes. The jigsaw-effect sketch above, simple as it is, will help you decipher the shapes and structure of a subject.

Apart from indicating the light and dark areas of a composition, you can also use tones to denote perspective. Note the differences in tones and spacing from the foreground to the distance in this sketch.

Whenever possible, I always make a tonal study of a scene before working up a colour sketch. Tonal studies help clarify and balance the design of the composition. Having both types of reference material gives you a strong base to work from. Try not to leave any blank spaces – you will never remember what you have left out!

Studies of delightful scenes such as Dedham Church, from Flatford River, look wonderful in an elongated landscape format. Spreading your sketch across two pages of the sketchbook allows you to create this shape without having to make the sketch too small to be really useful.

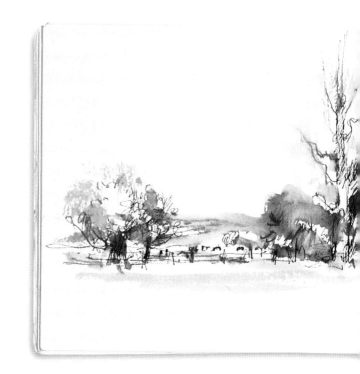

Tonal sketch

I spent just fifteen minutes in situ, *to sketch this tonal study with a sepia water-soluble pen. The assortment of trees, buildings, people, animals and the gateway all had to be simplified, but the path meandering towards the church, provides a perfect lead-in to the focal point.*

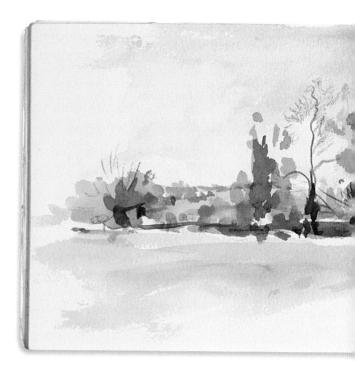

Watercolour sketch

I have a 140gsm (90lb) watercolour paper sketchbook which is perfect for both sketching and for painting small full watercolours. For this colour sketch, the range of greens are made from Hooker's green mixed with yellow ochre, cadmium yellow, burnt Sienna, cerulean blue and violet. The animals, foreground and buildings all echo these colours. For speed, I used grey and burnt sienna water-soluble pencils for some of the branches on the trees.

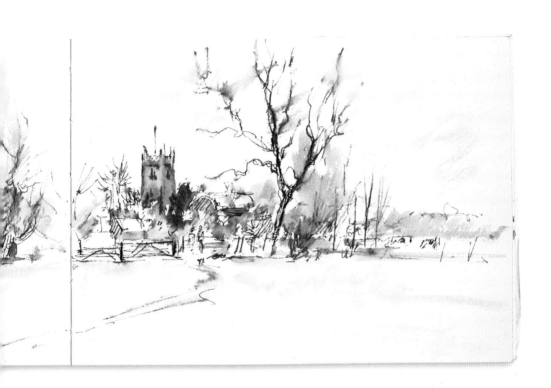

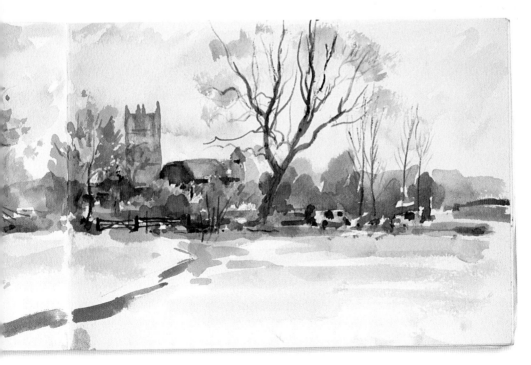

TEXTURE

I love twiddling and doodling in my sketchbook, and this is a page of experimental images in which I used a variety of strokes to capture different textures. Generally speaking, we are not good at really seeing things until we try drawing them and, without good drawing there is no good painting. One way of learning how to see the different textures in a landscape is to look at a small object such as a shell, a rock or a piece of wood. From a distance, these will be seen just as simple three-dimensional shapes. When you look at them closely, however, you will see that they have fascinating surface textures. Place them under a magnifying glass and they look gorgeous. Having got used to looking at small objects in this way, try looking at a wider scene and capturing the textures of different parts of the whole. Investing time in this type of exercise will enrich your future paintings.

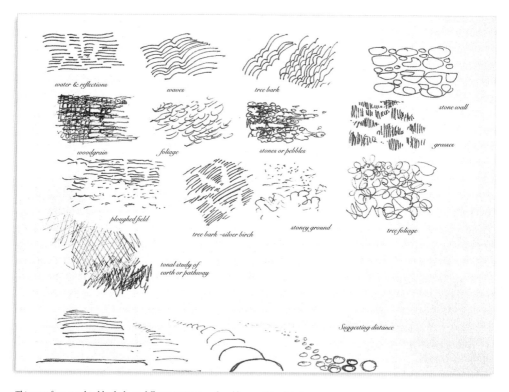

This page from my sketchbook shows different textures produced by a variety of strokes. Be selective when working up doodles such as these and just suggest texture. Do not try to draw everything.

I love sketching with water-soluble pencils, and these quick doodles from my sketchbook show some of the methods I use to capture texture in colour.

Wetting the tip of a water-soluble pencil and creating a coloured wash with a brush. A two-toned wash can be obtained by holding two pencils together and applying both colours to the brush.

Crosshatch different colours of water-soluble coloured pencils, then apply a wetted brush to the marks and blend them into a wash.

A mix two dry colours together on the paper can then be wetted to form a range of hues.

This leaf was created by laying a wash, taken from the wetted tip of a water-soluble pencil with a brush, then adding the details with the tip of the pencil.

Marks made with a wetted tip of a water-soluble pencil straight on to the paper will be dark and indelible.

A brown or burnt sienna water-soluble pencil is excellent for sketching and painting branches.

To draw a clump of grass, hold two contrasting pencils together, then use a flicking movement to create tapered strokes.

Drag the side of a wetted pencil randomly across the paper to form a shrub or tree.

Spatter a wetted tip of a water-soluble pencil on to a dry or wetted surface to give a good pebble effect. I used blue and burnt sienna for these marks.

Place small squares of dry pencil colour in a corner of your sketchbook to give you a good lightweight palette of colours to use for quick sketches.

Create a large colour wash by shaving the pigment from the pencil point on to a wetted surface, then brushing the pigment and water together. Form clouds by lifting out some of the colour with a small piece of paper towel.

Mauve thistles
Yellow flowers on cow parsley
Brambles
Pinky grasses

Chapman's Pool, Dorset

These two pages from one of my sketchbooks illustrate an exercise I set my students. I give them a photograph and ask them to sketch the scene, highlighting the different textures they see. This composition includes grasses, rocks and a selection of weeds and other foliage.

Try to create contrasting textural qualities as well as tones; if necessary, you can even exaggerate the texture in one area to counter something similar near by. Note how I have used a variety of line weights to help create depth and perspective in my textural sketch – thick, heavy lines in the foreground, soft and thin ones in the distance.

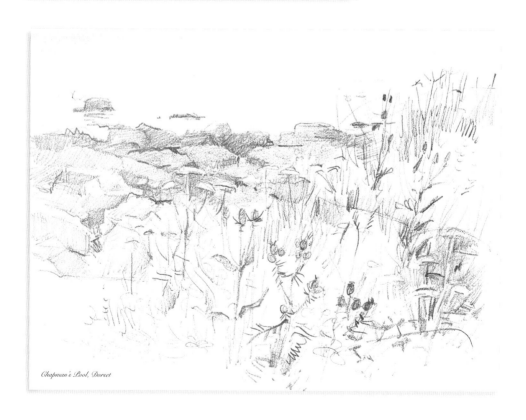

Chapman's Pool, Dorset

COLOUR NOTES

It was late autumn, a season I simply adore, when I happened on this country scene. The lush greens of summer had started to fade, and much of the foreground foliage had disappeared leaving stark, skeletal shapes. I only had a sketchbook, a few pencils and my camera with me, but I still managed to record enough information to create a finished painting in my studio (see page 126).

First, I made a tonal sketch of the composition. I was so pleased with the result that rather than spoil it with colour notes, I decided to make another sketch.

For this second, much rougher, sketch I simply marked in the outlines of the basic shapes. I then made lots of handwritten notes about the colours I could see. On this particular sketch I have made references to specific colours (burnt sienna, light red, etc.) and to general colour hues (orange tint, brighter green, etc.) I have also made separate notes about particular elements of the image (barbed wire, cow parsley and dandelion). You can never make your notes too detailed, especially if you do not have the equipment or time to make a coloured sketch.

I also took a few photographs. Notice that in the one reproduced here – taken from the same viewpoint as the sketches – there is a much wider field of view than the sketch. Photographs do have their uses, they are great for showing lots of detail, but I never rely on them for accurate colour reproduction.

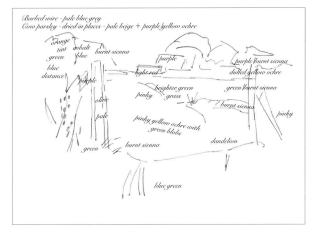

The Finished Painting

*I worked up this finished painting in my
studio from the reference material shown
on page 125. I sketched in the whole scene,
carefully formulating where my focal point
should fall. I applied masking fluid for the
light grasses and cow parsley, then used a
simple palette of mixed greens, burnt
sienna, yellow ochre and cobalt blue to
paint the picture. A wet-into-wet sky
diffused into the foliage on the left-hand
side, helped create depth and distance.
When this wash was dry, I painted the
buildings and foliage on the right-hand
side and the foreground area with bolder
strokes. The darker grasses and small
fence details were applied with water-
soluble pencils.*

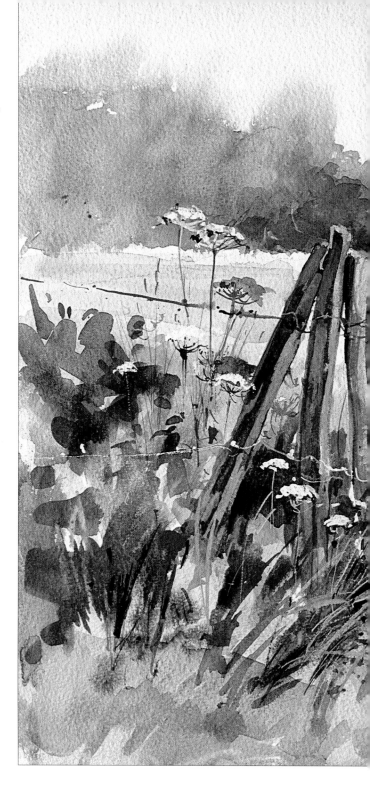

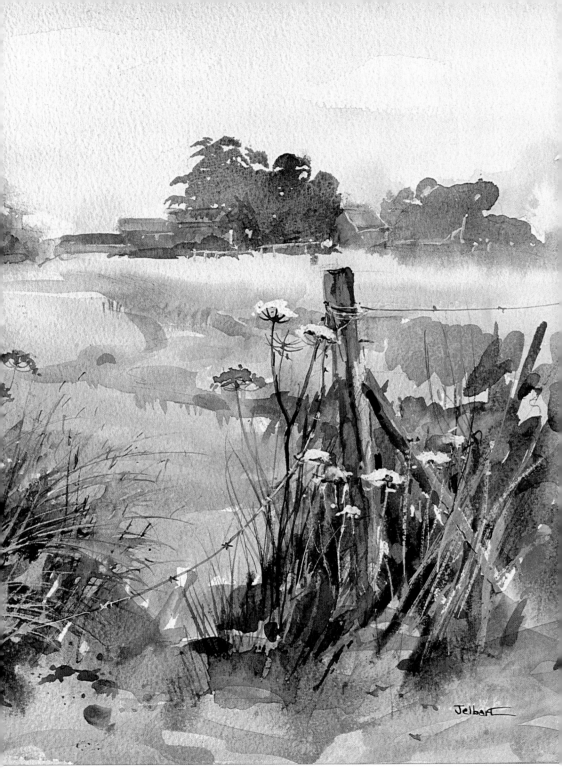

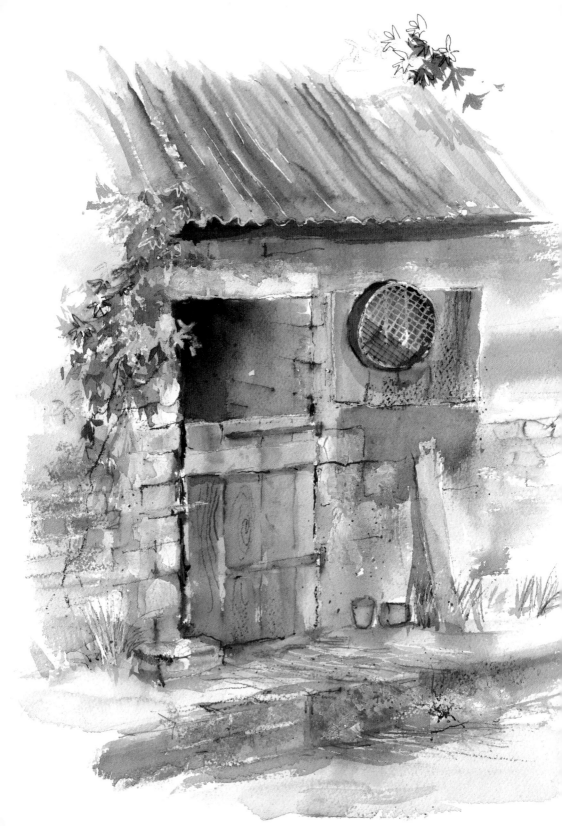

Farmyard Corner

Size: 305 x 405mm (12 x 16in)

Another wave of inspiration for textures can be triggered off by visits to farmyards. Farmyard scenes will widen your range of subject matter and they are wonderland places in which to explore and interpret all types of surfaces! They will provide a real challenge for your imagination, requiring you to become a magician when recreating feathers, stones, wood, grasses and rusty objects with your watercolours, pencils, pens and inks.

The finished painting opposite includes lots of textures worked from doodles in my sketchbook, some of which are shown here. These small details helped me enormously when I redrew the farmyard in my studio as a full painting and I needed to include things in more detail. My doodles are notes to myself, reminding me of pointers that may be useful later on. You are probably doing the same in your sketchbook, or will be very shortly!

We need to remember we are imitating nature and our interpretation will never achieve the perfection and draughtsmanship of natural things. We have to be content with simplifying objects and selecting the elements that form the basic character of our subject.

Apply spiky lines and shapes with light green and orange oil pastels, then lay a darker watercolour wash on top.

Draw the undulating outline of corrugated-iron with water-soluble pencils, then introduce water to diffuse the marks.

Use a waterproof ink to scribble random leaf shapes, then overlay these with strokes of watercolour that echo the ink shapes.

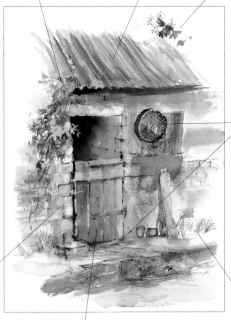

For objects such as chicken wire and straw, draw fine detail with masking fluid before applying watercolour. When the painting is nearly finished and everything is dry, rub off the masking fluid to leave white highlights. Add fine detail with water-soluble pencils or ink.

Use yellow ochre and mixed grey watercolours for stonework, and a sepia ink or sepia water-soluble pencil for the grooves and spacing between the blocks. A weathered effect can be created by applying a cream oil pastel on top of the watercolour when it is still wet or completely dry.

Hold two water-soluble pencils together then use small upward strokes to draw spiky and arched blades of grass.

Wash in the planks of the wooden door, then use similar shades of water-soluble pencil, to create whorls and wiggly lines which imitate the woodgrain.

For brickwork use masking fluid to define the mortar joints, then block in the bricks with watercolour.

Alternative, use the method described above for stonework, but use a light grey oil pastel for the mortar joints and mixtures of orange and pink for the weathering effect.

Test your choice of colours in the corner of your sketchbook.

French window

I love visiting France, and I often go there with students on painting holidays. This scene, of a sun-drenched window with long shadowed tendrils stretching down the walls, intrigued me as soon as I first saw it. I sketched two compositions; one in portrait format, one in a landscape format. I decided to use the portrait format for this demonstration, knowing that I could crop it to a landscape format at the end (see page 139).

The building actually has two similar shaped windows, one above the other, but I decided to omit most of the upper window, leaving just enough to explain the shadow patterns at the top of the picture. I usually like to include road signs, but left the one in this composition out because I felt that it was too distracting.

I love the contrasting textures in this scene; the shutters – precise and orderly – sit well against the random cascade of climbing plants and geraniums.

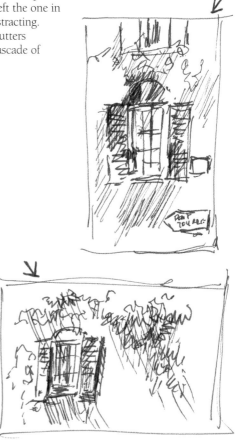

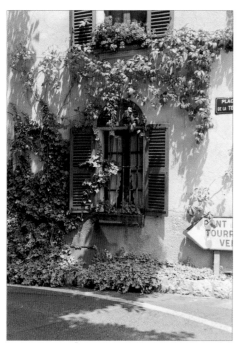

A reference photograph and two quick sketches of the scene that I made at different times of the day (note direction of the light source and the angles of the shadows).

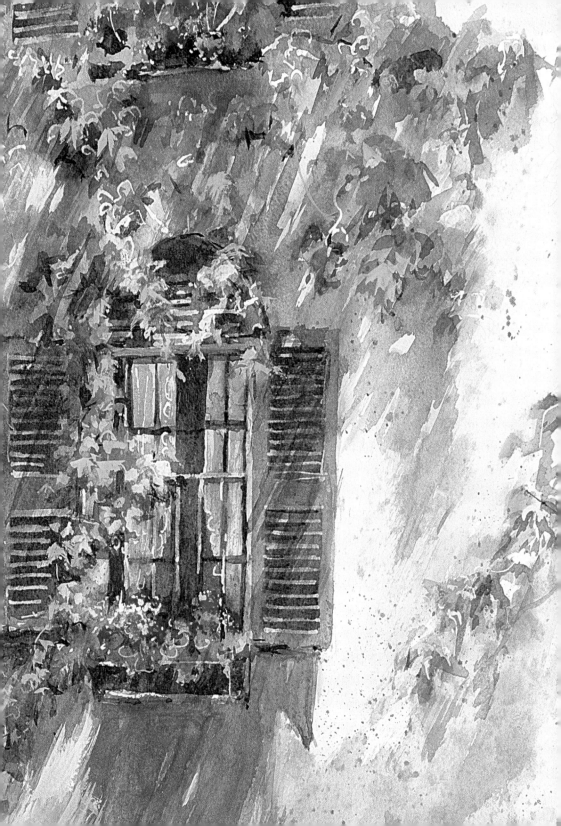

WATERCOLOURS USED FOR THIS DEMONSTRATION

YOU WILL ALSO NEED

Masking fluid for creating highlights. Some paper towel for lifting out colour.

Cadmium lemon · Russian green · Burnt sienna · Cobalt blue

Magenta · Vermillion · Yellow ochre · Titanium white

1 Use the tonal sketch and reference photograph to draw the basic outlines on to the watercolour paper.

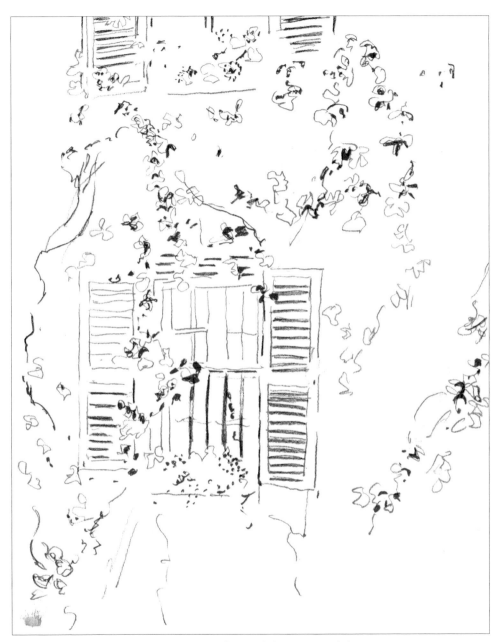

The finished pencil sketch. The red marks are where masking fluid is applied in steps 2–5 overleaf.

2 Apply masking fluid to the bright highlights. Hold the pen at steep angle to draw horizontal lines for the louvres on the window shutters.

3 Holding the pen nearly upright, tap the point on the paper to make groups of small dots for some of the flowers.

4 Holding the pen as flat as possible, move the point in circular movements to create larger puddles of fluid.

5 Draw curved lines by pulling the pen across the paper; twist it to form different weights of line.

The pencilled composition with all the highlights masked out.

6 Mix cadmium lemon and Russian green, then working wet on dry, block in the lighter parts of the foliage taking this colour over the masked out areas. Vary the shades from a pale yellow-green to a mid green.

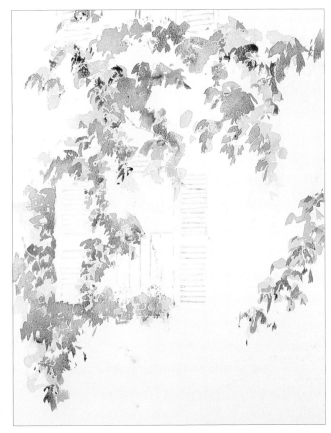

7 Now mix burnt sienna with Russian green to make darker shades of green then paint these colours into the paler marks – work some wet into wet, some wet into damp and some wet on dry.

8 Mix a strong dark green from Russian green, burnt sienna and cobalt blue, then paint the window details.

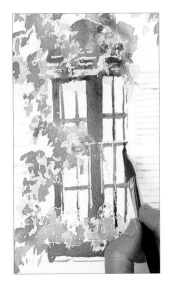

9 Use the same mix of colours to define the shadows and details below the window that bleeds off the top of the composition.

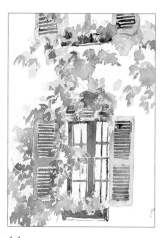

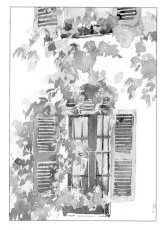

10 Add more cobalt blue to the colour on the palette to make a blue-green, then block in the shutters on either side of the main windows and those at the top of the painting. Dilute the wash for sunlit areas.

11 Use stronger mixes of the same colours to paint in the shadows on the louvres on the shutters.

12 Use cobalt blue with touches of green on the palette to block in the curtains. Indicate folds with vertical streaks of a slightly darker tone. Add more green to the mix, then define the edges of the curtains.

13 Use magenta and vermillion to paint the flowers in the window boxes – use strong colours for the flowers in the lower window box and slightly weaker colours for those in the upper window box. Use the point of the brush to make tiny marks.

14 Wet all the white areas of the wall. Mix a weak wash of yellow ochre and magenta, then, using broad loose strokes, wet into wet, block in the wall. Darken the wash with a touch of burnt sienna, then lay in some of this colour between the windows and below the bottom window.

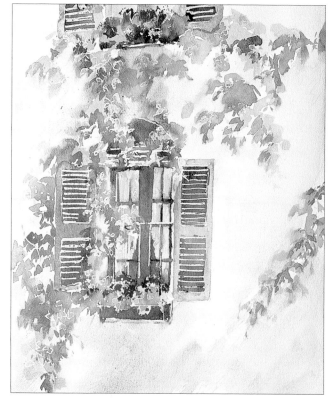

15 Working wet into wet, spatter a mix of burnt sienna and cobalt blue over the walls, allowing some of the marks to blend into the background colours. Leave to dry.

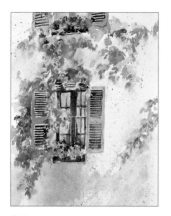

16 Use a mix of Russian green and burnt sienna to strengthen some of the dark green areas – the window frames and some of the foliage, particularly down the outer edge of the left-hand shutter. Leave to dry.

17 Mix yellow ochre and burnt sienna, then, using random strokes, glaze in cast shadows on the wall. Leave to dry.

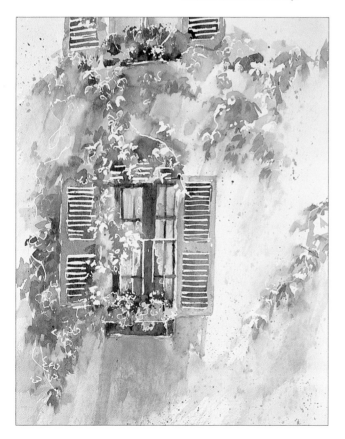

18 Remove all the masking fluid.

137

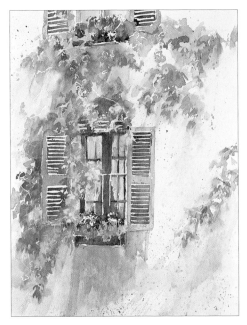

19 Use cadmium lemon with a touch of Russian green to cover some of the newly-exposed parts of the foliage. Add touches of cobalt blue to the shadowed areas of foliage.

20 Mix a weak wash of Russian green with touch of cobalt blue, then glaze over the window shutters.

21 Mix a weak wash of magenta, then block in the remaining 'white' areas of the flowers in both window boxes. Use a clean piece of paper towel to dab off excess colour.

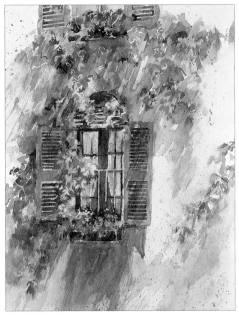

22 Mix a violet from magenta, cobalt blue with a tiny touch of yellow ochre (to dull the final colour) then lay in the deep shadows on the wall and the shutters. Reinforce the dark shadows on the shutters. Add small dark marks all over the painting. Finally, add touches of very dark green on the windows and foliage.

138

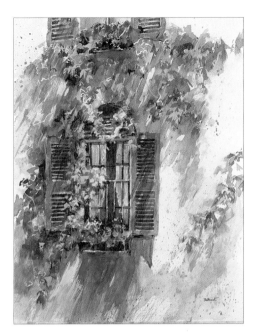

The finished painting

Having stood back and looked at the painting at the end of step 22, I decided to add a few highlights using titanium white mixed with touches of cadmium lemon and Russian green. I also used undiluted Russian green to add a few dark green accents.

TIP MOUNTING THE FINISHED PAINTING

I used a 305 x 405mm (12 x 16in) sheet of paper for this painting. To retain the portrait format, I would cut a mount with a 275 x 375mm (10¾ x 14¾in) aperture and set this centrally over the painting as shown by the red box rule.

Alternatively, you could turn the painting into the landscape format of the other tonal sketch shown on page 130. For this shape, I would cut a mount with a 285 x 225mm (11¼ x 8¾in) aperture and place this over the painting as shown by the blue box rule.

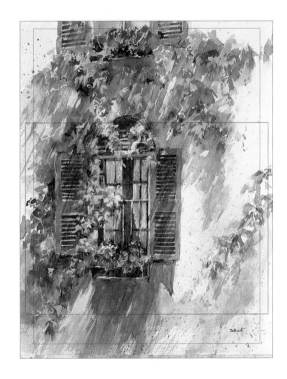

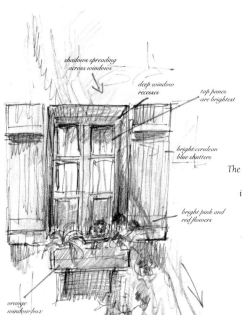

shadows spreading
across windows

deep window
recesses

top panes
are brightest

bright cerulean
blue shutters

bright pink and
red flowers

orange
window box

*Perhaps add lace curtains
instead of plain ones.*

busy blue
shadows

*Could add flower pots instead of
the window box.*

Greek Window

Size: 365 x 495mm (14½ x 19½in)

The original sketch for this scene was worked up with sepia and red pens with passages of water-soluble pencil to indicate basic colours. I also included additional, handwritten notes about particular colours and some suggestions about how I could modify parts of the composition.

In the finished painting below, I decided to change the arrangement of flowers. This proved to be an interesting challenge, but I am pleased with the result. Apart from putting the plants into pots, rather than the wooden window box, I also added a lace pattern on the net curtains by saving whites with masking fluid and touching up the finished painting with white gouache. I kept the bright highlights on the glass for extra contrast. The long shadows, the shape of which had to match the new arrangement of flowers, were lengthened and enhanced.

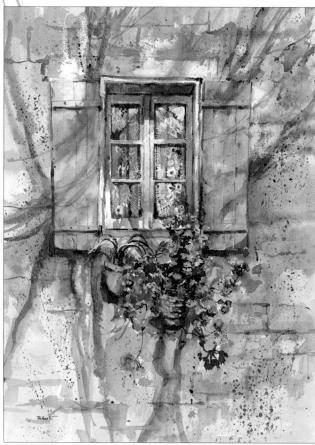

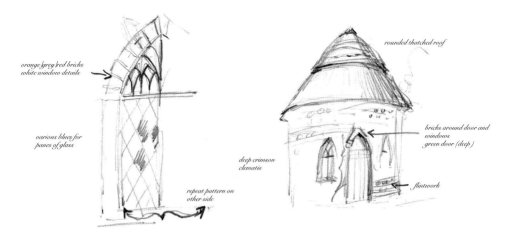

orange/grey/red bricks
white window details

various blues for
panes of glass

repeat pattern on
other side

rounded thatched roof

bricks around door and
windows
green door (deep)

deep crimson
clematis

flintwork

West Dean Window

Size: 305 x 455mm (12 x 18in)

This gorgeous characterful window belongs to the college where I teach several times a year. It is a round house with a tea-cosy thatch. I sketched the whole building briefly, and then selected an arched window for further study. Notice that I used a short cut for sketching the window; I worked up one half in full detail and made a note that the other side was a mirror image of the first. These two sketches, together with their constructive colour notes, helped me to complete the finished painting in my studio.

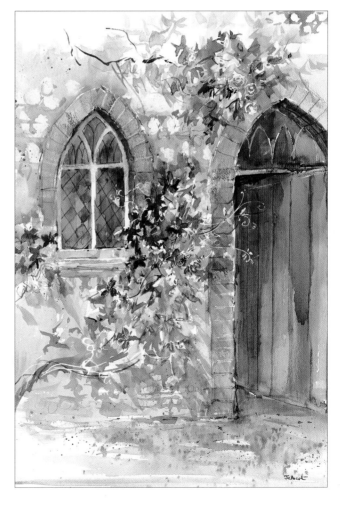

141

Using sketchbooks

In our efforts to depict a scene that is worthy of recording, we soon realise that we may have a problem. We cannot portray everything – especially a wide landscape crammed with information! Some of the definition and detail must be sacrificed and simplified. Although sound draughtsmanship should always be present, it is sometimes necessary to distort or exaggerate it to put across a point of interest or character. To express a feeling of vast expanse we can use our sketchbook in different formats.

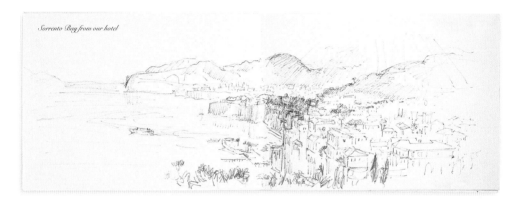

Sorrento Bay from our hotel

The wide vista of Sorrento Bay, with the unfolding views of the town and mountain, is enhanced by spreading it right across two pages of the sketchbook. The significant structure of this scene is the stepped collection of houses descending to the sea. These steps are emphasized by the dark tones of the trees and undulating sweeps of the mountains.

I used a burnt sienna water-soluble pencil for the initial sketch, then enhanced the tones with dense scribbles of sepia pen. The drama in this composition is enhanced by the pronounced platform of foliage against the paler, distant town buildings.

Here I used occasional small ink lines sparingly to create receding buildings whilst keeping the details for the foreground.

I painted the coloured sketch a few days later. The contrasts had lessened, but I still had to retain the feeling of sweeping distance, while being economic with both line and detail. Masking fluid highlights, which are small and diffused in the distance, get more precise and detailed as they come forward. Ribbons of gentle tones help to define the silhouettes of the distant mountains and the glassy sea. Bright colours in the foreground emphasize the roofs and trees.

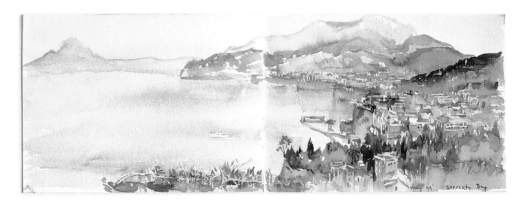

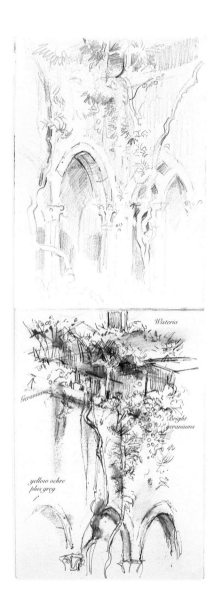

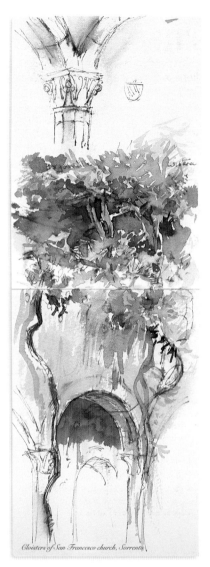

Cloisters of San Francesco church, Sorrento

My sketchbooks are also used as diaries, with times of the day, and an accumulation of facts and dates amid my sketches, plus local maps from the information bureau – a must if you are depending on finding sights in a strange place! The beautiful Sorrento cloisters inspired a feeling of awe and majesty, whilst the tumbling flowers and plants added a personal touch, and softened the arches, pillars and balconies.

First, I sketched in my initial impression with an HB pencil emphasizing the varied arches and the contrasting greenery that adorned the facades.

Next, I focused upwards to the balconies, festooned with vines and geraniums. I used a sepia water-soluble art pen to quickly capture the wide range of textures that were now visible in the bright sunlight.

The final sketch was in watercolours. I just could not resist this array of rampant vibrancy alongside the rigid, but beautifully designed man-made arches now deep in shadow. The contrasts were exquisite!

Farmyard

This old farmyard, off a quiet lane in Cornwall, seemed deserted and abandoned when I first saw it several years ago. It was like stepping back a century or so! No one was around, so I climbed over the gate and started to take some photographs. Suddenly, the farmer arrived and caught me in the act. Luckily, he was rather amused and invited me to his other farmhouse in which he lived. We became friends, and he now has a painting of his farmyard, with his geese, on his living room wall. Unfortunately, the old buildings have been thoroughly modernised, but I have painted many pictures from the photographs I took that day.

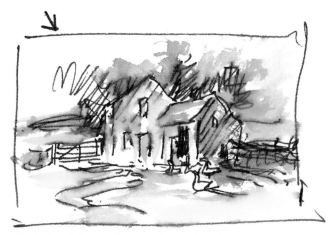

This sketch, worked up from the photographs below, shows the composition used for this demonstration.

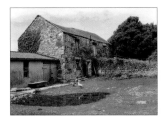

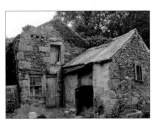
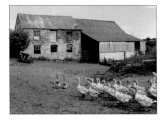

144

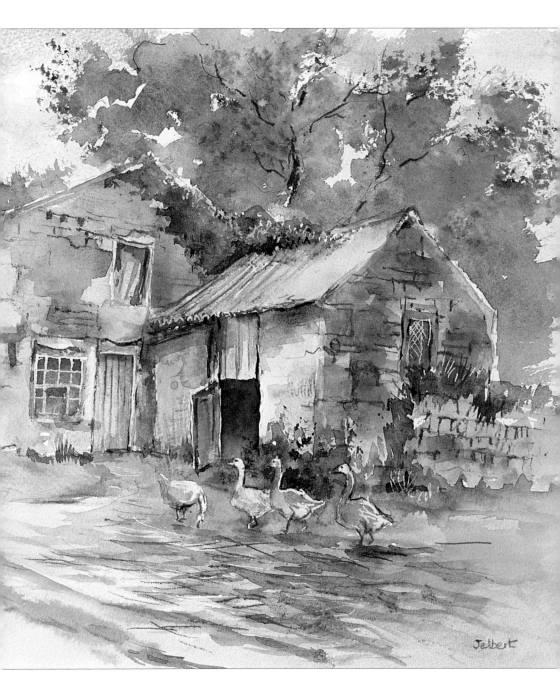

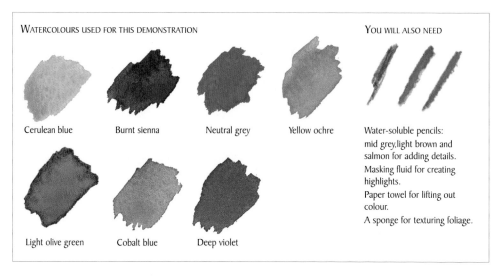

Cerulean blue Burnt sienna Neutral grey Yellow ochre

Light olive green Cobalt blue Deep violet

Water-soluble pencils: mid grey, light brown and salmon for adding details.
Masking fluid for creating highlights.
Paper towel for lifting out colour.
A sponge for texturing foliage.

1 Use the photograph of the buildings to sketch the house, placing it correctly for this composition.

2 Use the photograph of the geese to draw a few geese in the foreground.

3 Now draw the wall on the right-hand side of the building.

4 Referring to the last photograph, draw in the gate.

5 Finally, add a few trees in the background and some marks to indicate the yard in the foreground.

6 Referring to the red marks on the sketch opposite, apply masking fluid to create highlights.

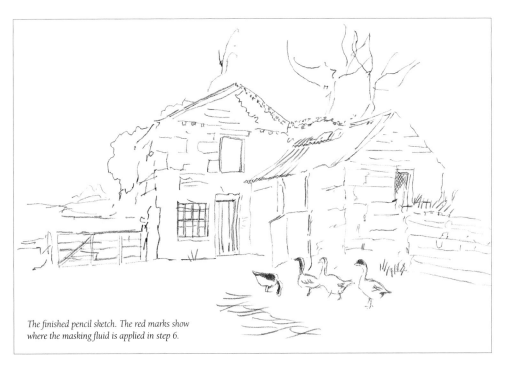

The finished pencil sketch. The red marks show where the masking fluid is applied in step 6.

7 Use light brown and mid grey water-soluble pencils, dipped in water, to make marks on the stonework and roofs on the buildings...

8 ...and the wall on the left-hand side.

TIP ERASING SMUDGES

If you smudge the wet pencil marks, use a clean piece of paper towel to lift out most of the colour. What remains can be treated as 'added texture' in the final painting.

9 Use a salmon coloured water-soluble pencil to make random marks in the foreground, to define the ridge of the right-hand roof, and to define a few of the roof tiles. Use the mid grey pencil to make marks on the branches of the background trees.

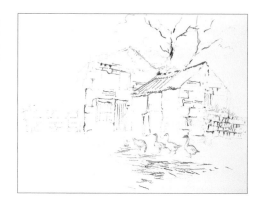

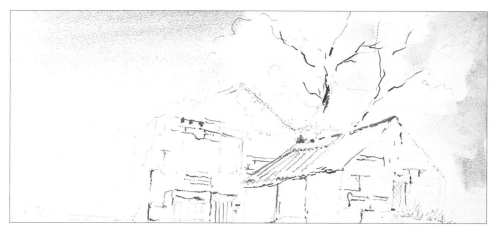

10 Wet the left- and right-hand areas of sky, and a few patches between the branches of the background trees, then lay in a wash of cerulean blue making the colour darker at the top. Soften the bottom edges with clean water.

11 While the colour is still wet, use clean pieces of paper towel to dab out indications of clouds.

12 Add a touch of burnt sienna to the cerulean blue, then paint a weak grey wash over the dabbed-out clouds. Use clean water to soften the top edges of these marks.

13 Use a cerulean blue wash and broad strokes to block in the doors and windows of the buildings. Note how some of the water-soluble pencil marks blend into this wet colour.

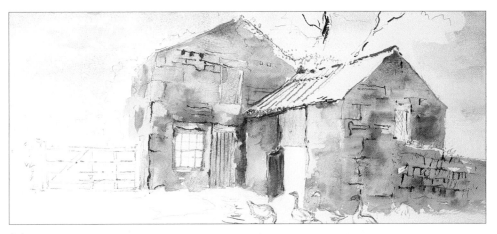

14 Use washes of neutral grey and yellow ochre, wet in wet, to block in the walls of the buildings. Vary the tones to reflect areas of light and dark, and the colours and textures of the stones. Leave to dry.

15 Mix light olive green with a touch of cobalt blue, then block in the foliage on the background trees, varying the tones to indicate light and dark areas. Add more blue to the mix then block in the foliage at the left-hand side of the building, leaving a white edge along the slope of the roof.

16 Use the different mixes on the palette and a sponge to add texture to the foliage. Note how these marks appear harder and sharper on the drier parts of the paper.

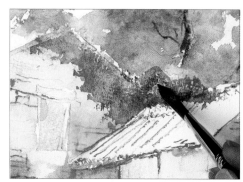

17 Use the same colour mixes to paint the foliage at the left-hand side of the building and behind the gate. Use a dry brush to 'feather' fine detail on the outer edges.

18 Use mixes of yellow ochre and cobalt blue to block in the ivy on the wall and roof of the building, dabbing the darker tones over the paler under-colours to create the texture of small leaves.

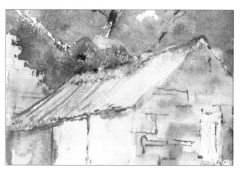

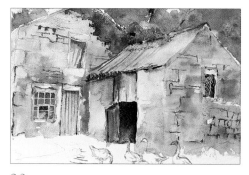

19 Block in the slope of the roof with neutral grey, allowing some of the salmon coloured pencil marks to bleed into it. Draw down some of the salmon colour from the ridge of the roof.

20 Mix deep violet with touches of burnt sienna and cobalt blue, then block in the dark shadows inside the open door, under the bottom edge of the roof, the panes of glass and the other shadows on the doorways.

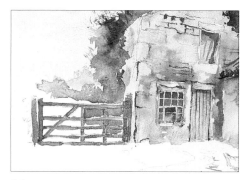

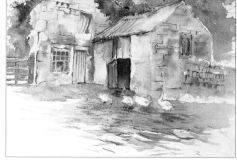

21 Add more burnt sienna to the mix, dilute it with water then paint the gate. Use darker tones at the left-hand side (dark against light) and paler ones at the right-hand (light against dark).

22 Use yellow ochre and burnt sienna to start blocking in the foreground, mixing the colours on the paper and cutting round the shape of the geese. Add touches of a very weak violet to create more texture. Work loose, random brush strokes on the outer edges of this patch of colour.

23 Use mixes of light olive green and cobalt blue to develop the greenery in front of the building, and up and across the top of the right-hand wall. Cut round the shapes of the geese, and make the tones darker behind them.

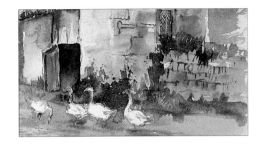

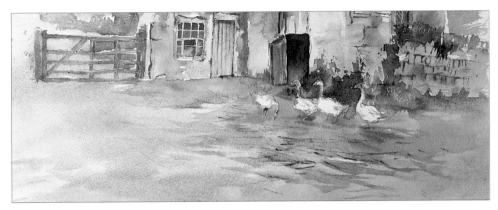

24 Use a weak wash of light olive green to block in the remaining white areas in the foreground and the white patches behind the gate.

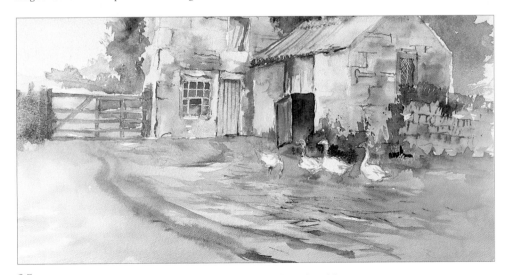

25 While the paper is still wet, mix a weak wash of burnt sienna with touches of deep violet, then paint in two long soft ridges of mud in the foreground, allowing these marks to blend and soften into the background colour. Add touches of this dark tone behind the geese to lift them away from the foliage behind. Add a touch of light olive green to the mix, then paint in an indication of foliage at the left-hand side of the gate.

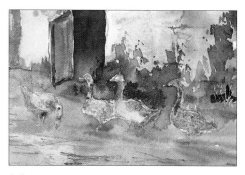

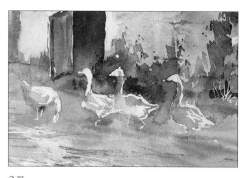

26 Use different mixes of deep violet and cobalt blue to block in the geese. Add touches of yellow ochre to the two geese at the right-hand side.

27 When the colours are completely dry, rub off the masking fluid from the geese...

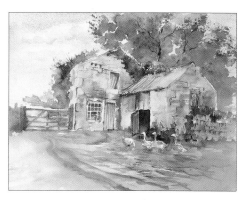

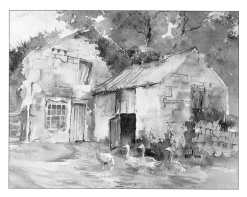

28 ...then from the rest of the painting.

29 Add touches of cerulean blue to the geese, door and windows, the ivy and along the slope of the left-hand roof.

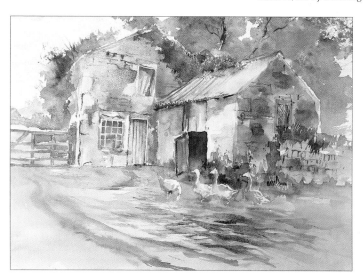

30 Prepare a weak wash of burnt sienna mixed with a touch of yellow ochre, then apply this as a glaze over parts of the walls of the buildings. Strengthen the mix, then add a few darker marks in the foreground, below the geese.

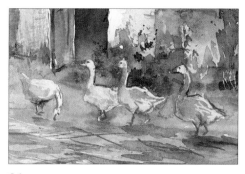

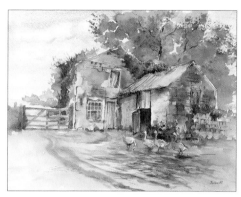

31 Finally, use the water-soluble pencils to define the shape of the geese and to add the finishing touch – the bright colour of their beaks.

The finished painting

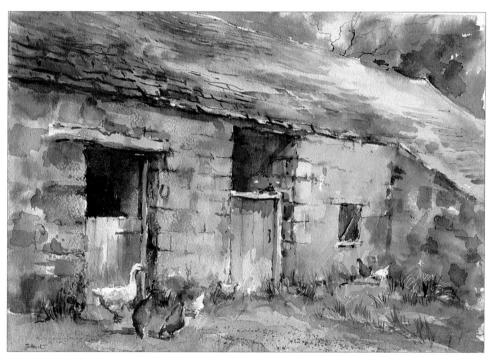

Peaceful Farmyard

Size: 355 x 255mm (14 x 10in)

I used the brightness of the left-hand door, the white of the goose's back and the dark shadows of the interior of the barn to form a good, strong focal point for this painting. I also echoed the burnt sienna colours of the chickens in the door hinges and horseshoe, to form exciting colour contrasts throughout this area.

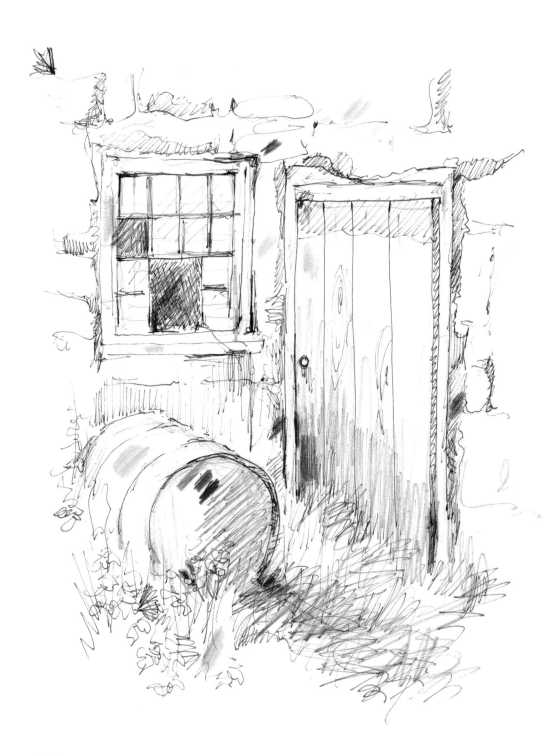

Farmyard Corner

The finished painting right shows another view of the farm buildings used for the step-by-step demonstration on pages 144-153. I painted it in my studio from the tonal sketch opposite and other reference material from my archives.

The tonal sketch, worked up with pencil and waterproof sepia ink, captured all the lovely textural surfaces of the stone walls, the grass, straw and weeds, the rusty container, the broken glass, and the old wooden door. I placed an arrow to remind me of the direction of the light source, and rather than adding handwritten notes, I used water-soluble pencils to scribble patches of colour in relevant places.

The geese and chickens, of course, wandered off before I got round to sketching them (this always happens), so I left them out, knowing that I had plenty of reference photographs.

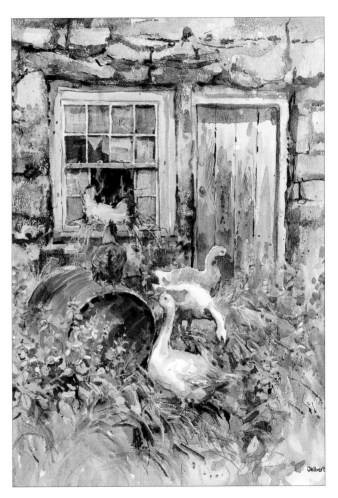

Sketching skills

Attempting to sketch and paint every detail in a scene is not the right approach, and is bound to lead to an overworked and rather stiff and photographic result! If you look at a subject through half-closed eyes, fine details disappear, and you are left with simple shapes of colour and tone; the building blocks of good paintings. So, look closely at the subject, simplify the textures or objects you see, and try to balance the different tonal areas within the composition. You may need to move things about, demolish a building, sink a boat or add a figure to achieve a good composition! This may take several attempts – do not be put off by this, it is what sketching is all about – determination will succeed!

SIMPLIFYING SCENES

On these pages are a few examples showing how to simplify a composition. The photographs have been included so that you can compare the scene that was in front of me with my pencil sketches, but, of course, these are not to hand when you are sketching *in situ*.

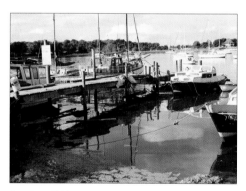 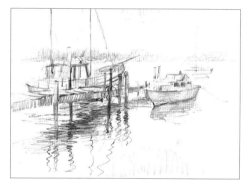

Del Quay, Chichester

This delightful working quay is a magnet for painters and I take students there every year. The photograph is very busy and a simplified composition is definitely needed here. It is, however, a good example of counterchange – light against dark, warm colours against cool ones. For example, the warm brown colours of the boat behind the pontoon and its reflection are light and bright and contrast well with the cool dark colours of the reflections of the pontoon and the dark hull of the small boat at *the end of the pontoon. Note also how the tone of the vertical posts changes from top to bottom depending on what is happening in the background. In the pencil sketch, I decided to leave out distracting details at both the left- and right-hand sides of the photograph. The house on the distant, wooded horizon plays no part in the composition, so I left it out. I also removed most of the small boats in the distance to leave a calm flat space behind the two boats moored to the pontoon, which accentuates their shapes.*

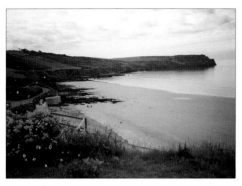
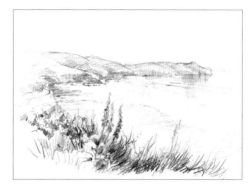

Cornish Cove

In this typical photograph of a coastal scene, the tones on both the distant hills are too similar and the individual shapes of the cliffs and fields are not clear. The road and beach details lack interest and the wooden rails in the foreground distract the eye. The angular shape of the beach is good, but lighter, brighter colours would make it better. The overall composition is too horizontal and would be improved with some vertical elements.

When composing the pencil sketch, I decided to make the foreground more dominant by adding extra detail, including some spiky foxgloves to lift the eye up into the picture. I removed the wooden rails and simplified the road and beach details. The distant headland has also been simplified to create fewer, but more definable shapes with good tonal contrast.

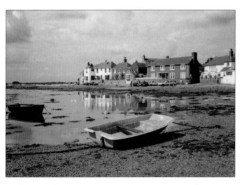
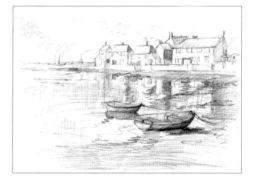

Bosham Harbour, Sussex

This photograph has lots of interest, but it lacks a single focal point. The buildings and their reflections form good shapes that lead the eye across to a point on the horizon, but the eye is distracted by the positions of the foreground boats which look uninspiring and boring. In the pencil sketch, the background buildings and their reflections have been retained, but all the cars and figures in front of them have been removed. The shape of the boat in the foreground has been made more interesting and the position of the other boat has been changed. Now, their combined, triangular shape leads the eye to the same point as that of the buildings. This focal point (which is rather indefinable in the photograph) has been emphasized by the addition of a small boat.

INTRODUCING FIGURES

Human figures have been a subject of paintings ever since painting began. Some pictures tell you about events, others about people. Figures in a scene provide a fresh element in your work, and often form a natural focal point. Build up confidence by drawing yourself – just prop up a mirror and sketch yourself in different poses and at various angles. Then, try sketching a friend sitting by a fire, at a table, sketching or reading. Do not try to capture movement at this stage or you will be deterred from ever trying again! When you have gained confidence in sketching a single figure, try working with a group.

Figures in a landscape make a considerable impact, but you must consider their scale, position and groupings. They must harmonise with the rest of the picture, and become part of it.

Get into the habit of using your sketchbook on the spur of the moment. It will improve your figures, and your sketches, no matter how rough they may be, are a record of ideas for future work. The pose, the colours or effects of light can then be developed in later sketches. You can always ask a friend to model for you so that you can recreate a more detailed pose.

These sketches show some of my students in various poses. They were sketched with water-soluble pencils and both waterproof and non-waterproof inks.

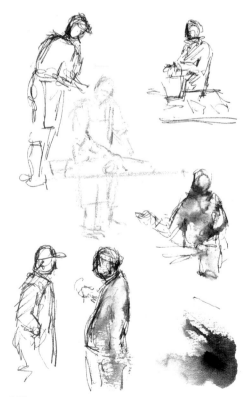

I work up match-stick-man sketches to construct the pose and proportions. Proportions do matter and must be checked – hold your pencil at arm's length to assess the relative proportions of head to body length, and legs and arms. Check that these agree with your drawing. Reassess your proportions every so often. Consider the composition around the figure, remembering that figures move and you have only a short time to act!

TIP USEFUL PROPORTIONS

Eyes are halfway down a face, the nose halfway between eyes and mouth, the mouth halfway between nose and chin, and ears extend from the top of eyes to the bottom of the nose. The hairline gives the character of the person. The neck must be thick enough to support the head. Shoulders slope downwards.

An adult man is roughly 7–8 heads high, a woman 7 heads, a child 5 heads and a toddler 3–5 heads.

A body can be divided into three roughly-equal sections. Arms are quite long, and extend to halfway down the thigh.

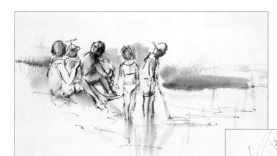

When sketching groups, try to visualise the shape of the whole mass of figures, not individual shapes.

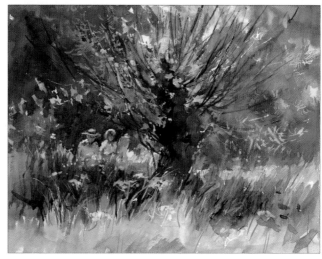

Sometimes, you need a counterchange of tone within a group of figures to convey depth and perspective. Note how the man at the bottom right stands out against the dark tones behind him. The lady (left of centre) is sketched with the same tones as the background tree, but she is set against paler tones used to depict another man in front of her.

All the studies above were quick and spontaneous sketches. Speed is essential, especially when trying to capture natural poses, and you must learn to memorise the shapes you first see. More often than not, when you glance up from your sketch the pose you are sketching will have completely altered and, sometimes, the 'models' will have even disappeared!

Painting for Pleasure

The figures in this painting are small and half hidden in the foliage. They are, however, bathed in sunlight and the light colours stand out sharply against the shaded background.

Quite often I come across a scene in which I would like to place a figure. On other occasions there are figures, but they are in the wrong place. This is the time to thumb through your sketchbook to find a suitable figure. I had to do this for the finished painting opposite which I painted in my studio. It is based on a sketch made *in situ* a few years ago. There are three figures in the sketch, but I wanted just one dominant figure to act as a focal point. I flipped through my sketchbooks and found a photograph of a man in just the right pose and in proportion to the scale of the sketch. I traced him, then moved him around to find the best position before transferring him on to the sketch.

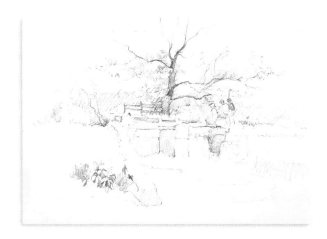

The original sketch and one of my reference photographs used as the starting point for the finished painting opposite.

TIP TRANSFERRING IMAGES

There are several ways of placing extra images in a composition. Using thumbnail sketches, tracing figures then placing them on your sketch, so you can see your scene through the tracing paper. You could cut out individual shapes and place them at various points to find where they look most at ease, or make a pencil image on tracing paper and move this about until you are happy with a position.

Make a tracing of the figure.

Move the image around the sketch to find the best position.

Transfer the image on to the sketch.

Shawford River

After trying several positions, I decided to place my new figure on the left-hand riverbank. He is sketching something in the water, on the other side of the river!

The tree was too central for a good composition, so I decided to move it slightly to the right.

I left the three figures with the umbrella in the modified sketch (for future reference), but omitted them in the final painting. I also left out the fence posts because they distracted my eye.

In my sketch, the foreground is rather stark and ugly, so I decided to embellish it with some spiky grasses and weeds.

I was teaching students when I made the original sketch, and did not have time to make colour notes, but my photographs helped me with the colours.

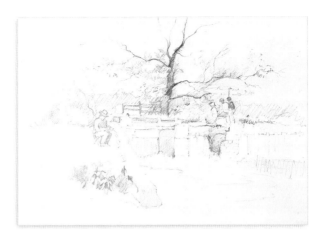

The modified sketch and, below, the finished painting.

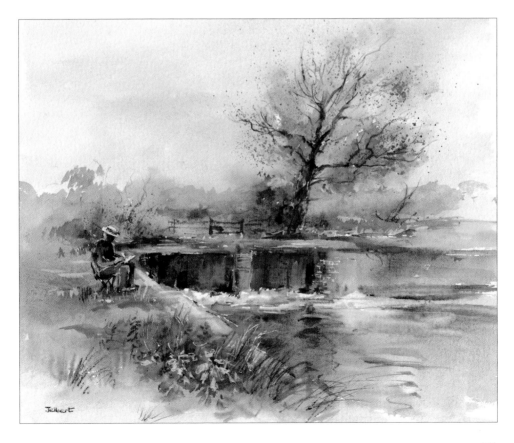

161

Quiet harbour

I love painting coastal scenes, so it was quite natural to choose one for this step-by-step demonstration. I have used the photograph for many finished paintings as it offers so many solutions. The sketch below, worked up in water-soluble pencils, is a simplified version of the photograph. The eye is carried down the steps at the left-hand side of the composition, then up into the flotilla of boats bobbing on the sea. The arrangement of the boats in the photograph seemed to be a bit of a muddle, so I left some of them out of the sketch to leave two groups, both of which have an interesting shape.

I emphasized the reflection detail to make the surface of the sea more alive and dramatic. The rigging and clutter on the boats was far too detailed, but some of it had to be included. I simplified this by using fine, dashed lines of masking fluid. For added texture in the reflections, I also used a candle as a wax resist.

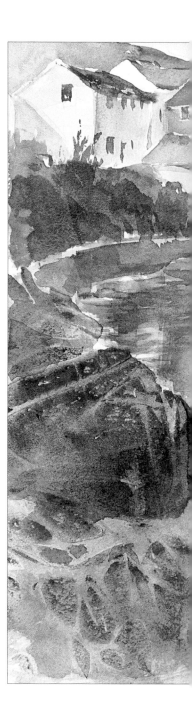

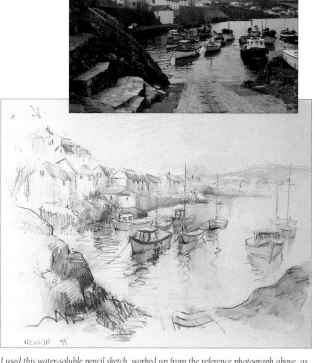

I used this water-soluble pencil sketch, worked up from the reference photograph above, as the inspiration for this demonstration.

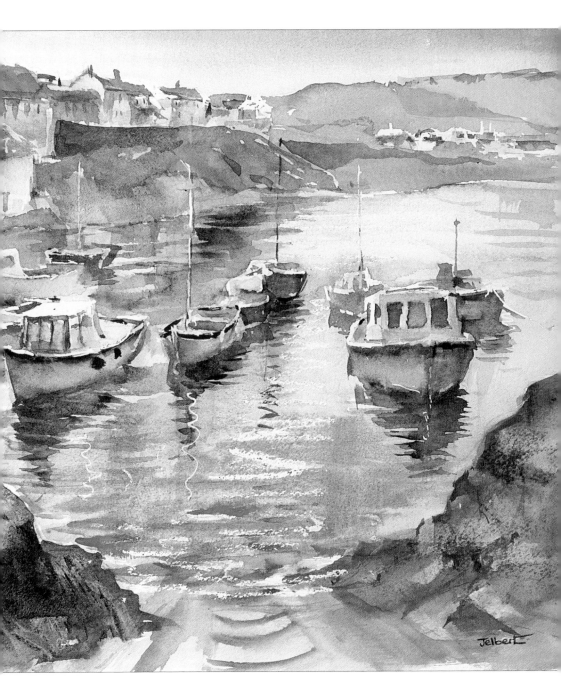

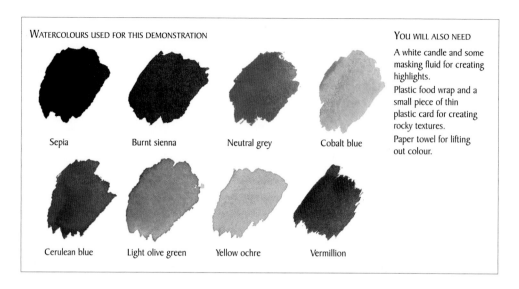

Sepia

Burnt sienna

Neutral grey

Cobalt blue

Cerulean blue

Light olive green

Yellow ochre

Vermillion

YOU WILL ALSO NEED

A white candle and some masking fluid for creating highlights.

Plastic food wrap and a small piece of thin plastic card for creating rocky textures.

Paper towel for lifting out colour.

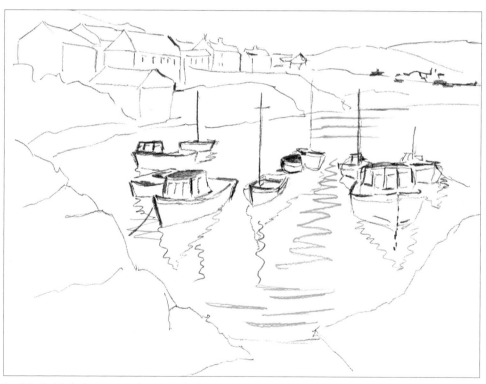

Pencil sketch of the final composition. The green marks show the marks made with the candle in step 1. The red marks denote the application of masking fluid in step 2.

1 Transfer outlines of composition on to watercolour paper, then use a candle to make marks on the paper that will eventually create texture in the highlights. These marks are shown in green on the sketch opposite.

2 Use masking fluid and a pen to draw in the highlights on the boats, houses and distant headland. These marks are shown in red on the sketch opposite.

3 Mix sepia with burnt sienna, then block in the foreground rocks on the left-hand side.

4 Place a piece of plastic food wrap on the wet paint, scrunching it up slightly to move the paint around.

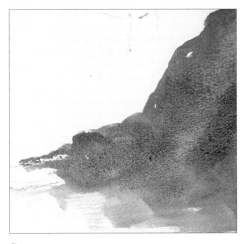 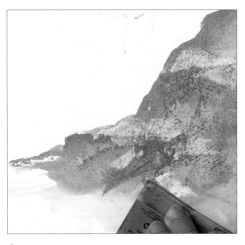

5 Block in the right-hand rocks with neutral grey, lay in touches of burnt sienna, wet into wet,...

6 ...then drag and slide a piece of thin stiff plastic (an old credit card is ideal) through the wet paint to create highlights and darker shapes.

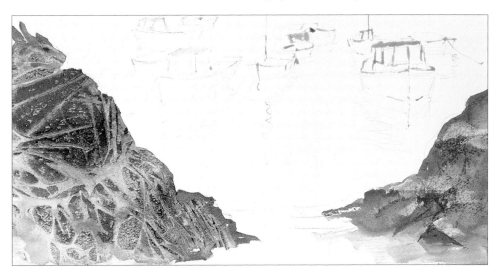

7 Remove the plastic food wrap from the left-hand rocks and leave the colours to dry thoroughly.

8 Wet the sky, then lay in a band of cobalt blue. Start at the right-hand side and weaken the wash as you work across the paper.

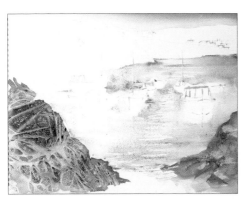

9 Wet the sea, lay in a wash of cobalt blue; work from the top right-hand corner and bring the wash down and across the paper. Note the effect of the marks made by the candle.

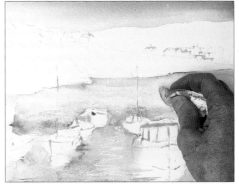

10 While the wash is still wet, lift out a band of colour in the distant water by dragging a clean piece of paper towel horizontally across the paper...

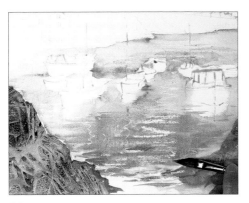

11 ...lay in horizontal bands of cerulean blue, wet into wet, in the foreground, then drag the brush downwards through the horizontal strokes...

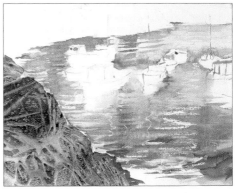

12 ...then, still working wet in wet, add touches of a weak sepia wash to form the base layer of rippled reflections.

167

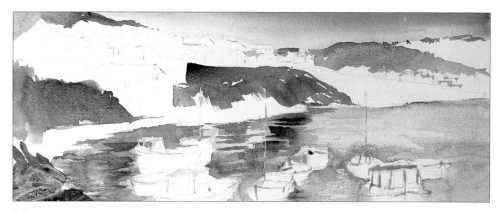

13 Use various mixes of cobalt blue and light olive green to block in the middle distant foliage and rocks. Lay bands of these colours into the ripples. Weaken the mixes and lay in the far distant hills.

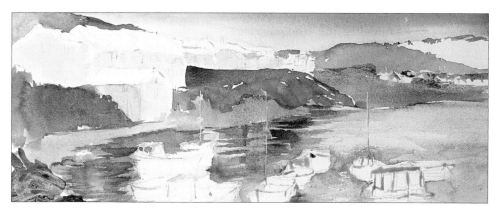

14 Use an even weaker wash of same colours to block in the walls of the middle distant buildings. Use burnt sienna to block in the edge of the harbour, the roofs of the small distant buildings and the ground in front of these buildings. Again, lay bands of this colour into the rippled reflections.

15 Block in the far distant field with a weak wash of light olive green. Add touches of yellow ochre here and there in the middle distance.

16 Use yellow ochre to block in the foreground slipway, taking some of this colour up into the water. Use neutral grey to define the shape and shadows in the slipway.

168

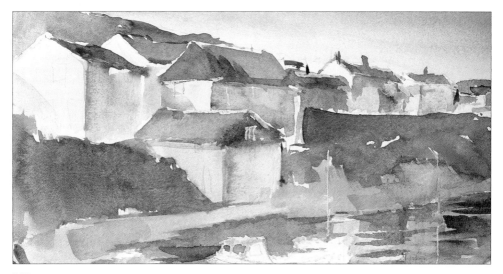

17 Mix burnt sienna with a touch of cobalt blue, then block in the roof shapes. Vary the colour from roof to roof, and weaken the tone as the roofs recede into the distance. Mix cobalt blue with a touch of burnt sienna, then block in the walls of these buildings – again vary the colour and tone. Add touches of cerulean blue here and there.

18 Mix burnt sienna with a touch of cobalt blue, then paint in the doors and windows. Vary the colours and make the window sizes smaller and closer together on the more distant houses. Use the same colours to define shadows under the eaves.

19 Darken the breakwater with a glaze of cobalt blue mixed with a touch of burnt sienna. Darken the left-hand foliage with a deeper glaze of light olive green. Wash over the boats and their reflections with yellow ochre to give them an underlying warmth.

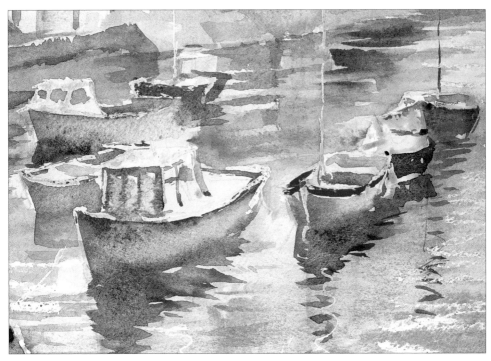

20 Paint the left-hand group of boats, which form the focal point of the composition, with a variety of colours worked wet in wet and wet on dry. I used light olive green, cobalt blue, vermillion, cerulean blue, sepia and burnt sienna. Use the same colours to create the rippled reflections.

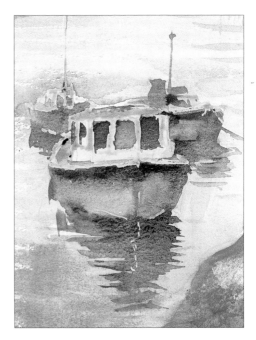

21 Now work the right-hand group of boats, using more muted colours than those used for the other group. Use cobalt blue and cerulean blue, mixed on the paper, for the basic shapes, and sepia for darker shadows and ripples. Leave to dry.

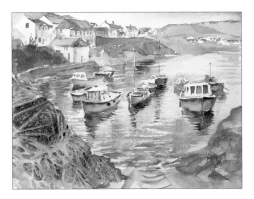

22 Remove all masking fluid.

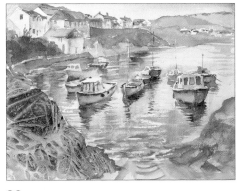

23 Mute some of the exposed white paper with weak washes of yellow ochre and cerulean blue.

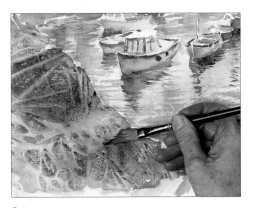

24 Use clean water to wet a 'ledge' in the left-hand rocks. Dry the brush then lift out the colour from this area to highlight the ledge.

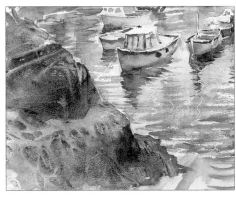

25 Wet other parts of the left-hand rocks then scrub over these to soften some of the marks made with the plastic food wrap. Introduce sepia to define shadows and shape.

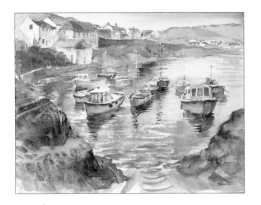

The finished painting. Having looked at the image at the end of step 25, I decided to improve the contrast by adding some deeper shadows here and there.

TIDELINE TREASURES

Coastal scenes are another of my favourite subjects, and I take every opportunity to make as many sketches as possible. Here are a few doodles from some of my sketchbooks.

These three colour sketches show the same boat at different levels of the tide. Each could bring character and beauty to a future masterpiece.

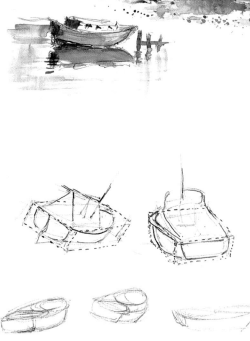

I sketched these quick sepia ink scribbles as I glanced along the shoreline. At the time I did not have a painting in mind, but I am always on the lookout for details such as these. One of them could be very useful later on.

A lovely reflection. Reflections are best when the image is wiggly in the water and is equal in length or longer than the object it is mirroring.

The construction and shape of a boat is easier to determine if you place the vessel in a tight rectangular structure.

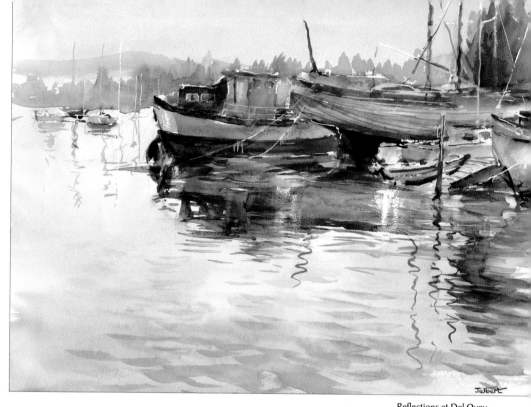

Reflections at Del Quay
Size: 405 x 305mm (16 x 12in)

*This finished painting contains many of the sketchbook
observations shown on the opposite page.*

Pin Mill, Suffolk

*I have used my photographs and sketches
of this fascinating place to create many
paintings. I took lots of photographs from
a variety of angles – including panoramic
views, close-ups, and middle-distance
studies. I had so much reference material,
I just could not fail when using them to
compose a picture!*

*I joined two photographs for this close-up
composition of old dark barges set against
the bright white building in the distance. I
used a 4B pencil to obtain the varied and
dramatic tonal content of this scene. It
has everything: buildings, reflections,
characterful boats, and both horizontal
and vertical interest.*

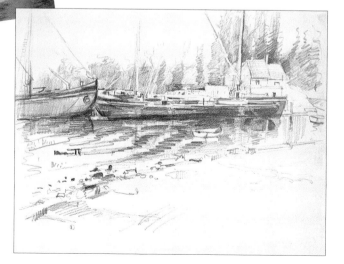

173

Using photographs

All my sketchbooks bulge with reference photographs that complement my sketches. Photographs, of course, are full of detail, much of which is often irrelevant to a composition, and you should take care to select only the information that you need for a successful painting.

A good mixture of photographs, sketches and colour notes will provide all the information you need for fruitful painting. By developing these elements you build a solid foundation from which other options and ideas will spring later on. Never rely solely on your memory – it plays tricks – so do not leave any blank spaces in your sketchbook. A photograph does not solve every problem, but it does remind you what was there in the first place!

LANGSTON MILL

This two-page spread from one of my sketchbooks shows how I link reference photographs with a sketch. For clarity, I have removed the staples holding the photograph on the far side, and moved it to show all of the pencil sketch. The photographs, taken from different viewpoints, contain all the detailed information I might need in the future. Together, the images cover quite a wide area of the scene and include lots of details around the mill itself. Although the seascape is less important than the mill, it can still form an integral part of any composition.

Photographs, of course, have to be processed, so making sketches of the scene *in situ*, and adding colours notes, etc., is more important. Remember that the purpose of a sketch is to spark your imagination at a future date. It must therefore contain sufficient information for you to relive the time spent on site.

The mill is a rather complex shape, so my pencil sketch concentrates on its structure and how it fits into the shapes around it. Although the buildings are the focal point of this composition, I decided to make a feature of the metal gate in the foreground. This automatically pushes the buildings back into the middle distance giving interest and a feeling of space to the muddy and empty sea plain. Here, although devoid of water, the flat surface reflected colours in superb abstract shapes. Even though it was mud, the colours – burnt sienna, olive green, yellow ochre and a host of blues – were gorgeous.

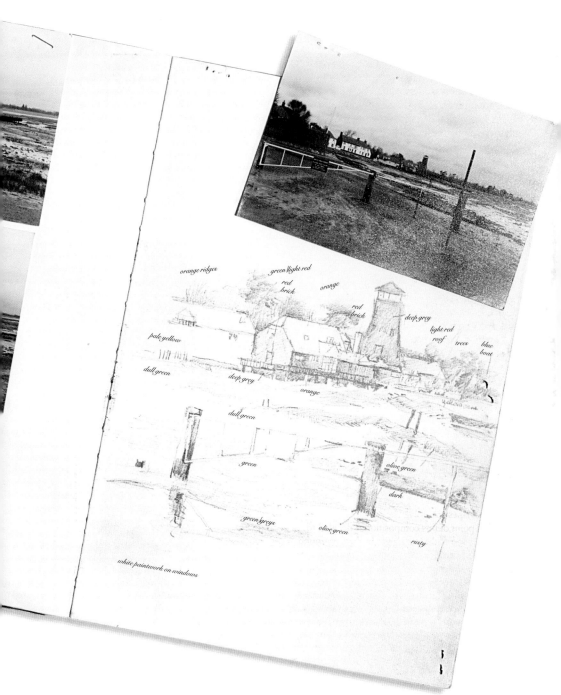

orange ridges

green / light red

red brick

orange

red brick

deep grey

light red roof

trees

blue boat

pale yellow

dull green

deep grey

orange

dull green

green

olive green

dark

green / greys

olive green

rusty

white paintwork on windows

175

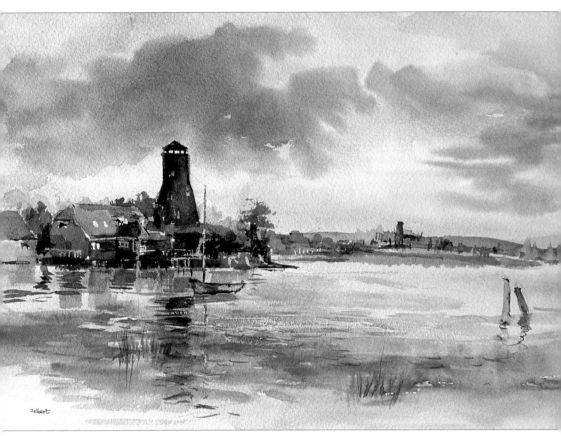

High Tide at Langston Mill

Size: 330 x 240mm (13 x 9½in)

I used the reference photographs and sketch on the previous pages to select key points about the accuracy of the mill for this finished painting. The mill is not the most attractive of buildings, so I decided to include another element to counteract this. I added a dramatic sky and reflected its colours on the surface of the water at high tide. The water sweeps around the mill highlighting other features within the composition. I also softened the contrast slightly and added some gentle colours to the dark shape of the mill.

TIP FILING PHOTOGRAPHS

Just to be safe, I often take too many photographs of a particular scene, but I never throw away anything other than abject failures. I select the most relevant and add these to my sketchbook. The others I file in a set of named boxes and files; seascapes, skies, buildings, gardens, flowers, cityscapes, etc. On a smaller scale, you could use an indexed concertina file available from most stationers.

Digital cameras are very useful. Their images can be stored on discs, which take up far less room than boxes, and they can also be enlarged on a computer when required.

I am old fashioned, however, and I just love mulling over and touching original photos. But, eventually, I am sure I will succumb to modern technology and become computerised and digital.

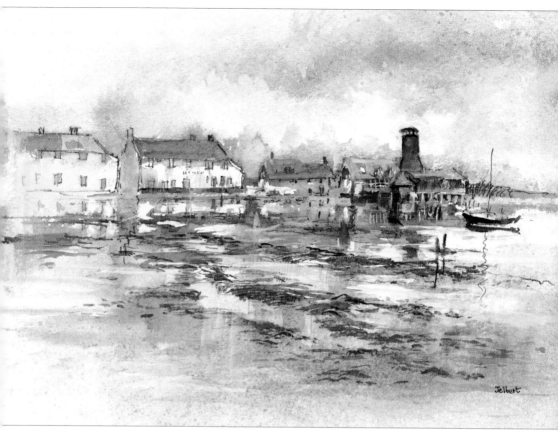

Low Tide at Langston mill

Size: 330 x 240mm (13¼ x 9½in)

*For this finished painting of the mill, I decided to retain the fascinating assorted shapes
between the seaweed and mud banks. Some poles, sticking up at random from the flats,
nudge the centre of interest towards the mill. The banks of seaweed circle expansively
towards the mill, starting from the stony foreground and coiling towards the other
buildings on the quay. These shapes also pull the eye in a clockwise motion towards the
focal point. I enhanced the sky and its reflection on the surface of the water in the harbour
with cobalt blue, giving more depth and colour to the composition. The reference
photographs proved invaluable, as they include details of the public house and other
buildings that I had not drawn in the original pencil sketch.*

Foxgloves

Surprisingly, I came across this typical English scene on a painting holiday in Brittany, France. It was late in the afternoon and I had to work quickly to get the reference material together. Before the light faded too much, I took a series of photographs, some of which are shown here.

I filled a page of my sketchbook with quick pencil scribbles of the different flowers, leaves and seed heads of the campions, ferns and foxgloves in the hedgerow.

Then, using a violet water-soluble pencil, I sketched the two compositions shown opposite. The top one was sketched from the same position as the bottom-left photograph on this page. The other sketch is a view from the same spot but in the opposite direction. Both sketches have an arrow to denote the direction of light source (the sun). This is an important reference when it comes to adding shadows and highlights on a finished painting.

I kept shapes very simple and very basic, especially in the background. I annotated both sketches with useful hints about the colours and plants I could see – an important backup to the photographs.

If you do not have a digital camera and colour printer, you have to wait until the film is printed before you know whether the prints convey the correct colouring, tones and details! The greens in the set of pictures above were a little bright, but I was pleased with the results.

Sometimes, I get an enlarged photocopy of a particular part of a photograph but, mostly, I use a small magnifying glass to study prints in more detail.

These are the four photographs I chose to place in my sketchbook to complement the sketches on this page. Notice that I took both landscape and portrait formats.

The close-up of the pink campions gives a fantastic contrast in both colour and texture to the background of grassy undergrowth. The three normal shots provide details of the dark, dominant tree and include information about the pattern of yellow ochre and light greens in the middle distance, and the blues in the distant, undulating hills.

Quick pencil sketches of flowers, leaves and seed heads can be a very useful source of reference.

Tip Checking detail

Nature books are excellent for checking details. I have built up a real treasure trove of second-hand books that I find in charity shops, markets and fairs!

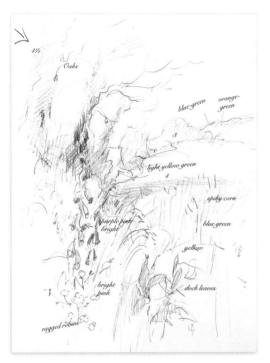

I used this composition for the painting on page 180. Note the use of tonal numbers (see page 118). The sketch below, made from the same spot, but in the other direction along the hedgerow, also provided useful information for the finished painting.

Tip Taking useful photographs

Try to take photographs at different times of the day. Mornings and evenings are the best times. Avoid very bright sunlight. A strong light source results in deep shadows which can black out the details within the shadow. Photographs without any direct sunlight will give you depth and detail without the drama – a good foundation on which to place your shadow shape.

Take close-ups of details as well as more general shots of the landscape. Include portrait formats as well as landscape ones; the tall, portrait format can often be used to good effect in landscape paintings. The finished painting on page 180 is a good example.

A useful code to remember is that the brighter the sunshine, the deeper the shadows will be.

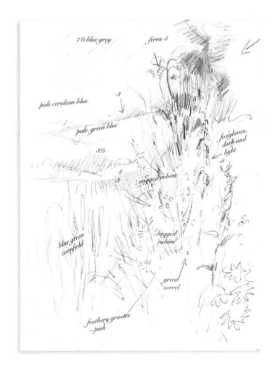

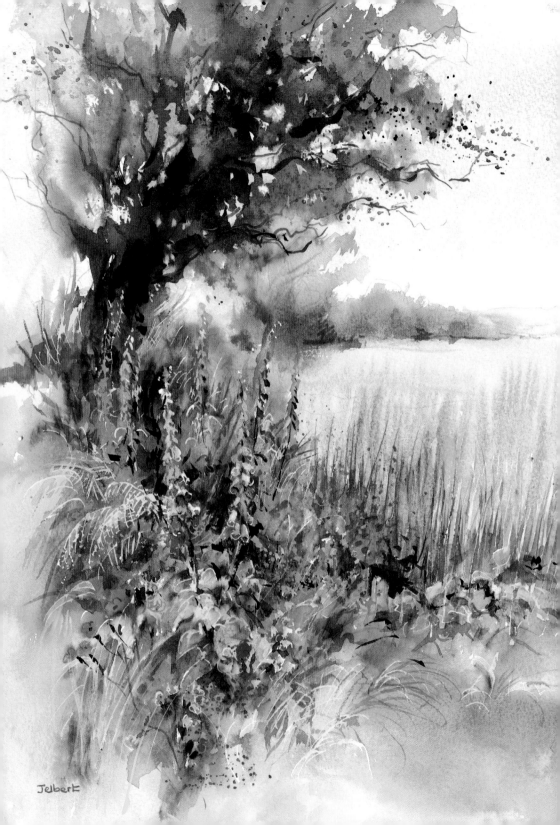

Jelbert

Poppies and Foxgloves

Size: 150 x 205mm (6 x 8in)

I painted this small watercolour sketch for the pure love of the flowers I picked on that day in Brittany. The colours – pink foxgloves and red poppies – should have clashed but, instead, they looked gorgeous together! The white daisies provide a complete contrast and peep out from the foliage like bright stars.

Opposite

Edge of the Cornfield

Size: 305 x 405mm (12 x 16in)

The composition of this painting includes details taken from all four of the photographs and the three sketches on pages 178–179. I had to use a magnifying glass to determine the detail for the foxgloves, but I also referred to my library of plant books. A very limited palette of olive green, yellow ochre, magenta, cerulean blue, burnt sienna and white gouache was used to paint this attractive scene.

Having made the initial drawing, I used masking fluid to save the lighter areas of the flowers and stems, and darkened several negative shapes with sepia water-soluble ink to contrast the highlights. I mixed white gouache with magenta to make opaque pinks for the very pale flower heads.

181

Themes

When going out on a sketching expedition, I often decide on a theme for the day. It may be garden corners, churches, tavernas, doors and windows, times of day or, as here, bridges. Having a theme makes you really look at the subject and forces you to study all aspects of it: its basic shape and structure; the details and textures; and the local environment, etc.

This small study shows how I construct bridges. The broken lines help me create the correct shape of the visible parts of the structure.

BRIDGES

Bridges fascinate me. They connect one side of a road, river or path with the other, and this link can be an important shape in a composition and could hold the focal point. An arch or span can be a beautiful feature in itself with, perhaps, a lovely reflection in the water. The angle at which a bridge is drawn or painted will also be crucial to the perspective. The materials used to build it – bricks, flints, blocks or stones – will have to be recognised and understood before you can recreate the bridge in paint.

A burnt sienna, water-soluble pencil sketch of Grange, in the Lake District, and a watercolour sketch of the same bridge, painted from a different position. The sketchbook paper was too thin to take watercolours, so I painted this on a loose sheet of watercolour paper, then glued it into the book opposite the pencil sketch.

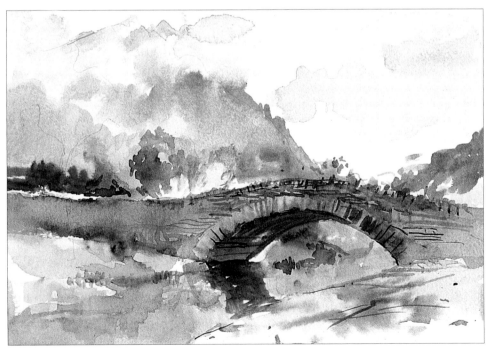

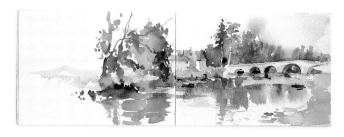

These two-page spreads from my sketchbook contain colour sketches painted in situ while on holiday in the Dordogne, France – we actually swam in this glorious river. The arches form integrating patterns in the water, and the pale reflection of the bridge contrasts with the backcloth of greenery and its reflection.

Below

This finished painting encapsulates everything I love about bridges and their reflections. The tiny vistas through the arches can often be miniature landscapes in themselves or, as in this case, provide tonal contrast to the bridge itself to draw the eye through them.

The hard reflections, painted with simple, yet forceful strokes and squiggles, add activity to the water.

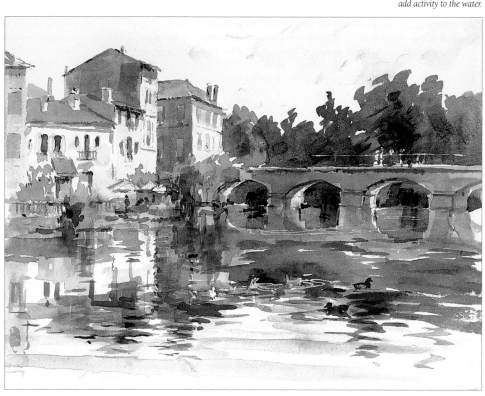

TIMES OF THE DAY

These pages show what I believe a sketchbook is all about –
documenting nature in all its moods. On one of my first trips to Paxos,
in Greece, I arose very early one morning and, clutching my tiny
paintbox and small sketchbook, I went to sit cross-legged on the edge
of a cliff, to paint the scene in front of me. I then returned at various
times during the day and painted the same scene. These five sketches,
painted between 7am and 8pm, illustrate how changes in the natural
light affect the colours and mood of the scene.

 You do not have to travel abroad to experience these differences, just
look out of your window at different times of the day and you will see
what I mean. So, whether you are at home or abroad, find yourself a
scene that you are comfortable with, and paint it at intervals to capture
the changes that you see throughout the day.

07.00: The sun was still behind the morning haze of pinks and misty blues. The headland was dark against the boiling hot sea.

*08.00: Later on, the sun – white with potential heat – was reflecting in the sea. The headland started to get brighter and contrasted less
with the background except at its tip. The distant hills all but disappeared in the haze on the horizon.*

12.00: *At midday the sea became more mellow and the distant mountains were covered by a heat haze which dissolved the image into a misty pink. The reflections also became more diffused, but the features on the headland became sharper and more visible.*

15.00: *In the bright afternoon light the sea became darker and took on a vivid blue hue. The distant hills were more prominent, and the headland was lighter and brighter.*

20.00: *As evening faded into night Paxos twinkled with glowing lights. The headland was illuminated with yellows and whites all reflected in the dark violet-blue sea. The top edge of the headland was like a silhouette against the various lights and darks of the sky.*

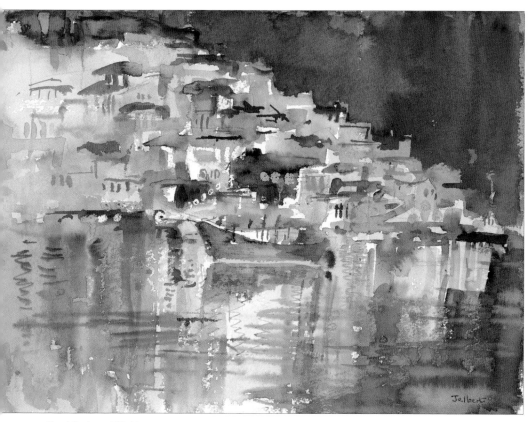

Greek Harbour at Night

Size: 365 x 275mm (14½ x 10¾in)

One of the treats I set my students when taking them to Greece, is a night scene. We try to find an ideal harbour setting so the lights are enhanced by the water. Some students will sketch the scene during the daytime to familiarise themselves with the buildings before it gets dark, whilst others turn up and hope for the best!

We spread our painting gear under lampposts or on taverna tables in the half light. Onlookers think we are crazy, whilst the local children are delighted and call us 'cool'! Several students mutter that they cannot see a thing, let along the colours!! But this is the fun element, and many do their best painting at this stage.

This is a typical Greek harbour, and we started by drawing simple shapes – the background, the sky and the sea areas. Then, working with pale oil pastels as resists, we marked the reflections of the lights on the boats and tavernas in the sea with long and expressive squiggles. Bright highlights, for the festoons of lights on the larger boats, the waterfront and surrounding buildings, were saved with dots of masking fluid. These marks allowed dramatic contrasts to be created between the dark sky and sea and the glittering yellow, red and green lights.

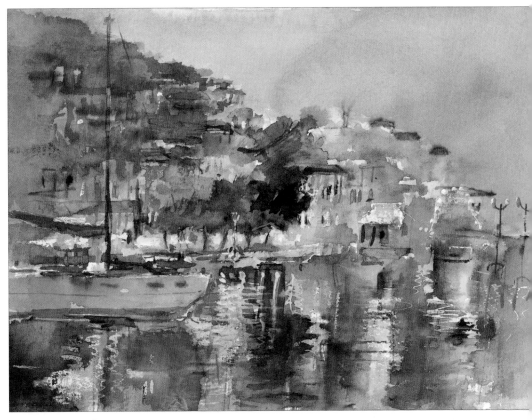

Greek Harbour at Night

Size: 365 x 275mm (14½ x 10¾in)

I wanted to create depth in this painting of the harbour, so I placed a large boat in the foreground to counter the background. The line of trees at the water's edge forms a lovely dark shape which emphasizes the glittering lights from the buildings behind. These are then echoed as reflections on the surface of the water. These contrasting and dramatic shapes combine with the lights from the restaurant and lampposts to form exquisite twinkling patterns – zigzag trails of pinks, yellows and creams – set against the dark blues and violets of the sea and sky.

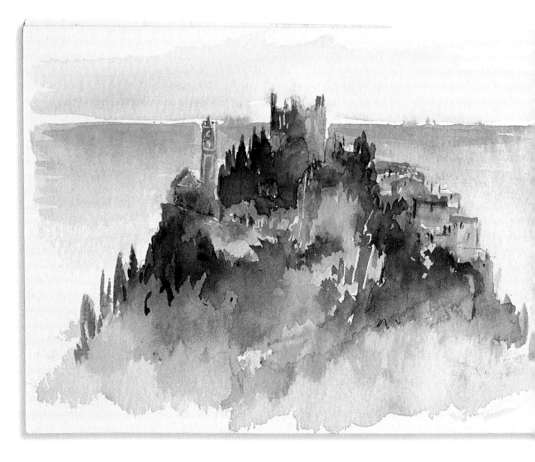

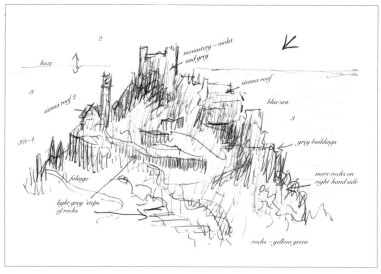

haze

2

monastery – violet
and grey

sienna roof

sienna roof 2

blue sea

grey buildings

3½–4

foliage

more rocks on
right-hand side

light grey 'steps'
of rocks

rocks – yellow green

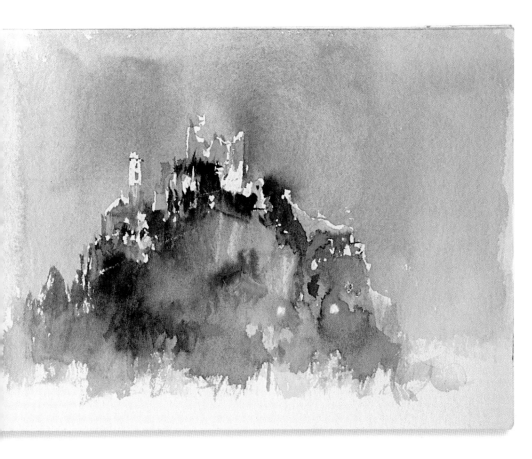

Eze, Provence, France

Elaborating on the times-of-the-day theme, I decided to try sketching and painting this wonderful medieval hilltop-town of Eze, east of Nice in Provence. On warm, balmy evenings it is so enjoyable to stroll through the town, which is bathed with twinkling street lights, and listen to the chattering crowds in the restaurants. As we wandered back to our hotel, I glanced back at the town and realised that I just had to capture the moment! I tried to memorise why I liked the scene: the contrasts; the shapes of darks and lights; and how the twinkling lamps glowed and diffused the colours about them.

Next day, when I returned to the spot, the whole scene was transformed by daylight. It was amazing to see that although the basic shapes were the same, details such as highlights were completely different. Working in situ, I sketched in the main features of the scene, then painted it in my sketchbook. Having completed this small painting (above opposite) I used a ballpoint pen to make the simple sketch (opposite) on which I added colour notes and tonal numbers. That afternoon, back in my hotel room, I used both sketches and my memory to help me paint the night scene (above).

The images in my sketchbooks do not always end up with large, finished paintings. Many of the small studies are created just for the sheer love of sketching, and I think of them as small journeys along the way. But, they always include enough information to make it possible for me to recreate the scene a year (or even ten years) later in a fresh and spontaneous way.

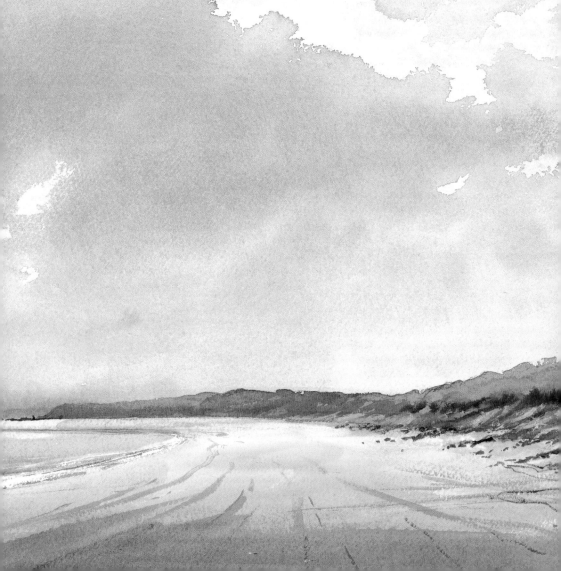

Perspective, Depth & Distance

GEOFF KERSEY

Make your paintings look more realistic using line, tone, colour
and detail. Six clear demonstrations show you how.

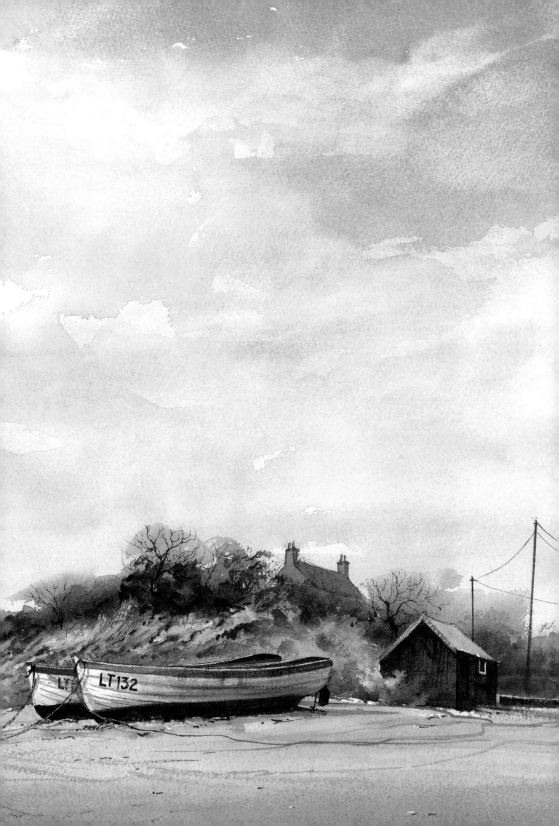

Introduction

The fact that you have picked up this book and started reading this section indicates that the types of paintings you are interested in are representative. You probably want them to look like a real place, perhaps to evoke a feeling of being there, or to remind you of a place that you enjoy, that makes you feel good. To this end a good knowledge of perspective, both linear and aerial, is a vital foundation.

 To form an accurate representation of a place and to evoke a feeling of being there however, are not the same things. At first if your painting works on a purely representational level, this in itself can be quite satisfying, and as you practise techniques, becoming more and more familiar with the medium and how it behaves, your accuracy improves.

You may (as I have) hear the comment, 'Isn't it realistic, it's like a photograph'. Whilst this is usually meant as a compliment, as an artist you should want to achieve more, aspiring to capture the atmosphere, mood, and that vital impression of depth and distance that makes the viewer feel involved in the scene, almost as though they could walk into it.

I found that when I took up landscape painting, it gave me a whole new interest in the countryside. I enjoy walking a lot more and am constantly on the lookout for fresh inspiration and new subjects. I notice with satisfaction the same growing enthusiasm in my students, arriving at class enthusing about the sky they have just seen on their journey, analysing colours in a dry stone wall or a tree trunk, where once they saw just brown or grey.

Certainly watercolour landscape painting can be a source of great pleasure, especially as we all enjoy success and the compliments of our peers; conversely we can soon become frustrated and disillusioned if it is just not happening. With the examples, illustrations and instructions in this book, I hope I can provide sufficient tips and techniques to encourage you to achieve the results to which you aspire.

Miller's Dale, Derbyshire
406 x 305mm (16 x 12in)
A limited palette of just four colours has been used here to create a harmonious effect, giving the scene a feeling of calm. I used phthalo blue, lemon yellow, aureolin and burnt sienna. I do not use phthalo blue very often as it is a very strong dye that can overpower a painting, but it does make good blue/green shades with just water added and rich dark greens when mixed with burnt sienna. I added touches of white gouache with lemon yellow in places to create a light on top of the dark. Note how a feeling of distance has been created by rendering the furthest hill with the same thin blue wash as the sky.

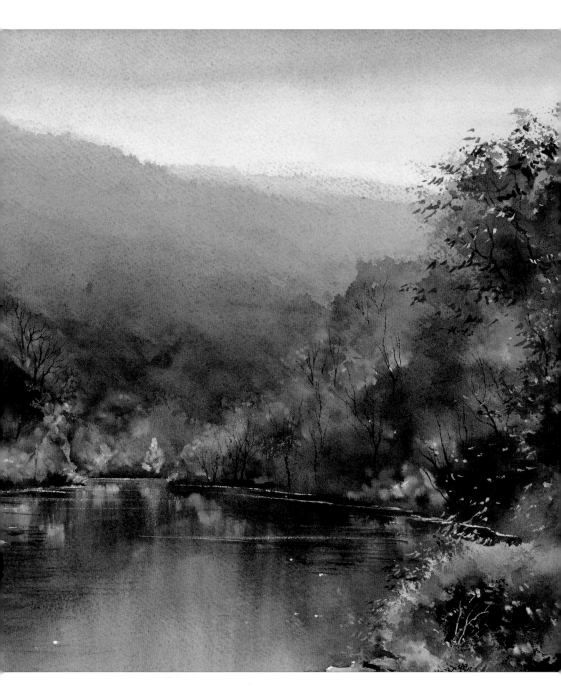

Materials

When you visit your local art shop for the first time, you are overwhelmed by the enormous variety of materials available to the watercolourist. There are papers by different manufacturers in blocks, pads and loose sheets, in four or five different sizes, three different textures and numerous different thicknesses. Paints come in several brands, in pans or tubes, large or small, in pre-selected sets or loose. The range of colours is enormous: nine or ten different blues, seven or eight different yellows and reds. Brushes seem to vary greatly in size, shape and particularly price, and while this bewildering array of products gives you plenty of choice, it's no wonder that beginners often start by buying products that they later wish they hadn't.

With this in mind I want to look briefly at the materials I recommend, and I have listed these in order of importance, in terms of how they ease the process and improve the result.

PAPER

I believe paper has the biggest effect on the finished result. Choosing the correct paper can make certain effects much easier to achieve. There are basically three surfaces, HP (hot pressed), Not (sometimes referred to as cold pressed) and Rough. To simplify this, think of them as smooth, medium and rough.

My personal preference is for Rough paper as you will see throughout this book, but a medium (Not) surface usually has enough texture to work with. I would not, however, recommend HP (smooth) paper for landscape painting as you don't have the benefit of the 'tooth', making certain dry brush effects almost impossible.

Students often ask me, 'What is the difference between a rag or cotton and a pulp-based paper?' To which my answer is, 'The price!' However, if you can afford to pay extra, it really does pay dividends. Rag-based paper is much tougher and more resilient; it is a joy to use. Look for good brands and don't buy anything lighter than 300gsm (140lb). Even at this weight I always prefer to stretch the paper so that it doesn't cockle and distort when it gets wet. This involves immersing it in water for about a minute before laying it flat on the painting board, where you leave it for another couple of minutes, during which time it expands. It should then be pulled flat and secured to the board by gummed tape, or stapled. This ensures that when it contracts as it dries, it pulls taut, creating a beautifully flat surface, crying out to be painted on.

Various different papers in blocks and loose sheets. I recommend Rough or Not surfaces for watercolour landscape painting.

PAINTS

There are basically two types of watercolour paint: artist quality and student quality. I have noticed in recent years that student quality paints have improved, but if you can afford the difference in cost it is worth investing in artist quality. The colours are generally brighter and richer, as they have a greater ratio of pigment to gum and so they go further, making student quality to some extent a false economy. I always prefer tubes to pans as they are in a semi-liquid state, making it much easier and quicker to mix plenty of washes for each stage of the painting. You will also find it much easier to vary the intensity of the colours with tubes. I squeeze the colours straight into the palette, where I have the following selection:

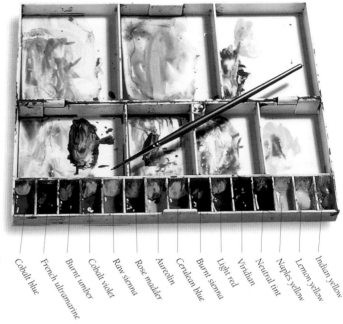

Cobalt blue · French ultramarine · Burnt umber · Cobalt violet · Raw sienna · Rose madder · Aureolin · Cerulean blue · Burnt sienna · Light red · Viridian · Neutral tint · Naples yellow · Lemon yellow · Indian yellow

I do use other colours from time to time, but this is my basic palette. I sometimes add tiny touches of white gouache. At the end of a painting session I place a piece of wet kitchen towel over the fresh paints and close the palette to keep them moist. If you spend money on tube paints and allow them to dry out you might as well use pans.

I use a plastic folding palette with fifteen small wells into which I squeeze fresh tube colour. The order of the colours does not have a definite purpose but has evolved over time and I have become accustomed to it. The palette has a further seven deep wells in which to mix the colours, thus keeping mixed and fresh colour separate. The fact that the palette folds is essential, as at the end of a painting session I place a piece of damp kitchen towel over the wells and close it to keep the paint moist.

Tube paints. I prefer these to pans as the paint is semi-liquid, which makes mixing washes quicker and easier. I use touches of white gouache to create certain effects, but this should never be put in your palette, or it will make the watercolours chalky.

BRUSHES

This is an area where I believe you can save money. I do all my paintings with synthetic brushes, apart from the extra large filbert I use for the skies, which is a squirrel and synthetic mix. My basic brush collection is as follows:

Round: numbers 4, 8, 10, 12 and 16
Flat: 1cm (½in) and 2.5cm (1in)

I also use a no. 2 liner writer or rigger. Check that this is very fine, as sizes vary according to brand. Ensure that all the brushes you buy have good, fine points, and when the point of a brush wears out, buy a new one, saving your old brushes for mixing, scumbling and various dry brush techniques.

Above: round and flat brushes. Whatever their size, round brushes should have a good

Left: large and extra large filbert wash brushes.

SKETCHING MATERIALS

For sketching I use a spiral bound A4 cartridge pad, a 2B 0.9mm mechanical pencil and a putty eraser. I also find a 6B or 8B graphite stick or a large, flat, carpenter's style soft pencil very useful. Both of these are ideal for filling in large areas of tone.

Water soluble pencils are fascinating to work with, and are especially good for creating quick tonal value sketches (see page 199).

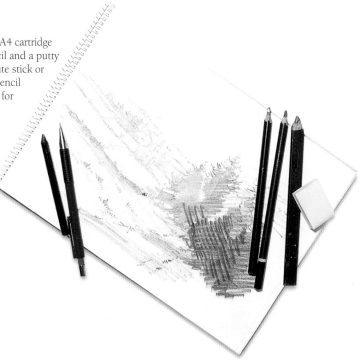

OTHER MATERIALS

I have a variety of painting boards, mostly made of 13mm (½in) plywood. I also have a few made of MDF, which also makes good painting boards but is quite heavy and not ideal for carrying a long way. Hardboard or 6mm (¼in) plywood are not suitable as they are too thin and can bow if you stretch paper on them.

I use a collapsible water pot as it takes up less space, a bottle of masking fluid, which I find essential and an old brush to apply it. I have an old large brush that lost its point long ago, for cleaning the palette (don't use good brushes for this purpose as it blunts them), and a natural sponge for applying water to the paper.

Masking tape comes in handy if you want to mask a long, flat expanse, for instance a straight horizon on a coastal scene, and I use 5cm (2in) wide gummed tape or a staple gun for stretching paper.

A craft knife blade is useful for certain scratching and scraping effects (see step 17 on page 244). A lightweight aluminium ruler helps with verticals such as boat masts and telegraph poles. A hair dryer can be used for drying washes if you are in a hurry, but I generally prefer to let them dry naturally, as the colours continue to mix and merge on the paper all through the drying process.

For painting outdoors you can avoid carrying a cumbersome painting board by buying paper in blocks, where the sheets are held in position with glue round all four sides. This makes it partly resistant to cockling, although in my opinion there is no substitute for stretched paper.

A painting board, metal ruler, gummed tape, masking tape, collapsible water pot, hair dryer, kitchen towel for lifting out paint, staple gun, pliers for removing dried-on lids from paint tubes, a craft knife and blade, old brushes for cleaning palettes and applying masking fluid, a sponge and masking fluid.

Drawing and sketching

To make a success of landscape painting, a knowledge of basic drawing skills is invaluable, as this is the underlying foundation of a satisfying and convincing picture. To make accurate drawings requires a rudimentary grasp of perspective and composition (covered in the next chapter), but to raise your drawings from simply accurate to lively and atmospheric depictions of what you see, you need to develop your powers of observation.

I often find people coming to my painting classes who say they can't draw when actually they are not looking thoroughly enough. Try comparing the height to width ratios of objects in the scene so the shapes look realistic. Look carefully at shapes and sizes; for instance, how many times does the length of a building or a tree go into the total width of the scene? These basics can be indicated with a few lines to make sure that the drawing is correct before continuing.

This is an ability most people can learn, but it takes a bit of application and practice. As you gain in confidence, the act of drawing becomes really enjoyable and no amount of time spent drawing and sketching is ever wasted as it hones your skills and sharpens your powers of observation.

Drawing and sketching is an excellent way to gather material from which to construct paintings. A full sketch book is a mine of information, which with accompanying photographs can provide the artist with subjects for hours of studio painting.

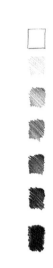

Explore the full range of tones from your pencil.

TIP

Don't spend too long on each sketch; limit yourself to fifteen to thirty minutes.

These are tonal value sketches, drawn quickly with ordinary graphite pencils. I use a 2B mechanical pencil and a 6B graphite stick which is excellent for filling in large areas of tone. The fact that the pencils are soft means that you can explore a full range of tones from a very pale grey to a rich black, (see the pencil swatches at top right). Don't forget to leave some white paper to contrast with the dark areas.

This long format sketch of Plockton, again, is all about tonal values. This time I have used a water soluble (dark wash) graphite pencil which is very good for laying in areas of tone quickly. These pencils are excellent for experimenting with; I scribble some graphite onto the corner of the page and pick this up with a wet brush. As with watercolour, the more water you add the paler the tone. In the final stage of the drawing you can tighten it up by working into it with both water soluble and ordinary pencil.

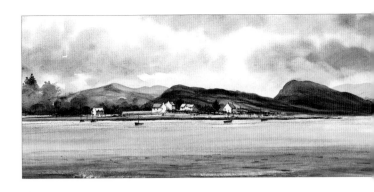

A couple of hours at a boatyard or jetty producing quick sketches of boats will really pay off if you come to do a painting of a coastal scene. At first painting a scene that contains a lot of boats is not easy, but as you practise, you gradually gain an understanding of their shape and structure. Beached boats make more interesting subjects because of the variety of angles and the fact that more detail is visible. See the painting on pages 248-249.

This is a half-hour watercolour sketch on tinted paper, containing sufficient information to work it up into a larger work later. I used white gouache on the walls of the farmhouse, which really makes it sing. Quick watercolour sketches, while untidy in places, can have a spontaneity often more difficult to capture in a more considered work.

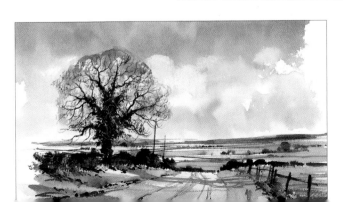

This very quick watercolour sketch is a monochrome, using just burnt umber. Having no other colours really makes you think in terms of tonal values; if your sketch is to have any impact, you have to explore the full range of tones available from almost neat paint to clear water. Choose dark colours such as Paynes gray, sepia and neutral tint for monochromes.

199

Using colour

Here is a selection of colour mixes taken from my basic palette, coupled with some suggestions of how you might use them. You will find it easier if you mix them in the order they are shown, but it is not just about the colours used; the density of a colour should vary enormously depending on where and how you intend to use it. Don't be afraid to mix the dark colours nice and strong, without adding too much water.

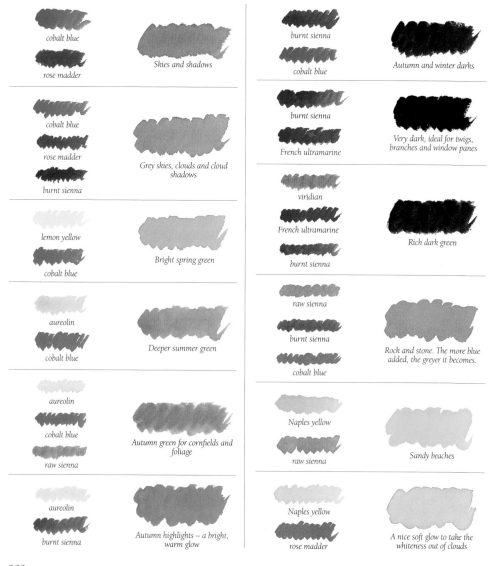

cobalt blue

rose madder

Skies and shadows

cobalt blue

rose madder

burnt sienna

Grey skies, clouds and cloud shadows

lemon yellow

cobalt blue

Bright spring green

aureolin

cobalt blue

Deeper summer green

aureolin

cobalt blue

raw sienna

Autumn green for cornfields and foliage

aureolin

burnt sienna

Autumn highlights – a bright, warm glow

burnt sienna

cobalt blue

Autumn and winter darks

burnt sienna

French ultramarine

Very dark, ideal for twigs, branches and window panes

viridian

French ultramarine

burnt sienna

Rich dark green

raw sienna

burnt sienna

cobalt blue

Rock and stone. The more blue added, the greyer it becomes.

Naples yellow

raw sienna

Sandy beaches

Naples yellow

rose madder

A nice soft glow to take the whiteness out of clouds

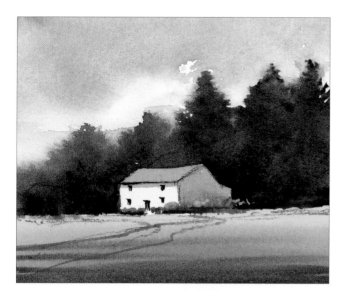

This small colour sketch shows how the three green mixtures can be used to create a feeling of light and distance. Immediately in front of the cottage the pasture has been put in with the bright spring green, followed by the deeper green, then right across the foreground is a sweep of the rich dark green. This then sandwiches the bright strip between the dark foreground and the dark fir trees behind the cottage, helping with tonal contrast as well as perspective.

Here I have used the range of autumn colours shown opposite. The burnt sienna mixed with aureolin creates an authentic warm glow, but don't forget that in autumn there is still some green around. Note how the rich, dark greens are carefully placed to provide maximum contrast with the light on the left-hand wall and the top of the right-hand wall.

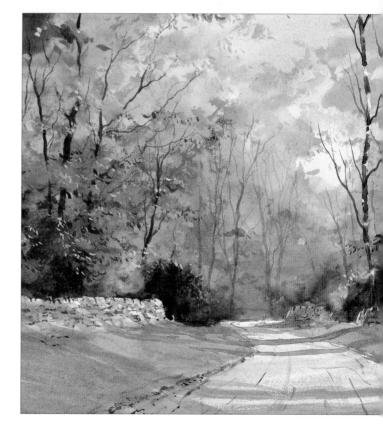

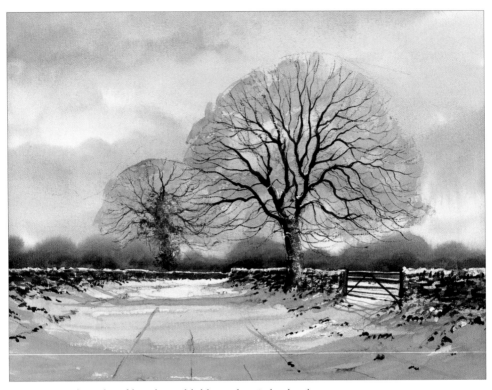

This snow scene makes good use of the medium and dark browns shown in the colour chart on page 200. Be careful when mixing the very dark colour that you allow the warmth from the burnt sienna to show through, or it can look too grey and lifeless. Note how the more distant tree has been rendered with a paler, slightly greyer colour to push it back into the middle distance, and the distant woodland is represented by an even paler, greyer mix. In this way, colours are used to create aerial perspective.

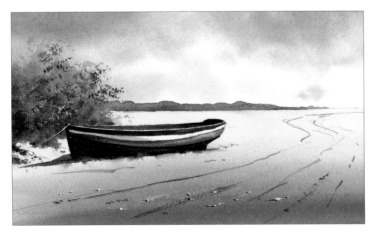

This coastal scene uses the sand colour shown on page 200. Starting with Naples yellow in the distance, I have then introduced Naples yellow and raw sienna, finally creating a shadow across the foreground with a wash of burnt sienna darkened with cobalt blue.

Notice how the far away strip of land is painted with the same cool grey used in the sky to push it right back into the distance.

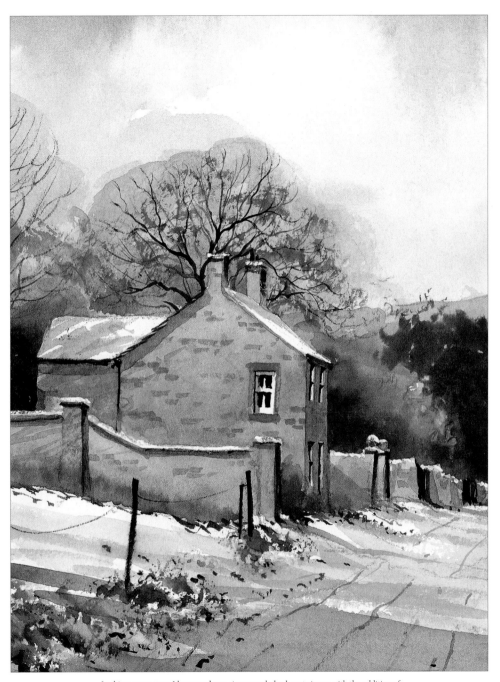

In this stone cottage I have used raw sienna and also burnt sienna with the addition of
a touch of cobalt blue for a slightly darker colour to suggest the stonework detail. It is
important not to overdo the detail in a painting like this.
Notice how a thin glaze of cobalt blue and rose madder, matching the sky, is used to
create a shadow on the front of the building, giving it a three-dimensional look.

Linear perspective

To construct an authentic looking landscape, you need a rudimentary knowledge of linear perspective. This can seem very complicated and technical, so it is my intention to focus only on the basic elements and how to apply them to solve some of the problems you may come across. Once the penny drops, it all falls into place and you don't forget it.

Linear perspective works by making objects look further away because they appear smaller. In the example shown in Figure 1 we have a straight-on view of a house on a flat, level plane. To draw this requires no knowledge of perspective, but it is not very interesting; observe in this example all the parallel lines shown with dotted lines. Now look at Figure 2. This shows the same house with the same parallel lines viewed obliquely. Immediately this image becomes more interesting – so what has changed? All the parallel lines now go away from the viewer, leading us into the picture and converging on a point called the vanishing point. This causes all the vertical lines to diminish as the eye follows them into the scene.

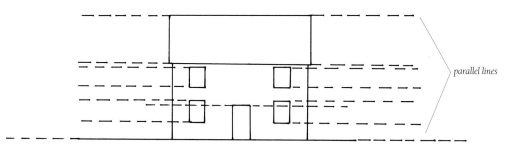

parallel lines

Figure 1

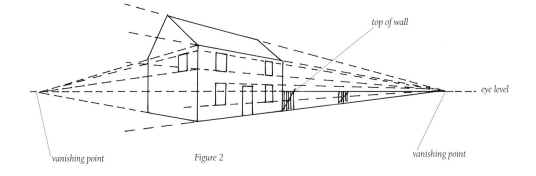

top of wall

eye level

vanishing point

Figure 2

vanishing point

A simplified example of this effect is shown using some telegraph poles on a roadside in Figure 3.

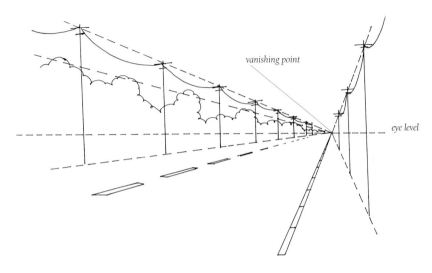

vanishing point

eye level

Figure 3
Notice how, when you take all the parallel lines to the
vanishing point, you can plot your verticals to create the
diminishing effect. Even the row of bushes indicated on the left
roughly follows a line to the vanishing point.

The vanishing point is always on the horizon or eye level. If you are looking out to sea, the horizon is where the sea meets the sky so it is very easy to see. Most of the time, however, it is obscured by hills, trees, buildings etc., so you need to ask yourself, 'Where is the horizon/eye level?' To find this, you need to be aware that all parallel lines below the eye level slope up to it and all those above the eye level slope down to it. Note in Figure 2 how the roof top, guttering, upstairs windows and top of the downstairs windows slope down. The base of the building and bottom of the downstairs windows slope up, so your eye level is somewhere in the downstairs window area, which when you think about your height in relation to a house, makes sense.

If you are working outdoors, hold up a ruler or pencil at arm's length between you and the scene, following the parallel lines that slope up and down. The point at which they converge is the vanishing point. Now form an imaginary level line that goes horizontally straight through this point from one side of the paper to the other, as shown in Figure 2. This is the horizon/eye level. You can then indicate this lightly on the paper. Alternatively, look for one of the parallel lines that neither slopes up or down but runs horizontally across the paper with sloping lines above and below; this will be on your eye level, (see the top of the wall in figure 2).

If you are working from a photograph, establishing the vanishing point and eye level is easier. Place a ruler along the parallel lines and draw them in lightly (see figure 4). You can easily see where they converge. Then rule a horizontal line through to establish the eye level.

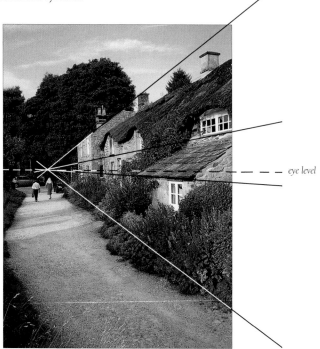

eye level

Figure 4
Note that in this example the eye level is above the heads of the people walking. This is because I stood on a wall to take the photograph, making my eye level higher than theirs.

If you look at the side of the building shown on the left of Figure 2 (page 204), you will see a second set of parallel lines leading to a second vanishing point. This is because, in life, this wall is at right angles to the front wall, not parallel to it. Though these lines have a different vanishing point, they have the same eye level: this is called two point perspective. Remember you can have numerous vanishing points depending on the complexity of the scene, but you can have only one eye level.

It is worth considering briefly how to place the point of the gable (Figure 5 point C) as this often baffles the aspiring artist. There is a relatively simple formula to achieve this, explained in this example.

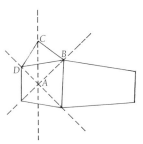

Figure 5
To position the end gable, take the basic rectangle that makes up the side of the building. Put a fine pencil line through each corner, crossing in the centre at point A. Draw a vertical through point A. Gauge the slope of the roof (you can do this by eye) and draw it from point B up to meet the vertical line, at point C. Draw a line from C to the far, top corner of the rectangle, D.

206

Don't be caught out when you view a scene on an incline; the level parallel lines are exactly the same except for the fact that the road itself, which in effect is the bottom of the buildings and walls, is not a parallel line – see Figure 6.

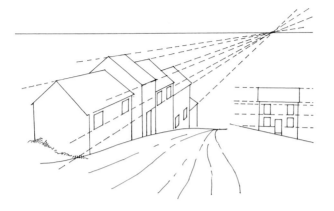

Figure 6
In this example we see a row of buildings on an incline. Note where the eye level is: up in the sky! This is because, although all the parallel lines that make up the shapes of the buildings remain the same, your viewpoint has changed. You are uphill from the scene, so your eye level is above it.

It is often the case that you find a scene that appeals to you, but it does not contain a natural perspective that will give you the opportunity to create a feeling of distance. An example of this is the simple sketch in Figure 7. This represents a popular location on a canal, where there are two boathouses on opposite banks; they are roughly the same size, and the same distance from the viewer. As an artist we do not have to accept it as it is.

Figure 7

Now look at Figure 8. I have taken the right-hand boathouse and enlarged it, creating perspective and bringing it nearer the viewer. This immediately improves

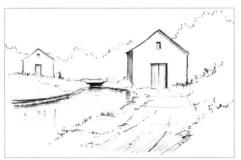

the composition as the positioning of the two buildings means that they now complement each other, rather than competing for the viewer's attention. It doesn't matter that it's not as accurate; your objective should always be to create the best interpretation.

Figure 8

Aerial perspective

Having considered how to use linear perspective to create a feeling of distance, we can now look at how to reinforce these principles by means of aerial perspective. Put simply, aerial perspective creates a feeling of distance by observing the effect the atmosphere has on the landscape, making the distance mistier, greyer and altogether less distinct than the foreground. This is a progressive effect i.e. the further away, the paler and less clear the scene becomes.

Nature, however, does not always make this easy for us. On a clear, bright morning without a cloud in the sky, the distant colours can be almost as vivid and sharp as the foreground. If we want a painting with such a feeling of depth and distance that the viewer almost feels they could walk into it, we need to interpret what is in front of us rather than just copy it exactly as it appears. After all we could produce an accurate record with a camera.

We can create aerial perspective by applying the following:

Cool colours (blues and greys) recede, warm colours (reds, browns and yellows) come forward. Look at the two squares of colour on the right. They are the same size on a flat piece of paper, but somehow the red one has more impact and looks nearer to you.

Lighter tones look further away than darker ones. Look at the example shown below.

When we view a scene, we can make out more detail in the foreground, but this detail gets progressively less as we travel into the picture. This seems like stating the obvious, but often what we know to be a fact, we don't think of applying to our paintings.

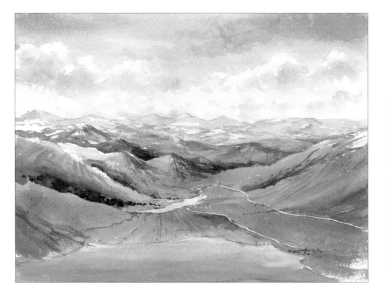

This range of mountains was based on a photograph taken from an aeroplane window. You can see such a long way that it is perfect for illustrating aerial perspective. Look at the most distant hills: these are merely suggested with a pale blue wash using the same colour as the sky. Warmer colours and stronger tones are very gradually introduced as we come further forwards in the painting.

Consider the two paintings below. There's no doubt that the one on the left looks like what it is supposed to be; green hills and pastures with a crisscrossing of dry stone walls and trees under a blue sky.

Now look at the painting on the right: the same scene, but what a difference when we apply some methods to create aerial perspective. First of all note how the sky is darker in tone at the top and lighter towards the skyline. Despite the fact that the distant hills on the photo were green, I've painted them in a pale blue-grey, the furthest hill indicated with the palest wash. A bit of light and atmosphere has been injected into the scene with the bright area in the centre, the tones gradually getting stronger and colours getting darker towards the foreground. Note how the distant trees are painted in softer, mistier shapes, becoming more clearly defined nearer the foreground. To emphasise this effect a hint of brown (a warmer colour) has been added to the nearer trees. Finally a few touches of detail: grasses, foliage etc., have been added to the foreground – remember that the nearer you are to something, the more detail you see.

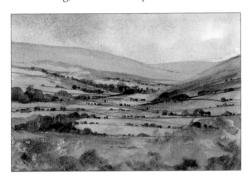 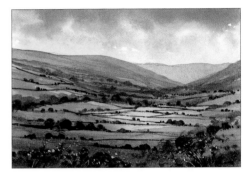

Now look at the painting below. Think about this simple scene and consider how both linear and aerial perspective has been used to create a feeling of depth and distance.

In this simple scene, linear perspective has been used to take the lane right into the distance. All the lines created by the tops of the hedges, the bottoms of the hedges and edges of the track converge on the eye level in the distance.
Also the trees gradually become smaller, less detailed and cooler in colour as they recede into the scene, thus employing aerial perspective as well.

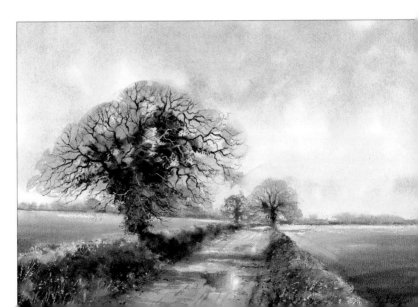

Skies

I believe that in most landscape paintings, whatever the medium, the sky is the most important element, as it sets the whole mood and atmosphere for the scene. Get the sky wrong and it is difficult to make a success of the painting; paint a good sky, however, and you are on your way, enthusiastic and motivated by the promising start.

The key to painting successful skies is preparation. This means taking the time to think about what you want the finished sky to look like, deciding which colours you intend to use and mixing all the initial washes before you put brush to paper.

When you are ready to commence, try and limit the time you spend painting the sky to thirty to forty seconds for each stage. I have seen more skies ruined by overworking than any other fault. Remember also that the glow in a watercolour depends on the light penetrating the transparent washes and reflecting off the paper, and the more you keep swirling the paint around, the greyer and more dense it becomes.

Here are seven different sky painting methods that are well worth trying. Paint them quite small at first, maybe filling a large sheet with numerous postcard size examples until you become more confident.

A WET IN WET SKY WITH THREE WASHES

1 Wet the paper over the whole sky area with a 2.5cm (1in) flat brush, and mix three washes: Naples yellow with burnt sienna, cobalt blue with cobalt violet, then the same again with burnt sienna added. I painted this sky with a large filbert wash brush.

2 Paint Naples yellow and burnt sienna across the lower part of the sky, then the cobalt blue and cobalt violet across the top, followed by the third mixture across the very top and a few dashes across the middle to represent hazy cloud shadow. Try to paint rapidly and then leave it alone.

3 The finished sky. When dry this will look quite different to when it was wet, the colours should have gently fused into one another, going slightly paler and creating a soft diffused look.

The soft, diffused shapes create a gentle effect and the slightly milky colour is ideal for portraying winter afternoon light. Don't judge your work while it is still wet —walk away from it and you'll be pleasantly surprised by the magic that takes place on the paper in your absence.

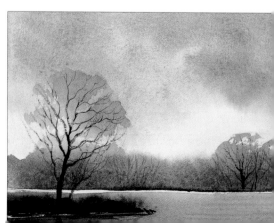

DABBING OUT CLOUDS

1 Mix two washes: cerulean blue for a cool colour near the horizon and cobalt blue with cobalt violet for a warmer blue at the top. Wet the paper with a flat brush, then using the same flat brush apply the washes with smooth horizontal strokes. Wetting the paper allows you more time before the washes dry. Dab out cloud shapes using a piece of kitchen towel. Scrunch up the kitchen towel to make smaller clouds lower down.

2 You can leave the clouds as they are, or add shadows. Wet each cloud individually with clean water and immediately drop in a grey created with cobalt violet and cerulean blue.

It is very important with this example to make each subsequent row of clouds smaller as it gets nearer to the horizon. This creates that all important feeling of distance and is what we mean by aerial perspective (pages 208–209).

3 The finished sky.

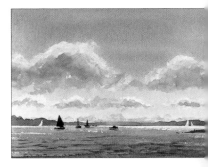

LIFTING STREAKS WITH A BRUSH

1 Mix two washes: cobalt blue and French ultramarine and a thinner wash of cobalt blue. Wet the whole page with clean water. Apply the first wash at the top, bringing it two thirds of the way down the paper, using the flat brush. Then change to the second wash so that the sky is cooler towards the horizon. Wash and dry the brush immediately until it is just damp and use it to lift colour out.

2 Keep cleaning and drying the brush to keep it 'thirsty'. Twist and turn the brush across the paper to make cloudy streaks, sloping them slightly uphill. Allow to dry.

This sky method works well when depicting a large expanse of flat land under a bright summer sky. The window for lifting out the streaks of colour is very small so you need to be well prepared and work quickly. The twisting motion of the brush helps to make the streaks look like cirrus clouds; if you don't twist and turn it enough, they are much less convincing.

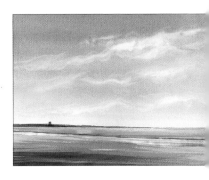

A SUNSET SKY

1 Mix three washes: a thin wash of lemon yellow; raw sienna with light red to make orange and cobalt blue with rose madder to make purple. Wet the background with a flat wash brush and clean water. Then drop in the washes from the bottom upwards: lemon yellow, then the orange in the middle, then bluey purple at the top.

2 Working quickly so the background is still wet, drop in cloud shapes using a no. 16 round brush and a mix of cobalt blue, rose madder and light red. This mix should be slightly thicker than the previous washes so that it spreads slowly into them without creating unsightly cauliflowers. Make the clouds larger at the top and smaller nearer the horizon, again to help with that feeling of distance.

3 The effects of this wet in wet technique will carry on changing as the loose cloud shapes soften into the previous washes until the painting is dry.

With a sky like this one you can not make out much detail on the land as everything is reduced to silhouettes. These dark shapes can be made up of stronger versions of the colours used in the sky so the whole scene has harmony – the benefit of the limited palette.

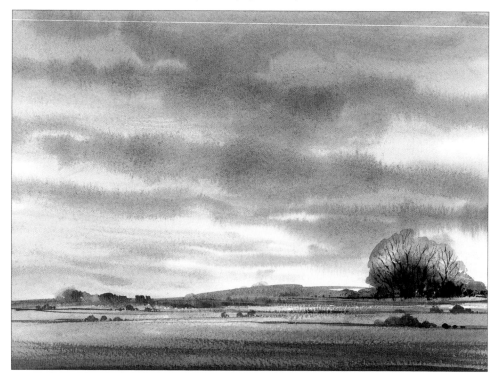

FOUR WASHES ON A WET BACKGROUND

1 First mix four thin washes: raw sienna, cobalt blue, neutral tint and sepia. Wet the paper with a sponge and with a filbert wash brush, apply a thin wash of raw sienna in the lower sky with the side of the brush. Clean the brush then wash on cobalt blue at the top, leaving some white paper. Add a wash of neutral tint at the top and bottom.

2 Paint on sepia at the top of the sky to darken it. Slope the board to allow the washes to spread into each other; do not work them with the brush for long as this will mix the raw sienna and cobalt blue, creating a grey-green. Do not judge the sky while it is wet, because it will lighten as it dries.

This combination of strong colours creates a dramatic effect, which can depict approaching bad weather and look very atmospheric. You have to be careful, however, to float the colours in and leave them to work their magic, as the more you swirl them about the more you are in danger of blotting out the light area in the centre, which you can use to great effect to illuminate the land.

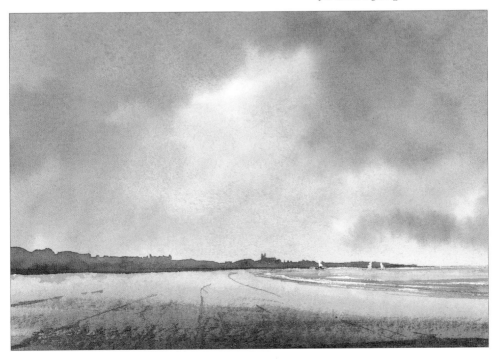

A GLAZED SKY THAT IS LIGHTER AT THE TOP

1 Unlike the previous skies which are lighter at the horizon and darker towards the top, this one is reversed. Mix three separate glazes: cadmium red, cobalt blue and neutral tint. They should all be quite thin so that they will be transparent. Apply the first wash of cadmium red with a no. 16 brush from the horizon line, thinning it towards the top with water so that it fades out to white. Leave the painting to dry completely.

2 Repeat this procedure with the cobalt blue, again softening with water towards the top. Allow to dry completely.

3 Repeat once again with the final glaze of neutral tint.

4 The sky when completely dry.

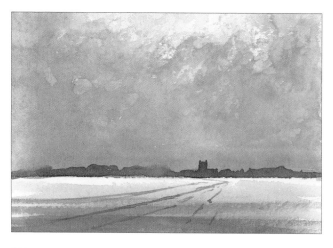

This type of sky is very useful for snow scenes or ploughed stubble fields where you can achieve a sharp contrast at the horizon with the dark of the sky against the brightly illuminated land.

SEPARATE GLAZES

1 Using a no. 16 round brush, wet the top right-hand side of the painting only. Wash in cobalt blue across the top of the whole painting and cerulean blue lower down. Soften with clear water to avoid any hard edges. Allow the painting to dry completely, so that later work will not disturb these washes.

2 Lay in grey cloud on the dry paper using a wash of neutral tint with just a touch of rose madder. Soften a few of the cloud edges with a damp, but not wet, clean brush. Don't soften all the cloud shapes as it is more interesting to have variation, with some hard and some soft edges. Leave this to dry.

3 Using the same mix of neutral tint and rose madder, add some dark cloud to the top left of the scene, again softening in places with a clean, damp brush.

As there are three glazes on this sky, it is important that each one is quite thin and transparent so that with each subsequent glaze you can glimpse the previous one underneath.

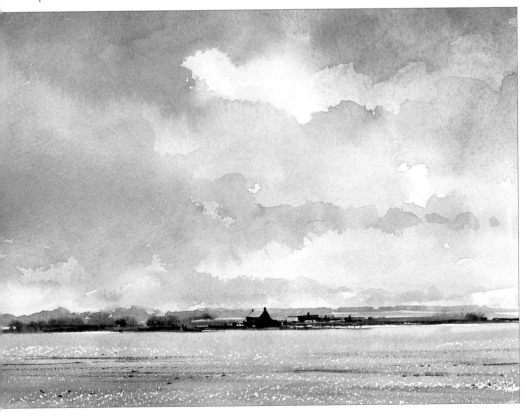

Holmfirth

During a hot summer's day walking in the hills above the attractive Yorkshire town of Holmfirth, I came across this scene and it struck me that the position of the track, fences and scattered buildings created a perfect perspective.

If you look at the photograph and sketch shown below, you can see how I have redirected some of the fences and altered the position of the telegraph poles to emphasise and lead the eye towards the distant hills. However, the basic ingredients were all there.

I felt that this scene had a natural perspective that led the viewer's eye down the path, along the line of trees and on to the small cluster of buildings in the middle distance.

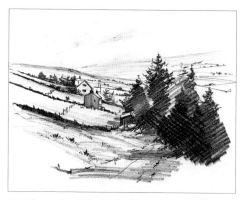

A quick, ten minute value sketch will help you to get a feel for the scene. Note how darkly I have rendered the fir trees on the left: this reminds me when doing the painting that there is a real counterchange of light against dark in this section.

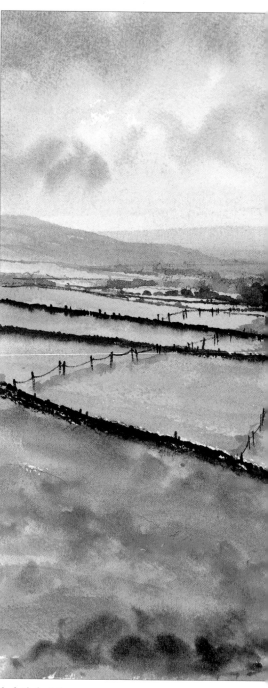

The finished painting

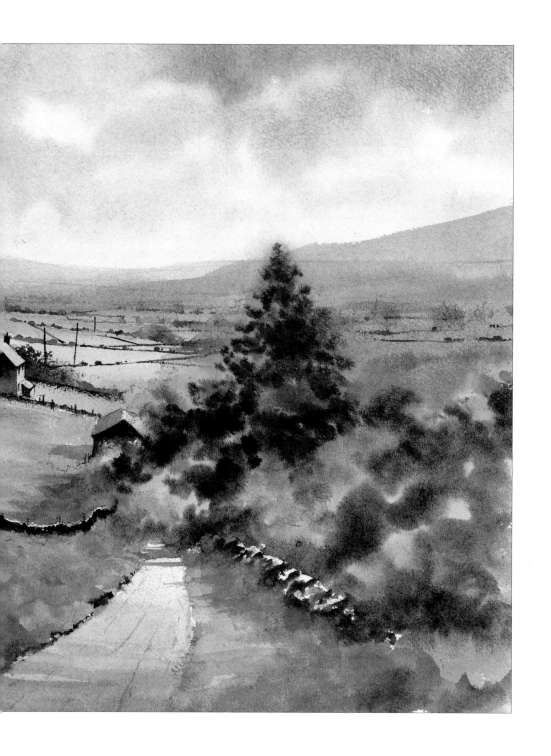

1 Draw the scene. Apply masking fluid to highlight areas on the buildings and the tops of the walls using an old paintbrush.

TIP

Do not leave masking fluid on a painting for more than a day or two; it can tear the paper when you remove it.

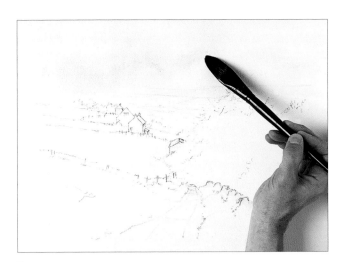

TIP

Drop the sky wash below the top of the distant hills. If you stop where the hills meet the sky, you will get an unnatural line.

2 Mix all your sky colours before beginning to paint, as you will need to work quickly once the paper is wet. Mix cobalt blue with cobalt violet; raw sienna with a little burnt sienna; and cobalt blue with cobalt violet and burnt sienna. Wet the sky area with clear water using a large filbert wash brush. Paint the lower part of the sky first, washing the raw sienna/burnt sienna mix on to the wet paper.

218

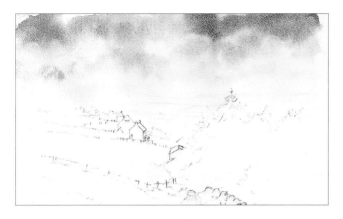

3 Next drop in the cobalt blue, cobalt violet mix above the first wash, working quickly while the paper is wet. Lastly wash on the cobalt blue, cobalt violet and burnt sienna mix at the top of the painting. The darkest wash always goes at the top, with the sky lightening towards the horizon to create perspective. Slope the board downwards just a few degrees for a moment to allow the washes to run into one another, then lay it flat and allow the painting to dry.

4 Mix all your colours for the next wet in wet section: cobalt blue and cobalt violet; the same colour with burnt sienna added; a thin wash of lemon yellow; green mixed from aureolin and cobalt blue and finally raw sienna, burnt sienna and cobalt violet. Using a no. 12 brush, paint stripes of colour to merge with one another. Begin with cobalt blue and cobalt violet, then below that the slightly greyer mix, then the warmer raw sienna, burnt sienna and cobalt violet; then lemon yellow for sunlit fields. Take a no. 8 brush and drop in a green/brown mixed from aureolin, French ultramarine and burnt sienna for distant trees.

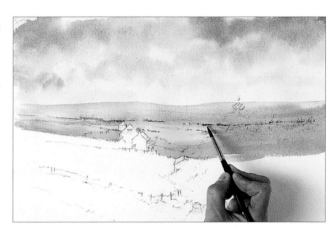

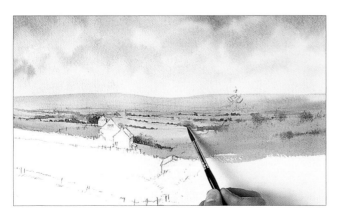

5 While the paint is damp, drop in a suggestion of walls, hedges and trees in the distance using cobalt blue, cobalt violet and burnt sienna for a warm grey. Allow the painting to dry.

6 Soften the line where the distant hills meet the sky using a wet brush, and dab it with kitchen towel.

219

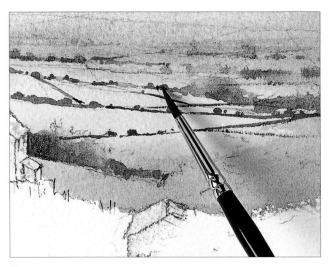

7 Use a no. 4 brush and a medium brown mixed from burnt sienna and cobalt blue for the dry stone walls in the middle distance. Add a darker brown of burnt sienna and French ultramarine nearer the foreground.

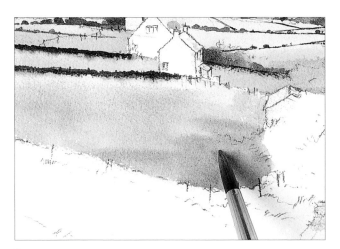

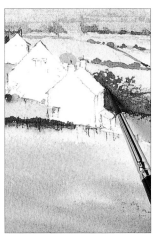

8 Remove the masking fluid from the left-hand wall. Paint the wall and fence posts with burnt sienna and French ultramarine. Paint the greens of the fields with a mix of aureolin and cobalt blue. Mix a straw colour from Naples yellow and cobalt violet and use this to soften the bottom of the wall. Add a hint of lemon yellow for the effect of sunlight in the field, and cobalt blue to darken the green. Allow the painting to dry.

9 Remove the masking fluid from the buildings. You may need to tidy the edges using the background colours.

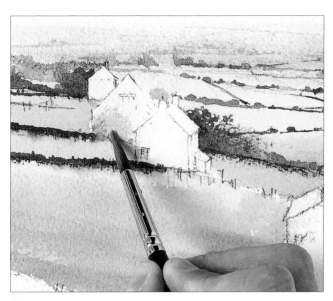

10 Make a thin mix of cobalt violet and burnt sienna and wash a pink glow over the area of the buildings using a no. 8 round brush. While this is still wet, mix a green from aureolin and cobalt blue and paint in the bush in front of the buildings wet in wet to achieve a soft-edged shape.

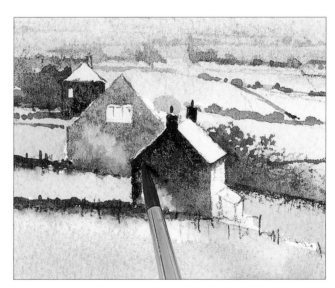

11 Drop in a mixture of burnt sienna, cobalt blue and cobalt violet for the shadowed part of the buildings. Immediately drop lemon yellow into the bush and allow it to spread upwards. Then, using a darker mixture of French ultramarine and burnt sienna, darken the left-hand and right-hand buildings, sandwiching the middle one between them. Leave a white ridge between the buildings to represent the slope of the roof.

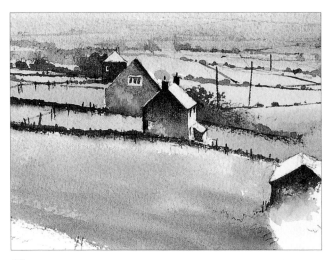

12 Use the same brown and a no. 4 brush to draw in the finer details of fence posts, windows and telegraph poles. Paint the very dark wall of the building on the extreme right. Dampen the area of foliage in front of it and add lemon yellow to contrast with the dark wall. Take care to leave the roof of this building white paper for the time being.

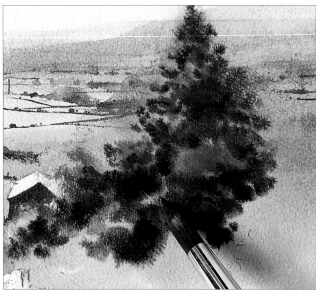

TIP

In the reference photograph the fir tree reaches exactly the same height as the distant hill, but this will look contrived in a painting, so vary it by making the fir tree taller.

13 At this point I decided that the hills on the right and left of the picture should be steeper, creating a deep valley typical of this part of the country. Mix large quantities of three colours for the middle to right-hand side of the painting: lemon yellow; aureolin with cobalt blue and viridian with French ultramarine and burnt sienna. Wet the area first and wait for the shine to go (this indicates that the paper is damp rather than wet through). Then drop in the darkest green first for the fir tree. If the paint spreads wildly, the area is still too wet, so wait a few seconds longer. Drop in lemon yellow with a no. 16 brush.

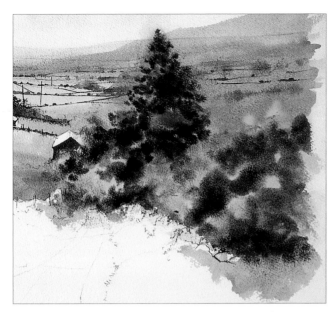

14 Add more of the lemon yellow and more mid green, painting wet in wet. Mix burnt sienna with Naples yellow and drop it in where the grasses soften into the green. Paint the right-hand side of the scene with a touch of lemon yellow, and add darker greens, as with the fir tree. Add a rich yellow mixed from Naples yellow, burnt sienna and lemon yellow at the bottom right and tip the board upwards to encourage the colour to spread upwards, indicating the tufts of grasses. Allow the painting to dry.

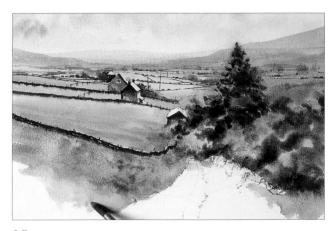

15 Mix more colours in preparation for painting rapidly wet in wet from the middle ground wall downwards. Rub off the masking fluid from the wall and paint it using French ultramarine and burnt sienna. Paint the darkest details such as fence posts using this same mix. With a no. 12 brush, soften the bottom edge of the wall using Naples yellow mixed with burnt sienna. Paint a little pink below this, mixed from Naples yellow and cobalt violet, to tie in with the sky, then continue downwards with a green mixed from aureolin and cobalt blue with a hint of raw sienna.

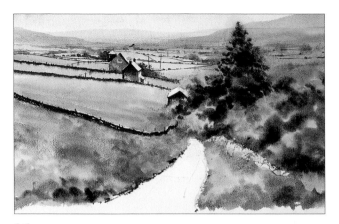

16 Work wet into wet on the foreground. Mix a green from aureolin and cobalt blue, add burnt sienna to brown it and drop it in to create grassy tufts. Add touches of pink. Use the dark green to paint rich darks in the foreground to give it a rough, textured feel, softening the edges. Paint the foreground area on the right-hand side of the path in the same way, using pink, green and dark green.

17 The path should look as though it is reflecting colours from the sky. Paint on watery mixes of Naples yellow and burnt sienna and cobalt blue and cobalt violet, allowing them to merge on the paper. Leave some areas white for intense brightness. Allow to dry.

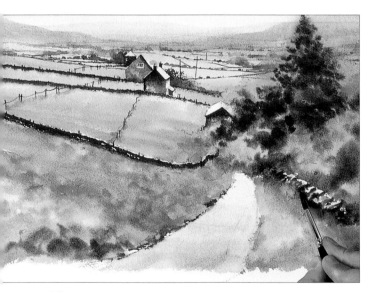

18 Add fence posts in the left-hand field using a no. 4 brush and burnt sienna mixed with French ultramarine. These will lead the eye into the painting and create linear perspective. Remove the masking fluid from the right-hand wall and paint it using the same dark brown, but leaving highlights of white paper.

224

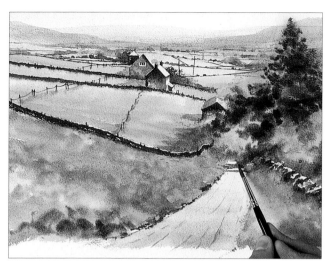

19 Use burnt sienna to suggest red bracken under the dry stone wall and on the right-hand side of the path. Mix cobalt blue and cobalt violet (sky colours) for shadows. The light is coming from the right in this scene, so shadow the left-hand side of the roof of the building on the far right. Indicate shadows cast to the left from the buildings and trees.

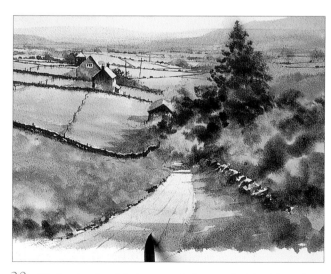

20 Paint broad strokes of shadow across the foreground to bring it forward, softening the top edge a little with a damp brush. Drop in burnt sienna to warm the shadow at the bottom, and paint perspective lines on the path.

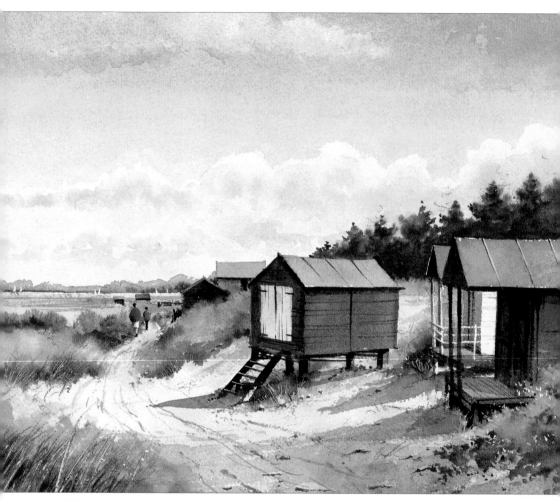

Beach Huts at Minehead

34 x 27cm (13½ x 10½in)

Whilst this is a totally different scene to that of Holmfirth, it shares the same basic idea, that we can create perspective by the position of the buildings. The suggested lines in the path through the sand help this effect. The viewer's eye follows the figures and is drawn towards the white and red sails in the far distance. Note how the rich dark green of the fir trees pushes forward the shapes of the beach hut roofs.

Boatyard at Woodbridge

340 x 270mm (13½ x 10½in)
*Here the positioning of the boats leads the eye to the distant area just to the right of
the whitewashed building. Note that the planks of timber at the bottom right plus the
suggested lines on the yard also point to this area. There is no mistaking where we are
meant to look in this scene.*

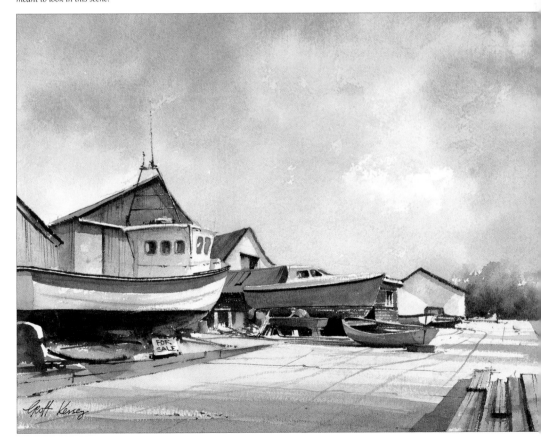

Snowscene

The first few days of 2003 gave me some marvellous weather conditions for gathering painting subjects. There was a light coating of snow under crisp, bright, clear skies and I knew this scene was a painting as soon as I came across it, on a woodland walk in the Peak District.

I find that nature does not often give us a perfect composition, but I think this is one occasion where all the main aspects of the scene are perfectly placed. Our eye is led from the large silver birches on the left, along the winding path to the smaller birches and out into the distance, where we get a glimpse of the hills beyond the woods.

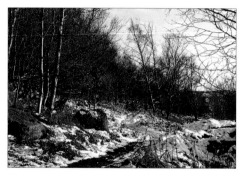

When I came across this scene on a New Year's day walk in the Peak District, I knew instantly that it was a ready-made painting and couldn't wait to get back to the studio to get cracking. A digital camera is ideal for such moments!

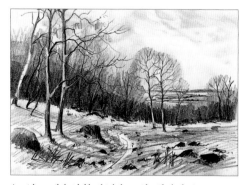

A quick pencil sketch like this helps to identify the basic elements and simplify the scene.

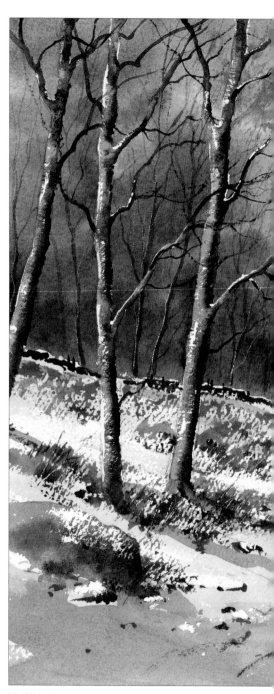

The finished painting

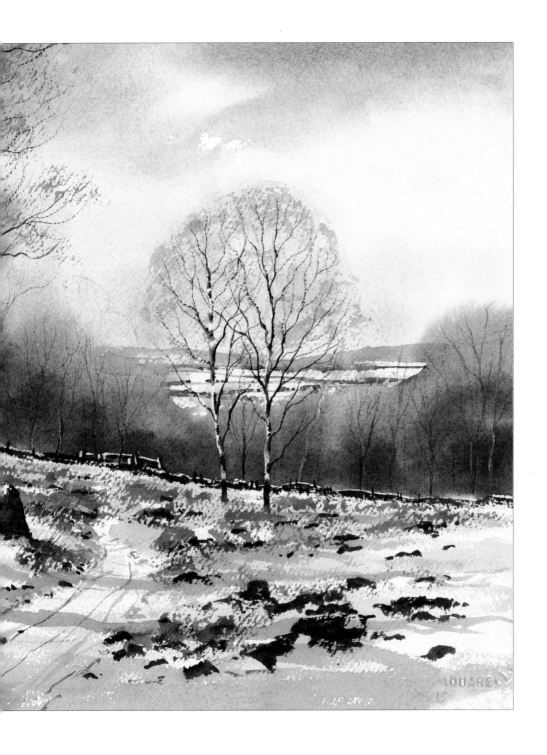

You will need

Rough paper, 380 x 300mm
(15 x 11¾in)
Masking fluid
Naples yellow
Cobalt blue
Cobalt violet
Burnt sienna
Raw sienna
French ultramarine
White gouache
Old paintbrush
2.5cm (1in) flat wash brush
Large filbert wash brush
Round brushes: no. 12, no. 4,
no. 16, no. 8, rigger
Craft knife

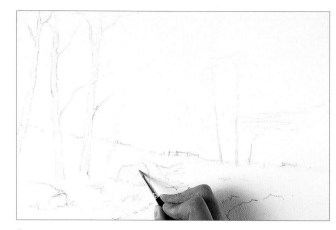

1 Sketch the scene and using an old brush, paint masking fluid on to the silver birches, the rocks in the foreground, the birches in the middle ground and the line where the snow meets the woodland.

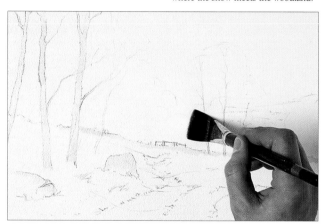

2 Use a 2.5cm (1in) flat brush to wash clear water over the painting from the top to the horizon.

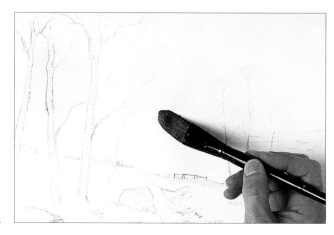

3 Using a large filbert wash brush, drop Naples yellow into the wet area in the lower part of the sky to create a glow.

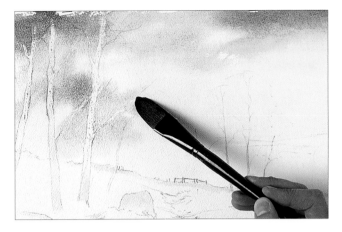

4 While the paper is still wet, drop cobalt blue and cobalt violet in at the top of the painting, down to about half way. The sky should be darker at the top, which gives the impression of perspective. Leave areas of white paper to suggest clouds. Add burnt sienna to the previous mix for a cloudy grey and drop this in.

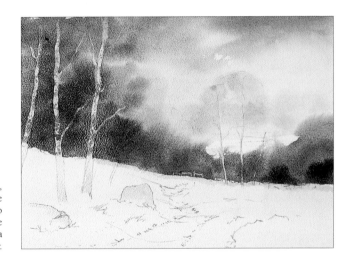

5 Drop in a thick mix of cobalt blue, cobalt violet and burnt sienna for the tree area. Use the side of the brush to suggest soft edges at the tops of the trees. Add raw sienna and burnt sienna for a red glow.

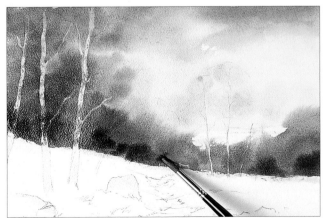

6 Working wet in wet, add cobalt blue and burnt sienna for the darker area at the bottom of the trees. Allow the painting to dry.

TIP

For dry brush work, hold the brush on its side with four fingers on one side and the thumb on the other so the side of the hairs just catches the raised area of the Rough paper.

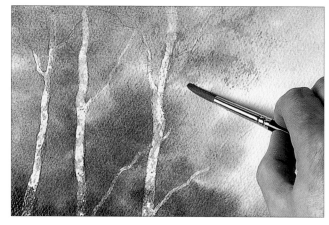

7 Use the side of a no. 12 round brush and the dry brush work technique to suggest the finer foliage at the ends of branches.

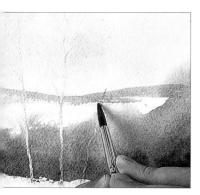

8 Mix cobalt blue, cobalt violet and burnt sienna, the colours that made up the grey and blue of the sky. With the no. 12 round brush, paint in the distant hills, wet on dry. The cool colours will make the hills recede into the background.

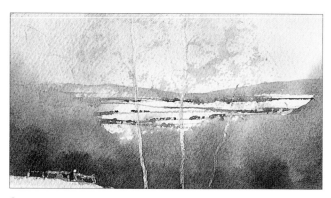

9 Using the same colour mix and the very tip of the no.12 brush, suggest the distant trees and dry stone walls. Use a little bit of dry brush work to emphasise the tops of the trees in the middle distance with raw sienna and burnt sienna.

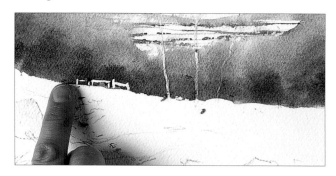

10 Rub off the masking fluid at the base of the treeline using a finger. Clean up with a putty eraser if necessary.

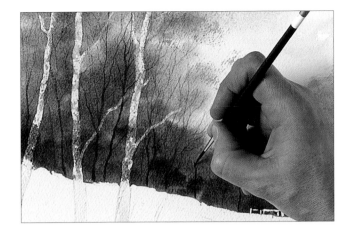

TIP

Rapid strokes of the brush look more convincing when painting trees in the distance. Always paint trunks and branches from the bottom upwards.

11 Mix a brown using cobalt blue mixed with burnt sienna, and with a no. 4 round brush, paint in distant tree trunks. Make some look further away by adding more water to the mix, and some nearer by using thicker paint. Use a rigger brush for finer branches.

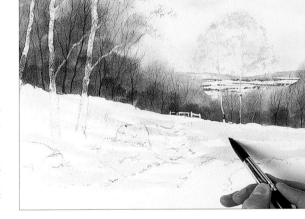

12 Mix the sky colours cobalt blue and cobalt violet for the snow shadows. Wash them on using a no.16 round brush, taking care to leave some of the paper snow-white. Your brush strokes should follow the contour of the land. Dampen the paper for softer areas. Use a weaker wash in the middle distance, and begin to pick out the shape of the path.

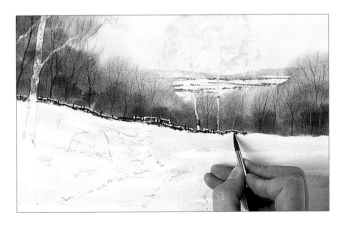

13 In the middle distance, develop the hint of a dry stone wall using a no. 8 round brush and a very dark brown mixed from burnt sienna and French ultramarine. The richer colour of the French ultramarine creates a richer, darker brown. Keep the brush fairly dry and use it to catch the texture of the paper, leaving a sharp white edge to represent snow on the top of the wall. Use the point of the brush for fence posts against the wall.

233

14 Make a thick mix of raw sienna and burnt sienna and use the side of a no. 8 round brush to catch the paper texture to indicate bracken in the snow.

15 Drop dark brown in to the red bracken while it is wet. The effect will be soft where the paint is wet and scumbled where it meets the dry paper. Scratch out the shapes of grasses and twigs using a craft knife.

TIP

The scratching out technique depends on good timing. If you scratch out when the paint is too wet, colour runs back in to the grooves; if you leave it too late, the dry paint will not scratch out. The best time is when the shine has just gone from the paint.

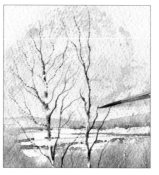

16 Rub off the masking fluid from the middle trees. Wet the trunks with clear water and drop in dark brown using a no. 4 round brush. The paint will spread into the wet area. To bring these trees forwards, the darks on their trunks should be darker than the background and the lights lighter.

17 Take a rigger brush and indicate the finer details of the branchwork.

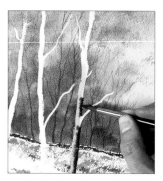

18 Rub the masking fluid from the foreground trees. Wet the right-hand trunk and drop in a mix of Naples yellow and raw sienna. Working wet in wet to avoid stripes, drop in a mix of cobalt blue and cobalt violet, then add a dark brown mixed from burnt sienna and French ultramarine on the right-hand side, since the light is coming from the left. Paint the finer branches in the same way using a rigger brush.

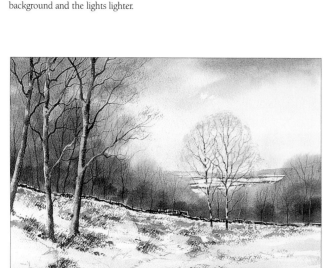

19 Work the remaining two foreground trees in the same way.

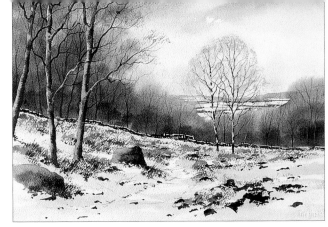

20 Rub the masking fluid off the large rock. Mix raw and burnt sienna plus a green from raw sienna and cobalt blue, and for the darker areas of stone mix burnt sienna and French ultramarine. For shadow use the sky colours, cobalt blue and cobalt violet. Mix all these colours wet in wet on the rock, leaving white for a hint of snow.

21 Paint the other rock in the same way. Use a no. 8 brush and dark brown to suggest stones sticking up through the snow. Make these larger nearer the foreground to help the perspective.

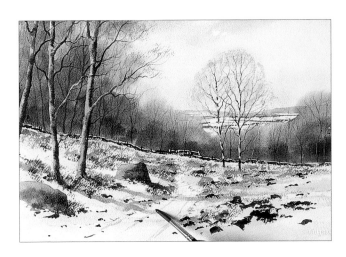

22 Paint the shadows in cobalt blue and cobalt violet. It is important that the paint is transparent so that the colours underneath show through. Put in long shadows for the left-hand trees to emphasise the direction of the light.

23 Paint in shadows to suggest trees beyond the left-hand edge of the picture casting shadows into the scene, and indicate the ruts in the path to create linear perspective. Make your marks stronger near the foreground, which creates aerial perspective. Take a no. 16 round brush and add more of the same colour to bring the foreground forwards. Soften any hard edges with a damp, clean brush.

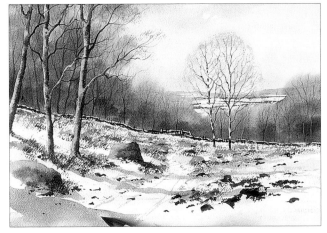

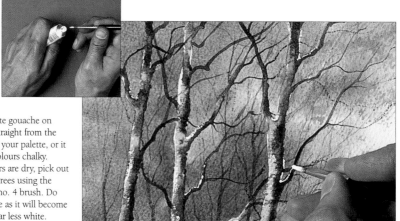

24 Place some white gouache on your board or use it straight from the tube. Do not put it in your palette, or it will make the other colours chalky. When the watercolours are dry, pick out snowy details on the trees using the white gouache and a no. 4 brush. Do not dilute the gouache as it will become less opaque and appear less white.

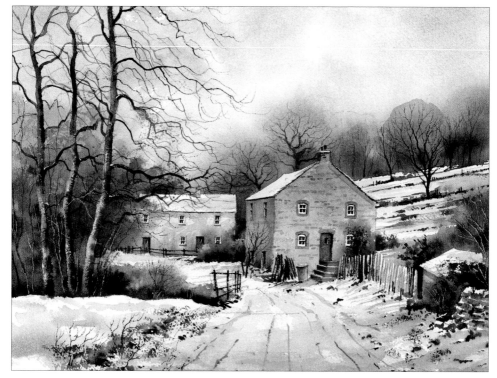

Winter in Padley
35.5 x 27cm (14 x 10½in)
This is one of my favourite areas in the Peak District; I must have painted here dozens of times. The main blue in the sky and in the shadows is cerulean; this is quite a cold colour and really injects a wintery feel into the scene, especially when combined with the milky sunlight effect in the lower part of the sky, suggested with a thin wash of Naples yellow. Note how the shadows have been indicated with the same cold blue, warming it slightly with a touch of rose madder in the foreground to bring it forward.

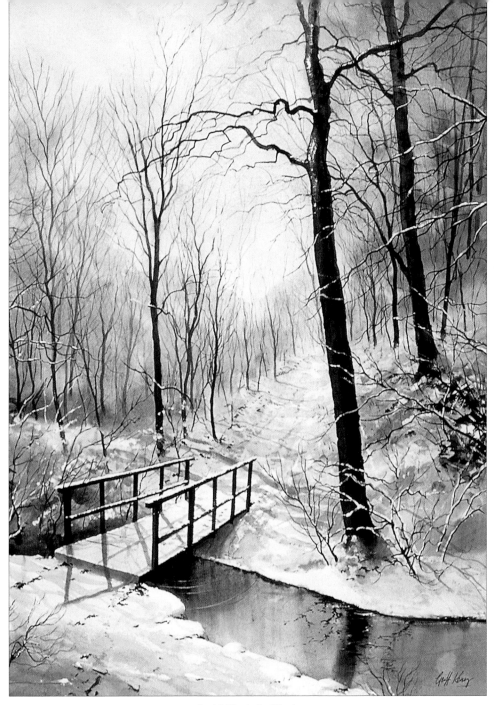

Foot Bridge in the Woods

530 x 750mm (21 x 29¾in)

This is a little hidden location twenty minutes' walk from my home. The light was perfect on this cold winter's afternoon with that beautiful red glow, which I recreated with thin washes of Indian yellow and cadmium red. Note the aerial perspective created by rendering the more distant trees in cooler colours and lighter tones.

Glencoe

This atmospheric scene from the Highlands of Scotland is a good illustration of how to combine aerial and linear perspective to create a feeling of distance in a painting.

The linear perspective is simply the path of the river winding into the composition. Note that it disappears out of view, leading your eye to the focal point to the right of the centre. Had this been dead centre it would have ruined the composition, dividing the paper down the middle. The aerial perspective is created by making the left-hand hills become gradually cooler in colour and paler in tone, creating the feeling of recession. The dark, shadowed hill on the right pushes back the distant hill behind it even further. Don't be afraid to use strong, dark colour when necessary. Being timid is the short-cut to mediocrity in a painting!

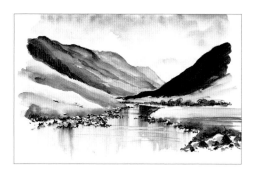

I felt that I captured this wild scene perfectly, with plenty of information contained in this sketch carried out with water soluble pencils. A few colour notes in the margin can also be helpful.

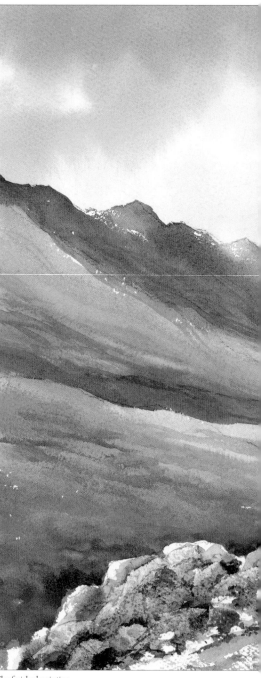

The finished painting

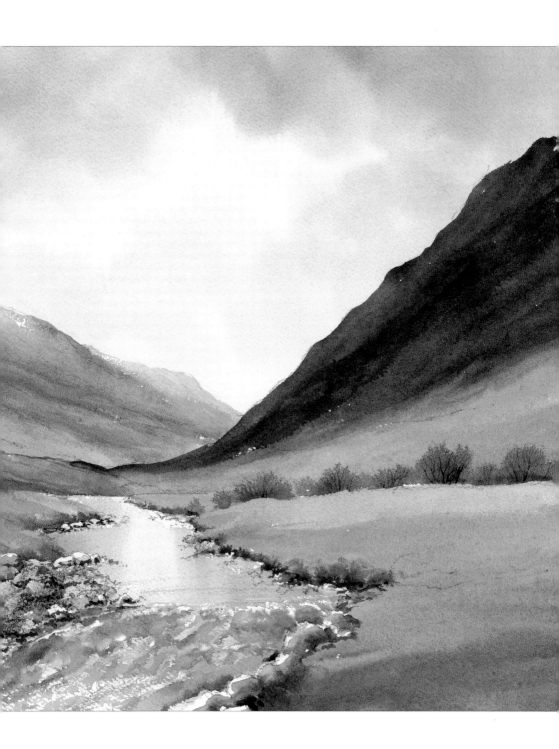

1 Use an old paintbrush to paint masking fluid on the line where the river bends out of view, and on the tops of the rocks and stones.

2 Mix four sky washes in advance so that they are ready for painting quickly: raw sienna, cobalt blue, neutral tint and finally sepia. Wash the sky area with clean water applied with a sponge, coming down below the tops of the hills.

3 Wash raw sienna on to the lower part of the sky, then carefully float in some cobalt blue. Don't swirl it around too much or you will create a green. Then add neutral tint towards the top, and finally sepia at the very top. This will make the sky considerably darker at the top and lighter towards the horizon, creating aerial perspective. Allow the sky to dry.

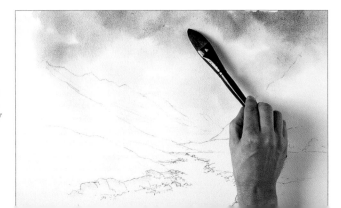

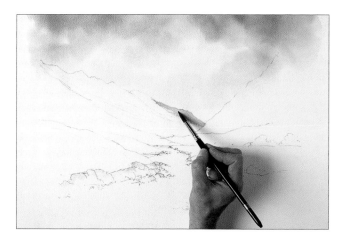

4 Using a fairly dry no. 12 brush, paint the distant hills in pale cobalt blue, greyed slightly with neutral tint.

5 Add burnt umber to the cobalt blue/neutral tint mix to warm it, and paint the middle distance using a no. 16 brush. Paint more cobalt blue and neutral tint at the top and a little raw sienna for more warmth at the bottom.

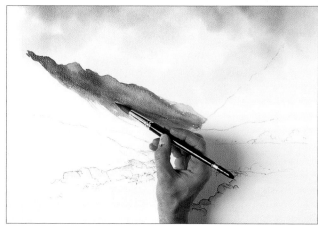

TIP

In a mountainous scene like this, it is important that your brush strokes follow the contours of the land.

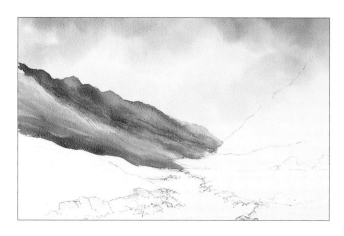

6 Add a green mixed from aureolin and cobalt blue. Wash cobalt blue mixed with neutral tint over this, working wet in wet to avoid making stripes. This will darken the area, to contrast with the lighter hill. Wash sepia on top to darken further. Add more cobalt blue and neutral tint to suggest dark cloud shadows. Allow to dry.

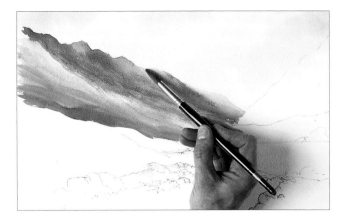

7 Brush the most distant hill with clear water fading it to push it further back into the scene. Make sure it is fully dry beforehand, or you will remove the pigment rather than just fade it. Using a no. 12 brush and cobalt blue mixed with neutral tint, add streaks. Use sepia to paint in the dark ravine, and fade the top using clear water again.

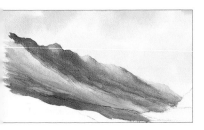

8 Use sepia to create crags and gullies on the left of the green area, and neutral tint with cobalt blue to reinforce the darks, for greater contrast with the lighter hill. Streak in the darker paint with a dry brush to give the land a rough look.

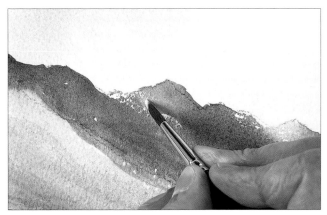

9 Using neat white gouache straight from the tube, catch the surface of the Rough paper very lightly on the tops of the hills to suggest snow. You can use a damp brush in one or two places to lighten the gouache.

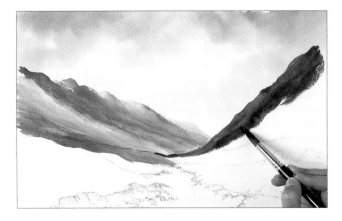

10 Paint the dark hill on the right using a no. 16 brush and a mix of burnt umber with neutral tint. This must be strong enough to make the distant hill behind it appear to recede, so cover all the white paper.

242

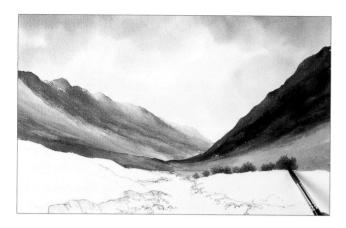

11 Carry on down the hill painting wet in wet and bringing in raw sienna for brightness and a touch of green mixed from aureolin and cobalt blue. To paint the stand of trees on the right of the painting, mix burnt umber and neutral tint and drop soft shapes into the wet paint. Use the same dark paint to darken the upper part of the hill on the left, to create contrast with the lighter part to come. Allow to dry.

12 Make a thin wash of raw sienna for the brightness on the left-hand middle ground. Paint a stronger mix of raw sienna and burnt umber on top, softening it into the contrasting dark above it. Add cobalt blue and neutral tint to darken the area in streaks. Bring in some green mixed from aureolin and cobalt blue.

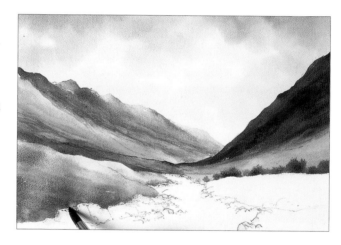

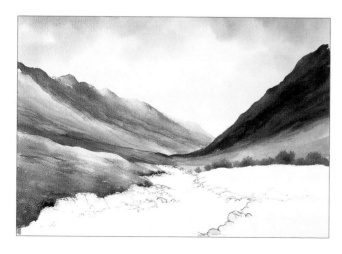

13 Use a dry brush with burnt umber to paint streaks of dark into this triangle of land, to give it a patchy look. Take a no. 8 brush and use a dark mix of burnt umber and neutral tint for the dark areas of soil where the land meets the water, allowing this to drift into the lighter colour above it.

243

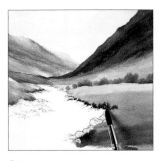

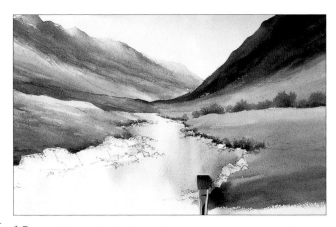

14 On the right-hand side of the river, wash on raw sienna to contrast with the dark hills. Add raw sienna and burnt umber to give a warm brown tint. Mix green from aureolin and cobalt blue. Paint raw sienna, burnt umber and green towards the foreground, leaving spaces for stones. Use burnt umber and neutral tint for the dark patch at bottom right. Paint dark brown for the soil at the river's edge.

15 Rub off the masking fluid from where the river bends out of view. The river is painted in two parts; firstly the slow flowing part that reflects the sky. Take three separate washes: cobalt blue, neutral tint and raw sienna. Wet the reflective river area with clean water down to where the river rushes, then float the three colours into this wet background. Immediately, using a 1cm (½in) flat brush, drag the colours down vertically to the stones. Allow to dry.

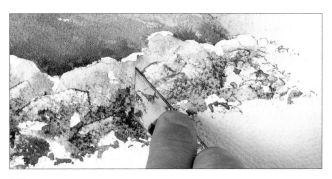

16 Rub off the masking fluid from the stones. Take a no. 4 brush for the smaller stones and a mix of burnt umber and neutral tint and work the shapes of the stones. Make tiny marks to create form – do not attempt to draw round the stones, or they will look flat.

17 Wet the area of the stones in the middle ground. Make a thin wash of raw sienna and float it in, then drop in cobalt blue on top, and neutral tint on top of that. Make a very dark mix of burnt umber and neutral tint and drop that in wet in wet. Take a craft knife blade and move the colours around by scraping it over the paper, using the flat of the blade to create form and texture.

18 Take a no. 4 brush and mix a dark shade of burnt umber and neutral tint. Work this dark into the rocks to emphasise their shape. Allow the painting to dry.

Tip

It is important to use colours for the stones that have already been used elsewhere, or the stones will look as if they belong in another painting.

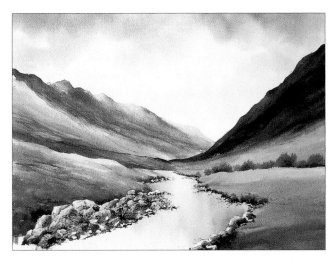

19 Paint some of this dark brown into the rocks in the foreground and allow to dry once more.

20 Find the horizontal line in the painting where the water begins to run downhill. Drop in a little neutral tint and sepia, then take a no. 8 brush and use white gouache straight from the tube, adding this while the watercolour is dry in some parts, wet in others, to suggest foam. The white gouache can also be used to suggest splashes and add horizontal lines in the water.

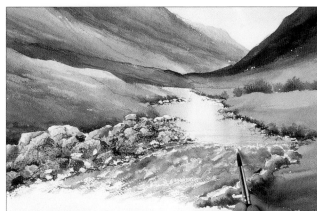

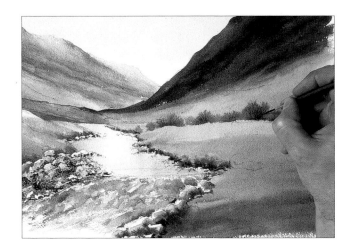

21 Develop the shapes of trees using a rigger brush and burnt umber mixed with neutral tint to indicate the branches. Paint the trees, as always, from the bottom up.

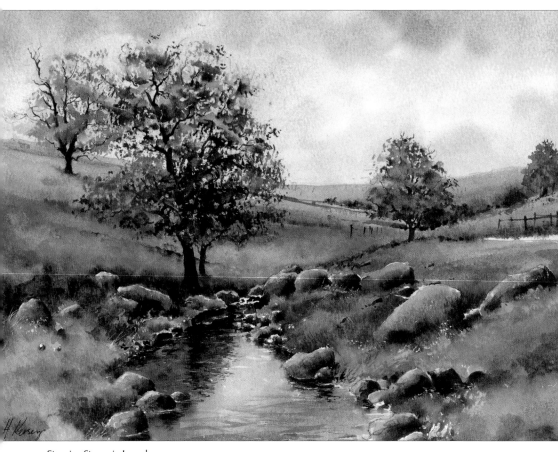

Stepping Stones in Longshaw
406 x 292mm (16 x 11½in)
The bright afternoon light in this scene, created with a mix of cobalt violet, raw sienna and burnt sienna, contrasts well with the rich darks in the shadows and reflections. Don't just think of water as blue; it reflects all the colours around it. To help this effect it is a good idea to write down the colours you are using, so that when you come to painting the water, you can remember the colour mixes and match them.

Watendlath Beck, Cumbria

420 x 292mm (16½ x 11½in)

*A beautiful location with a paintable view in every direction. It has all the right
ingredients: a packhorse bridge, rustic old farm buildings and a shallow beck or
stream leading to a still mountain lake, all set to a backdrop of the Cumbrian hills.
All elements in the scene lead the viewer to the focal point of the bridge. Note the
person on the bridge wearing red which catches the eye, and how the tonal value of
the hills is reduced as they recede into the distance. You don't have to work too hard
on rocks and stones: observe how simply they have been treated here – just as areas
of light and shadow.*

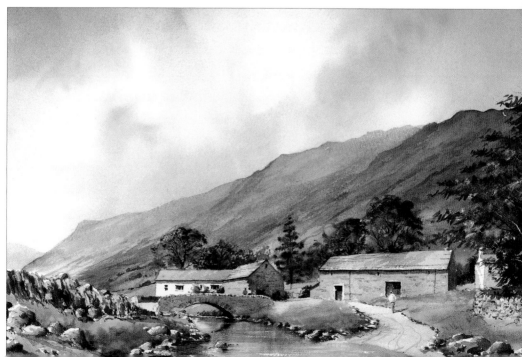

Boats at Bosham Quay

In this painting the distinctive shape of the Saxon church across the water makes an excellent focal point. Note how this is a third of the way into the picture, always a good position compositionally. The cluster of boats make excellent foreground detail, but note how I have reduced the number of these and altered their positions slightly. You don't have to copy slavishly what is on your photograph; you should take some time at the outset to consider any changes or simplifications you wish to make. I have found that most picture buyers, even if they are familiar with the location, expect you to use some artistic licence.

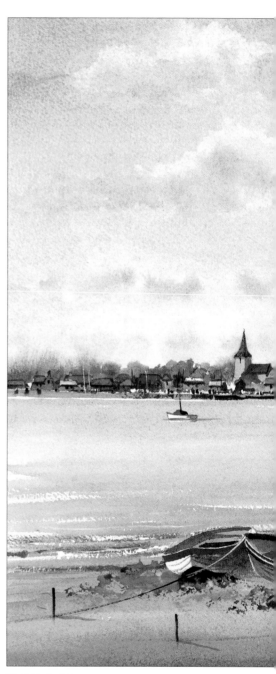

I took many shots of this scene, as I often do, to give me plenty of choice back at the studio. I chose this one for the jumble of boats that added a lot of interest to the foreground.

Before setting about the finished painting, I used a quick pencil sketch to simplify the foreground, deliberately not including all the boats. What to leave out and what to put in is a personal decision and one you have to get into the habit of making yourself.

The finished painting

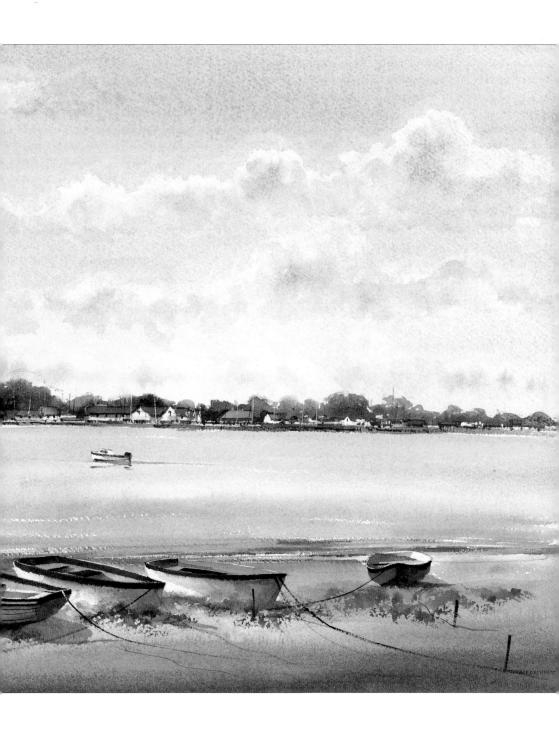

1 Sketch the scene and use an old paintbrush to apply masking fluid to the rooftops of the buildings across the estuary. Do not mask the boats yet, or your hand will disturb the masking fluid as you work on the top of the painting.

2 Mix two washes for the sky: cobalt blue with cobalt violet for the top of the sky and cerulean blue for the lower part of the sky. Using this colder blue near the horizon will make it look further away, helping the aerial perspective. Wet the sky area and paint on the washes wet in wet using a large filbert wash brush. Immediately dab areas with a kitchen towel to suggest clouds. Allow the painting to dry.

TIP

Make the cloud shapes smaller nearer to the horizon to create a feeling of distance.

3 Now work on one cloud at a time, re-wetting each one with clear water then dropping in a cloud shadow colour mixed from cerulean blue and cobalt violet. Move on to other clouds and work them in the same way. Continue softening the clouds with clear water to prevent hard lines from forming; you are trying to achieve a soft, vaporous look. Allow to dry.

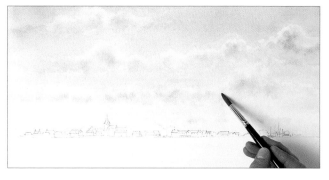

250

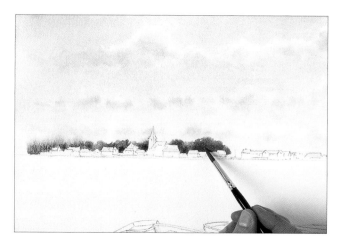

4 Mix cobalt blue and cobalt violet with aureolin. Take a no. 8 brush and paint vague tree shapes in the distance. Before they are dry, soften the edges with a clean, damp brush to make them recede into the distance. Make some trees softer and leave others with harder lines for variety. Drop viridian and burnt sienna into one or two of the tree shapes to make them bolder.

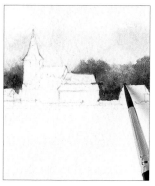

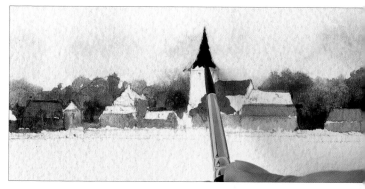

5 Remove the masking fluid from the rooftops. You may need to tidy up some of the edges using background colour and a no. 4 brush.

6 Mix four washes for the buildings: aureolin and burnt sienna for the roofs; raw sienna; burnt sienna and cobalt blue and burnt sienna with French ultramarine for darker details. Paint shapes for the roofs and buildings: you are not looking for accuracy but for general rectangular shapes which will suggest walls and rooftops. Use the dark brown for shadows and to paint the suggestion of windows with a dash of the no. 4 brush. Mix two greens: viridian with burnt sienna and aureolin with cobalt blue, and drop in trees in front of the buildings. Paint the church steeple in a mid-brown made from cobalt blue and burnt sienna.

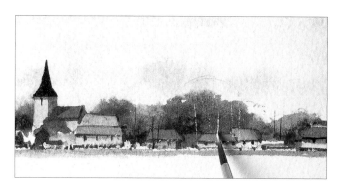

7 Continue to paint finer details with the dark brown mix and the shadow on the right-hand side of the church. Paint masts using white gouache straight from the tube. Add a few small shapes to represent vehicles on the road and boats on the quayside using bright colours such as cadmium red and cerulean blue, don't try to render these in any great detail – a suggestion is far more interesting.

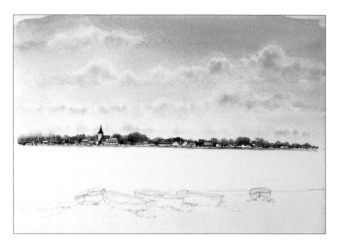

8 Paint masking fluid on to the top parts of the boats so that you can paint the sea and sand washes behind them without losing the shapes. It is important to stand back and have a good look at a painting at stages along the way. At this point I decided that the distance looked too sharp, which reduced the effect of aerial perspective. If this seems a problem, take a mix of cerulean blue and cobalt violet, like the one used for cloud shadows, and paint a haze over some of the background. Leave the church sharp and clear so that it remains the focal point of the painting.

9 Mix washes for the water. The water will show some reflection of the sky colours, so you will need cerulean blue with cobalt violet. However, the water will be greyer than the sky, so make another wash of cobalt blue and cobalt violet, but grey it using burnt sienna. Take a no. 16 brush and paint the cerulean blue and cobalt violet wash at the top of the water area in quick horizontal strokes, catching the surface of the paper so that some white shows through. Leave a tiny white line at the quayside. While the paint is wet, drop the greyer colour in wet in wet. Add raw sienna to warm the foreground and to suggest a glimpse of sand showing through the water.

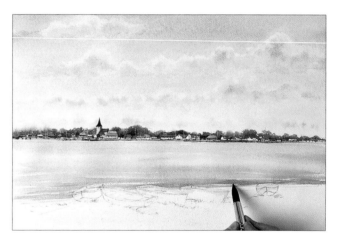

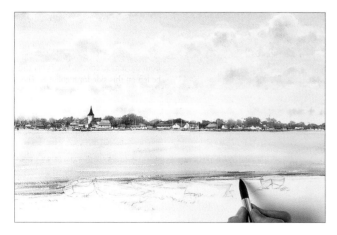

10 Leave a little white paper at the water's edge to suggest foam, and add a little dark shadow underneath using cobalt blue and burnt sienna.

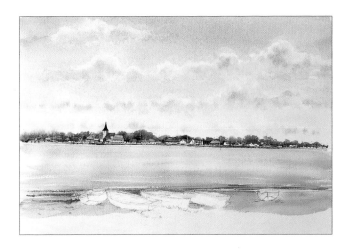

11 Paint the sand between the boats using Naples yellow mixed with burnt umber and a little cobalt violet. Fade the edge with clear water to avoid a hard line forming later. Allow to dry, then rub the masking fluid off the boats.

12 Start to build up the boats using a no. 8 brush and some fairly bright colours: burnt sienna and burnt umber; cerulean blue; raw sienna; burnt sienna and French ultramarine for darker details and cobalt blue and cobalt violet with a little burnt sienna for shadows.

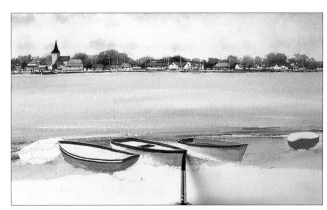

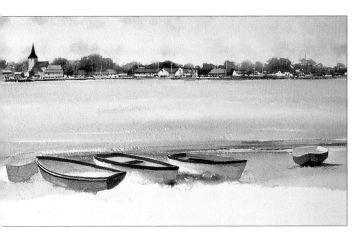

13 Continue building up the boats. Bear in mind that the light is coming from the left, so some white paper can be left on this side for highlights. The shadows should be painted using the sky colour cobalt blue and cobalt violet; they should be transparent so that the boat's colour shows through, and they should be more intense further away from the light. Paint the insides of some of the boats with a thin grey wash and add shadows. Add a dark brown mixed from burnt sienna and French ultramarine for the tar on the base of the boats.

253

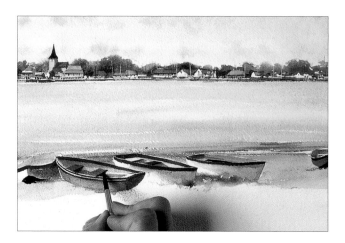

14 Continue building up the insides of the boats, using your reference photograph for details. Use French ultramarine for the rim of the left-hand boat. Work wet on dry, waiting for one colour to dry before carrying on with that area. Paint round the seats in the foreground boat and place dark brown shadow underneath them.

15 Some of the boats in the photograph where made from fibreglass, but it adds interest if you paint them as clinker-built boats, made from overlapping planks. Suggest this using swift strokes in the same dark brown. Paint the boats in the harbour in less detail, using white gouache with cerulean blue for the left-hand boat and with burnt umber for the right-hand one. Touch the bottoms of the boats in white gouache to place them in the water. Use the same gouache for the highlights on the foreground boats, the waves at the water's edge and for the ropes where they cross a dark background.

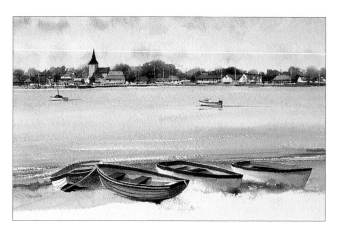

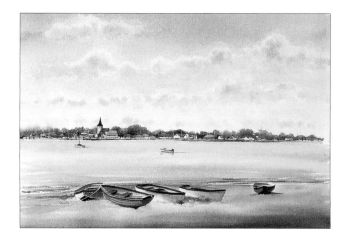

16 Mix Naples yellow and burnt umber with a hint of cobalt violet for the foreground sand. Use a no. 16 brush to sweep the sandy wash across. At the bottom edge add burnt umber and cobalt blue so that the foreground is darker, thus bringing it forward.

17 Dampen the sides of the boats and use a no. 8 brush and lemon yellow to suggest greenery growing round the boats. Drop a dark green mixed from viridian, French ultramarine and burnt sienna on top. I have painted less greenery than actually appears in the reference photograph, because I like the colour of the sand.

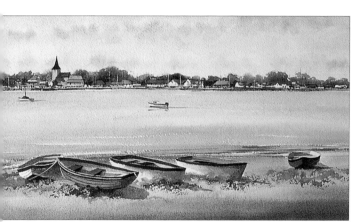

18 Paint the shadows cast by the boats in cobalt blue and cobalt violet. Soften the shadows into the hulls of the boats. Darken the weed around the extreme left-hand boat to contrast with the light tone of the hull.

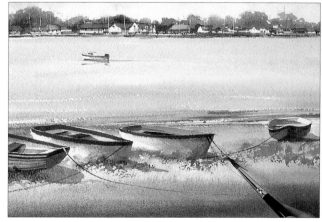

19 Paint the parts of the ropes that appear darker using burnt sienna and French ultramarine and a no. 4 round brush. Streak them in quickly, dark against light. After this I added posts for the ropes and the posts' shadows (see the finished painting on pages 248-249).

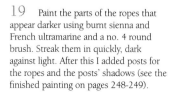

255

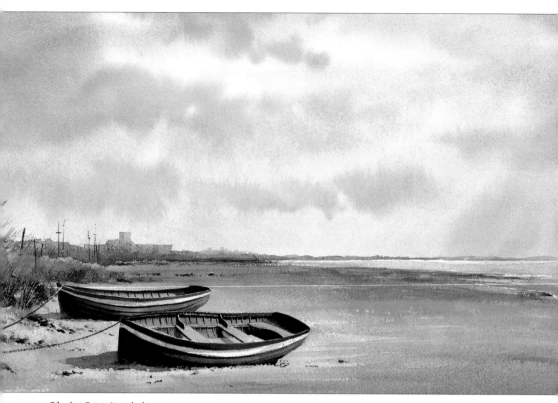

Gibraltar Point, Lincolnshire

508 x 330mm (20 x 13in)

Just a three mile walk along the beach from the hurly-burly of Skegness on the Lincolnshire coast lies this quiet stretch of beach where all you can hear is distant birdsong. A scene like this is three quarters sky, and it presents the watercolourist with a marvellous opportunity to create atmosphere. The sky is painted with three separate washes: Naples yellow with rose madder, a mix of cerulean and cobalt blue and a wash of neutral tint with just a touch of rose madder. I sloped the paper slightly and floated the washes into a wet background, determined to work on it very quickly then leave it alone to perform its magic. There were no boats on the sand – I cheated by adding these from a separate sketch.

Staithes, Yorkshire Coast

460 x 305cm (16 x 12in)

*A Mecca for artists, this little coastal village with its weathered cottages and jumble of
outbuildings is a world away from Bosham, the scene of the main painting in this chapter. This
has been painted with a limited palette of six colours. Note the light against dark in the left-hand
third of the scene, where the road disappears out of view. This is a really bright area that gives the
painting a glow and draws the viewer's attention.*

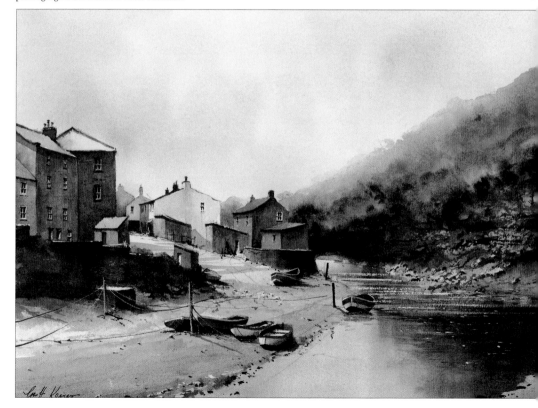

Cromford Canal

This little stretch of canal near Matlock Bath in Derbyshire, now a favourite spot for weekend walkers, was once the main transport route to and from a cotton mill, representing a significant part of the North of England's industrial heritage.

I love painting scenes like this where the initial stage consists of laying in a series of wet in wet washes, loosely forming the shapes of the foliage. The key to this scene is simplification. If you try to copy every bit of foliage too literally, the result will look crowded and overworked. Your aim should be to capture the essence of the subject.

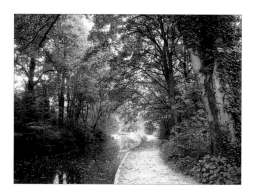

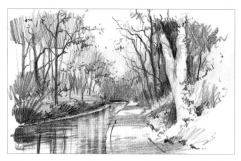

When you are presented with the mass of foliage and jumble of branches, a scene like this seems a daunting prospect, but doing the pencil sketch really starts you thinking about how you can simplify. What to leave in and what to leave out? I created the feeling of reflections in the water simply by running a putty eraser over the sketch in vertical strokes.

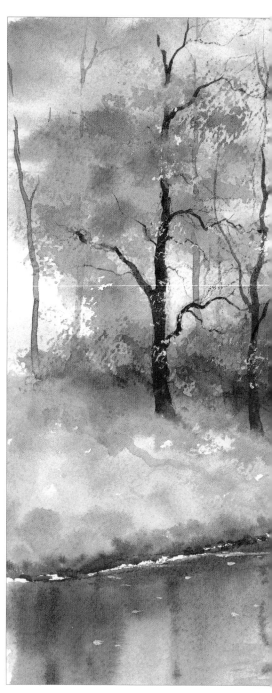

The finished painting

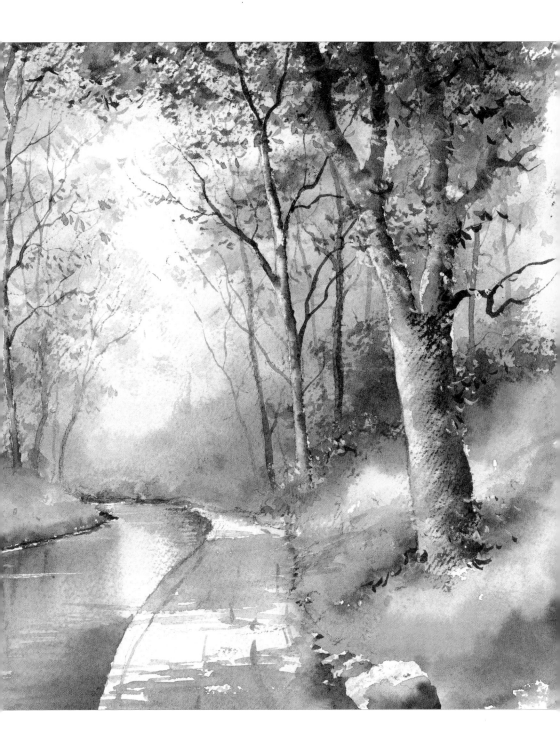

You will need

Rough paper, 360 x 270mm
(14¼ x 10¾in)
Masking fluid
Cobalt blue
Rose madder
Naples yellow
Lemon yellow
Aureolin
Viridian
French ultramarine
Burnt sienna
Cobalt violet
Raw sienna
Indian yellow
White gouache
Old paintbrush
2.5cm (1in) flat brush
1cm (½in) flat brush
Round brushes: no. 12, no. 10, no.
8, no. 4, rigger
Kitchen towel

1 Draw the scene. Using an old paintbrush, apply masking fluid to the edge of the path to protect it later when you paint the water. Mask the large tree and one or two tree trunks where the trunk will be lighter than the background.

2 Much of the background will be painted in one go, floating colours on to wet paper. Mix seven washes before you start: 1) cobalt blue and rose madder; 2) Naples yellow and rose madder; 3) lemon yellow; 4) green mixed from aureolin and cobalt blue; 5) Naples yellow and lemon yellow; 6) viridian, French ultramarine and burnt sienna; 7) viridian and cobalt blue. Wet the paper down to the ground with a 2.5cm (1in) flat brush. Wash on cobalt blue and rose madder at the top, then Naples yellow and rose madder to create a pale pink glow in the lower part of the sky.

3 Float in a wash of lemon yellow followed by a mixture of lemon yellow and Naples yellow. If these look a bit too acid at first, don't worry; the colour will change as the later washes fuse in with them.

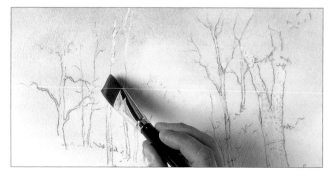

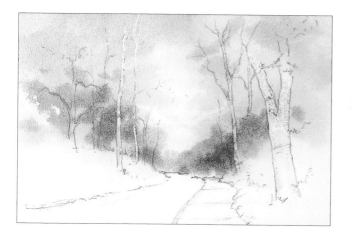

4 Still using the 2.5cm (1in) flat, continue adding colours, working light to dark. Add the green made from aureolin and cobalt blue. Change to a no. 12 round brush and add rose madder and cobalt blue for the browner colour near the ground. Add more green wet in wet.

5 Add the deep green made from viridian and cobalt blue. It will mix with the other colours on the page. Where a rich, dark green is required, add viridian, French ultramarine and burnt sienna. Use the side of your no. 12 round brush to make shapes to suggest foliage.

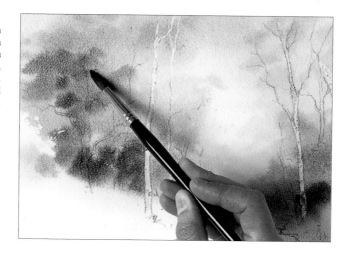

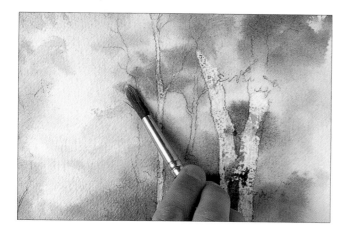

TIP

When working on the trees, take some detail from the reference photograph but do not try to make an accurate copy of it. Remember, the key to a scene like this is to simplify it.

6 Still working on the damp background, take a no. 10 brush and more bright green. Use dry brush work so that some of the marks look dry and others blend in for variety.

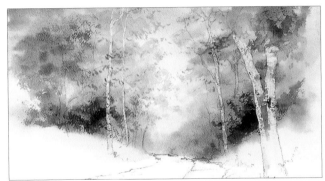

7 Continue with the same technique using viridian and cobalt blue. Take a no. 8 brush and work the shapes at the edges of the branches using aureolin and cobalt blue. At this stage the shapes begin to look like leaves and the washes should suggest tree shapes.

8 Apply the dark green in the same way. The darkest greens should appear at the base of a tree. Use cobalt blue and rose madder for the purplish foliage at the top right and far left.

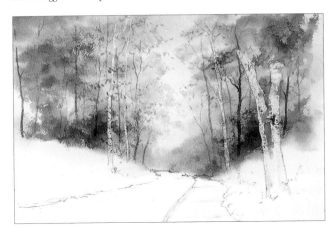

9 Paint the distant tree trunks with a mix of cobalt blue, rose madder and burnt sienna, working upwards with a no. 8 brush. Use a lighter version of the mix for faraway trees, and paint some of them with the side of the brush and the dry brush technique to add to the distant feel. Use the same colour at the centre of the painting over the bend in the canal.

10 Paint darks on the far right of the painting to contrast with the tree. The colours should merge with the wet background. Push the paint around quite vigorously using a worn brush. Add lemon yellow. Use viridian and cobalt blue for the cool green at the base of the left-hand trees. Paint the bank on the left with lemon yellow and Naples yellow. Add warmth using raw sienna and burnt sienna.

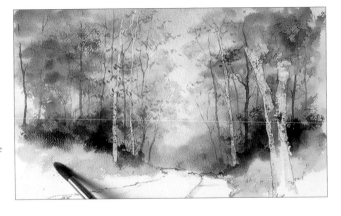

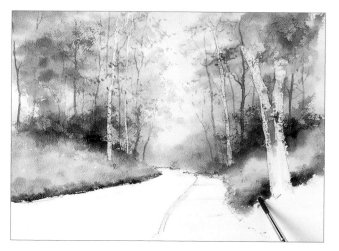

11 On the left of the painting, paint the green mixed from cobalt blue and aureolin down to the canal's edge. Add lemon yellow for brightness and Naples yellow for creamy highlights. While the painting is still wet, paint the darks by the water's edge using the mixture of viridian, French ultramarine and burnt sienna. Brown this area using burnt sienna to suggest the exposed soil on the bank under the trees. On the right-hand bank, paint raw and burnt sienna for warmth and add lemon yellow and then dark green down to the right-hand bank. Add darks round the tree trunk, and cobalt blue mixed with aureolin around the base of the trunk.

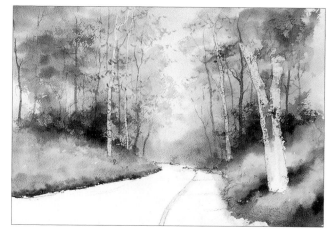

12 Add a hint of cobalt blue and rose madder at the edge of the path, and burnt sienna for a touch of warmth. Allow the painting to dry.

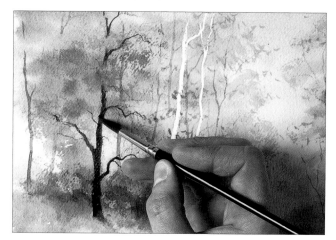

TIP

When painting from a complex photograph like this, use it as inspiration but do not copy it slavishly.

13 Rub the masking fluid off the trees. Mix burnt sienna and cobalt blue to make brown, warm it with a touch of rose madder and paint the dark tree on the left. This should be a stronger mix than used for the trees behind it to make it appear further forward. Leave some gaps in the top of the trunk so it appears as though you are glimpsing it through the foliage.

263

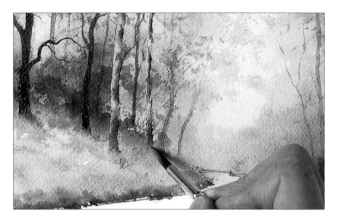

14 Fill in the trunks of some of the trees quite darkly, and water the mix for a fainter look at the top. Strengthen the tone where the trees are nearer the foreground. To avoid trees looking as though they are standing on the ground rather than growing out of it, soften the area around the base of the trunks. Take a wash of Naples yellow and rose madder (the colour which gave the sky its glow) and fill in the lighter trunk. Paint some brown to shade the left-hand side.

TIP

With a subject like this it is important to keep reminding yourself which direction the light is coming from.

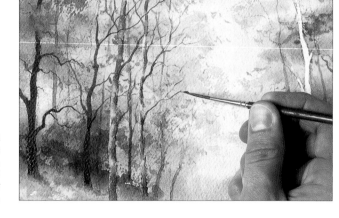

15 Use more dark brown and a rigger brush to put in the very fine branchwork at the top of the tree. This makes sense of the foliage you have already painted by connecting it to the tree.

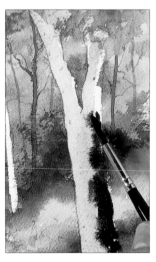

16 Paint the right-hand trees in the same way, wet in wet. Paint pink on to the lighter trees, using Naples yellow and rose madder. Add cobalt blue and rose madder. Drop in burnt sienna for the base of the tree, and burnt sienna and French ultramarine with a little rose madder to shade the right-hand side.

17 Continue with the right-hand tree. Use the Rough paper and a bit of dry brush work to create the effect of bark. Soften the trunk with clear water and create texture by dabbing with a piece of kitchen towel.

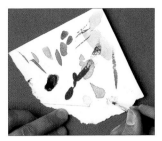

18 On scrap paper mix white gouache with lemon yellow and white gouache with viridian. Do not mix these in the palette, or for several weeks afterwards you may find that the colours you mix take on a chalky appearance.

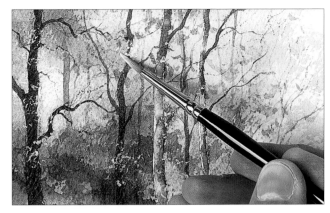

19 Use the gouache mixes to highlight the foliage with small marks interrupting the view of the trunks.

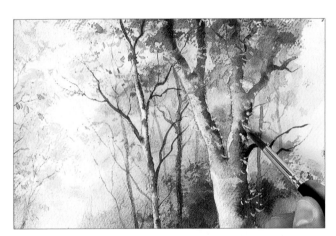

20 Work on the canopy of the right-hand tree using a no. 12 brush and scumbling with a dry mix of viridian, French ultramarine and burnt sienna. Add darker leaves in shadow. Use dry brush work at the top to indicate foliage and frame the painting, using aureolin and cobalt blue. Use the same colour lower down among the brighter leaves.

21 Create more texture on the bark if necessary, using burnt sienna and cobalt blue with a little rose madder and dry brush work. Add a hint of warmth by painting on burnt sienna in the same way.

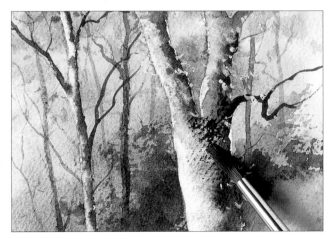

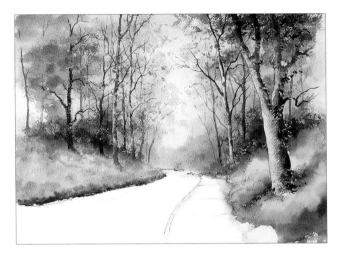

22 Make very dark marks on the bark using burnt sienna and French ultramarine. Touch in foliage around the base of the trunk.

23 Most of the colours you have already used are needed for the reflections. Rub off the masking fluid at the top of the canal bend and neaten the edges. Wet the whole water area, leaving a fine gap along the left-hand edge dry to separate the canal from the bank. Drop in reflection colours: yellow, purple, pink at the bottom from the sky, green in the middle. Reflect the brown darks from the bank, working quickly while the painting is wet. Add viridian and browns at the top right-hand edge of the canal. Add lemon yellow for brightness. Take a damp 1cm (½in) flat brush and drag down the reflection colours in vertical strokes. You have to work rapidly on this stage as the dragging down effect will not work on dry paper.

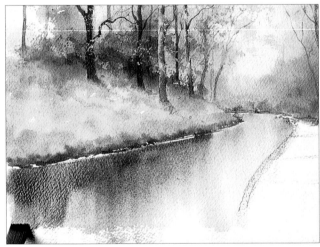

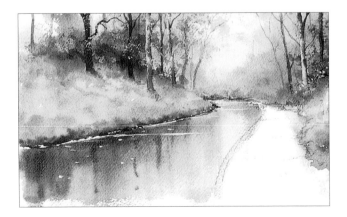

24 Work on the details of the water. Using a no. 4 brush, darken the water's edge with a very dark brown and dampen it in with green. Tint the white line at the water's edge using a little raw sienna. Use white gouache straight from the tube to paint horizontal streaks on the water's surface. Mix Indian yellow with white gouache to paint the leaves floating on the surface. Touch in dark reflections of tree branches.

25 Mix a pink colour again using Naples yellow and rose madder, for the path. Rub off the masking fluid. Wet the area and drop in the pink over the entire path area. Mix the sky colours cobalt blue and rose madder and use this mix to indicate shadows.

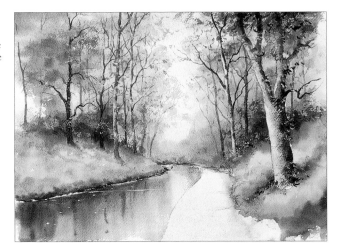

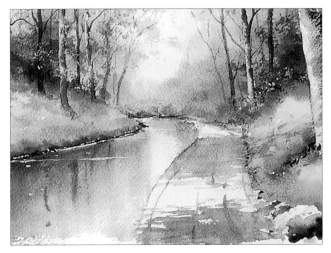

26 Paint more shadows with the same sky colour with a little burnt sienna added. Soften them with a damp brush. Paint dappled shadows in the foreground using a no. 12 brush. Use burnt sienna and French ultramarine to shadow the dark side of the stone on the right-hand side.

27 Scumble darks at the right-hand edge of the path and in the foreground. After standing back to consider the result, I decided to add contrast between the canal and the path by darkening the water with brown and green right in the foreground.

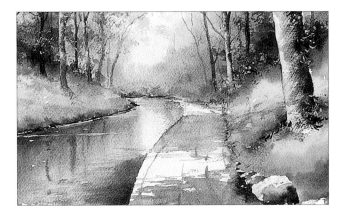

267

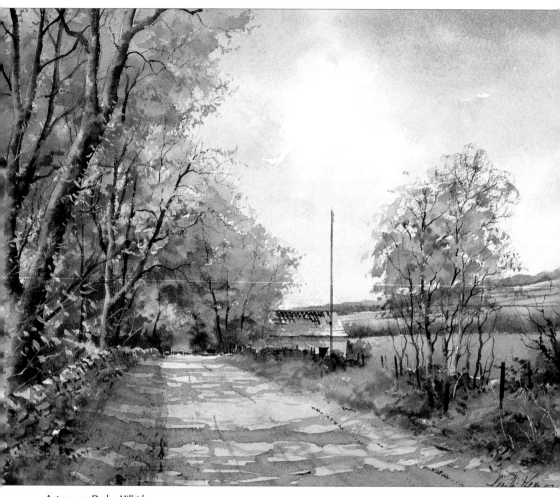

Autumn on Darley Hillside

355 x 280mm (14 x 11in)

When you get a crisp, bright light on an autumn day, you don't have to go far to find a subject. This is another example of how to simplify a mass of foliage by not trying to copy it exactly. Again here I have used a bit of white gouache with a touch of colour to pick out a few highlights like leaves against the darks of the tree trunks and masses of foliage. Note also how the shadows, indicated in a warm purple, help to describe the slope of the verges and the flatness of the road, while at the same time emphasising the perspective. These shadows are also suggested on the roof of the old barn in the middle distance, helping to reinforce the direction of the light.

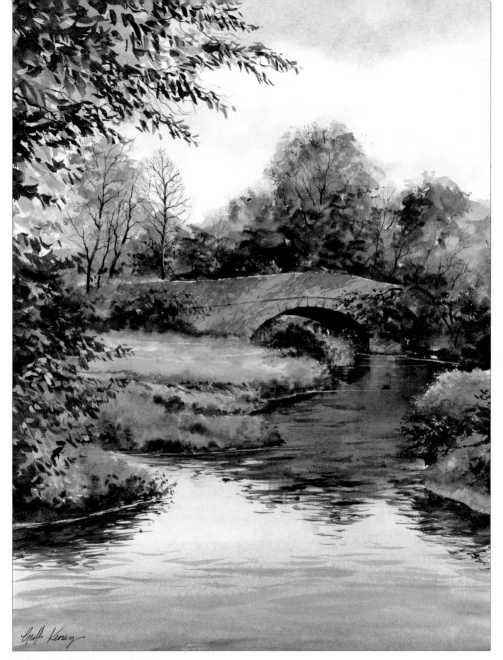

Packhorse Bridge, Sutton on the Hill

508 x 406mm (20 x 16in)

In this scene I have used two methods to depict the reflections in the river. Those nearest to the bridge have been created using the same method as the main painting in this chapter, i.e. pulling down the colour with a flat brush to make the washes vertical. As the water gets nearer to the viewer, the gentle ripples disturbing the surface are more noticeable, so I have created a more broken look to the reflections. Note how the darker colour at the top of the sky is echoed in the water in the foreground, almost framing the scene. The contrast between the red coloured bridge and the rich greens give this painting good visual impact.

Farm buildings

I particularly enjoy this composition and have painted it many times. The farmer does not share my enthusiasm for the tumbledown old barn, looking forward to the day when it will be repaired, so I have made sure I have a collection of photographs and sketches.

Notice how you get just a glimpse of the distant woods on the slope, indicated in a soft violet that matches the sky. The shadows help the perspective on the road as well as adding warmth. Shadows should always be laid in thin transparent glazes, enabling the viewer to see a hint of the earlier washes underneath.

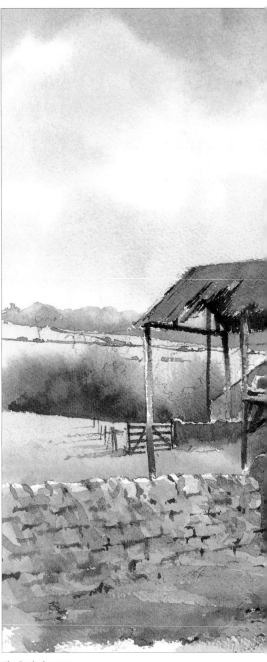

The finished painting

Here I have taken three portrait format photographs and taped them together, providing me with quite a large image showing plenty of detail. I have a box overflowing with these, and although with all the lines down them and bits of tape holding them together they do not look very attractive, they are packed with reference and information.

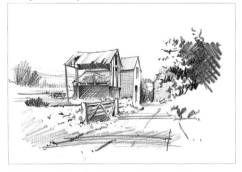

I decided to include quite a bit of detail in this painting, so I didn't really need to simplify the scene in the sketch.

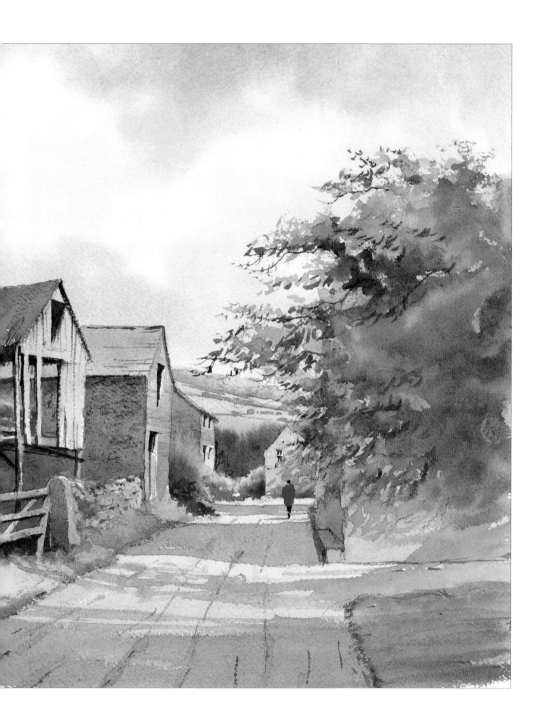

YOU WILL NEED

Rough paper, 460 x 350mm
(18 x 13¾in)
Masking fluid
Naples yellow
Indian yellow
Cobalt blue
Rose madder
Burnt sienna
Aureolin
Raw sienna
Viridian
Burnt umber
Cerulean blue
Cobalt violet
French ultramarine
Cadmium red
White gouache
Lemon yellow
Old paintbrush
2.5cm (1in) flat brush
Large filbert wash brush
Round brushes: no. 6, no. 10,
no. 12, no. 4
Kitchen towel
Tracing paper
Craft knife
Sponge

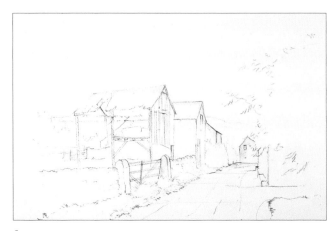

1 Sketch the scene and apply masking fluid to the tops of the roofs, the beams of the open-sided building, the gateposts and the top of the foreground wall.

2 Mix the sky colours: Naples yellow and Indian yellow; cobalt blue and rose madder; cobalt blue, rose madder and a little burnt sienna. Wet the background using a 2.5cm (1in) flat brush, down to the masking fluid. Use a large filbert wash brush to paint a yellow glow at the bottom of the sky. Wash the brush and then add cobalt blue and rose madder at the top of the sky. Finally add cobalt blue, rose madder and burnt sienna to suggest a hint of cloud. Allow the painting to dry.

3 Use a wash of cobalt blue and rose madder for the distant bushes and trees. Soften their tops using a damp brush. Add a little burnt sienna to the mix to paint a darker colour at the base. Take these colours through to the other side of the barn.

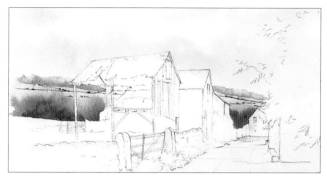

4 Mix aureolin and cobalt blue to make a green, brushing this in to indicate the land on the left. Paint the bush on the left by dropping in aureolin and cobalt blue mixed with burnt sienna. Continuing to paint wet into wet, drop in viridian and burnt sienna, which will create a dark to contrast with the top of the wall.

5 Continue with the same effects on the right of the painting, dropping in a touch of lemon yellow, then allow it to dry. Take a no. 6 brush and a mix of burnt sienna and cobalt blue and paint a suggestion of dry stone walls and hedges across the fields in the distance.

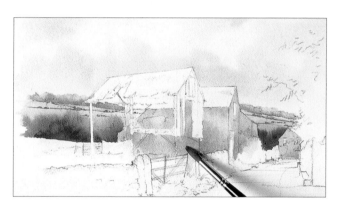

6 Remove all the masking fluid from the main building, but leave it on top of the wall. Apply a mixture of raw sienna and Naples yellow on to the building at the end of the lane, leaving spaces for windows. Paint the buildings on the left in the same way and soften the colour at the bottom. Painting wet in wet, add a pink mix of Naples yellow and rose madder over all the buildings, and drop in patches of burnt umber.

7 Drop in a touch of cerulean blue to create a warm grey here and there, then use a piece of kitchen towel to blot out the area of the left-hand building that will be covered by haystacks.

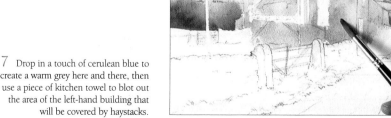

273

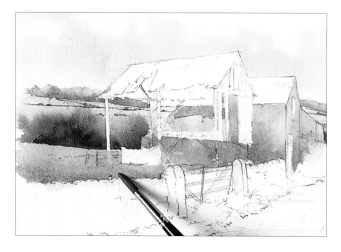

8 Add a mixture of cobalt blue, rose madder and burnt sienna for the darker colour in the stonework, and allow it to dry. Paint the light in the field on the left using Naples yellow and Indian yellow and a no. 10 brush, then add green mixed from aureolin and cobalt blue nearer to the top of the wall.

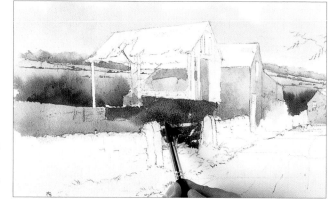

9 Drop the same green in behind the gate and soften it into the background. Mix a rich brown from burnt sienna and cobalt blue and paint this below the barn. Mix an even darker brown from burnt sienna and French ultramarine for areas of deep shadow.

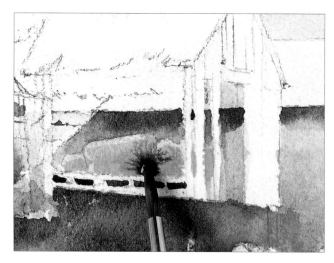

10 Use the same dark brown under the guttering of the middle building. Paint raw sienna for the haystacks, leaving the white of the paper for the light catching the tops. Use cobalt blue and rose madder for the shadow on the haystacks.

274

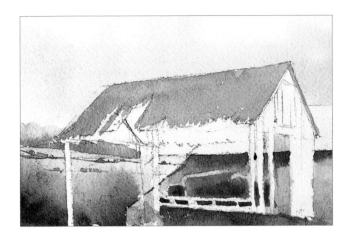

11 Paint the rusty roof of the barn using Indian yellow and cadmium red. Exaggerate the orange as it creates a good contrast with the sky. Leave a few very small patches of white paper to suggest the ragged, broken edge of the roof.

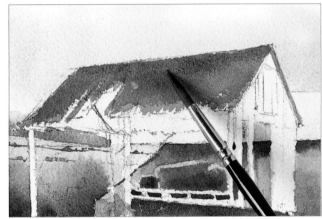

12 Drop in burnt sienna to deepen the colour of the rusty roof, then add cobalt blue and rose madder to darken it slightly. This should tone down the bright orange of the roof, but don't overdo it or you will lose that all important feel of the sunlight catching the rusty roof.

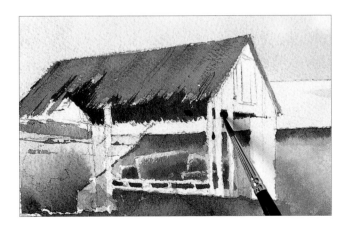

13 Mix white gouache and Naples yellow on a piece of scrap paper and use dry brush work to add a bit of detail to the haystacks. Mix a rich dark brown using burnt sienna and French ultramarine and paint the inside of the barn roof using a no. 12 brush. Fill in the shapes of the broken roof and very gently add a few fine lines to suggest the corrugation using a no. 4 brush.

275

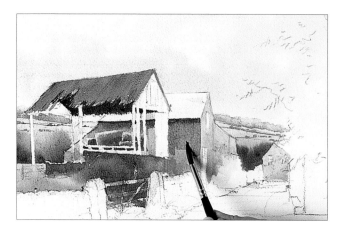

14 Wash the shadowed side of the barn with a thin glaze of cobalt blue and rose madder. Add burnt sienna to warm the bottom of the shadow for reflected light. Make sure this wash is not too strong so the transparency of the watercolour means that you can see through the shadow to the layers of wash underneath. Continue painting the shadow colours over the whole side of the building.

15 Intensify the shadows at the edges, against the light, to create contrast and form. Drop lemon yellow into the shadow of the second building from the right to suggest some foliage. Mix viridian, French ultramarine and burnt sienna to make green and drop this in with a no. 6 brush, allowing it to wander into the other colours to accentuate this bush shape.

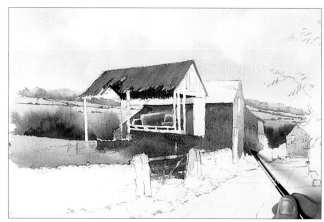

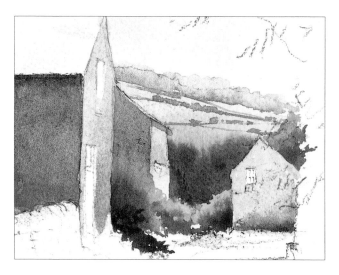

16 Paint a bush next to the cottage at the end of the lane in the same way: the darkness will help to pick out the lighter wall of the cottage. Darken the cottage near the ground by floating in a little shadow colour and allow to dry.

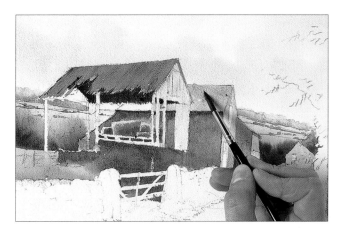

17 Rub the masking fluid off the barn and the gate. Paint a pale wash on the barn's woodwork of cerulean blue with a hint of green mixed from aureolin and cobalt blue. Paint the middle roof with the same green. Add a touch of cobalt blue and rose madder to hint that sky colours are reflected in the roof.

18 Mix a dark brown from burnt sienna and French ultramarine and use a no. 4 brush to paint the finer details on the barn. Use dry brush work and the same colour to paint the dark window-like hole at the top.

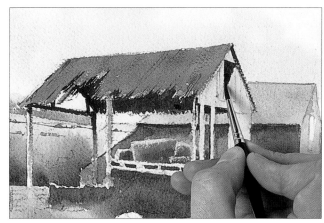

TIP

Fine details are most effective when 'drawn' with quick strokes of a fine brush.

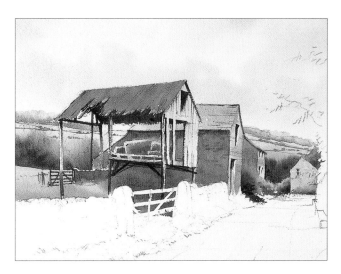

19 Continue painting details with the point of a no. 4 brush. Add shadows to the barn, leaving the uprights free of shadow where the sun shines. Paint in the distant five bar gate on the left, supports under the hay loft and suggestions of slates on the middle roof. Paint the front door of the middle building with a drop of cerulean blue and then dark brown for the interior. Use the same dark brown to paint the top window and suggest the windows of the distant cottage.

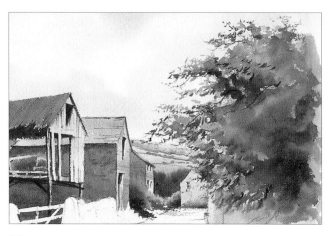

20 Paint the tree on the right with a glimpse of wall showing beneath it. Wash on the stone colour first, mixed from raw sienna, Naples yellow and Indian yellow. Then drop in the green, mixed from aureolin and cobalt blue. Use dry brush work to suggest foliage, and continue in this way with a darker green on top.

21 Mix a dark green from viridian, French ultramarine and burnt sienna and paint this on wet in wet. Use a no. 6 brush and aureolin mixed with cobalt blue to suggest leaves at the ends of the branches.

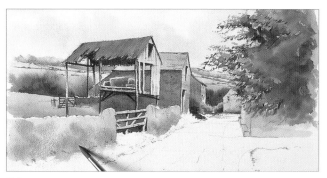

22 Paint the gate with a mix of cerulean blue, Naples yellow and Indian yellow, leaving a few glimpses of white paper to give the timber a washed out look. Allow this to dry and then add a touch of detailing using burnt sienna mixed with French ultramarine.

23 Rub off the masking fluid from the wall. Now paint the wall and the grass verges together so that they soften into one another. Paint on a wash of raw sienna, leaving a glimpse of white at the top, and drop in green mixed from aureolin and cobalt blue, and then burnt sienna.

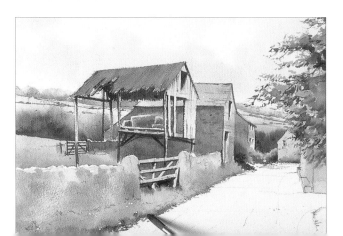

24 While the wall is still wet drop in some of the sky colour, cobalt blue and rose madder. Paint the grass using lemon yellow and green. Add more lemon yellow to make tufts, then raw sienna for warmth. Use the point of the brush to suggest the edge where the grass meets the lane. Keep this line irregular or it will appear as though the grass has been trimmed. Towards the foreground add dark green mixed from viridian, French ultramarine and burnt sienna for the roadside tufts of grass.

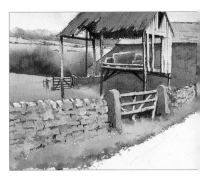

25 Dab the stone wall just before it dries with a piece of kitchen towel to create texture.

26 Work on the shape of the wall by adding shadow mixed from cobalt blue and rose madder. Shadow the gateposts and add a touch of burnt sienna to represent reflected colour. Use the point of a no. 12 brush to suggest the shape of stones and crevices. Vary the pressure you apply to create an irregular look to the crevices.

27 Continue working on the wall. Use cobalt blue and rose madder to darken some of the stones, and dry brush work to create texture. Paint the deepest crevices using burnt sienna and French ultramarine. Remember that the details should all be smaller when they are further away. Darken the bottom of the five bar gate using the same dark brown, and soften the bottom edge.

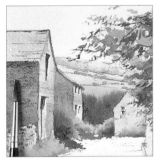

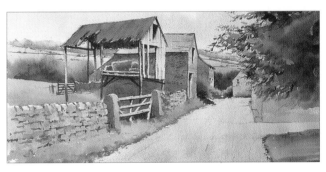

28 Use dry brush work to paint the perspective lines of texture on the middle building.

29 Mix two washes for the path: Naples yellow with Indian yellow and cobalt blue with rose madder, reflected from the sky. Wash in the yellow colour from the top. Clean the brush and brush in the shadow wash on top. Wash from side to side with horizontal strokes to accentuate the flatness of the road. Allow the painting to dry.

30 Use a no. 10 brush and a mix of cobalt blue and rose madder to paint dappled shadows on the wall of the cottage at the end of the lane, and down the stone wall on the right. Paint cast shadows from the gate posts on the wall and gate. Paint a large shadow, as though from a tree, across the foreground to bring it forwards. Use the same shadow colour to paint perspective lines down the lane.

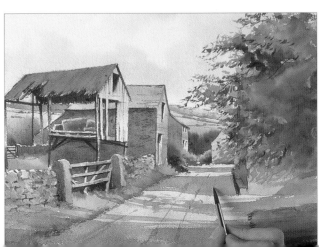

 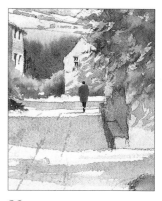

31 To place a figure, draw a simplified, tapering shape on a piece of tracing paper and try positioning it to see how it looks in the painting.

32 When you are satisfied with the placing of the figure, place the tracing paper on a cutting mat and cut out the shape of the torso using a craft knife. Place the tracing paper on the painting again and using it as a stencil, dab over it with a damp sponge to remove pigment.

33 Paint the figure in cadmium red, with burnt sienna and French ultramarine for the trousers. The feet should come to a point for a walking figure, or it will look as though the person is stationary. Add more dark for the head, leaving a gap for the collar, otherwise the figure may look hunched.

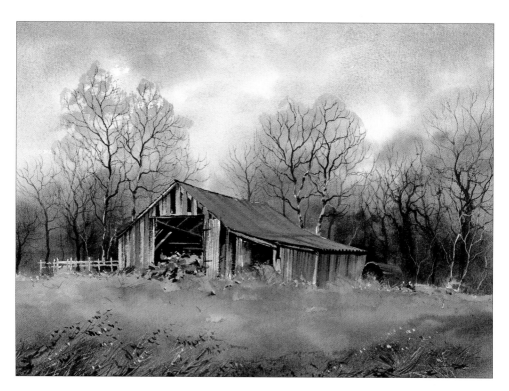

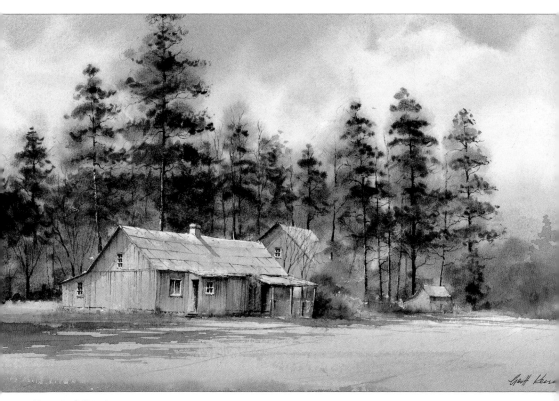

Homestead, Estonia

457 x 305mm (18 x 12in)

*I've never been to Estonia, in fact I don't even know where it is, but one of my
students brought along a photograph of this scene she had taken on holiday and I
asked if I could use it. What appealed to me was the soft light and the tumbledown
nature of the buildings, perfectly framed by the tall trees behind them.*

Opposite
Old Woodshed, Sandringham Estate

318 x 230mm (12½ x 9in)

*I discovered this tumbledown old wood store, just over the fence from a cottage I stay
in when teaching at the West Norfolk Art Centre. When I spoke enthusiastically
about it to the man who owns the cottage, I think I probably reinforced the notion
that artists are a bit eccentric. I have exaggerated the warm colours, using plenty of
burnt sienna and Indian yellow to try to create a soft glow. It is good fun to
exaggerate the colours sometimes rather than trying to analyse and reproduce them
exactly as they are. Of course you could come unstuck and overdo it but take the risk
– it's only a piece of paper.*

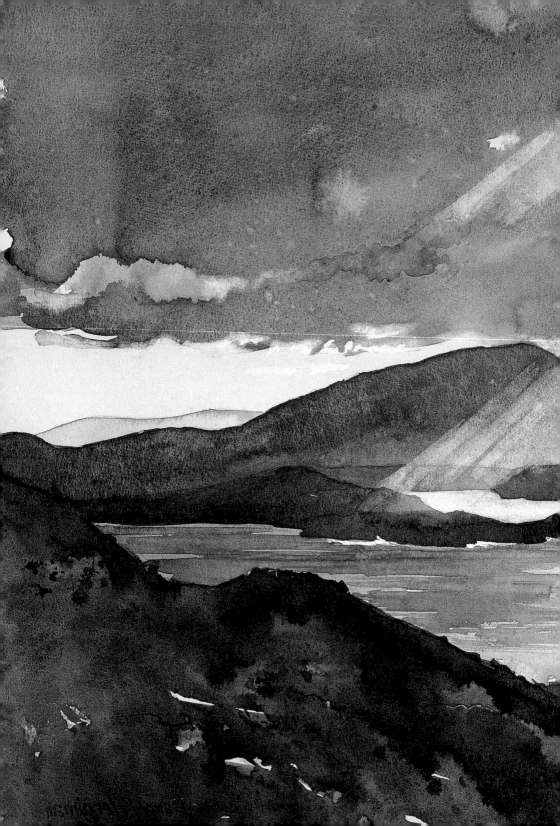

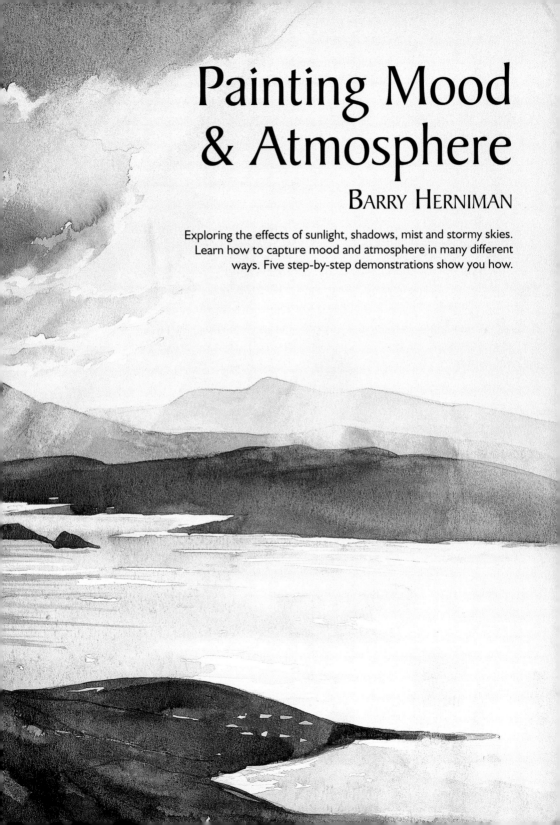

Painting Mood & Atmosphere

BARRY HERNIMAN

Exploring the effects of sunlight, shadows, mist and stormy skies.
Learn how to capture mood and atmosphere in many different
ways. Five step-by-step demonstrations show you how.

Introduction

When I first started painting, my intention was to produce a worthwhile facsimile of the scene in front of me. Basically, this was fine, and I learnt a lot of my painting craft that way. As time went on, however, I became less enamoured with creating just 'straight' paintings, and I started to explore other ways of putting paint on to paper.

What I really wanted to do was to capture the essence of a scene, 'the sense of place', and to inject the subject with that extra something... mood and atmosphere! Mood comes in many shapes and forms, and is open to individual interpretation. Each of us has our own perfect time of day, a favourite season or certain weather conditions that set our senses alight. When these elements prevail, that is the time to get painting.

Every landscape is dependent on light. Whether it is diffused through a soft hazy morning mist or coloured with the intense glow of a hard-edged sunset, light is the main governing factor. How often have you passed by a scene that is totally familiar to you, then, one day, the light changes or some unusual weather sets in and wham! the ordinary becomes the extraordinary?

To me, that is what painting is all about, and I call it 'art from the heart'. Before I start to paint, I ask myself what it was that grabbed my attention and made me look twice. When I have answered that question it is then a matter of deciding how to capture it.

When it comes to painting, try not to be too literal with the colours, but rather use mixes that respond to your feelings. Too much time and energy can be used mixing *just* the right green only to be disappointed with the rather static result that the colour mix produces.

Let the watercolour have its head and allow it to move about of its own accord. This can be quite scary, but I am sure you will be surprised at some of the results.

This is what I am endeavouring to impart to you with the projects in this section – to move away from just realism, and inject your paintings with mood and atmosphere.

So, good luck, and get moody!

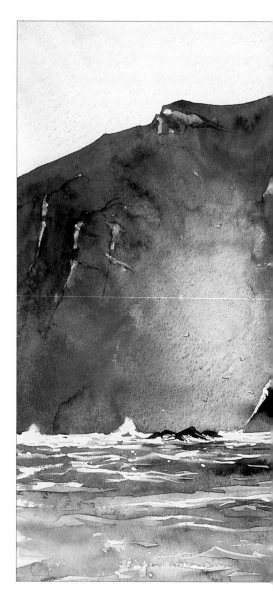

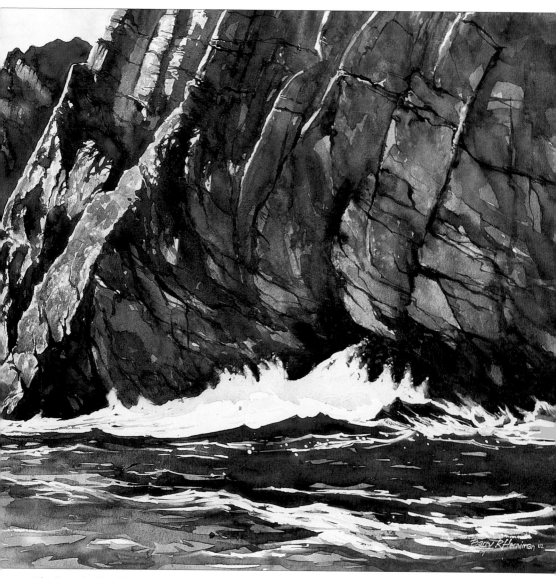

Wheeling in the Mist, Horn Head, Donegal

Size: 680 x 420mm (26¾ x 16½in)

You really cannot get moodier than Horn Head, a great slab of rock on the northern tip of Donegal. I have witnessed the peninsular in all weathers, but on this day I hired a boat to take me to the foot of the cliffs to get the view looking up at them.

Because we were so close to the rock face the sun was shielded behind cliff tops but it caught the leading edge of the head which counterchanged beautifully with the shadowed cliff face in the distance. Seagulls were wheeling about in the up currents of the early morning mist.

A very exhilarating day which inspired me to do a series of paintings of this wild Irish coast.

285

Materials

In today's painting world there is a whole host of materials to suit all tastes and pockets. This can become a problem in itself: because choices are so great it can be a nightmare to sort out which materials are right for you. For this reason art shows and fairs are a great place to talk to manufacturers and try out the materials before you shell out your hard earned cash; 'try before you buy' is a good policy to adopt! Also keep your equipment to a minimum, buy less but buy the best.

PAINTS

It is paint that brings light and life to a picture and the colours I use have changed over the years as I am always striving to get transparency into my work. With this in mind, I always use artist's quality watercolours which have the purest pigments available. I have tended to shy away from the earth colours – raw sienna, yellow ochre and the browns – as they are slightly opaque. I never use Payne's gray or black, and sepia and indigo are also rather heavy, but I still love burnt sienna. Mixed with French ultramarine, burnt sienna makes a great dark.

When choosing a colour the manufacturers colour chart is a good first point of reference, but there is no substitute for getting to grips with the pigment and seeing how it works for you. Colours can also vary between different brands so, if possible, it is best to try them out first.

My palette for this book consists of rich, transparent colours as I maintain you can subdue a bright colour, but you try and get life into a dull one!

I use 15ml tubes of watercolour and squeeze the paint directly into the palette. I do not use pans as I never seem to get the same richness of paint as I do with freshly squeezed paint.

PALETTES

When working in the studio I use a variety of different palettes. My favourite is my trusty Robert E. Wood palette which my good friend, Bob Blakely, sent me from the USA. It has deep paint wells and a large mixing area with a central dam. When painting large washes, I like to use ceramic palettes with deep wells to hold lots of pigment.

TIP NEW PLASTIC PALETTES

Paint tends to 'bead' when you mix it on a new plastic palette due to the very smooth surface. Gently rubbing household liquid scourer on the mixing areas will remove the surface shine and allow your mixes to hold together.

BRUSHES

Kolinsky sable brushes are a joy to use but I find I wear down the points rather quickly (especially the way I paint!) and once you lose the point, the brush loses its appeal. The price of some of these brushes can be astronomical but there are some super sable/synthetic brands on the market which are exceptionally good – and at a fraction of the cost of sable brushes. Not only do these have the good colour carrying capacity of pure sable brushes, they also have the durability of the synthetic materials.

The brushes used for the projects in this book, from right to left: Nos. 16, 12, 10, 8 rounds; No. 3 rigger; hoghair brush for lifting out; and my well-worn sable (I use that term very loosely!) for applying masking fluid.

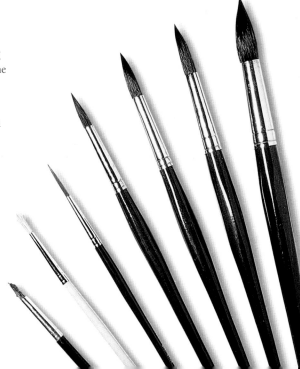

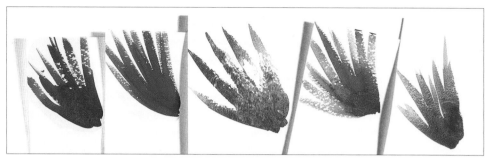

I find it useful to obtain swatches of different types of watercolour paper and see how my brush strokes work on each surface texture.

PAPERS

There are some super papers on the market and most are at very affordable prices. I have always tended to paint on 300gsm (140lb) paper, stretching it before use. But now I am using 640gsm (300lb) more often; with certain brands I can tape a piece of paper straight on to a board and start painting without stretching. Heavy papers are great for painting outdoors and for demonstrations as they do not buckle and bend as do the lighter weights. However, they do bow slightly under the weight of my washes!

Papers come with three main surfaces: Hot Pressed (HP) is very smooth and is ideal for high detail and fine line work; NOT (not hot pressed) or cold pressed paper has a semi-rough surface and is a great all rounder; and Rough which has a very pronounced surface or 'tooth', that is superb for textures and dry brushing.

Another surface I particularly like is Torchon; this has a dimpled rather than a rough surface and is very good for large wet washes.

TIP PLASTIC LAMINATE BOARD

This type of board is useful, but not for stretching paper. It has no grip for the tape and, more often than not, the tape will lift off as the paper dries. Overcome this problem by roughly brushing varnish over the surface to create a tooth.

BOARDS

My boards are made from 25mm (1in) thick marine plywood which I find stronger and lighter than MDF (medium density fibreboard). I coat them with clear varnish to seal the surface, leaving the brushstrokes to create a 'tooth' for the tape to adhere to when I stretch lighter weight papers.

TIP ANTI-SLIP FABRIC

This is a very useful material, especially when painting outdoors. Taped on my painting board, it allows me to rest a watercolour block or sketchbook directly on to an inclined surface without it slipping off. I can also move my painting every which way without undoing the easel.

OTHER EQUIPMENT

The other equipment in my work box includes the following items:

Graphite sticks (grade 2B to 8B)
I use these for drawing quick tonal sketches with plenty of oomph! (A technical word!)

Water-soluble coloured pencils
A recent addition to my work box which I find really useful for quick, on-the-spot sketching.

Clutch pencil (2B lead)
This goes everywhere with me. I am rather heavy handed when sketching and tend to break leads quite frequently, so I also have a **small lead sharpener** which enables me to keep a sharp point with minimum fuss.

Masking fluid
This is very useful if used judiciously. (Some students apply it with all the finesse of a sledge hammer.)

Spray diffuser bottle
I really would be lost without my 'squirt bottle'. Not only does it keep my paints nice and moist, but I use it to move paint around on the paper to create all sorts of effects.

Gouache (or opaque white)
This is great for ticking in those final details that add sparkle to the finished painting.

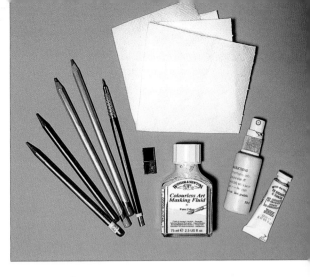

Paper towel (or paper tissues)
I use this for lifting out and general purpose cleaning. Take care though, some modern tissues are impregnated with lotions which, although good for the skin, make the paper greasy and unworkable.

Craft knife
A good tool for scraping out colour and general purpose use, but do not carry it in your hand luggage when flying!

Sketchbooks
I keep a journal of my travels in hardbound sketchbooks filled with rough watercolour paper. I paint *en plein air*, with the emphasis on speed and vitality, rather than technical expertise, to record all those special places I visit. It is quick and immediate, and I really get a lot of pleasure from sketching them. When I want to capture a wide view, I often paint right across the spine.

Watercolour field box
My field box, which is shown in the photograph (left), was handmade in brass by Craig Young and it goes everywhere with me. It folds down quite small, but there are good-sized compartments for me to squeeze my paints into. What I really love about it are the deep mixing wells in the lids which, for me, are invaluable. I have just ordered a six-well version and I cannot wait for it to arrive!

Colour mixing

At a quick glance, and before you read on, how many colours do you think went into the doodle opposite – six, eight, ten maybe? Well, there were just three! A blue (French ultramarine), a red (alizarin crimson) and a yellow (Winsor yellow).

Doodles like this show the multitude of colour mixes and tones you can create from just a few colours. Below, I have pulled out some of the colours and hues that are mixed within this doodle to give you an idea of the combinations. Simple exercises like this enable you to get to know your colours and how they work together. This only comes with practice – so get doodling!

Try this exercise yourself. First mix three generous wells of colour into a top-of-the-milk consistency – one yellow, one red and one blue – any colours you fancy, it does not matter. Fully load a large round brush with the yellow, then, with your paper at 25º to the horizontal, make some lovely loose brush strokes across the paper. Clean your brush and do the same with the red, taking some of the strokes across and into the yellows, then watch them start mixing on the paper. Don't go back into it with your brush or you will spoil the mixing process. Now do the same with the blue, making marks over both the yellow and the red. While the paper is still wet, tilt the painting board backwards and forwards and watch out for the 'happenings'. You will be staggered at the wonderful array of colours that appear before your eyes. This is the basis of all the colour mixing in this book, mixing loads of lovely bright transparent colours right there on the paper!

French ultramarine

Alizarin crimson

Winsor yellow

Steely spring greens

Lively bright oranges

Warm yellows

Velvety purples

Superb strong darks

Bright summer greens *Reddish browns* *Subtle mouse greys* *Late-summer greens* *Rich dark browns* *Pine tree greens*

Having seen what can be achieved using the three primary colours on the previous pages, try some different combinations.

Here I have used an altogether quieter palette – aureolin, rose madder genuine and cobalt blue.

Look at the wonderfully subtle colours that can be achieved with this trio of colours. Soft but still very vibrant, there are some lovely shadow areas in there.

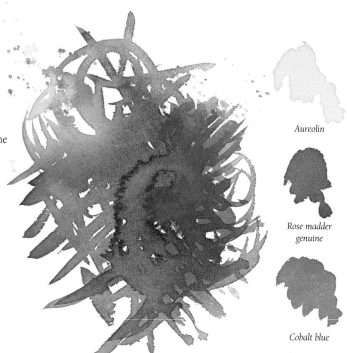

Aureolin

Rose madder genuine

Cobalt blue

If you use the trio of Indian yellow, scarlet lake and phthalo blue, you will get the much stronger mixes shown left.

Indian yellow

Scarlet lake

Phthalo blue

Now if you take all nine colours – the three yellows, reds and blues – and mix and match them, just think of the endless possibilities you could get. Some of these combinations are shown below. All this with just nine colours. You may never use P.G. (you know the one!) again.

Welcome to the wonderful world of colour.

Alizarin crimson and Indian yellow

French ultramarine and alizarin crimson

Winsor yellow and cobalt blue

Aureolin and manganese blue

Phthalo blue and Indian yellow

French ultramarine and brown madder

French ultramarine and burnt sienna

I could fill a book just on colour and colour mixing, but, rather than get bogged down in a whole lot of technical jargon I want to give you a few basic tips on colours and some of my favourite mixes. Remember that nothing is set in stone and each picture should dictate the palette of colours needed to grab that particular mood.

When you first set out to buy colours, the first thing that becomes evident is that there is a staggering array of different hues across the whole spectrum. Pick up a manufacturer's colour chart and prepare to be dazzled! What I have done is to whittle down my colours to a basic minimum and add the odd exotic colour here and there when the situation calls for it.

My basic colours are cobalt blue, French ultramarine, phthalo blue, Winsor yellow, aureolin, Indian yellow, rose madder genuine, madder red dark, brown madder, also manganese blue (or cerulean blue), quinacridone gold and manganese violet.

Capturing the mood

There is mood and atmosphere all around you, even on a bright sunny day – depending where you look! This was the case with this rather tranquil scene at Faversham in Kent. I went to the boatyard and there were a multitude of wonderful subjects all in the glare of the afternoon sun. Boats, buildings and water all in sharp relief and all very colourful. When I looked over my shoulder, however, the scene changed dramatically; I was now looking into the sun, *contra jour*, and all those bright colours were severely muted, but there were some beautifully highlit shapes counterchanged against some velvety details. Painting a scene *contra jour* bleaches out a lot of the colour, but it does produce a moody scene where shapes and shadows merge together.

I took some reference photographs, but, mindful of the fact that I had to wait to see the results, I set about doing a quick tonal sketch to work out the main lights and darks and the mid tones. I then painted the loose colour sketch (opposite) *in situ* as a demonstration of how to paint highlights without using masking fluid.

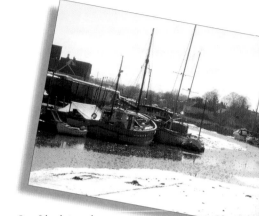

One of the photographs taken on my visit to the boatyard at Faversham. Beware when taking any photographs into the sun as the lights go white and the shadow areas go black.

This tonal sketch was worked up using a 4B water-soluble lead pencil.

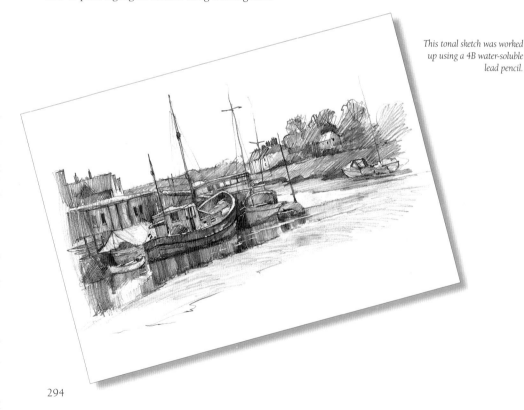

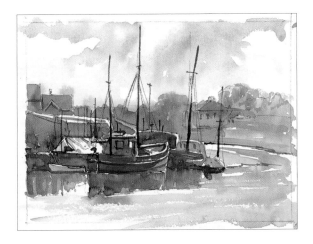

Quick colour sketch

This quick sketch demonstrates how you can paint a scene directly, without using masking fluid. I just painted around all the highlights as I worked down from the sky. It is very rough and ready, but I think it gets across the prevailing mood of the scene, and it also loosened me up to do the finished painting.

Moored up for the Day – Faversham, Kent
Size: 460 x 340mm (18 x 13½in)

This small watercolour, built up with a series of wet overall washes, was painted when I got back to my studio. The highlights were masked out so I did not have to worry about reserving them and I could concentrate on getting the washes down.

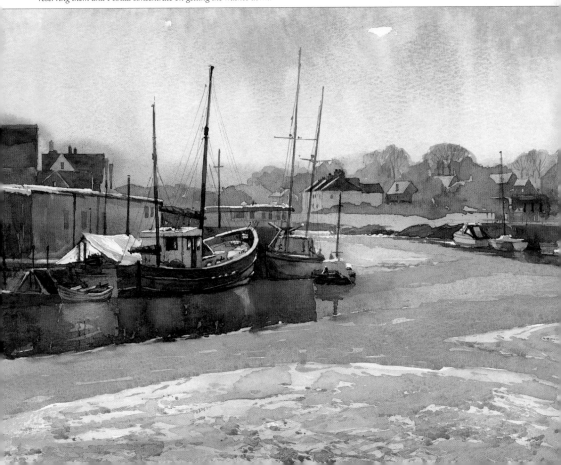

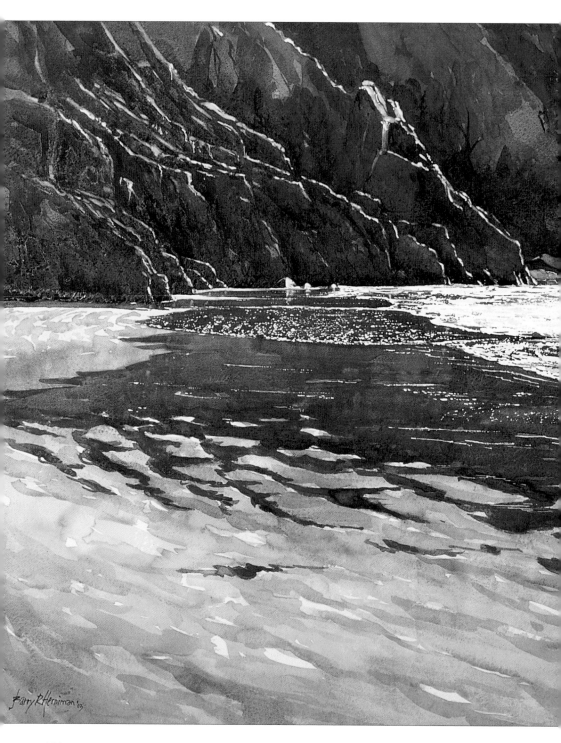

When you have found a scene that excites and inspires, all you have to do is paint it! While the adrenaline is running, I sometimes dash off a quick watercolour painting just to see how it works and comes together. Here are two versions of the same scene, one painted on site, the other worked up in my studio.

Receding Tide, St Catherine's Rocks
Size: 400 x 300mm (15¾ x 11¾in)

This painting was quite small, but I had a great time getting all the rock colours moving and mingling together, and highlighting their edges to give them a little lift.

I experimented with masking fluid for the highlights in the water to get the sparkling effect and built up the colour densities of the sea with a succession of transparent glazes.

Receding Tide, St Catherine's Rocks
Size: 775 x 660mm (30½ x 26in)

Having completed the small painting above, I was all fired up to paint this much larger version – with a few modifications. I was happy with the colour combinations in the rocks and the sea, but the overall format was not what I wanted. I felt that a larger expanse of foreground beach would give the scene a greater air of solitude. Having worked up various pencil compositions, I decided on this almost-square format. It has a good amount of wet and dry sand in the foreground that helps lead the eye into the painting, and this also acts as a foil to the darkness of the sea and rocks.

MAGIC OF THE MOMENT

It is not always possible to sit and paint a scene that really grabs you, but, when you can, it is a bonus. I was very lucky with this scene of the Roman Bridge at Penmachno, North Wales. While giving a painting demonstration one morning, I was able to get the magic of the moment down on paper. In this very quick, direct painting, I was intent on capturing certain light qualities rather than concentrating on detail. The morning sun was just clipping the fringe of yellowish grasses on top of the bridge, and the strong silvery light on the water brought the underside of the bridge into sharp relief.

It was quite a magical moment!

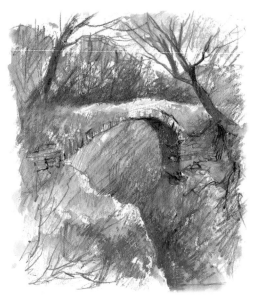

Back in my studio I played around with water-soluble coloured pencils, simplifying some of the elements and emphasising others to give a more dramatic slant to the scene.

Catching the Light
Size: 430 x 330mm (17 x 13in)

298

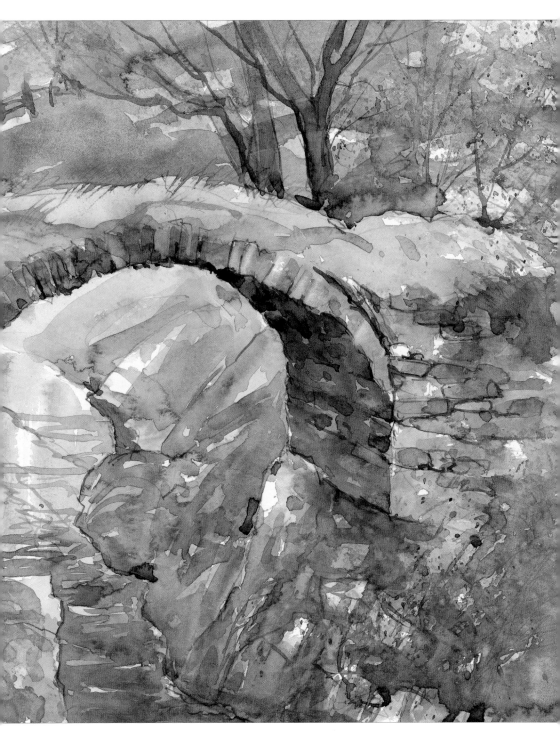

299

Techniques

There are many diverse and wonderful methods of making marks on paper and I am always experimenting with different ways of creating textures and patterns that will enhance a painting. However, do not let techniques take over! Techniques for techniques' sake will make a painting contrived and overdone, and the question asked will be, 'how did you do it', rather than 'why did you do it'. Techniques should only be used to enhance a painting and produce textures that cannot be accomplished by regular painting methods.

TIP REMOVE MASKING FLUID AS SOON AS POSSIBLE

Be careful not to leave masking fluid on the painting too long. Get your initial washes down, then, as soon as they are dry, get the masking fluid off.

Masking fluid applied with an old brush.

MASKING FLUID

This is a really great medium which enables you to do a wet into wet wash over the whole painting and still reserve your whites. But beware! If masking fluid is applied with a heavy hand – slopped on as if with a plasterer's trowel or squeezed out like toothpaste from a masking fluid pen – you could end up with something rather horrid. I apply masking fluid with an old brush, a twig, a piece of string or anything else that makes a delicate painterly mark and the result is better for it.

TIP MASKING FLUID AND HAIRDRYERS

Take care when using a hairdryer to dry paintings with masking fluid on. The heat can make the masking fluid rubbery, causing it to smear when you try to remove it.

Masking fluid spattered on to the paper, then moved around with the handle of a brush.

Highlights scraped out of dry paint with a scalpel.

SCRATCHING OUT ON DRY PAINT

Use quick sideways movements of a craft knife to carefully scratch highlights out of dry paint. A great technique for those final sparkles across water. But, it does damage the surface of the paper and you will not be able to paint over it once done.

Scraping out from wet paint

This is a great way to produce light tree trunks against dark backgrounds. The underlying paint must be just damp for this to work. Lightly scrape the side of a palette knife, finger nail or credit card (nothing with too sharp an edge) into the paint to produce your light marks. If the paint is still too wet the mark that is left will be considerably darker – which is fine if you planned it that way!

Tree trunks scraped out of wet paint with the handle of a brush.

Lifting out

You must let the paint dry for this technique to work, and you should use a brush that is slightly more abrasive than a watercolour brush (a hog or bristle brush is ideal). Wet the brush with clean water, gently rub the area to be lifted, then dab the wet marks with a clean piece of paper towel to lift the colour.

Highlights lifted out with a damp brush.

Dry paint spatter lift

Another way of lifting out paint is to use the spatter technique. Flick a brush, loaded with clean water over a dry passage of colour, leave for a while, then dab the wet marks with a clean paper towel. Alternatively, use a squirt bottle to apply a light spray of clean water over an area and lift out with a paper towel. These methods of lifting out create a really good random texture which is great for rocks and cliffs.

These marks were made by lifting out colour after flicking a brush loaded with clean water on the dry paint.

Here I used my squirt bottle to spray water on the dry paint before lifting out the colour.

Backruns

The last thing you want in the middle of your lovely sky wash is a backrun or 'cauliflower'. But, in certain areas, you can use backruns to great effect. Leave the wash until it starts to dry, then touch a brush loaded with colour on the spot where you want the backrun and see what happens. This is a rather unpredictable technique, so use it with care.

Backruns can be used to great effect.

Dry brush

This technique works best on a rough paper that has plenty of tooth; it is perfect for speckled highlights on water. Load a brush with colour (not too wet, or it will flood into in the 'valleys' of the paper and you will lose the sparkle), then drag the side of the brush quickly across the paper catching the 'ridges' of the paper surface.

Speckled highlights created by dragging a dry brush (loaded with blue paint) across the surface of rough paper.

Salt applied to wet paint creates a random patterned effect.

Salt

Using salt is lovely way to create texture, especially within foliage areas. Allow the wash to dry slightly, then drop in dry salt crystals where you want the texture to be. The pattern that emerges is completely unpredictable, as it is dependent on the dampness of the paper and the size of the salt crystals.

GOUACHE (OPAQUE WHITE)

Gouache is a good way of producing small, crisp, wispy highlights. Here, I used gouache to brush in some water rivulets over the rocks, then flicked on more paint to form the spray. Do not overdo the use of gouache; remember that it is opaque and you can very easily create a very dull passage of colour.

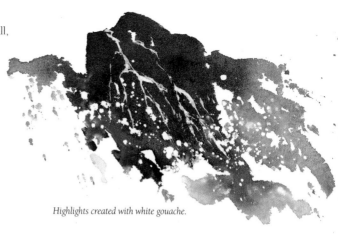

Highlights created with white gouache.

TIP USING GOUACHE

Unlike watercolours which tend to dry lighter than the applied wet colour, gouache dries darker – and the more you dilute it the darker it becomes. If you want a really white highlight, you will have to use almost neat white gouache.

Two colours spattered together on dry paper (left) and wet paper (right).

SPATTERING

This technique can be done in any number of ways and combinations. In this example, I loaded a brush with yellow paint, then flicked the point diagonally across the paper. While that was wet I introduced some blue. Half the paper was dry and the other half had water on it – notice how the paint diffused nicely on the wet side.

303

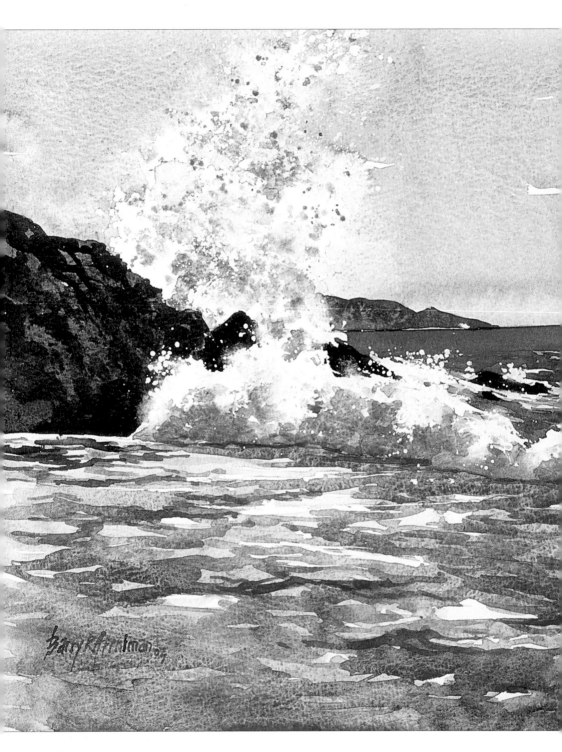

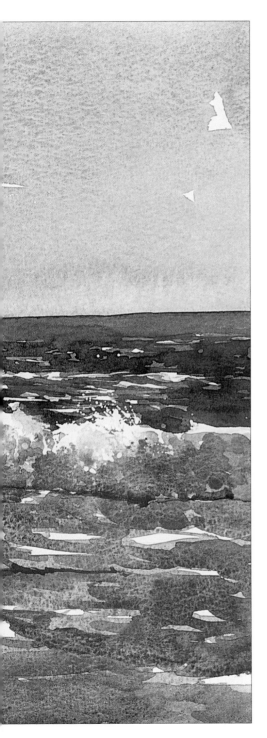

Breaking waves

I love the sea and all its moods, so I just had to start the step-by-step demonstrations with a seascape. I have such an affinity with water whether it is the sea, rivers, streams, lakes or ponds, that I feel that I should have been born under Aquarius. Water, in some form or other, seems to find its way into most of my paintings, even if it is only a puddle! I can spend hours just looking at the sea, watching the patterns that emerge, then disappear; all quite mesmerising. Because of the fluidity of water I am able to give vent to my artistic temperament. I am not restrained by architectural detail and I can 'splash' around quite freely.

What I wanted to convey here was the simplicity of a scene with a rather dramatic, crashing wave. On this particular morning the wind was quite strong and, although the sea was not overly rough, it created a deep swell and some hefty breakers on the rocks. This gave me the chance to lay in some gentle, gradated washes for the sky and some loose, flowing ones for the sea.

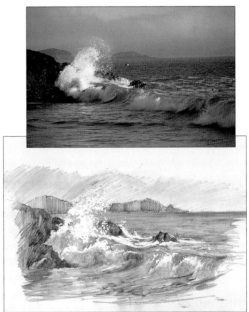

The photograph and tonal sketch above were used as the reference material for the demonstration. Quick tonal sketches (this was worked upon cream paper using water-soluble pencils) are useful for defining the lights, darks and mid tones in the composition.

YOU WILL NEED:

Watercolours –
 aureolin
 Indian yellow
 cobalt blue
 French ultramarine
 manganese blue
 phthalo blue
 alizarin crimson
 Winsor red
 manganese violet
 brown madder
 burnt sienna
White gouache
Masking fluid and an old brush 2B pencil
Nos. 10 and 16 round brushes
No. 3 rigger brush
Bristle brush
Paper towel
Water sprayer

1 Use the reference material to draw the outlines of the composition on to the watercolour paper. Do not make the pencil marks too faint, or you will not be able to see them when the first washes have been applied.

2 Use masking fluid and an old brush to spatter highlights in the spray from the wave crashing against the rocks. Work carefully, changing the angle of the brush with the direction of the spray...

The paper with all the masking fluid applied.

3 ...then use the handle of the brush to blend some of the spatters together to form nearly solid areas.

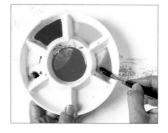

4 Using a palette with large deep wells, prepare the initial washes: cobalt blue, Winsor red, Indian yellow and manganese blue.

5 Spatter clean water round the big wave (to stop hard edges forming), then use the No. 16 brush to lay in a band of cobalt blue.

6 Add some Winsor red, then blend this into the blue. Spread the colours down towards the horizon, blending in touches of Indian yellow in the lower sky. Allow a bead of colour to form on the horizon line.

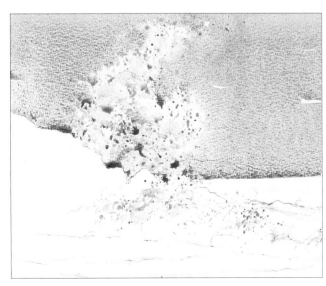

7 Leave the wet bead of colour to form a hard edge, then use a dry brush to remove the excess water.

8 Spatter clean water into the large spray area, then drop in touches of manganese blue, cobalt blue and Winsor red. Spatter more of the same colours to create smaller marks.

9 Add the sea colours – phthalo blue, aureolin, alizarin crimson and French ultramarine – to the palette, then work on the area of sea behind the waves, wet on dry. Lay a band of cobalt blue along horizon followed by a band of phthalo blue. Add touches of alizarin crimson and aureolin. Dipping the brush into various colours, make the brush strokes looser and the saved whites bigger as you work down the paper. Turn the painting upside down to create a strong edge on the horizon and leave to dry.

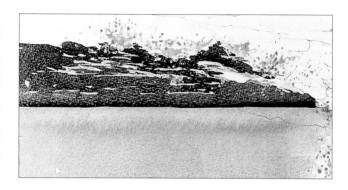

10 Use weak washes of manganese blue and alizarin crimson to lay in the pale area of sea below the large breaking wave at the left-hand side. Develop the remaining part of the foreground with loose brush strokes of cobalt blue, Indian yellow, alizarin crimson and aureolin. Push, press and pull the brush on each stroke to create the small wave shapes. Again, make the saved whites bigger as you work down the paper.

11 Angle the painting board up at the left, then drop in more cobalt blue, Indian yellow and alizarin crimson, wet in wet, and allow these to run across the paper. Lift the other side of the board to make the colours flow back across the paper, then leave to dry with the top edge raised slightly; the hard edges that form create shadowed areas among the waves.

308

12 Spatter clean water over the left-hand side of the large spray area, then start painting at the left-hand side of the paper. Using rock colours – brown madder, burnt sienna and French ultramarine – block in a base coat of colour for the rocks, then drop in touches of alizarin crimson and Indian yellow here and there.

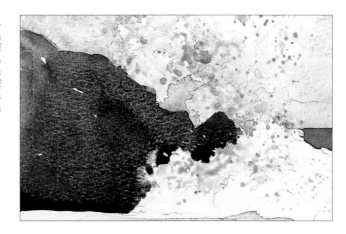

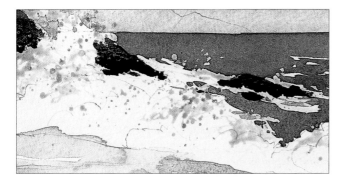

13 Use the same colours to paint the rocks at the right-hand side of the wave. (There is a lot of masking fluid in this area, so you can still use bold brush strokes.)

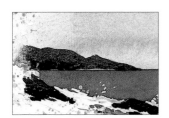

14 Wet the left-hand edge of the distant mountain, then use weak washes of the same colours with a touch of cobalt blue to paint the mountains. Leave a thin white line between the mountains and sea to suggest breaking waves.

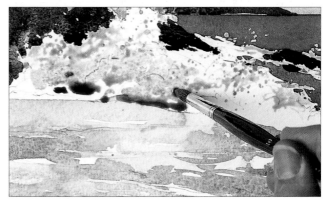

15 Now work up the shadows on the breaking waves with cobalt blue, alizarin crimson and a touch of manganese blue. Holding the brush nearly vertical, trickle the colours into the bottom area of the wave. Work the colours between each other, then allow them to blend. Allow beads to form to create sharp edges at the bottom of the wave.

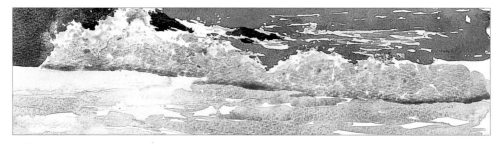

16 Continue building up the shadows across to the right-hand side. Use a dry brush to remove some of the excess wash colours from the bottom of the wave. Leave others to create hard edges. Leave to dry completely.

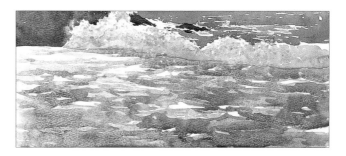

17 Dipping into the sea colours – cobalt blue, French ultramarine, manganese blue, alizarin crimson and manganese violet, and working wet on dry with a near-vertical No. 10 brush and a trickling action – start to strengthen the colours in the foreground. Vary the angle of the brush strokes to suggest movement in the water.

18 Continue building up the foreground leaving some of the saved whites from the initial layer of colour. Push, press and pull the brush to create the wavelet shapes. Apply a weaker wash over the nearest part of the foreground.

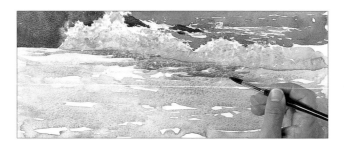

19 Dipping into the rock colours with a No. 10 brush, start adding colour along the top edge of the rocks then use the handle of the brush to pull the colour down to form fissures.

20 Create shadows on the rocks with a rigger brush. Load the brush by dipping into the rock colours, flatten it on the paper then drag it sideways and downwards across the rocks.

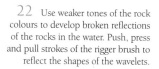

21 Spatter darks over the rocks, then spray a fine mist of water over the wet paint to soften some of the hard edges of the fissures. Leave to dry, allowing the shape and structure of the rocks to develop on their own.

22 Use weaker tones of the rock colours to develop broken reflections of the rocks in the water. Push, press and pull strokes of the rigger brush to reflect the shapes of the wavelets.

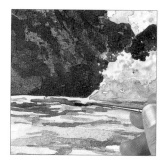

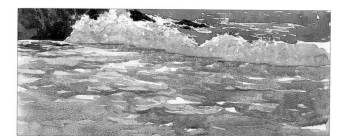

23 Working with the shapes already on the paper, use darker tones of the sea blues in the palette to accentuate them and create shadows against the highlights.

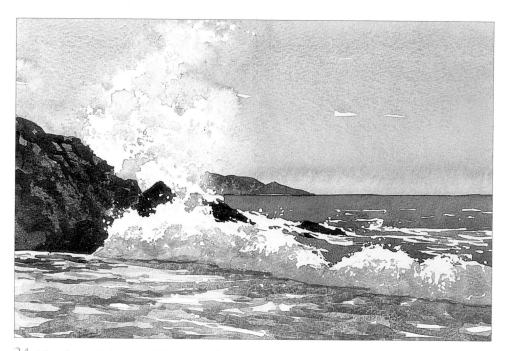

24 When the painting is completely dry, remove all masking fluid (I use an old piece of dried masking fluid as a 'lifter'). Run your fingers all over the surface to check for small areas you might have missed. We now have to go into these stark white areas and soften some of the hard edges (see steps 25–27).

25 Now go into the exposed, stark white areas and soften some of the hard edges. Use a bristle brush to wet the edges of colour where the spray falls on the rocks …

26 … use clean paper towel to dab the wetted area …

27 … then lift off to reveal the softened edges.

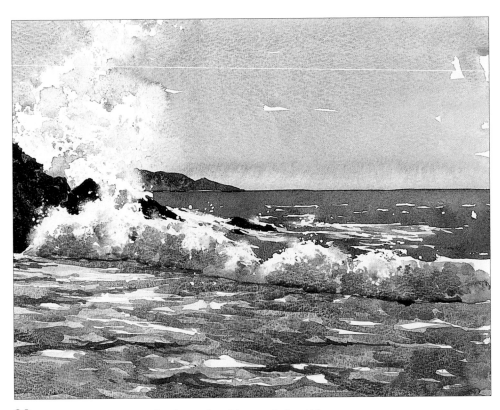

28 Work the same technique to soften the top edges of the waves in the middle distance and some of the edges of the shadows in the larger breaker and in the area of spray. Spatter water in the shadowed area of the breaker then trickle accents of darker tones of the sea blues to develop shape and form. Spatter small spots of colour into the waves, then soften all edges with clean water.

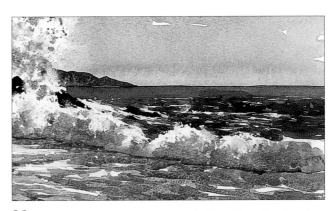

29 Develop the colours in the large spray area by spattering some darks followed by water to soften the edges.

30 Develop the middle distant area of sea with phthalo blue and touches of alizarin crimson and Indian yellow. Cover some of the saved whites but leave others. Wash a mix of these colours across the far distant sea.

31 Complete the spray area by spattering touches of white gouache over the top part of it, then develop the fine spray along the top of the breaking waves. Vary the angle of the brush as you spatter.

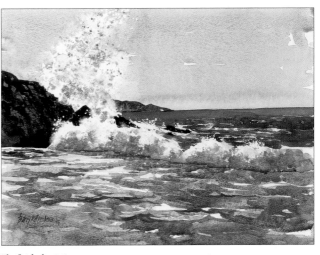

The finished painting.

TIP WHITE GOUACHE

This white will not be as bright or white as the paper but it is good to add tiny highlights.

It is, however, a very opaque white, so never put it in your palette of watercolours – even a touch of it can spoil the transparency of watercolour.

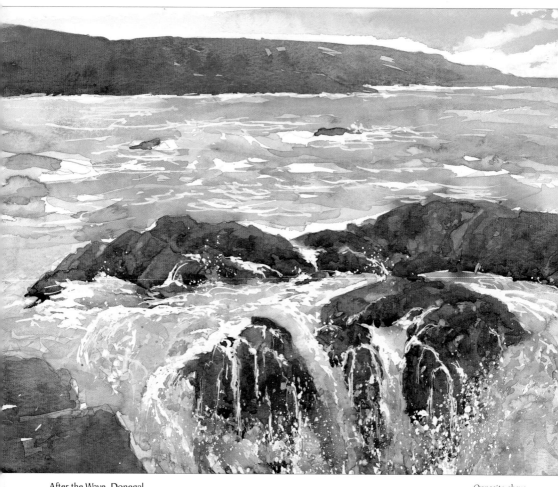

After the Wave, Donegal.
Size: 460 x 350mm (18 x 13¾in)

The sea on this day did not look overly rough but there were some deep swells, which produced some fairly spectacular spray where the sea met the rocks. I was in danger of being engulfed by a couple of them.

This was the aftermath of one such wave which left behind a welter of white foam and spray as the sea slid down between the rocks.

I did this as a demonstration and wanted to capture the chaos of the water as it bubbled over the rocks.

I masked out some areas of foam and flicked and spattered white gouache on others to get this random effect.

Opposite above
Classic Wave
Size: 500 x 355mm (19¾ x 14in)

This was a simple painting of one wave, which caught the late afternoon sun. The slow lap of the wave as it broke on itself was quite mesmerising. The crest of the wave was almost translucent as the sun shone through the thin veil of water.

Opposite
Last Light, Caldey Island
Size: 490 x 185mm (19¼ x 7¼in)

This small painting was done in response to a rather quiet scene that would soon kick up rough. There was a slight sense of foreboding so I used dark colours to amplify this feeling.

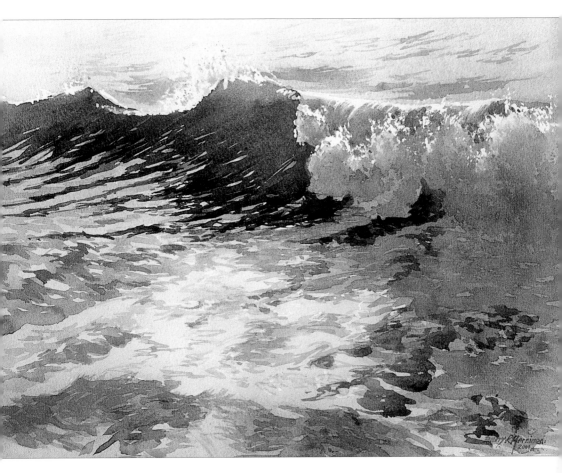

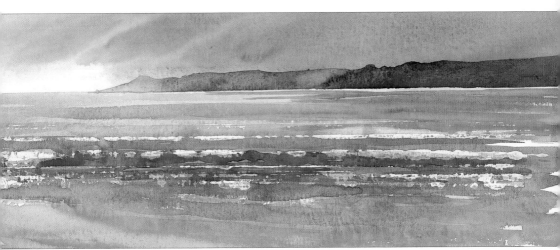

315

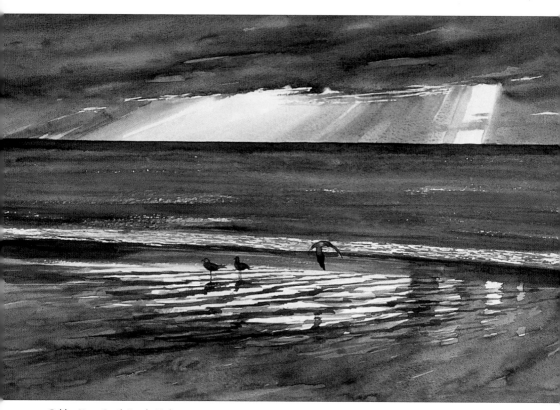

Golden Hour, South Beach, Tenby

Size: 640 x 400mm (25¼ x 15¾in)

The storm had passed over and the evening light was starting to come through the clouds at the horizon. The sea was calm and flat now, and the beach, still wet from the rain, was reflecting the bright sky.

Break in the Clouds, Tenby

Size: 460 x 320mm (18 x 12½in)

This was a moment just before the sun appeared and lit up the whole scene. There was a strong glow around the edge of the clouds suggesting that the sun was on its way.

I have accentuated the billowing action of the cloud forms to get a lot of movement into the scene.

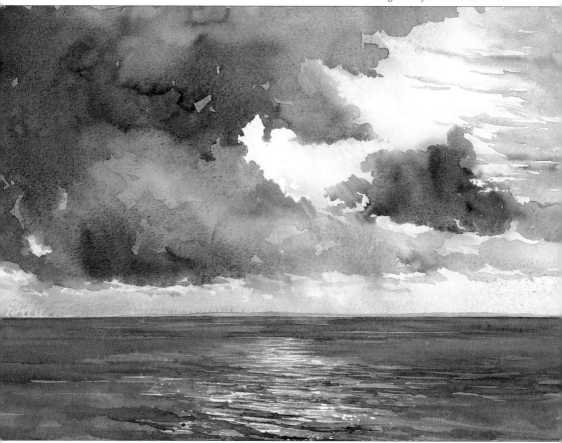

Stormy skies

Recently, I travelled up to Argyll in the west of Scotland and was greeted with some kind Scottish hospitality and some terrific Scottish scenery. Because the landscape is crisscrossed with so many lochs and valleys, the weather systems tend to move through at a considerable rate of knots. Wait five minutes and you can have a complete change of weather! All this adds up to some pretty dramatic skies and it is one such sky that I want to portray in this demonstration.

I took several photographs all of which had completely different skies. In the one used as the reference for this painting, I managed to catch the scudding clouds as they clipped the top of the mountains. The clouds were quite dark and foreboding, but they had a tremendous luminosity that made them shimmer.

The natural tendency is to make dark clouds much *too* dense and heavy, especially when working from photographs. I recommend that you try to keep your skies light and airy and very transparent, even when dealing with storm clouds. If you do not, you could end up with a rather clumsy result.

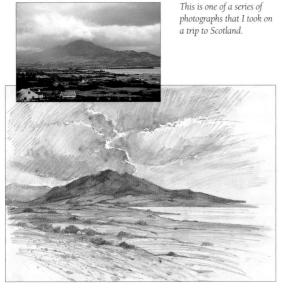

This is one of a series of photographs that I took on a trip to Scotland.

I used the photograph and water-soluble pencil sketch above as the reference material for this demonstration.

Water-soluble pencils are great for getting texture into tonal studies. Here I used them to get the tones into the sky and land, softening the hatching by rubbing the marks in the sky with my finger. I used a brush and clean water to merge the marks in the mountain area.

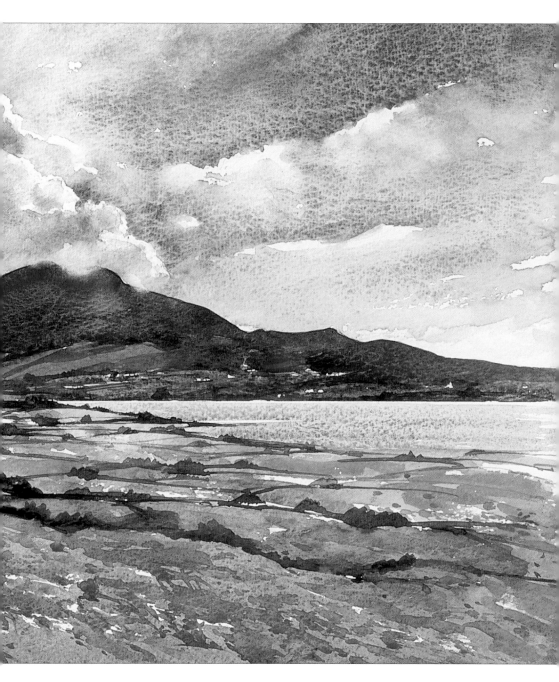

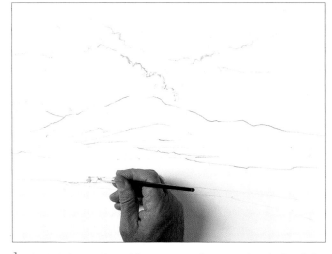

1 Sketch the basic outlines of the composition (keep it simple and only include the main elements), then use an old brush to apply masking fluid to some of the cloud edges and to the end of the small house in the middle distance.

2 Prepare the initial washes: quinacridone gold, French ultramarine, Winsor red, manganese blue, cobalt blue, rose madder and Indian yellow. Wet the top of paper, then start the sky by introducing French ultramarine, Winsor red, and cobalt blue. Push the brush into the cloud area and roll it from side to side to create texture.

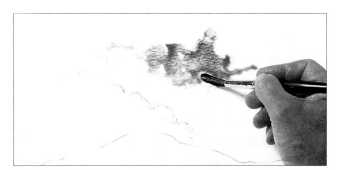

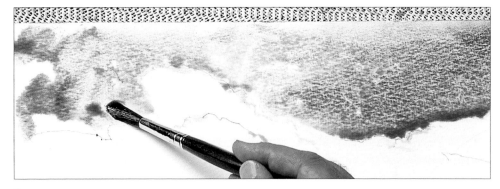

3 Pull the colours down to the top edge of the clouds. Tilt the board to allow the colours to run into each other, then introduce quinacridone gold, with touches of Indian yellow, Winsor red and cobalt blue into top left of the wet paper.

4 Work down the paper, adding more cobalt blue and Winsor red, then soften the tones beneath the clouds with rose madder genuine.

5 Pull the colours down into the mountains, diluting them slightly, then, at the right-hand side of the sky, introduce manganese blue and touches of rose madder genuine.

6 Tilting the painting board to allow the colours to flow across the paper, add weaker washes of the sky colours to the lower right-hand side of the sky, softening the bottom edges. Accentuate the billowing clouds with cobalt blue and Winsor red.

7 Add manganese blue and Winsor red to the centre sky. Touch the tip of the loaded brush on to the surface of the paper and allow the paint to run out into the wet area.

8 Strengthen the top, left-hand corner of the sky with more cobalt blue and Winsor red...

9 ... and the top, right-hand part of the sky with French ultramarine.

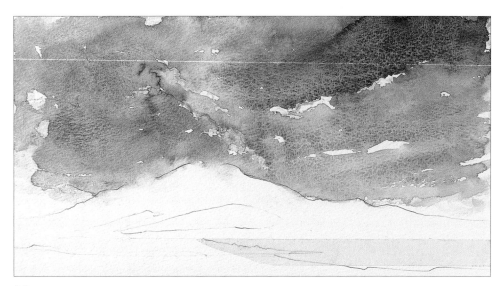

10 Allow the sky colours to dry, then, referring to the tip below, apply a strip of masking tape to the top edge of the loch.

TIP MASKING TAPE

This is ideal for masking sharp-edged straight lines. If it is applied to watercolour paper straight from the reel, however, it could damage the paper when it is removed. Reduce the tackiness of masking tape by rubbing your fingers over it before you stick it to the paper.

11 Prepare the washes for the landscape: Indian yellow, Winsor red, permanent magenta, French ultramarine, cobalt blue and quinacridone gold.

12 Referring to the diagram above, wet the edges of the mountains shown in red, then drop in the colours. Use French ultramarine, cobalt blue and permanent magenta on the highest peaks and the other mountains to the right of these, adding touches of quinacridone gold on the lower slopes. Use permanent magenta for the distant mountain at the left-hand side to reflect the pink in the sky. Bring quinacridone gold across from the right-hand side to define the far bank of the loch.

13 Lay in the middle distance area at the left-hand side with quinacridone gold and Winsor red, warming up tones as you move to the right. Use touches of cobalt blue, French ultramarine and permanent magenta to work up shape and form on the far bank of the loch.

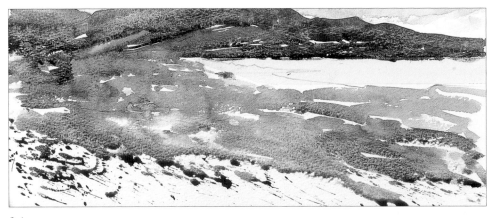

14 Dipping a No. 12 brush in quinacridone gold, Indian yellow and Winsor red, work up the lower slopes of the mountain, then work up the foreground area with the same colours, adding touches of permanent magenta and cobalt blue at the right-hand side. Raise the top, left-hand corner of the painting board, then spatter Winsor red, quinacridone gold and cobalt blue over the bottom of the paper.

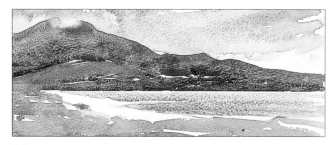

15 Leave to dry, then remove the masking tape to reveal the sharp edge of the far side of the loch.

16 Use a weak wash of manganese blue and long horizontal strokes to block in the surface of the loch, leaving a thin white line below the far shoreline. Lay in touches of permanent magenta across the near side of the loch and allow the colours to blend together. Leave to dry.

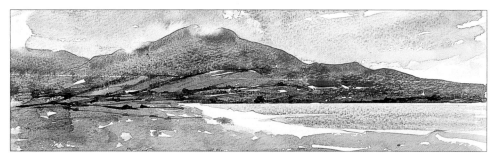

17 Dipping the rigger brush into cobalt blue, brown madder, French ultramarine and permanent magenta, work up shapes on the lower slopes of the mountain (to suggest hedges and foliage) and areas of shadow along the far bank of the loch.

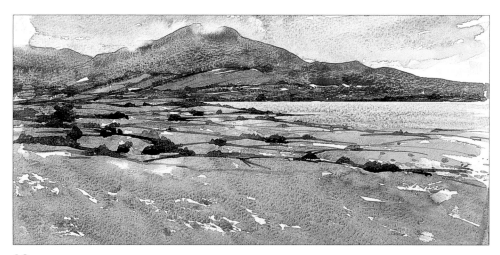

18 Define the near shore of the loch with quinacridone gold and touches of Winsor red. Use a No. 3 rigger and the dark tones on the palette to start defining shapes in the middle distance. These marks should be slightly larger and more spaced apart, slightly stronger in tone and slightly more detailed than those further back.

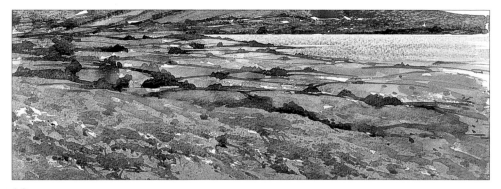

19 Spatter quinacridone gold, Indian yellow and permanent magenta diagonally across the foreground, spatter some smaller spots of manganese blue into these to create slightly darker tones, then use the brush to blend some of the speckles together to form larger marks. Use the darks on the palette to add a hedge to separate the high foreground from the lower land beyond. Leave to dry.

20 Re-wet the soft areas on the mountains, then, dipping a No. 8 brush into French ultramarine, quinacridone gold, permanent magenta and brown madder, apply darker tones to the mountain. Leave to dry completely.

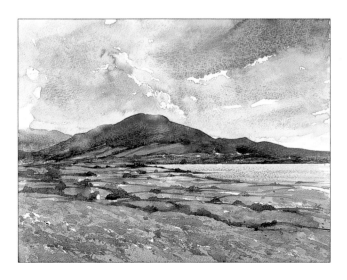

21 Remove all masking fluid. Note that the exposed white areas are very harsh, so they need to be softened in places (see steps 22–24).

22 Use a bristle brush and clean water to soften the two mist-covered parts of the mountain…

23 …then use a clean paper towel to lift out colour.

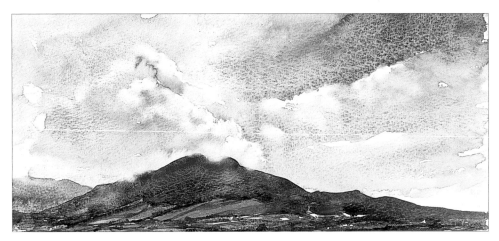

24 Now, using the bristle brush and clean paper towel, rework the whole sky, leaving some hard edges, blending some cloud colours and lifting out some colours to create shape and form.

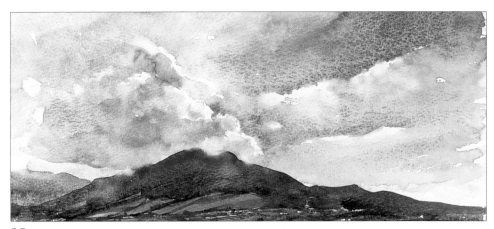

25 Develop shadows in the clouds with permanent magenta, quinacridone gold, cobalt blue and tiny touches of brown madder and French ultramarine. Work small areas at a time, wetting the paper then dropping in the colours.

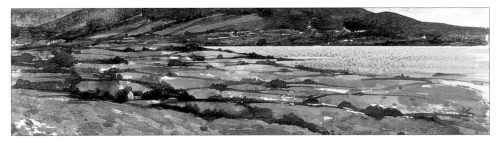

26 Use the darks on the palette to add detail to the small house in the near middle distance. Add small marks to the white patches on the distant shore of the loch to suggest buildings. Strengthen the tones of the foliage between the foreground and middle distance.

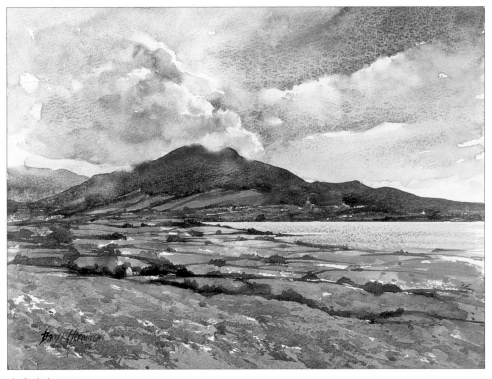

The finished painting.

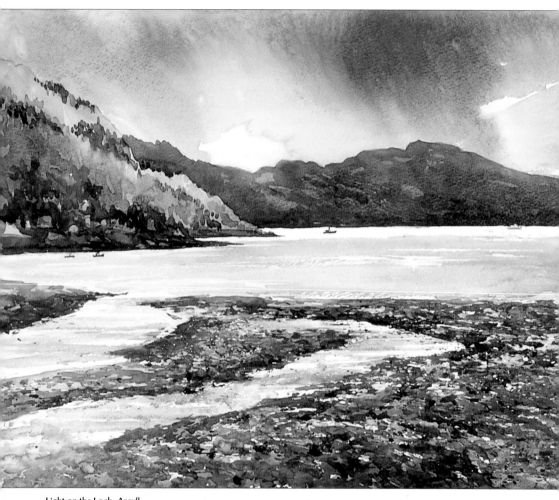

Light on the Loch, Argyll

Size: 620 x 485mm (24½ x 19in)

It had been threatening to rain all morning, but the clouds broke and cast a strong light on the water which was counterchanged by the dark shadowy hills in the background. Quite often, awful weather can produce the most wonderful subjects.

This painting was worked up on a large sheet of watercolour paper as a demonstration piece at an exhibition. When you have a large area to cover, it is best to mix up your paints in large wells before the off; once you start painting, you have to move fast and stopping mid flow can cause some disastrous effects.

The Poisen Glen, Donegal
Size: 395 x 290mm (15½ x 11½in)

I revisit the Poisen Glen every chance I get, and it always seems to catch some really unusual weather. On this particular visit, the crescent-shaped valley was actually glowing in this spectacular shaft of light. It all made for a superb scene filled with real mood and atmosphere.

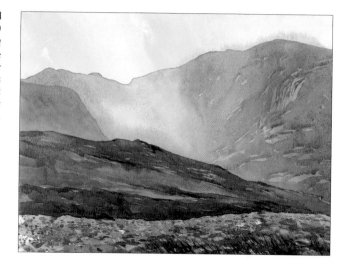

Yorkshire Dales
Size: 490 x 335mm (19¼ x 13¼in)

In complete contrast, this view of the Dales is a much more mellow scene.

The clouds were scudding across the sky casting great shadows over the landscape, then this really strong shaft of light cut a diagonal swathe through the shadows.

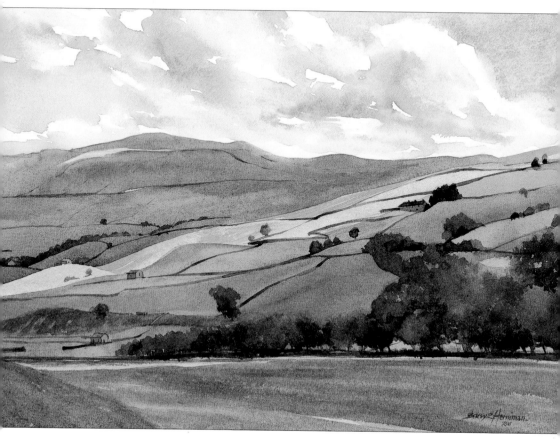

Silver Linings, Fanad, Donegal

Size: 390 x 300mm (15¼ x 11¾in)

This northern tip of the Atlantic Drive in Donegal really catches some weather, especially in winter. This is the view from my friend Keith's house, and I have painted it many times in many different moods. This quiet, unspoilt peninsular, however, is destined for a lot of change if the planned development of a new road bridge goes ahead.

Granulation is very pronounced in this painting. This is the result of tilting the paper from side to side while the paint was still wet.

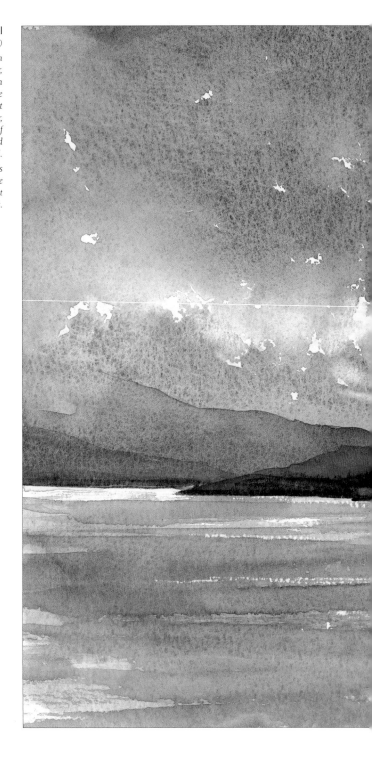

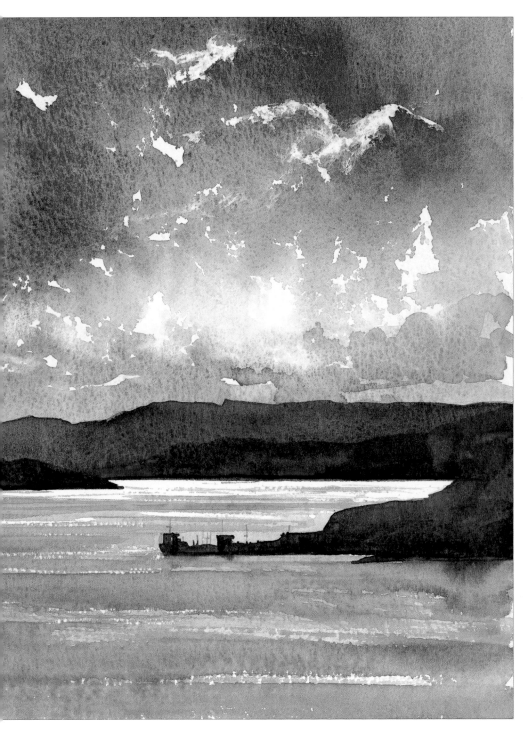

Weathered timbers

New England is a magical place with its lakes, mountains, rivers, streams and wonderful wooden buildings. In autumn, when the trees take on their fall colours, it is even better. This cluster of timber barns caught my eye while travelling up into the Green Mountains of Vermont late in the afternoon. The light was catching the corrugated tin roofs, creating some striking shapes and contrasts, and the well-weathered clapboard sides of the old barn produced some lovely textures. For me it was a perfect combination, so I took the opportunity to take several photographs and copious notes.

I used one of these photographs as a reference for this demonstration in light and shade, playing off the harsh angular lines of the buildings against the softer, rounder shapes and random quality of the foliage and undergrowth. I like the finished painting very much, so I think I will be painting these buildings quite a few more times before I tire of them.

One of several reference photographs taken during a painting holiday in Vermont. You never know when you might stumble on scenes such as this, so never travel without your camera.

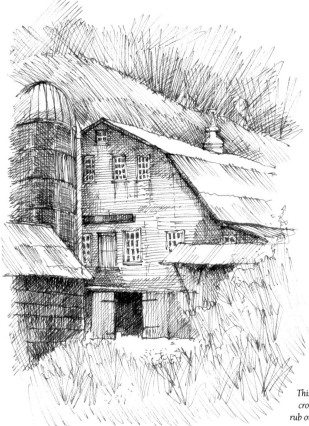

This quick tonal sketch was worked up with sepia ink, cross hatching to build up the dark areas. You cannot rub out ink, so all the lines have to be decisive and bold.

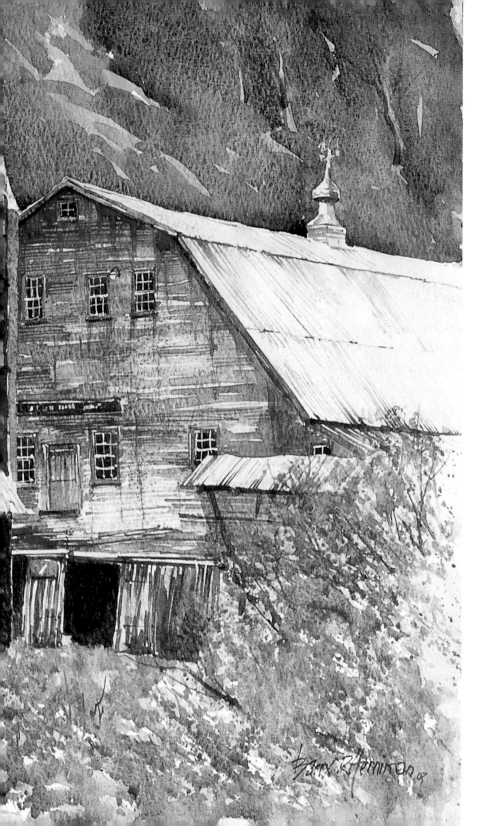

You WILL NEED:

Watercolours –
 quinacridone gold
 alizarin crimson
 permanent magenta
 Winsor red
 cobalt blue
 cobalt turquoise light
 manganese blue
 French ultramarine
 brown madder
White gouache
Nos. 10, 12 and 16 round brushes
No. 3 rigger brush

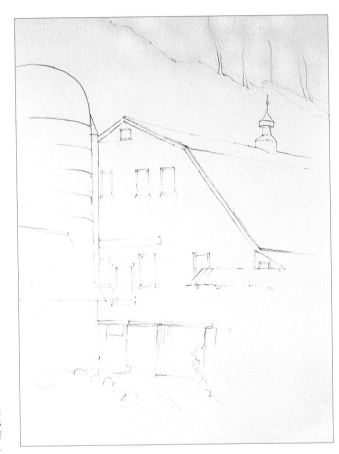

1 Referring to the tonal sketch and photograph on page 332, use a 2B pencil to transfer the basic outlines of the composition on to the paper.

2 Prepare the initial washes: cobalt blue, quinacridone gold, permanent magenta, cobalt turquoise light, alizarin crimson and manganese blue. Wet the top edges of the buildings, then use the No. 16 brush to lay manganese blue into the roof of the large building and the top of the silo. Working quickly, wet in wet, pull the colour down the paper (roughly following the shape of the roofs) and drop in touches of alizarin crimson, cobalt turquoise light and permanent magenta…

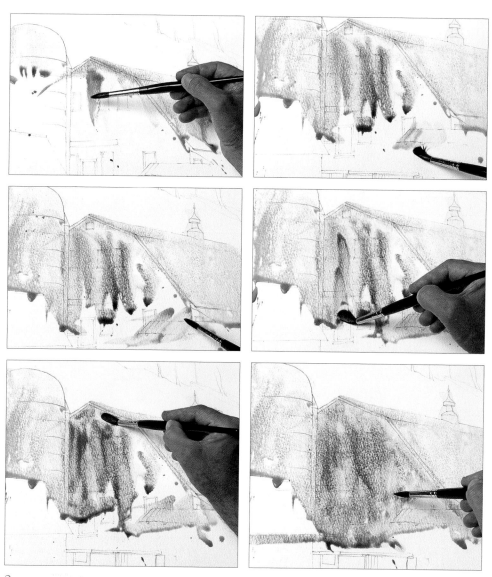

3 … continue working on the buildings pulling the existing colours down the paper, adding more colour wet in wet and allowing these to blend together to create the desired tonal effect…

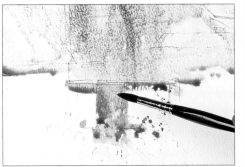 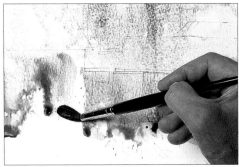

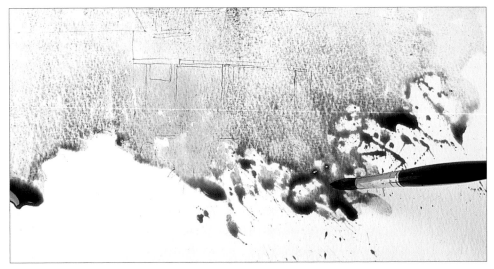

4 ...then, while the colours are still wet, start to work on the foreground.
Develop the background tones for the two smaller buildings, centre and left, then
start to work up the foliage. Use a No. 8 brush to spatter quinacridone gold,
permanent magenta and cobalt blue, then use the handle of the brush to draw
some of the spatters together to create the rough texture of foliage. While these
colours are still wet, flick in some bright accents of cobalt turquoise light.

5 Mingle and merge the colours across the entire width of the foreground, then complete the initial washes by spattering colour up into the damp area of the buildings at right-hand side to suggest more open foliage.

6 Leave the initial washes to dry completely.

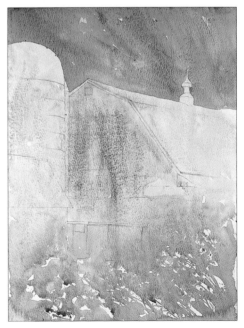

7 Turn the painting upside down, then, working down from the hard edges of the tops of the buildings, lay in the background washes of quinacridone gold with touches of manganese blue and cobalt blue. Start wet on dry, then work fresh colour into the wet ones on the paper.

8 When the background wash is complete, leave the painting to dry.

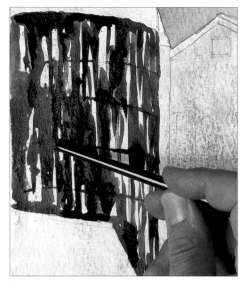

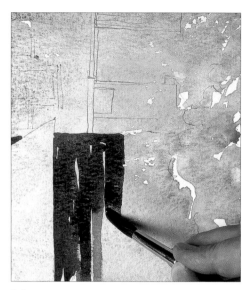

9 Use a No. 10 brush with brown madder and touches of French ultramarine to work on the grain silo. Drop in colour along the top edge of the side of the silo, then drag down streaks of rust and water marks. Cut along the edges of the roof of the building in front of the silo. Spatter on a few specks of quinacridone gold and allow these to blend with the darks. Using the handle of the brush, draw through the wet paint to indicate the curved sections of the silo.

10 Turn the painting on its side, then use the same colours to paint the planking of the wall on the small building below the silo.

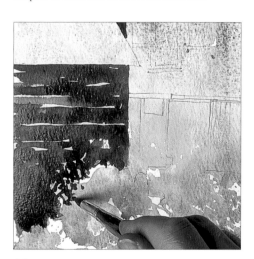

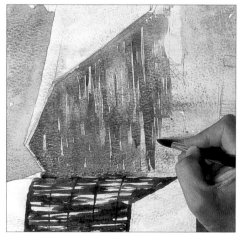

11 Continue working down to the top of the foliage, turn the painting right way up, then trickle colour along this edge. Soften some of the marks with clean water.

12 Turn the painting on its side and use the No. 10 brush with cobalt blue, manganese blue, permanent magenta, Winsor red and French ultramarine to lay in the planking on the large building. Work wet on dry, then wet in wet, laying in streaks of colour. Suggest the deep shadow under the eaves with darker tones.

338

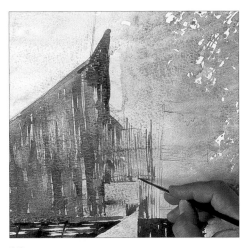

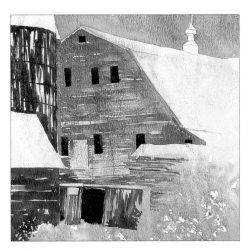

13 Continue working colour into colour to build up random tones, then use the handle of the brush to reinstate the outline of the doors and windows. The bottom of the building has reflected light from the structures around it, so use the rigger brush to define the planking in this area.

14 Cut round the small pitched roof on the front of the building, turn the painting the right way up, then use a mix of French ultramarine, permanent magenta and brown madder to block in the windows. Use the same colours to start defining the shapes for the foreground building.

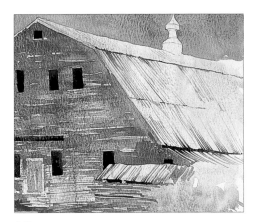

15 Block in the long signboard above the door, then use the rigger brush with manganese blue, permanent magenta and cobalt blue to develop the texture on the corrugated iron roofs. You only need an impression, so do not try to reproduce every undulation. Then, using the darks on the palette, define the shadows along the edges of the roof.

16 Turn the painting upside down, then use a semi-dry brush loaded with cobalt turquoise light and permanent magenta to paint the top of the silo; drag the brush lightly over the undercolour, varying the angle of the strokes to follow the curve of the top of the silo.

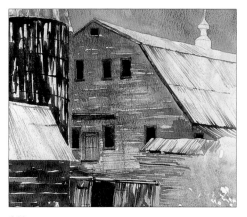

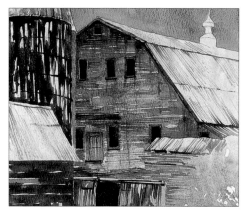

17 Define the corrugations on the roof in front of silo as before. Then, still using the rigger and a mix of cobalt blue, quinacridone gold and permanent magenta, define the window frames and doors on the barn. Use the same colours to paint the barge boards that edge the roof.

18 Use the rigger brush with French ultramarine, cobalt blue, brown madder and a touch of alizarin crimson to lay in deep shadows under the eaves; pull down vertical streaks of colour to suggest water stains. Darken the left-hand side of the large building so that the second silo becomes obvious.

19 Use the same colours to strengthen the tones on the front of the left-hand building.

20 Use the rigger to define the detail on the air vent.

21 Develop the background. Use the No. 12 brush with quinacridone gold, cobalt blue and touches of permanent magenta, to lay in random patches of dark tones to suggest foliage. Carefully cut around the shape of the air vent and the top edge of the roofs.

22 Lay in a wash of quinacridone gold over the right-hand side of the silo.

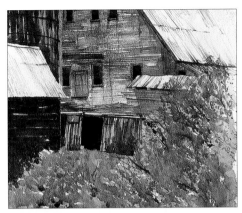

23 Develop the foreground foliage by spattering all the colours in the palette. Scrape the handle of the brush through the spattered colours to suggest stalks and twigs.

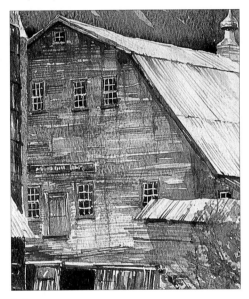

24 Working on a separate palette, tint some white gouache with touches of cobalt turquoise light and a brown from the watercolour palette, then use the rigger to define the window bars and to suggest wording on the sign.

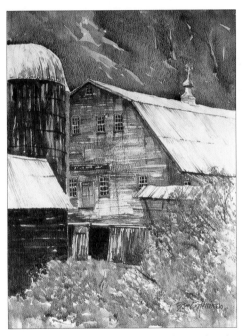

The finished painting. Having stood back to look at it at the end of step 24, I realised that I had omitted the support for the small pitched roof on the front of the barn. I painted this with a rigger brush and a mix of brown madder and ultramarine. I then added some more foliage to cover the bottom of the support.

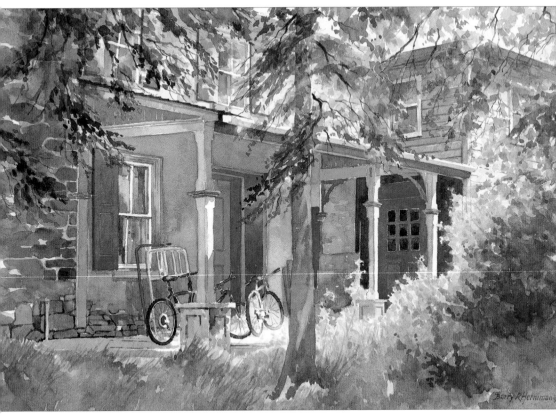

Ferbotniks Porch, Pennsylvania

Size: 520 x 340mm (20½ x 13½in)

A scene of strong light and sharp contrasts. This wonderful porch was built on to the side of an old farmhouse in Bucks County – a very pretty county in Pennsylvania. I was on a search for old-style barns and bridges and came across this farmstead with its coloured timber frame and doors. With the kids' bikes plonked up against the wall, this scene said, 'lazy days', to me. The afternoon sun was catching the pink uprights of the porch, contrasting with the darker red doors.

Opposite above

Two Bridges, Marsh Bridge, Somerset

Size: 520 x 340mm (20½ x 13½in)

My Dad and I went on a trip down memory lane, visiting the area where he was brought up as a child. He took me to some of his old haunts and this scene on the Barle River was one of them.

The whole day was rather dull and overcast but even so there was a soft muted light throughout the scene, which I rather liked.

A very low-key picture, with its subtle contrasts and colours, but a very atmospheric one. I went back a few years later and the sun was shining; an altogether different scene!

Opposite

La Fuente, Zuheros, Spain

Size: 390 x 285mm (15¼ x 11¼in)

Zuheros is a small village perched on the side of a mountain in Subbetica Natural Park – a two-hour drive north of Malaga.

This is a study of light and shade with underlying warmth. Although more than half of the picture is in shadow it is not cold, as I infused the shadows with rich, warm reflected colours, which make them glow.

When it is hot here, it is very hot, so I bleached out some of the colour from the sunlit areas to intensify the feeling of heat.

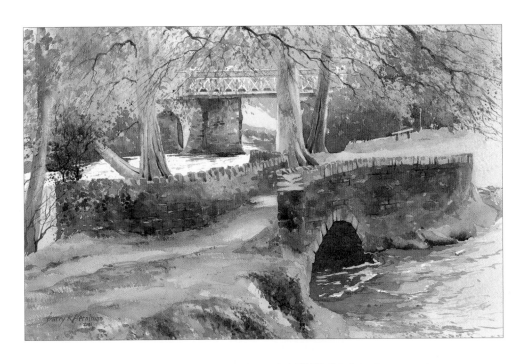

343

Frosty morning

When you have lived in an area for a while, it is easy to become complacent with the surrounding scenery – familiarity, and all that! You tend to go searching further afield (excuse the pun) for that great subject, when it could be waiting for you just round the corner.

This is a scene from my small corner of Herefordshire. I know every inch of these fields, but it never ceases to amaze me just how different the scene becomes when the light changes and the seasons move on. It just goes to show that the combination of weather, lighting and season can produce some wonderful painting subjects right on our doorsteps.

On this particular late autumn morning, the first frosts had arrived. The air was crisp and clear, and the sun had just risen above the background hills. There was a lovely warm glow over the whole of the countryside, and the sun was shining through the trees in the foreground. Because of this, I was able to look directly at the scene without being blinded and capture the bright light that silhouetted the trees.

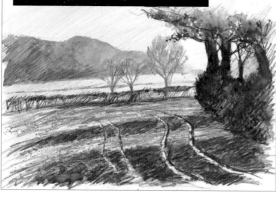

I got out my water-soluble coloured pencils for this quick preliminary sketch. I hatched in yellow over most of the picture, leaving white areas around the trees, built up the colours with a series of overlays, then softened some of the areas with clean water. I changed the angle of the tractor tracks so that they entered the composition from the bottom-right.

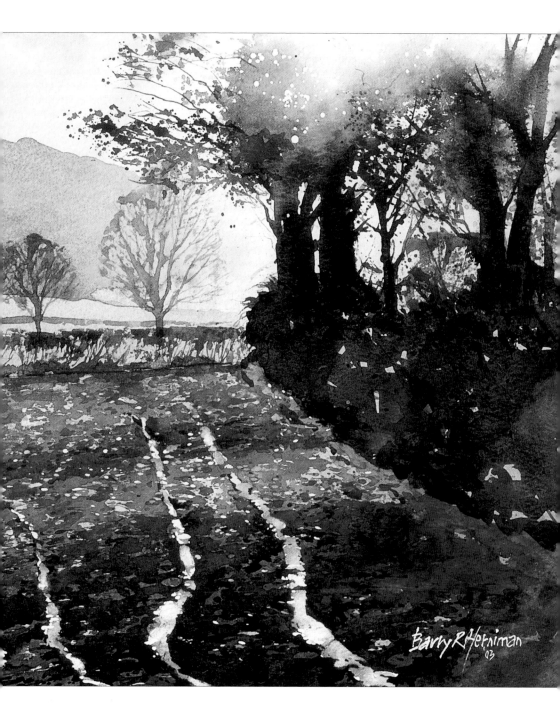

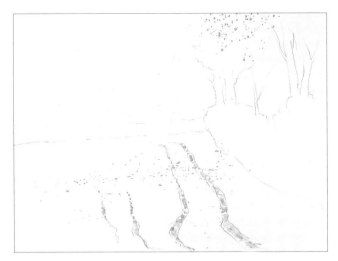

1　Transfer the main outlines of the composition on to the watercolour paper. Note that the detail on the left-hand side of this composition is barely suggested. Apply masking fluid (tinted here with a touch of manganese blue) to the icy water in the wheel ruts in the field. Spatter some into the top of the tree at the right-hand side, then across the foreground as frosty highlights on the ploughed field. Prepare the initial washes: aureolin, Indian yellow, quinacridone gold, Winsor yellow, Winsor red and manganese blue.

2　Spray a liberal amount of clean water over all the paper...

3　...then, working quickly and leaving the highlight area among the trees as white paper, start to lay in Winsor yellow, aureolin and Indian yellow.

346

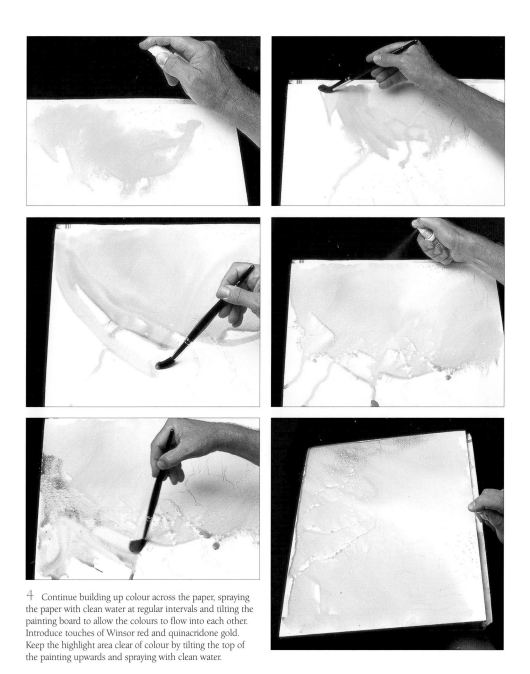

4 Continue building up colour across the paper, spraying the paper with clean water at regular intervals and tilting the painting board to allow the colours to flow into each other. Introduce touches of Winsor red and quinacridone gold. Keep the highlight area clear of colour by tilting the top of the painting upwards and spraying with clean water.

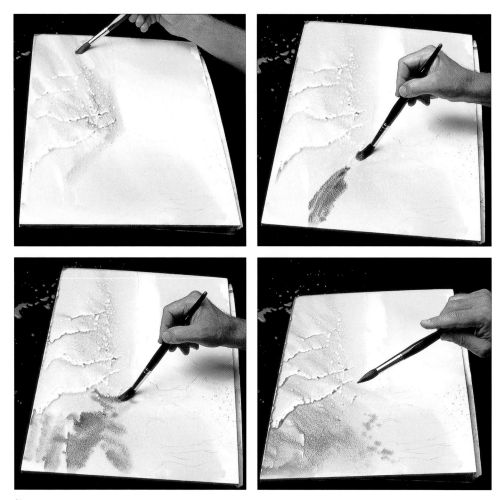

5 Still working quickly, wet in wet, add more Indian yellow at both the left- and right-hand sides. Lay in a weak wash of manganese blue to define the background area where the hedges are. Add Winsor red and quinacridone gold across the right foreground area, then spatter more quinacridone gold wet in wet.

When laying in my initial washes, I am continuously tilting and turning the paper to allow the colours to blend on their own. In the series of photographs above, the top of the painting is at the right-hand side.

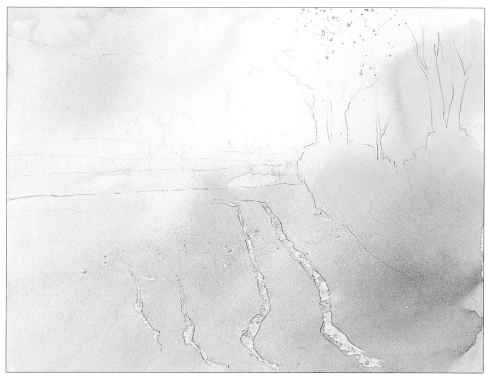

6 Leave the initial washes to dry.

7 Turn the painting on its side, then, working wet on dry, use the No. 12 brush to apply cobalt blue, with touches of French ultramarine and rose madder genuine, into the distant hillside...

8 ...work down (across) the paper, adding more of the same colours, and introducing Winsor yellow to give a warmer glow towards the right-hand trees.

9 When you get close to the right-hand trees, spray the Winsor yellow with water, then use paper towel to absorb any excess paint.

10 Leave the painting to dry.

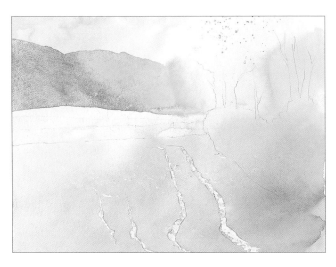

11 Turn and tilt the painting board, then use the No. 10 brush to spatter the foreground with water followed by Winsor yellow and quinacridone gold. Use your other hand to mask the edge of the field.

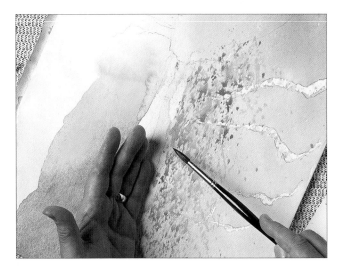

12 As you work down the field, spatter more water followed by Winsor red, more Indian yellow and brown madder. Spatter some cobalt blue to create darker tones. Gently move the paint around with the brush to pull the colours together.

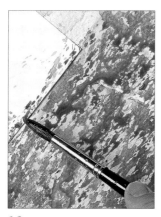

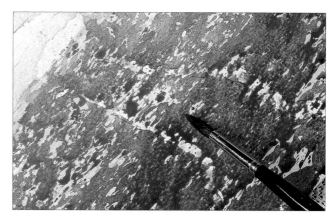

13 Mask the middle distance with a sheet of paper, then, tapping the side of a loaded brush with your finger, spatter smaller marks of the previous colours over the foreground.

14 Darken the right-hand corner of the foreground with cobalt blue to create shadow areas. Then, keeping the painting angled down so the paint runs and colours mingle, bring this colour across over the centre of the foreground. Use the brush to soften the edges.

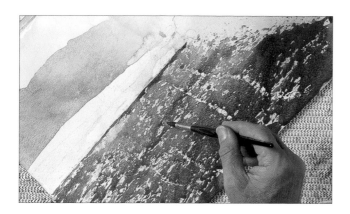

15 Use cobalt blue and brown madder to introduce a shadow area under where the hedge will be. Use the same colours to work smaller shadows in the field. Leave to dry.

16 Now start to work on the right-hand trees. Spray the paper with clean water, then, masking the paper with your other hand, use the No. 8 brush to spatter Indian yellow into the tree. Mop up excess water and colour with clean paper towel.

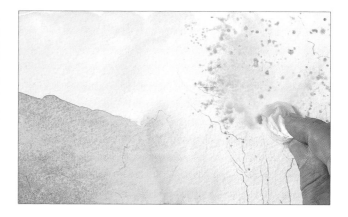

17 Spatter quinacridone gold into the damp yellow and allow colours to merge. Raise the top of the painting, then add brown madder and cobalt blue to the lower area.

18 Allow the colours to merge then pull the bead of colour down to form the trunk. Use the handle of the paint brush to pull the colour down to form two smaller trees. Spatter dark tones of colour to suggest foliage on these trees.

19 Spray the foliage area with water, then paint the two right-hand trees. While the paint is still wet, add touches of French ultramarine on the shadowed sides of the trunks.

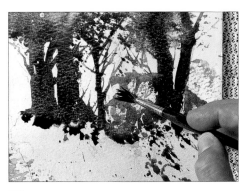

20 Spatter more foliage wet in wet, then pull out more branches. Drag the side of the brush over the surface to create background foliage between the trees.

21 Use French ultramarine with touches of rose madder genuine to accentuate the branches and shadows. Bring these colours down over the area beneath the trees, then introduce touches of brown madder and cobalt blue.

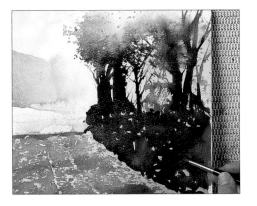

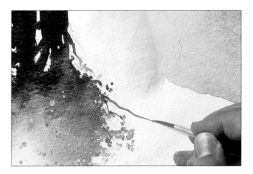

22 Turn the painting upside down, then use the rigger brush with brown madder and cobalt blue to paint some thin branches.

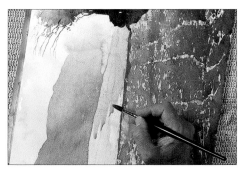

23 Turn the painting on its side so that the colours will run down the paper, then use a No. 12 brush to apply a flat wash of Winsor yellow over the middle-distant fields.

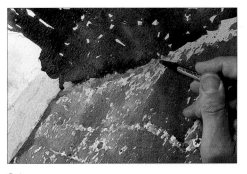

24 Working into the drying edge of the woodland, add a band of Indian yellow down the edge of the field where it meets the wooded area.

25 Still working at an angle, mask the middle distance with paper, then, painting wet on dry, use the No. 8 brush to flick darker tones of quinacridone gold into the foreground field.

26 Spatter more quinacridone gold, cobalt blue and the reds on the palette into the field, then push and pull the colours together. Develop the distant edge of the field.

27 Suggest undulations in the field by creating areas of shadow with the dark colours on the palette.

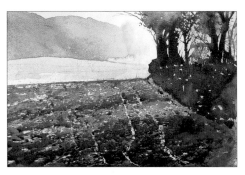

28 Use a No. 10 brush to spatter more reds and cobalt blue on the near foreground. Add touches of French ultramarine, then blend the colours with the brush.

29 Use the same colours to develop the whole width of the foreground. Add some dark shadows at the right-hand side of the field.

30 Accentuate the ruts in the field by creating shadows with touches of French ultramarine and brown madder. Spatter these colours over the foreground as you work.

31 Working wet on dry with a No. 3 rigger brush, lay down flat brush strokes of cobalt blue, quinacridone gold, Indian yellow and rose madder genuine to form the more distant of the two hedges.

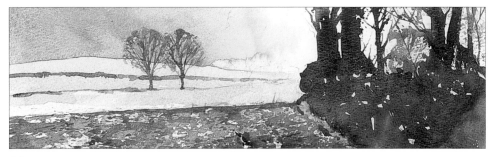

32 Weaken the colours as you work towards the right-hand side. Lay in another band of the same colours to form the nearer hedge. Create the trunks and branches of two trees then, using a damp brush, drag it across the surface of the paper to suggest some foliage.

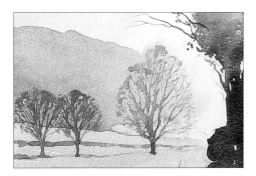

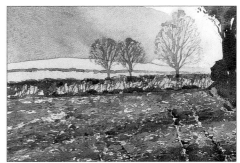

33 Now use a weak brown wash to work up a larger tree to the right of the others. While this is still wet, drop in a blue wash on the shadowed side of the trunk and branches. Work up some foliage with quinacridone gold and touch of brown madder. Notice that there is more detail on the left-hand side; the right-hand side is blurred by sun.

34 Using a No. 8 brush, apply downward, near-vertical, dry brush strokes of brown madder, cobalt blue and quinacridone gold to form the top of the hedge. Use similar colours and upward strokes to form the bottom of the hedge, then use the rigger brush to link the top and bottom parts of the hedge. Add touches of quinacridone gold to the brighter right-hand end of the hedge.

35 Remove all the masking fluid in the field and in the large sunlit tree. To remove large areas of masking fluid, lift one edge and carefully pull the rest off the paper.

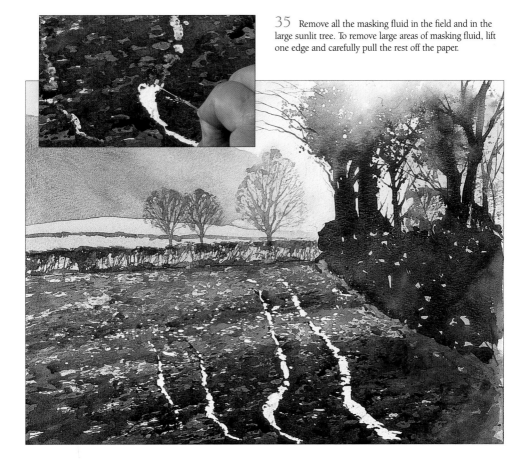

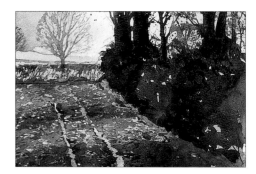

36 Brush Winsor yellow, with touches of quinacridone gold, into the icy ruts in the field and over some of the white highlights created by the masking fluid.

37 Spatter darks from the palette into the deep shadowed area at the right-hand side. Trickle more colour into this area, then use the brush handle to create 'squiggles'. Spatter a few specks of quinacridone gold.

38 Use the No. 8 brush and delicately spattering to suggest foliage on the bare branches of the trees at the top of the painting. Pull the brush handle through the paint to redefine the structure of branches.

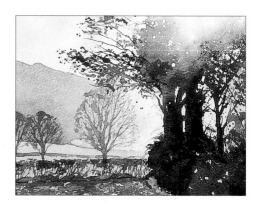

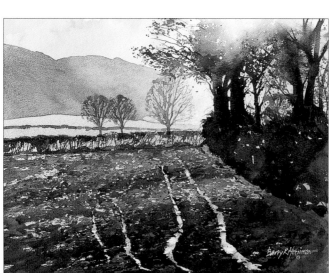

The finished painting. Having stood back to look at the painting at the end of step 38, I decided to use a bristle brush, clean water and some paper towel to lift out a few highlights from the icy ruts.

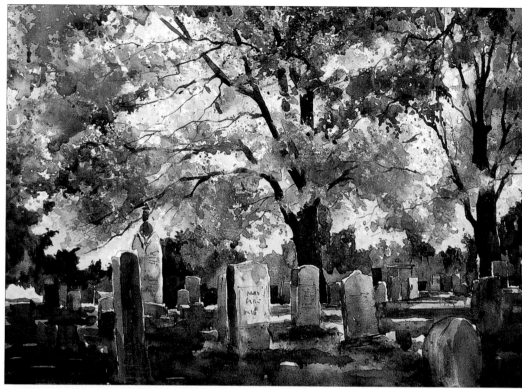

Sunlight in the Cemetery, Belmont, USA

Size: 520 x 340mm (20½ x 13½in)

The sunlight shining through these autumn leaves was almost blinding. The leaves were made all the more dramatic by contrasting them with the purple shadows and gravestones. I used pure colours for the leaves: yellows, reds and golds straight from the tube.

Overleaf

First Frost at Way-go-Through, Llangarron

Size: 535 x 335mm (21 x 13¼in)

This is one of the walks around our village which we have done many times. This particular morning there had been a heavy frost. The early morning sun was just filtering through the trees infusing intermittent areas with warmth in an otherwise cold scene.

I flicked and spattered paint over the foreground making the colours progressively cooler the further they were from the light source.

This painting is reproduced by kind permission of the owners, Jacqs and Ken Anstiss.

Scottish Solitude, Argyll

Size: 630 x 465mm (24¾ x 18¼in)

A rather 'soft' Scottish day, but with some strong accents of light around the small castle on the edge of the loch.

The rather milky clouds were obscuring the hillside in places so I kept the whole painting low key to accentuate the mistiness.

This was a demonstration painting to show how a build up of glazes can capture the transient light that was visible over the loch.

Fall, New Jersey

Size: 380 x 290mm (15 x 11½in)

On one of my trips to America, I had left Vermont (where the fall colours were in full flow) and travelled down to New Jersey to find that most of the foliage was still green. I was heading up into the hills beyond a small village when, almost by accident and to my complete surprise, I came upon this stream where the leaves had started to turn. Rather than use masking fluid, I reserved my whites by painting around them – a practice which produces a lively, spontaneous painting.

Making Tracks, Llangarron

Size: 490 x 320mm (19¼ x 12½in)

Our local farmer had left this field fallow over the winter and there was a lot of old growth still evident. With the heavy frost and the glowing light the whole scene was a patchwork of colour – lights and darks, warms and cools – all dancing together.

This is fine example of an ordinary scene being transformed by special lighting conditions. Always keep a look out for the extraordinary, even when your surroundings are totally familiar.

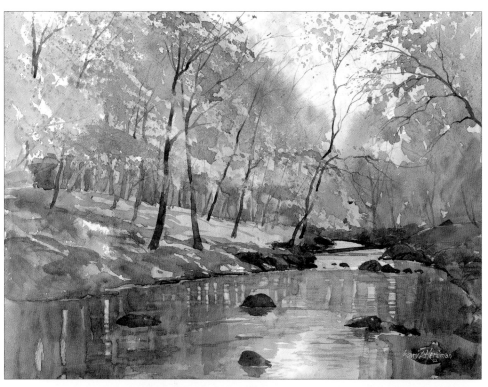

Harbour 'lights'

I first went to Tenby with my brother about four years ago, and have been going back year after year ever since. I never tire of the Pembrokeshire coast, and Tenby in particular, as it offers a wealth of painting subjects in all weathers. Whenever I am painting down there, I take an early morning stroll on South Beach (when the tide is out) and up into the harbour. On one particular morning the sun had not risen above the rooftops but the pervading light was bouncing about between the houses and alleyways. The whole scene had a warm, rosy glow which was evident even in the shadows.

The sluice, the local name for this dry dock, was almost in total shadow but some of the morning light was filtering between the buildings and lighting up a few details. I wanted to capture the quietness and tranquillity of the small boat moored to the harbour wall, with the two men in casual conversation, one in the boat and the other on the wall.

This photograph and the tonal sketch were used as reference material for this step-by-step demonstration.

The overall scene had a rather large lifeboat in the foreground, and there were a lot of mooring ropes cutting across the field of view. These would have made the picture rather messy, so, in the tonal sketch, I closed in on the small boat, simplified the ropes and concentrated on the shapes and tones. I used 2B and 4B water-soluble pencils to draw the sketch on a square block. For the painting, however, I wanted to get a better feeling of depth so I painted it in portrait format.

362

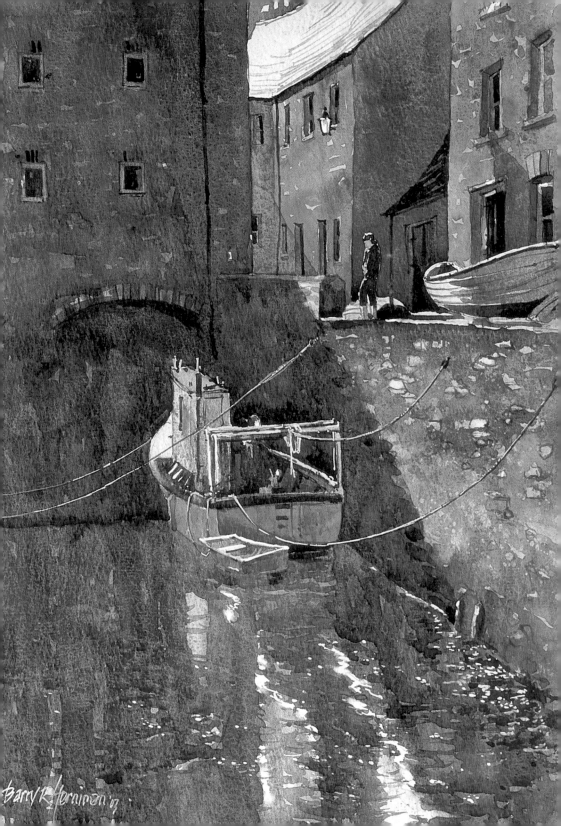

YOU WILL NEED

Water colours:
 aureolin
 Indian yellow
 madder red dark
 rose madder genuine
 Winsor red
 cobalt blue
 French ultramarine
 manganese blue
 manganese violet
 brown madder
White gouache
Water sprayer
Masking fluid and an old brush
Nos. 10, 12 and 16 round brushes
No. 3 rigger brush
Bristle brush
Paper towel

1 Draw in the basic outlines for the composition. Use masking fluid and an old brush to mask the highlights on the boat and dinghy, the figures and the boat on the harbour wall, along the top of the low wall and the lamp. Spatter a few spots on the water below the harbour wall, then mask the edges of the reflections and the edge of the water against the harbour wall. For this project I tinted the masking fluid with a touch of rose madder (a non-staining colour).

2 Prepare the initial washes: Indian yellow, aureolin, manganese violet, manganese blue, brown madder, rose madder genuine and cobalt blue.

3 Spray clean water over the top of the paper, then, working quickly wet in wet, start to lay in the initial washes of colour.

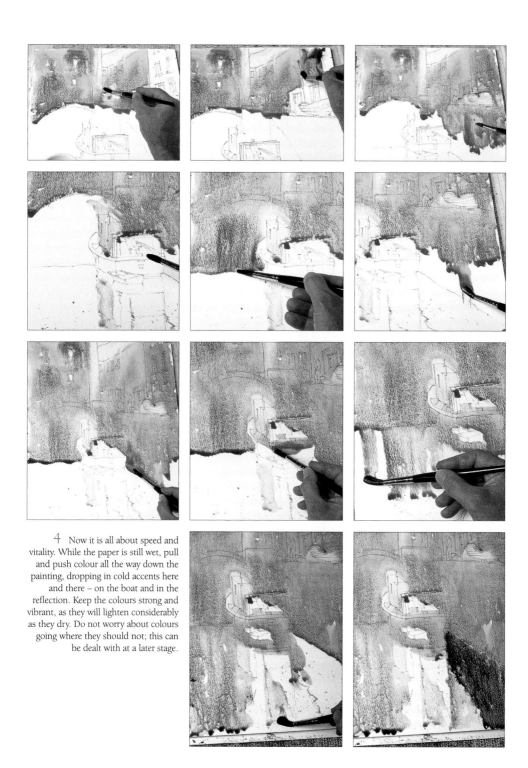

4 Now it is all about speed and vitality. While the paper is still wet, pull and push colour all the way down the painting, dropping in cold accents here and there – on the boat and in the reflection. Keep the colours strong and vibrant, as they will lighten considerably as they dry. Do not worry about colours going where they should not; this can be dealt with at a later stage.

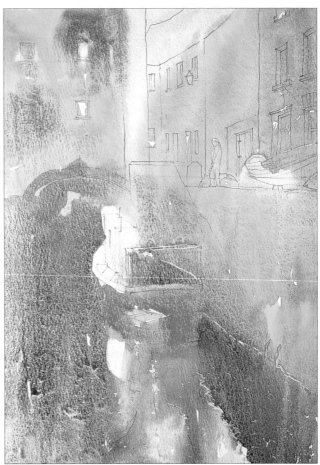

5 Complete the initial washes by adding colour to the boat, then leave until thoroughly dry.

6 Using the No. 12 brush with cobalt blue and brown madder, and working wet on dry, work up the shadowed wall of the building at top left, cutting round the windows. Add touches of manganese violet but leave some of the background colours as highlights on the stonework.

7 Work the darks under the arch with French ultramarine, cobalt blue and brown madder. Pull down the darks in the wet bead of colour above the arch to suggest brickwork.

8 Bring the colours down to the water's edge, then introduce cooler tones at the left-hand side. Cutting round the shape of the boat, use the same colours to create the cast shadow on the harbour wall, but add more blue as you work forward.

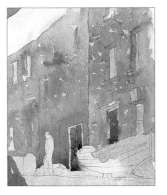

9 Use Indian yellow and brown madder to paint the sunlit walls of the buildings at top right; again, cut round the windows and leave some of the undercolour shining through. Add touches of manganese blue here and there to cool some areas. Use cooler tones to add the distant buildings at the top left corner of the composition.

10 Use the same colours but with more Indian yellow to work up the right-hand building. Use manganese violet to paint the two doors.

11 Spatter water on the harbour wall then, using cobalt blue and brown madder, touch a loaded brush gently on the paper and allow the colours to disperse randomly creating hard and soft edges.

12 Spatter aureolin and manganese blue on the lower part of the wall, followed by brown madder and cobalt blue just above the water line. Turn the painting upside down and drop in more colour and allow a bead to form to define the hard edge along the top of the harbour wall.

13 While the colours are still wet, use the handle of the brush to indicate mortar joints between the blocks of stone, then leave to dry.

14 Use manganese blue and manganese violet to paint the left-hand side and back of the boat's superstructure, and the inside of the dinghy. Use brown madder, cobalt blue and a touch of manganese violet for the shadows in the stern of the boat. Paint the cabin roof with aureolin and madder red dark. Use brown madder to paint the side and stern of the dinghy, then add a touch of cobalt blue to the brown for the reflection.

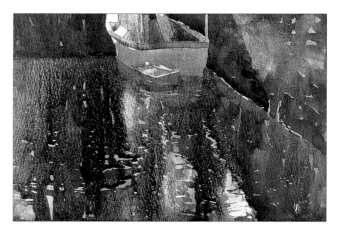

15 When I laid in the initial washes, I allowed some colour to spread over the boat on the harbour wall. On reflection, this should be removed. Use a small bristle brush and clean water to wet the unwanted colour, use a clean piece of paper towel to lift it off the paper, then use manganese blue and manganese violet to block in the side and inside stern of the boat.

16 Brush a few vertical bands of clean water on the area of water, then, starting at the water line against the far building, lay in reflected colours with touches of cobalt blue, brown madder and manganese violet and allow them to blend. Add a few horizontal squiggles in the foreground. Drop some French ultramarine and aureolin into the reflection of the harbour wall at the right-hand side. Apply a weak cool wash over the orange reflection of boat. Referring to step 13, use the handle of the brush to create fine ripples in the reflections. Leave to dry completely.

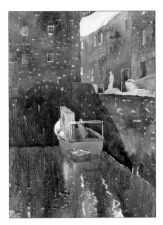

17 Remove all the masking fluid to reveal the saved whites.

18 Referring to step 15, use clean water, a bristle brush and paper towel to soften some of the hard edges created by the masking fluid on the water and the boat. Lift out colour from the windows and from the brickwork in the arch and harbour wall. Spatter water over the harbour wall, leave for a few seconds, then lift out some of the colour to create small areas of soft highlights.

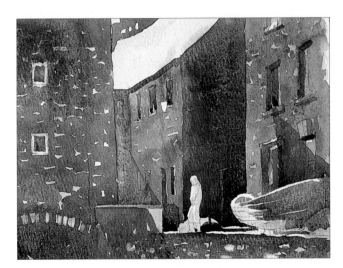

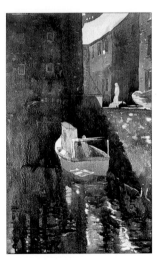

19 Use a No. 12 brush and a weak wash of cobalt blue with touches of manganese violet and brown madder to block in the shadowed end of the middle building and the cast shadows on this and the right-hand building. Use a dry brush to lift off excess colour from bottom edges. Use a No. 10 brush to paint shadows under the eaves and in the windows, on and under the boat on the harbour wall and across the end of the low wall.

20 Using a No. 16 brush with French ultramarine, cobalt blue and brown madder, and starting at the top of the left-hand building, pull the colours down the paper to the bottom of the wall. Cut round the boat shape. Bring the same colours down through the water with broad vertical strokes, then work some narrow horizontal ones. Add a few squiggles of darker tones in the bottom right-hand corner. Leave until the paint is completely dry.

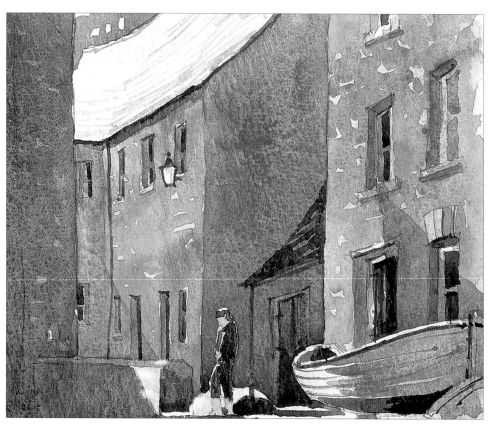

21 Dipping into each colour in turn, load a No. 3 rigger with French ultramarine, brown madder and cobalt blue, then add dark shadows under eaves and round the windows and doors. Use the same colours to develop the shape of the lamp and the roof of the lean-to between the buildings. Use cobalt blue and Winsor red to develop the dark shadows on the boat. Use the same colours to block in the clothes of the figure, leaving some of the undercolour as highlight. Use manganese blue to add texture on the roof, then add a touch of this colour to glass of the lamp. Use Indian yellow for the highlights on boat and the man's boots.

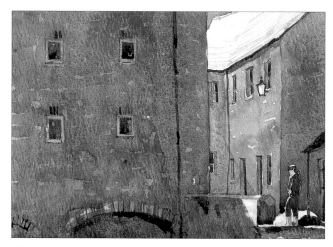

22 Add darks in the windows of the left-hand building. Indicate a few bricks over the windows and add the drain pipe. Develop the deep shadow under the arch and add a couple of dark patches on the low wall.

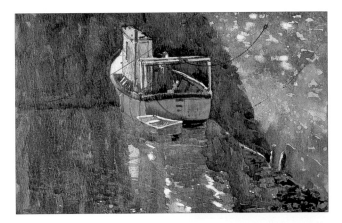

23 Apply a wash of Indian yellow on the white highlights on the boat. Using a dark mix on the palette, paint the mooring ring on the harbour wall and the mooring ropes. Develop the shadowed stern of the boat with Indian yellow, cobalt blue and a touch of brown madder. Darken the area behind the dinghy with more cobalt blue and develop the shadows with darks from the palette. Use manganese blue with a touch of Winsor red to paint shadows on the cabin, then use the darks on the palette to define detail inside the hull of the boat. Add the same darks to the reflections at bottom right.

24 Finally, use white gouache to add fine, bright highlights on all the mooring ropes.

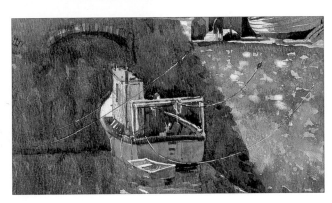

The finished painting.

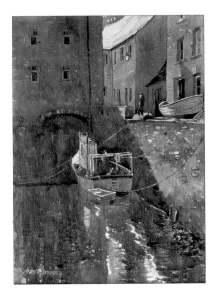

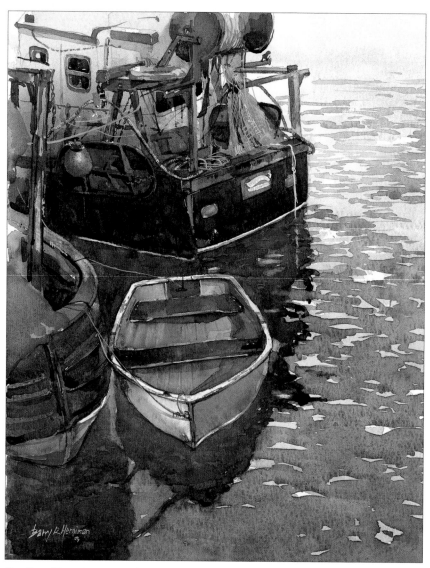

New Coat of Paint, Stornaway Harbour

Size: 290 x 375mm (11½ x 14¼in)

Stornaway harbour, on the Isle of Lewis, always has a whole host of magnificently coloured fishing boats moored up for the night. On this visit, my eye was drawn to this small rowing boat tied up behind the fishing boats and lying in their shadow. It was in the process of being painted blue, hence the two-tone hull!

Boats make wonderful subjects, but they can be quite daunting when you first look at all the lines and details. I tend to simplify things a lot; I concentrate more on the main structures then, when I am happy with those, I use a rigger brush to 'tick' in a few fine details.

Opposite

Morning Light, Tenby Harbour

Size: 350 x 535mm (13¾ x 21in)

Whenever I visit Tenby, I endeavour to take an early morning walk around the harbour. At low tide, you can walk on the sand between the tied up boats. From this viewpoint, looking up at the boats and the buildings beyond, you get a completely different slant on the scene. The small rivulets of water and the crisscross pattern of the mooring ropes and chains make a pleasing detail in the foreground that helps lead the eye into the picture. The main area of light is between the two buildings, top left, and this reflects nicely into the water on the sand.

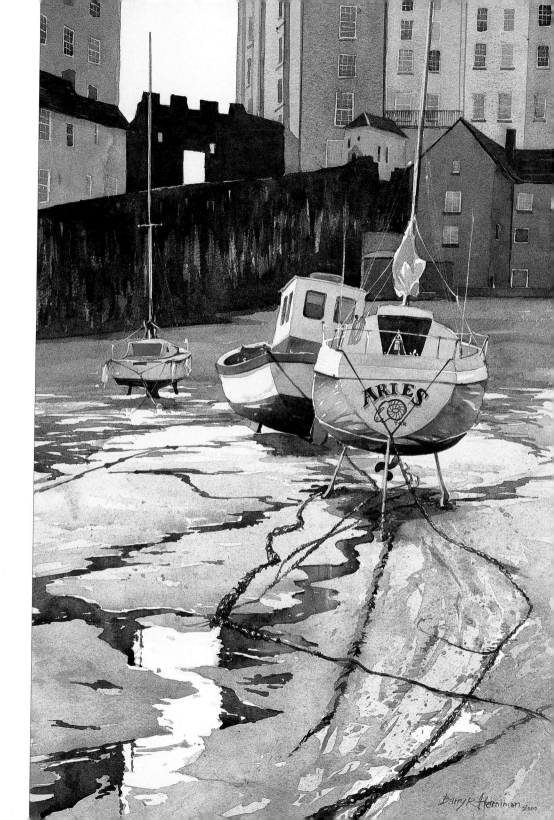

Barry R Herniman
2000

About the authors

The four authors contributing to this book are experienced artists and tutors and they all have their own way of interpreting what they see. They understand completely the problems encountered by students, so the book is practical and packed with expert advice. Each author explains the techniques clearly, with detailed information on how to sketch and how to paint landscapes, skies, flowers, buildings and much more.

ARNOLD LOWREY

Arnold Lowrey has been painting in a variety of media for over twenty-five years. His motivation has been the use of light in painting, but he now experiments more with colour and texture. His seascapes are especially vibrant and full of movement. Arnold also likes painting still life, landscapes, portraits and abstracts. He exhibits his paintings in Wales and London.

Arnold holds regular workshops and weekly painting courses, residential watercolour courses and demonstrations for art societies. He is also a painting demonstrator for several art material suppliers.

WENDY JELBERT

Wendy Jelbert studied sculpture, abstract art, pottery and printmaking at Southampton College of Art. She is a teacher and professional artist who works in pastels, oils, acrylics, inks and watercolours. She enjoys experimenting with different ways of using mixed media and texture, and her sometimes unconventional methods produce surprising and original results.

Wendy demonstrates and lectures to art groups throughout the south of England and teaches locally as well as in leading residential art colleges. She is a member of the Society of Floral Artists, the Society of Women Artists and the Wildlife Society. She lives in Lymington, Hampshire, has three children, two of whom are professional artists and thirteen grandchildren.

Galleries in Cornwall, Hampshire and London regularly exhibit her work, and she writes for both *Leisure Painter* and *Paint* magazines.

Wendy has written sixteen art books and has also made seven videos on a variety of art-related subjects.

Geoff Kersey

Geoff Kersey is an experienced watercolourist and is much in demand as a teacher and demonstrator. With his flowing washes and intuitive use of colour, he captures the essence of his subjects, creating beautiful paintings full of atmosphere, mood and with a great sense of place. He has had articles published in *The Artist and Illustrator* and *Paint magazines* and has also written two books for Search Press and made several DVDs.

Geoff lives and works in the Peak District and runs regular watercolour painting breaks and workshops. He exhibits extensively and many of his paintings are inspired by the landscape surrounding him. They feature meandering rivers, steep dales and valleys, villages and more. He has also been spending time collecting subject material along the Heritage Coast, where the marshes, fens and coast provide a wonderful contrast to his home region.

Barry Herniman

Barry Herniman worked as a draughtsman and surveyor before emigrating to South Africa. He then took up a career in advertising and travelled throughout South America and the USA before returning to the UK in 1980. He became a full-time student at the Gloucester College of Art and Technology where he gained a Higher Diploma in Information Design, then became a member of the Chartered Society of Designers in 1986 and formed his own graphics company in 1988. His first solo exhibition of watercolours was in Ross-on-Wye in 1991 and he soon went on to pursue painting full-time. He now travels extensively tutoring workshops and demonstrating and has had exhibitions in England, Ireland, Canada and the USA. Barry won the Artist of the Year Award for the SAA in 2001 and the Harper Collins Award Patchings 2000. His hobbies include travelling, walking and playing the mandolin.

Index